ART ON THE EDGE AND OVER

ART ON THE EDGE AND OVER

LINDA WEINTRAUB

ARTHUR DANTO
THOMAS MCEVILLEY

SEARCHING
FOR ART'S MEANING
IN CONTEMPORARY
SOCIETY 1970s–1990s

ART INSIGHTS, INC., PUBLISHERS

Published by:

Art Insights, Inc.
Box 626
Litchfield, CT 06759

*Distributed in the U.S., Central America, South America,
Great Britain, Scandinavia, Europe, Australia, Africa,
and Asia by:*
Distributed Art Publishers
155 Avenue of the Americas
New York, NY 10013
Tel: (212) 627-1999
Fax: (212) 627-9484
Toll Free: (800) 338-BOOK

Editor: Lesley K. Baier
Design: Lydia Gershey of Communigraph
Production: Karen Warren and Marjorie Finer of
STUDIO KaMa, NYC
Printed and bound in Hong Kong by Everbest Printing Co.,
LTD.; First Printing
ISBN: 0-9651988-1-2 (soft cover) and
0-9651988-0-4 (hard cover)
Library of Congress Catalogue Card No. 96-86221

Cover:
RIMMA GERLOVINA and VALERIY GERLOVIN
Tic-Tac-Toe, 1990
Ektacolor print, 48 x 48 in.
Courtesy Steinbaum Krauss Gallery, New York

CONTENTS

THE COMMUNAL SELF

PUBLISHER'S COMMENT

ALMOST SIX YEARS AGO, I went to the Whitney Museum of American Art in New York to see an exhibition of contemporary art. I was completely bewildered. I didn't understand what the artists were trying to say, or why their work was considered art at all. A guide was available to give tours and answer questions, but she couldn't satisfy my curiosity or explain away my frustrations.

I went to a leading bookstore to read about the puzzling works I had seen. But there was no book to buy, only a chapter here and there in a variety of books that just touched on the subject or the artists. I spoke to a curator who writes extensively about contemporary art in catalogues and journals. She confirmed that there was no such book in print, that one was needed, but that she was too busy to write it.

Then a friend told me about Linda Weintraub, a curator and writer who for years had heard hundreds of people like me asking the same questions about contemporary art, and had spent two years writing the book that addressed them. *Art on the Edge and Over* discusses these issues in a style and language so clear and accessible that I was reluctant to put the manuscript down. I felt like I was reading a detective story that did much more than ponder the mysteries of contemporary art...it also clarified and enhanced my perceptions of modern culture.

The book includes thirty-five essays, each devoted to an artist Linda interviewed and/or researched. It identifies the aspects of our modern, changing, and overwhelming society that have stimulated these artists to express themselves in new ways and in new media. It points out that when most of us visit a museum or gallery to look at contemporary art, and particularly art on the edge, we still use old thought patterns and biases. We expect the mediums to be painting or sculpture. W expect to evaluate works almost totally through our visual sense. In short, we expec the art to be familiar.

No wonder many of us are confused—or put off—by artworks that use pollen, old clothes, toxic earth, used dolls, a few words, flowers, the artist's own body, consumer products from shopping malls, menstrual blood, urine. These are works that cannot possibly be absorbed simply by looking. The require explanations of the artist's intention point of view, and social environment. This book will help you understand these works, including some that have so outraged everyday citizens, people who are normally indifferent to museum art, that they compelled Congress to reduce—and possibly terminate—all funding of the National Endowment for the Arts.

Not all responses to this art are so passionate. Some people may reject these works as merely uninteresting, or classify them as non-art, or assume that they are made for—and only accessible to—an elite audience. But *Art on the Edge and Over* is written for everyone who is curious about what going on in today's art as well as the worlds we live in. It is like a Rosetta Stone of new ar languages that will make it easier for you to decipher what's in the museums and galleries, and also to enjoy insights about modern-day society. I am sure that after you have read this book, you will first applaud Linda's achievement. And then your own daily life—how you perceive it and react to it—will change enormously, unexpectedly, and for the better.

Ira Shapiro

8

ACKNOWLEDGMENTS

WRITING A BOOK has been likened to a self-imposed sentence of long duration in solitary confinement. I cannot claim any such heroic or self-punishing measures. From the first, this project was supported and my efforts were encouraged. One benefit of publishing this volume is that it provides a forum to publicly acknowledge the contributions of this all-star team:

Andrew Weintraub, who has been a loyal advocate of this endeavor from its inception, through its gestation, to its delivery.

Ira Shapiro, who is an author's dream publisher. This manuscript has been lavished with his business acumen, vision, and devotion.

Arthur Danto and Thomas McEvilley, who wrote the thought-provoking comments that introduce and conclude this volume. Their essays treat readers to two of the greatest minds currently engaged in art analysis.

Ann Middlebrook, project manager; Lesley K. Baier, editor; and Lydia Gershey, designer, who contributed more than their expertise. This project also benefited from the gracious manner in which they enacted their tasks.

Chris Tamagni, Adolfo Vargas, and Karen Warren and Marjorie Finer of Studio KaMa, who contributed generously to this book's production.

The Bard College Center, which provided a fellowship supporting my initial research.

The artists' studio assistants and gallery representatives, who greatly facilitated the preparation of this book.

But above all, it is the artists themselves who must be honored. They originated the ingenious solutions and astute observations that comprise the content of this book. Their artworks promise to delight audiences and challenge art historians for generations to come.

Linda Weintraub

INTRODUCTION

THE ARTIST, Andres Serrano, models khakis for the Gap. What greater proof of celebrity status does our culture provide? Evidently, Gap executives believe that Serrano is good for business, an astonishing fact since his work exists at the epicenter of a fierce, national art dispute. Pious citizens condemn his art as a religious sacrilege. Art critics and curators praise it as a visually resplendent comment on church doctrine. The artist identifies it as a personal search for faith.

And what does Serrano mean to the kids, teens, and young adults who are the Gap's primary customers? Perhaps wearing Gap's mass-produced, mass-marketed clothes now carries the aura of rebellion against the establishment. Possibly it demonstrates the Gap's multicultural sympathies. Maybe it indicates that being an artist carries status. Certainly, this tall Hispanic male with electric eyes presents a captivating image as both fashion model and role model.

Hanging a corporate logo on a renegade artist typifies the convoluted position of art in the 1970s, 80s, and 90s. This is no tidy contest between traditionalists and vanguardists. Conflicting agendas and dissonant voices have multiplied to produce a cacophony of condemnations and commendations of today's art. Nonetheless, one rule seems to apply to all: emotions flare in proportion to a work's deviation from established canons. The more lavish the praise from one group, the more vehement the scorn from the other.

Today's artists violate conventions once considered fundamental to art. Their work raises such questions as: Is it art if it doesn't sit on a pedestal or hang on a wall? If it isn't made by the human hand? If it isn't the product of an inspired moment? If it isn't enduring or pleasing? If visual stimulation is not the artist's primary concern?

This book explicitly addresses such questions, but it avoids standard art-survey approaches. It eliminates movements, because today, artists are more distinguished by theme than style. It omits medium as the organizing scheme, because so many living artists adopt multiple means of expression. It also rejects chronology as a serviceable framework, because art at the end of the twentieth century changes too quickly and is too multifaceted to be resolved into neatly ordered progressions. Most significantly, its interpretations are not based on the search for art historical precedents or on unmanageable complexities of theoretical discourse. Instead, explanations are grounded in the familiar experiences and common sights that have propelled art into new domains.

In this book, thirty-five deviations from standard artistic behavior are explored by relating each to one specific artist. These artists have all earned distinguished reputations. But their credentials in the art world have not exempted them from accusations of violating their obligation to broader audiences. Most have transformed art so radically that few people can decipher meaning in the work they produce. This book hopes to demonstrate that the strangeness of their work is not intended as an affront. Visual languages, like verbal ones, have never been static constructions. Imagine, for instance, if we had only Ben Franklin's vocabulary to describe scud missiles, cyberspace, and satellite transmissions. Artists respond to change by inventing new art syntax and grammar that are capable of conveying

their experiences. Necessity motivates them to tease and stretch the vocabulary that has traditionally sufficed in art, sometimes going "to the edge," sometimes going "over."

The artists in this book have devised a tumultuous array of unlikely options to match the scope, speed, and complexity of current events. They respond to the dynamics of the media-permeated environment; the illusions generated by Hollywood and Madison Avenue; the crisis of a defiled environment; the trends originating from Silicon Valley, Wall Street, and Pennsylvania Avenue; the sensibilities formed by digital imagery, fiber optics, superhighways, decibel-detonating music, supersonic speeds; and the clash of competing goods in the marketplace. Some artists celebrate these new determinants of contemporary experience, but others resist, escape, or attempt to correct them.

The bewilderment that often accompanies encounters with contemporary art exists because we check our real-life sensibilities at the museum coatroom. But the same events that control our lives are catalysts for change in art. Thus, if we view today's art from the perspective of everyday life, our receivers will be tuned to the artists' transmissions.

Art on the Edge and Over is dedicated to this tuning process. Wherever possible, artists participate through the incorporation of their words into the text. These quotes invite readers to compare motivations with end-products, and to supplement their art experience with verbal evidence of the artists' agile minds. Many of these statements disclose the intention to challenge complacency and disrupt belief systems. But they also confirm that these effects are rarely ends in themselves. Instead, they are strategies employed to engage an audience that, today, tends to be disinterested, complacent, or already overloaded.

Neither the artists' statements nor the author's commentaries are intended to dictate the reader's own responses. They are offered to initiate dialogues, and in this way to encourage everyone to pursue a personal engagement with the art of our contemporaries. All art, but particularly the vanguard art produced since 1970, fulfills its potential only if an active search for meaning is undertaken. This potential pays dividends far beyond the gallery or museum. By intensifying our perceptions, exciting our intellects, stirring our souls, and interpreting our dilemmas, artists help guide our passage through today's perplexing world.

Linda Weintraub

WHY DOES ART NEED TO BE EXPLAINED?

HEGEL, BIEDERMEIER, AND THE INTRACTABLY AVANT-GARDE

ARTHUR C. DANTO

IN THE INTRODUCTORY PAGES of his stupendous lectures on aesthetics, delivered in their final version in Berlin in 1828, Hegel offered his hopeful hearers some dismal thoughts on the future and indeed on the present condition of art. "Considered in its highest vocation," he wrote, "art. . .is and remains for us a thing of the past." It was not, he meant to say, that art was going through some particularly bad patch. It was rather that, in terms of what it had once been able to furnish the human spirit, art was over with and done. "Neither in content nor in form is art the highest and absolute mode of bringing to our minds the true interests of the spirit," Hegel wrote. "The peculiar nature of artistic production and of works of art no longer fills our highest need." He continued, "It is certainly the case that art no longer affords that satisfaction of spiritual needs which earlier ages and nations sought in it and found in it alone, a satisfaction that, at least on the part of religion, was most intimately linked with art. The beautiful days of Greek art, like the golden days of the later Middle Ages, are gone."

Hegel's extraordinary speculation on the end of art seems to imply that it had once been true that art spoke immediately and directly to the hearts and minds of human beings, without the mediation of interpretation or critical thought. It was his view that we had outgrown this possibility, and that, whatever art was to do or be from this point on, it had, as he put it, "lost for us its genuine truth and life." This must have come as an immense disappointment to his hearers, for German artists felt themselves poised on the threshold of a new civilization in which art would play as fundamental a role as it had in ancient Greece. What instead was happening, Hegel appeared to argue, was an ever widening gap between art and life. "Art invites us to intellectual consideration, and that not

for the purpose of creating art again, but for knowing philosophically what art is."

Profound a thinker as he was, Hegel would not have been able, in 1828, to foresee the kind of work that was to make up the history of art over the succeeding decades. And even his interpretative powers would be daunted by the kind of art men and women of the late twentieth century are obliged to call their own. There would have been no way in which, for example, most of the art described in this volume—art of the present moment—could even have been accepted as art in Hegel's era. The actual art of that era is known as "Biedermeier," which was, like so many artistic labels, meant to connote ridicule: Biedermeier was a fictional character who, ignorant of art and poetry, embodied the solid if philistine values of the middle-class German who liked pictures he could recognize by artists who showed they could paint by filling their pictures with minute and, if possible, amusing detail. Biedermeier furniture is as solid as the bodies that sat in it, and makes a point of its workmanship. Biedermeier architecture, utilitarian and unostentatious, projected the good old-fashioned virtues of those it sheltered.

Herr Biedermeier enjoyed sentimentality and humor, and it certainly would have been difficult to imagine that Biedermeier aesthetics held promise of satisfying the highest spiritual needs of humankind! But neither could most of the art described in this book have been accepted as art by Biedermeier criteria. Of course the art of our time is separated from those whose art it is meant to be by a far wider gap than anything the Biedermeier era could have known. But in its way contemporary art really does struggle to meet the challenge Hegel put: it tries to do for the human spirit what Hegel supposed philosophy alone could do. The obstacle it faces is to close the gap when in truth the aesthetic tastes of average men and women today are far more Biedermeier than the passage of time would indicate.

For the past few years, the Russian emigre artists Vitaly Komar and Alexander Melamid have undertaken to discover what sort of art people really prefer. Famous for the wit and biting political satire of their art, Komar and Melamid were forced into exile

"The works discussed here cannot easily be thought of as becoming good aesthetic citizens. They define, rather, a limit that will always be a limit. It is no part of their intention to be accepted in the way in which even avant-garde art before has been accepted. Their intention is to change the world, and if that happens they have no further reason to exist."

as dissidents, but with the breakup of the Soviet empire, they lost their target and in a way had to reinvent their artistic agenda. Clever satirical stabs at Stalin and Lenin were no longer particularly relevant to a Russia gone capitalist. So, since the free market was all at once celebrated in Eastern Europe as the path to prosperity and freedom, they hit on the idea of using the mechanisms of market research to help them discover their own path. The decided to use questionnaires and scientifically designed opinion polls to learn what kind of art people would choose. And then they would produce that art— would produce what they wryly termed "The Most Wanted Painting." This turned out to be a landscape of a certain size, with a lot of blue sky. Since those they canvassed liked the idea of historical personages in a landscape, or families having a nice time, or wild animals, Komar and Melamid generously gave them all three. "The Most Wanted

Painting" had George Washington, an American family in outdoor clothing, and a hippopotamus in the river, along with feathery trees painted with a nineteenth-century exactitude.

Komar and Melamid first exhibited their painting in a New York space, framed in gold and, of course, protected by a red velvet rope. (Since blue was far and away the "most wanted color," visitors were served blue vodka.) The painting itself could hardly be more Biedermeier. It was pretty, sentimental, and funny. But it was, exactly, what scientific opinion research and the use of focus groups demonstrated that an objectively selected sample of the American population most liked in art. A follow-up study in Russia led to nearly the same result, as did similar studies in France, the Scandinavian countries, and Kenya. A team of researchers is completing a comparable poll in China, knocking on doors

> *"...people are almost universally unprepared to respond to the vanguard art of our present age. They are indeed unprepared, almost as if they belonged to an earlier century, to acknowledge it as art!"*

because of the lack of telephones. It might not be surprising that Denmark aesthetics is Biedermeier, inasmuch as the Biedermeier movement encompassed Denmark in the years of its ascendancy. But that can hardly have been true of Kenya! The overall outcome is that the Biedermeier landscape has become virtually an a priori aesthetic universal—what most people have in mind when they think of art. And if that is true, people are almost universally unprepared to respond to the vanguard art of our present age. They are indeed unprepared, almost as if they belonged to an earlier century, to acknowledge it as art!

Even a more sophisticated populace, at home in museums of modern art, knowledgeable through university courses and travel with the art of this century, hospitable to what it considers experiment in the visual arts, will have great difficulty in responding

to the bulk of the works presented here. That is because this art is what I would term *intractably* avant-garde. And by this I mean that a certain sort of narrative will have no application to it. The narrative I have in mind is the familiar one of the advanced art of a given time being scorned by critics and condemned as unacceptably wild by more casual viewers, which then, by a predictable reversal of taste, all at once is found to be acceptable, and actually quite pleasing, and finally transcendently beautiful. The standard example of this of course is the art of the Impressionists. It is almost impossible to understand, in view of their familiar popularity today, how critics and collectors at one point felt that the artists who painted under that label were inept and cynical, and out only to shock. The paradigm Impressionist canvas, of seashore or meadow or Parisian boulevard or revellers by the riverbank or seated under umbrellas at outdoor cafes, is so pleasing, so aesthetically delicious, that even those with Biedermeier preferences should be able to accept it with equanimity. And whatever the resistances initially, it found its way into the gold frame and behind the protecting velvet ropes, and became classed with the artistic treasures of the world.

The same thing happened, of course, with Van Gogh and Gauguin. Women fainted at Gauguin's exhibitions, and Van Gogh sold nothing in his lifetime. But when nations today mean to demonstrate their level of civilization and their attitude of friendship, they can make no more significant gesture than to send their Gauguins and Van Goghs abroad. So much is true of Matisse, Modigliani, and Picasso. So much, indeed, is true even of Jackson Pollock and Willem de Kooning. Their canvases, initially accepted by a narrow circle of admirers, become democratized, and everyone learns to respond to them. Probably the extraordinary prices brought at auction in the past season by Warhol and Lichtenstein show that Pop art too has

passed the test, and now belongs to the domain of visual beauty as defined by these examples.

I think it fair to say that nothing like this will ever happen with most of the art described in this book. It is intractably avant-garde in the sense that it will never become something that pleases the eye and enlivens the spirit. It will never become the ornament of a museum's collections. It will never be segregated off by the gold frame and the velvet rope. It is difficult in some cases to know how to deal with it in terms of the attitudes appropriate to the museum of fine arts. The works discussed here cannot easily be thought of as becoming good aesthetic citizens. They define, rather, a limit that will always be a limit. It is no part of their intention to be accepted in the way in which even avant-garde art before has been accepted. Their intention is to change the world, and if that happens they have no further reason to exist.

From perhaps the mid-1960s on, two changes, one internal to the history of art and the other internal to the history of society, combined in such a way as to produce works of art of a kind, and in a variety, that had never been seen before. The internal change involved the abandonment of painting as the central form of artistic expression. Up until then, the great changes of modernism, beginning with Impressionism and proceeding in a sequence of revolutions from Neo-Impressionism through Cubism and Fauve, to abstraction, Surrealism, Abstract Expressionism, and Pop, had as it were taken place within the implicit space of the picture frame: they were changes in form and content, and of course, each initially injured the expectations that those who admired paintings had formed. But then, in part because pictorial space itself was never especially abandoned as the scene of artistic experiments, those who were interested in art learned to accept and even to love what had at first been resisted. By the mid-sixties, pictorial space was no longer the scene of revolution: artists moved outside the picture into forms of productions quite unprecedented, for the understanding of which pictorial aesthetics was of relatively little use. There were happenings, there was performance, there was installation, there was that shapeless array of avant-garde gestures known as Fluxus, there was video, and there were mixtures of multimedia artworks—combinations of readings, performances, video, soundwork, and installation. There was fiberwork and body art and street

"The experience of art becomes a moral adventure rather than merely an aesthetic interlude."

art and outdoor art, by artists who accepted and even endorsed ephemerality.

That was the internal change. Art no longer was viewed as a progressive developmental history, but as a diffuse, polymorphous, fluid, and interpenetrating set of endeavors that underwent constant change: a process in which artists themselves as well as, ultimately, the whole infrastructure of the art world—the collection, the gallery, the art journal, the art critic, the work—were inevitably redefined.

The external change was due to the fact that artists often found themselves increasingly involved in political causes and concerned to put their art to work in effecting social change, and the internal change in the modes of artistic expression placed at their disposition the widest imaginable array of means. They no longer had to rest content with painting pictures of what they wanted to call attention to. In the sixties, and through the seventies and on into our own decade, artists became committed to work for change in the mutual perception and treatment of the genders and the races. Feminism, the various liberationist movements, and such causes as the violation of the environment inevitably entailed that art was politicized if not radicalized. The old opposition between capitalism and communism, the old class conflicts between owners and workers, gave way to a menu of oppositions and confronta-

tions in which art was believed to be a means to social change. It would be that because its aim was the bringing to consciousness and then the overcoming of whatever it was for which the artist sought remedies. And there were so many causes and such a variety of artistic menus that the art world took on the form of a cacophony of indignant voices. The culmination of this was the widely resented Whitney Biennial exhibition of 1993, which had the air of a convention of moral enthusiasts, with the consciences of the audience as their collective target. The audience, carrying within its collective mind the Biedermeier aesthetic which the work of Komar and Melamid has brought to the surface, felt itself attacked and oppressed. Felt itself the true victim of all the artists proclaiming victimhood on their own behalf.

The mistake—or one of the mistakes—of the 1993 Biennial was to put together in the format of an exhibition a number of works that in various ways were challenging the institutional infrastructure of the art world. That format, ideal for seeing paintings or pieces of sculpture, caused the works to cancel one another out by their raucousness. What the exhibition demonstrated was that the exhibition is no longer the ideal format

external and too—visual. No word has been found with which to replace it, but perhaps "encounterer" might be appropriate until a better term can be found. One must set forth to encounter the works, to meet them on their own terms, one at a time, to see what they are trying to say, and what they are trying to bring about as a consequence of the encounter. The experience of art becomes a moral adventure rather than merely an aesthetic interlude.

This makes a guidebook indispensable. Linda Weintraub, an experienced curator and a dedicated educator, is at home with the intractably avant-garde of this moment in history. She has gone to immense pains to put into the reader's hand a description of its objects and their purposes, explaining a set of serious works of a kind never before encountered in the history of world art. It is art that really attempts to meet Hegel's challenge by rising to the level of philosophy while at the same time remaining concrete and physical. It is an art, certainly, that requires thought in order that it be encountered productively. It is an art that exacts sacrifices of its practitioners no less than of those who encounter it, if only, in the latter case, sacrifice of their underlying Biedermeier predilections. It is an exciting moment in the history of art, but a very different moment from any our predecessors have lived through. And because of its resistance to institutional absorption, we have to encounter this art in terms the history of viewing has not prepared us for. Just as there is

> "It is an exciting moment in the history of art, but a very different moment from any our predecessors have lived through. And because of its resistance to institutional absorption, we have to encounter this art in terms the history of viewing has not prepared us for."

for the intractably avant-garde artworks of the present moment. After all, their intentions are not Biedermeier and are not even aesthetic. Their intentions are to change the state of being of the viewer. Too many changes were being asked for all at once in the Whitney Biennial of 1993. These works should instead address the viewer singly. The word "viewer" is itself in need of change. The experience of viewing is altogether too

no art like it, there is no book like the present book. I am beyond measure grateful that Linda Weintraub has undertaken the immense labor that making this art available must have required. All of us who care about art, but more important, who care about what this art itself cares about—and these are the issues that affect us most closely in our humanity and moral being—are greatly in her debt.

ANDRES SERRANO
Piss Christ, 1987. Cibachrome, silicone, plexiglas, and wood frame, edition of 4, 60 x 40 in.

Courtesy the artist and Paula Cooper, Inc., New York

ROSEMARIE
TROCKEL
Balaklava Series (5),
1986. Wool hat,
edition of 10

Courtesy Barbara
Gladstone Gallery,
New York

DONALD SULTAN
Plant May 29 1985,
1985
Latex paint and tar
on vinyl composite
tile on masonite,
96 x 96 in.

Courtesy the artist

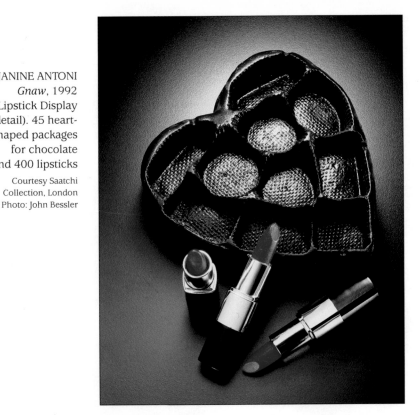

JANINE ANTONI
Gnaw, 1992
Lipstick Display
(detail). 45 heart-
shaped packages
for chocolate
and 400 lipsticks

Courtesy Saatchi
Collection, London
Photo: John Bessler

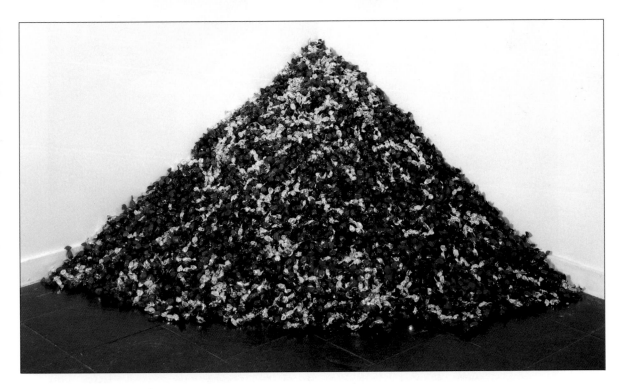

FELIX GONZALEZ-TORRES
Untitled (USA Today), 1990. Red, silver, and blue cellophane-wrapped candies, endless supply. Ideal weight 300 lbs.
Collection The Dannheisser Foundation, New York

Courtesy Andrea Rosen Gallery, New York. Photo: Peter Muscato

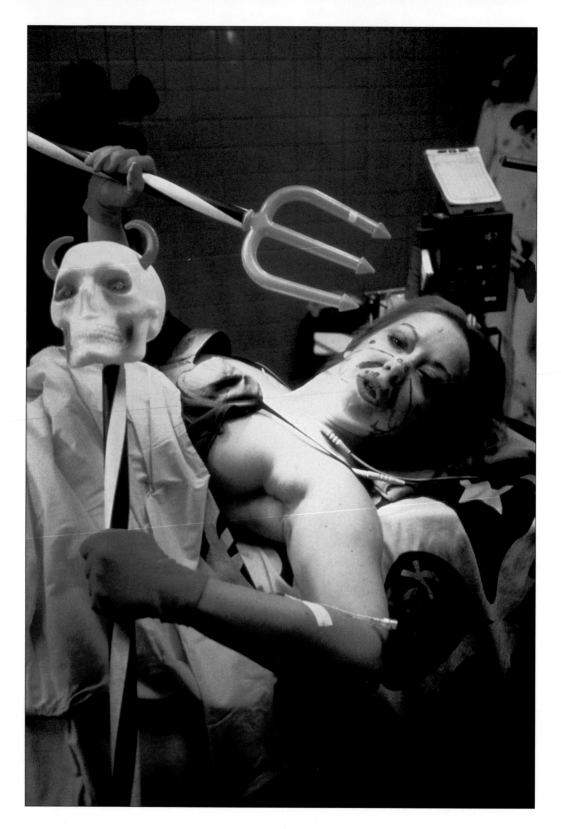

ORLAN
Trident and Skull, 1991. Cibachrome in diasec vacuum, 43³/₈ x 65 in.

Operation conducted by Dr. Kamel Cherif Zahar in Paris. Costume by Frank Sorbier. Accessories and decor by Orlan. Performance by Jimmy Blanche. Courtesy the artist and SIPA-Press. Film: Alain Dohme

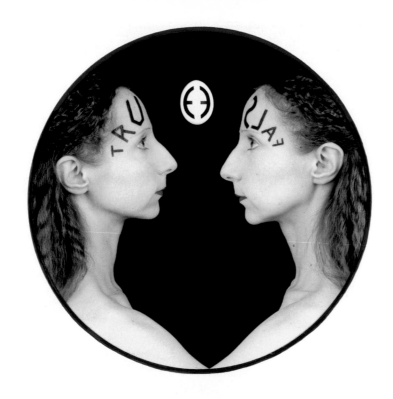

RIMMA GERLOVINA
and VALERIY GERLOVIN
True-False, 1992
Ektacolor print,
48 in. diameter

Courtesy Steinbaum Krauss
Gallery, New York

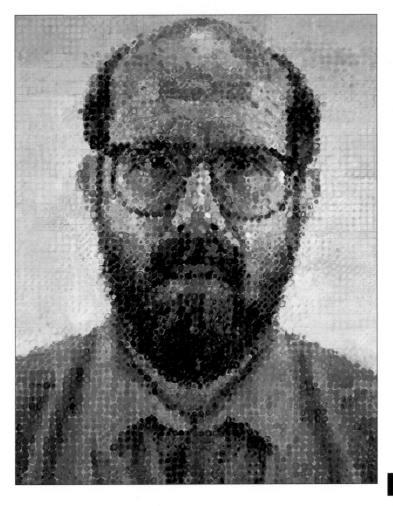

CHUCK CLOSE
Self-Portrait, 1986
Oil on canvas,
$54^{1}/_{2}$ x $42^{1}/_{4}$ in.

Courtesy the artist and
Pace/Wildenstein
Photo: John Back

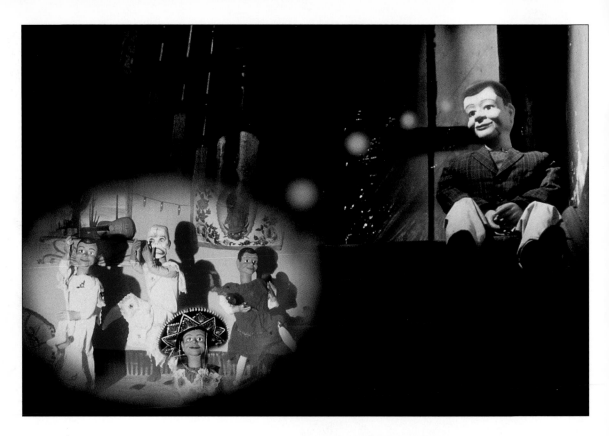

LAURIE SIMMONS
Mexico, 1994
Cibachrome,
35 x 53 in.

Courtesy the artist and
Metro Pictures, New York

TOMIE ARAI
*Self-Portrait
with Fan*, 1992
Mixed media
Courtesy the artist

DAVID SALLE
Mingus in Mexico, 1990 (with detail). Acrylic and oil on canvas, 96 x 123 in.

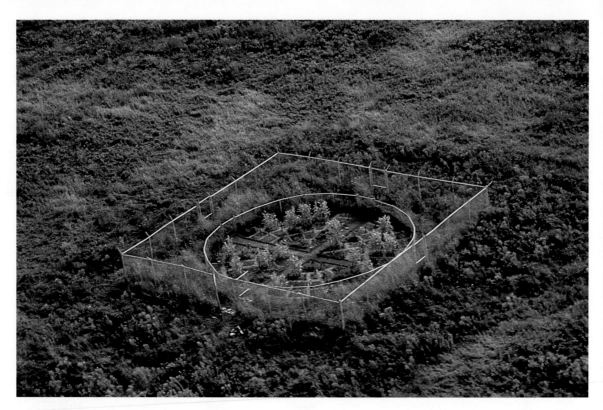

MEL CHIN
Revival Field, Pig's Eye Landfill, St. Paul, Minnesota, 1993. Aerial view
Courtesy the artist. Photo: David Schneider

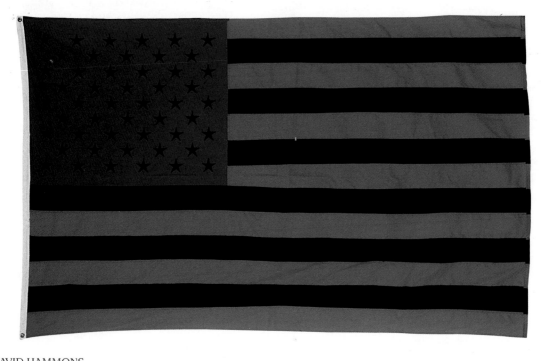

DAVID HAMMONS
African American Flag, from *Whose Ice is Colder?* 1990. 60 x 96 in. Installation at Jack Tilton Gallery, New York
Courtesy Jack Tilton Gallery, New York. Photo: Ellen Wilson

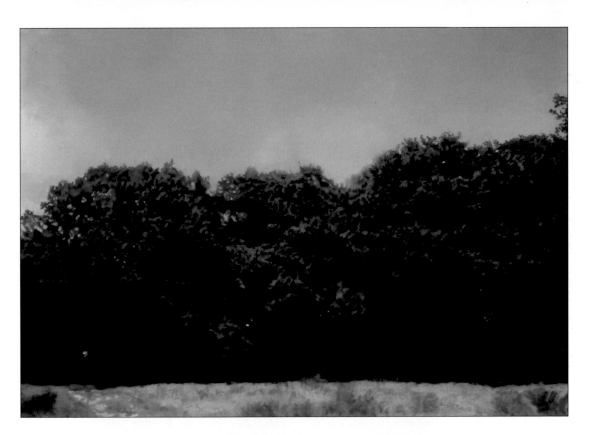

GERHARD RICHTER
The Trees, 1987
Oil on canvas,
52 x 72 in.

Courtesy Marian Good-
man Gallery, New York

GERHARD RICHTER
*592-3 Abstract
Painting*, 1986
Oil on canvas,
$31^1/_2$ x $25^1/_2$ in.

Courtesy Marian Good-
man Gallery, New York

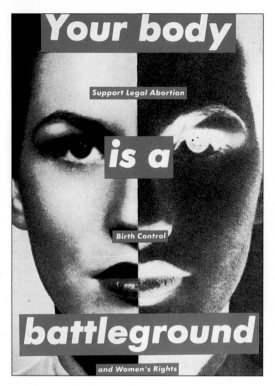

BARBARA KRUGER
Your Body is a Battleground. Postcard, 6 x 4$^{1}/_{4}$ in.

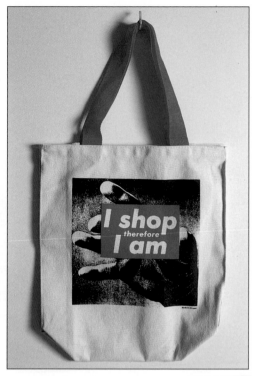

BARBARA KRUGER
I Shop Therefore I Am. Tote bag, 14$^{1}/_{2}$ x 17 in.
(plus strap)

Courtesy Mary Boone Gallery, New York

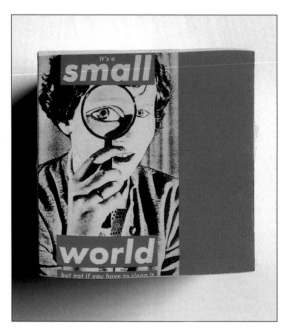

BARBARA KRUGER
It's a Small World, but not if you have to clean it
Note cube, 2 x 2 x 2 in.

Courtesy Mary Boone Gallery, New York

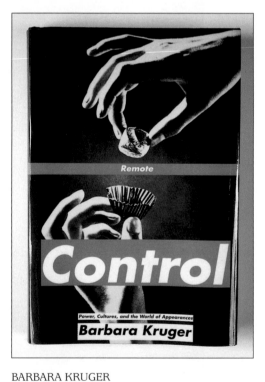

BARBARA KRUGER
Remote Control, Power, Culture, and the World of
Appearances. Book, 9$^{1}/_{2}$ x 6$^{1}/_{8}$ x 1$^{1}/_{8}$ in.

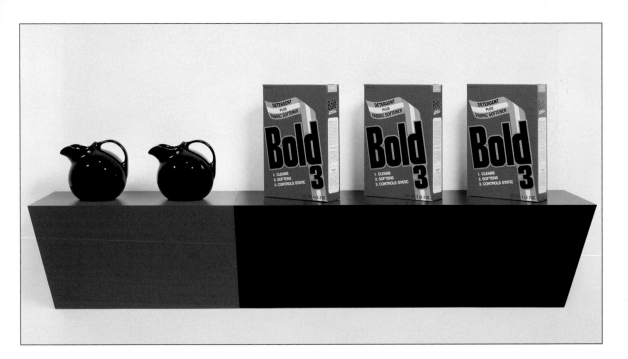

HAIM STEINBACH
Supremely Black, 1985. Mixed media construction, 29 x 66 x 13 in.

Courtesy the artist and Sonnabend Gallery, New York
Photo: Lawrence Beck

JEFF KOONS
Ushering In Banality, 1988. Polychromed wood, 38 x 62 x 30 in.

Courtesy the artist

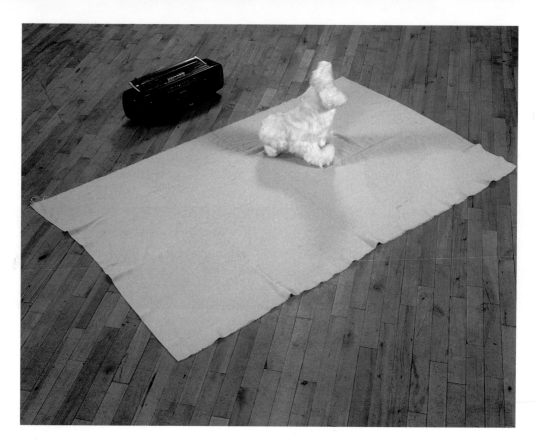

MIKE KELLEY
Dialogue #5 (One Hand Clapping), 1991. Blanket, stuffed animals, and cassette player, 74 x 49 x 11 in.
Courtesy the artist and Metro Pictures, New York

MEYER VAISMAN
*Untitled Turkey XVI
(Peg)*, 1992
Synthetic hair, steel
wire, bobby pins,
stuffed turkey, and
mixed media on
wood base,
33 x 28 x 14 in.
(turkey),
31 x 21 x 29 in. (base)
Collection Jay
and Donatella Chiat,
New York
Courtesy the artist
Photo: Steven Sloman

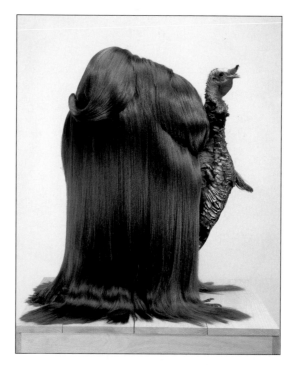

CAROLEE SCHNEEMANN

Artist creating *Hand/Heart for Ana Mendieta*, 1986. Center panel of triptych: chromaprint of action painting. Blood, ashes, and syrup on snow, 46 x 18 in.

Courtesy the artist. Photo: Dan Chichester

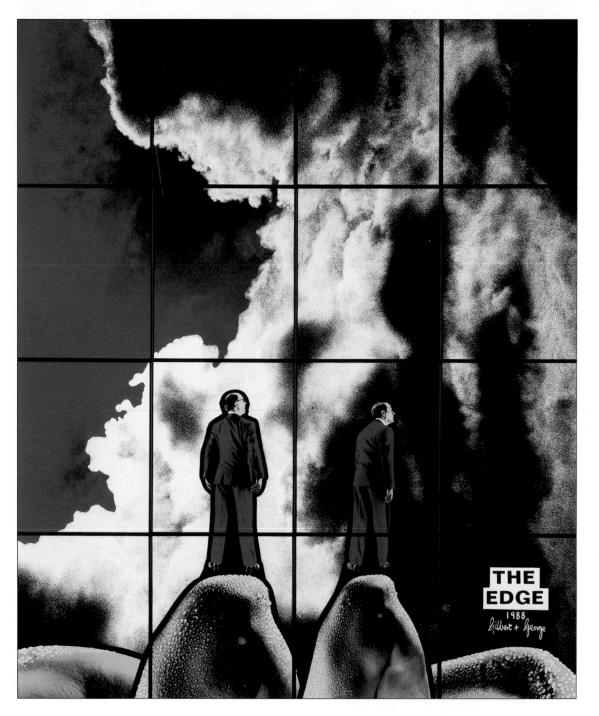

GILBERT and GEORGE
The Edge, 1988
Black-and-white photographs handcolored,
mounted and framed, 94$^7/_8$ x 79 in.

Courtesy the artist

ANDREA ZITTEL ▶
Perfected Pillow, 1995
Velvet upholstery fabric, trim, zippers.
Edition of 38 plus 1 prototype.
Bed 40 x 80 in., pillow 18 x 36 in.

Courtesy Andrea Rosen Gallery, New York
Photo: Peter Muscato

PAUL THEK
Ark, Pyramid, 1972. Mixed media, dimensions variable. Installation: Documenta 5, Kassel
Courtesy Alexander and Bonin, New York

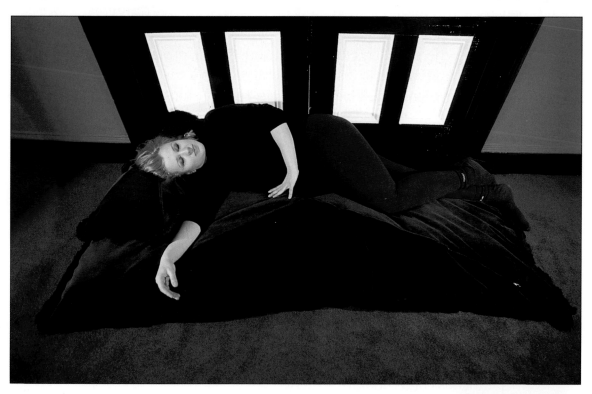

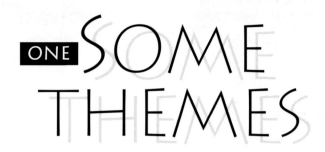

ONE SOME THEMES

NATURE THE ARTIST THE COMMUNAL SELF

THEME is typically the generative force that kindles an artist's desire to create. Many themes being addressed today are new not only within the history of art, but within the whole history of the human race. Contemporary artists are pioneers, the first to react to the impact of the media, ecological disaster, gender role instability, information proliferation, the inversion of time, the decoding of life. Because these subjects are without precedent, the means to convey them are not readily discovered in the annals of past art. They transcend not only conventional styles of expression but also traditional methods of art's production. Yet instead of concluding that they lie beyond the province of art, today's artists frequently invent novel tools suited to the task of communicating novel subjects. Emboldened by the urgency of their messages, these artists introduce new materials for fabrication, new processes of creation, and new manners of public presentation.

Theme, therefore, lays the groundwork for the deviations from artistic norms that are in dispute among today's art-viewers. The first two sections of this book explore artists' relationships with nature and with self.

The third section explores the communal self. In the past, Western artists tended to give form either to their individual personalities or to universal truths. Neither tendency prevails today. The concept of self succumbed to the anonymity of life in a high-tech, mass-marketing society. The concept of universality vanished with the erosion of faith in absolute, timeless truths. Many artists have responded by sub-stituting the concept of group self. They define identity according to collective nouns designating ethnicity, sexual preference, gender, or race. As a result, the work of white male artists and the tastes of white, educated audiences are no longer privileged as the norms. They represent one approach among many. Each chapter in this section presents one artist who has added a voice to the multicultural chorus that enriches contemporary society.

LAURIE SIMMONS perpetuates the tradition of realism in art, but her work does not look natural. She has created a confederacy of dummies that simulate human activities in settings where every detail describes the consumer utopia concocted by the media. Because no television viewer can be immune to TV's impact, these scenes mirror the collective myth of our era.

Laurie Simmons

Caroline's Field, 1994. Cibachrome, 35 x 54 in.
Courtesy the artist and Metro Pictures, New York

Simmons's work demonstrates that our sense of what is real in contemporary life is more likely to be represented by the M*A*S*H* mess hall, the Cheers bar, and Seinfeld's apartment than by weather, season, climate, and terrain. Its artificiality exposes the dominance of media-induced experiences over natural ones.

Detachment from NATURE

Laurie Simmons

Born 1949, Long Island, New York
Tyler School of Art, Philadelphia, Pennsylvania: BFA
Lives in New York City

See colorplate 6, page 22

IMAGINE the beginning of a typical day for a typical woman living at the end of the twentieth century. The birds are still asleep. The sun has not yet risen. It is the digital alarm by her bedside that announces the start of her day. She lifts her head from the foam-rubber pillow, casts aside her Dacron blanket, and shuffles across the nylon carpet to the vinyl-tiled floor of the bathroom, where she removes her polyester

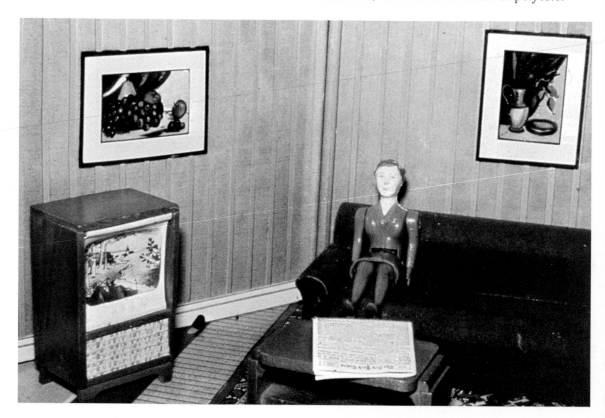

LAURIE SIMMONS
Woman Watching TV, 1978
Color photograph,
5³/₄ x 8³/₄ in.
Courtesy the artist and
Metro Pictures, New York

nightgown and dons a rayon dress. She then settles on a plastic chair beside the formica table to eat a simple breakfast of food that has likely been refined, processed, decaffeinated, preserved, bleached, flavored, puffed, freeze-dried, and genetically altered.

In this first hour of every day, she has flicked the switches on lights, coffeemaker, hairdryer,

toaster, television, microwave, toothbrush, razor, dishwasher, contact lens cleaner, and computer. She hears newscasters several states away chatting about events beamed to her via satellite against a backdrop of traffic, sirens, and engines. Sensations produced by human contrivance for human convenience dominate her sight, touch, smell, taste, and hearing. Many of these stimuli did not exist fifty years ago.

Her home, her car, her workplace are cocoons designed to insulate her from nature and its annoyances: bugs, dirt, mold, and discomfort. Nature is welcome only as the fulfillment of some marketing strategy. Pine scent originates in the bathroom air freshener. Mountain dew is a soda. Wintergreen is a backrub. Sunny delight is a juice.

Nature has long supplied art with subject matter, metaphors for states of being, and irrefutable canons of proportion. But as nature has lost its preeminence in human experience, it has relinquished its impact on art. Many artists living in an environment that is more artificial than natural have reconsidered nature's once honored position. In their art, as in life, nature is usurped by manufactured objects and synthesized sensations.

Laurie Simmons, for example, has severed her work from an allegiance to nature. If her images refer to the natural world at all, they do so by reflecting a version of it fabricated by the Wild Kingdom, the Enchanted Village, Magic Mountain, Marine World, the Hawaii Dolphin Show, Gorillas in the Mist, Smokey the Bear, Barney, Big Bird, and Yogi Bear. Adjectives describing these media fabrications also apply to Simmons's works of art. Most begin with such prefixes as "hyper," "super," or "pseudo."

Simmons has helped redefine the tradition of realism in art by attuning her imagination to an environment of special effects. *"I realized early on that artifice attracted me to an image more than any other quality—I mean artifice in the sense of staging and heightened color and exaggerated lighting, not a surreal or fictive moment . . . I think the lighting and feeling of Cinemascope, the movies I saw as a kid, always stayed with me as a kind of glorious vision of reality."*[1] Her blatant acceptance of artificiality

suggests that the word has lost its negative connotation. "Artificial" no longer implies phony, mock, abnormal. At the same time "naturalism" has lost its monopoly on such affirmative attributes as proper, genuine, and beneficial. Artificiality has earned its own aesthetics and its own appeal. It has come to provide the thematic and aesthetic resources from which Simmons and many of her contemporaries draw.

> **"People are much more willing nowadays to believe that pictures lie than {that} they can express any kind of truth."**

Simmons's tableaux take the form of miniature domestic interiors and theatrical stage sets, which she meticulously furnishes with little couches, cans of soup, pictures, rugs, wallpaper, and, of course, televisions. None of the flora and fauna introduced into these settings have ever been alive. They came into being in factories. Even humans are represented by plastic and molded surrogates, dolls and puppets that are posed taking baths, preparing food, reading newspapers, and so forth. These intentionally stultified arrangements are appropriately described as "still lifes." Suggesting the perfectly controlled environments of black-box theaters, or windowless office buildings, or climate-controlled shopping plazas, they coincide with an era in which weather prediction derives from televised reports, not from personal observation of clouds and animal behavior. We live in a time when breezes emit from air conditioners, moonlight succumbs to streetlights, and rocks and shells are sold in "Nature Stores."

Simmons does not exhibit these tableaux as sculpture, nor does she employ them as subjects for painting. Instead she photographs them, utilizing a tool that has outstripped the brush and the chisel as an agent of fiction and a source of visual stimulation. The camera is intrinsic to an age in which the firsthand sights and sounds of nature have been eclipsed by their mass-media fabrications. The photograph's artificiality is highlighted in Simmons's work: *"I think of scientific veracity as an idea from the past—the scientists say it is so, the photo is proof. Even the authoritative power of the word 'actual'—an actual what? An actual retouched photo, an actual collaged photo? People are much more willing nowadays*

to believe that pictures lie than [that] they can express any kind of truth."[2]

Stylistically, Simmons rejects the camera's potential for capturing spontaneous, accidental, and hence "naturalistic" effects. She purposefully adopts the calculated constructions used in the media: the cropping, zooming, and highlighting that dramatize subjects.

Simmons's photographs of pseudo-characters in pseudo-situations constitute realistic art for an era in which people conduct both work and leisure activities in synthetic settings, not natural environments. Lives that were once spent out-of-doors—ranching, pioneering, home-steading, mining, and farming—are now spent under roofs sitting in front of desks or assembly lines, or settled into couches in front of televisions. It is through detachment from nature that Simmons fulfills her intention to *"dissect the American dream and the unconscious."*[3] People really do choose astroturf over grass, polyester over silk, margarine over butter, visits to Disney World over trips to the Grand Canyon. In works like *Mexico, Caroline's Field*, and *Chicken Dinner*, all of 1994, Simmons plays the role of a ventriloquist or puppeteer examining the desires and discontents of real people impersonated by inanimate figures in contrived settings.

Mexico features the interior of an elegant home located north of the Mexican border. The title refers to the reverie that absorbs the central figure, a snappily attired dummy. He is a generic version of the affluent white male in mainstream society. A balloon encircles his thoughts. It divulges that the dummy is contemplating an escape from his materialistic comforts and social

Simmons raids the mood-enhancing devices of Hollywood and television to compare the sultry world of the dummy's desires to his tepid reality. The Mexican scene is bathed in joyful, rosy light, whereas the dimly lit interior of the Western setting is cast in sober tones of brown, black, and blue. Likewise, the dummy's fantasy is crowded with figures reveling in sensual pleasures, whereas his own environment is static, cool, solitary.

In *Caroline's Field*, a dummy sits in a field of flowers. Every detail of the setting is perfect. Colossal crimson blossoms surround him. Their leaves erupt in verdant profusion. The turquoise sky is dotted with flawless white clouds. But life amidst the plastic perfection of this stage-prop world has not fulfilled the dummy's deeper desires. The dream that occupies his thoughts is proof that such fulfillment depends on escape from inanimate ideals. He has discovered that the source of absolutely transparent and uniform light is electric, that unblemished vegetation is molded, that consummate atmosphere is stultifying. Two antidotes to his discontent occupy his imagination. They appear as attributes of the women he envisions. These women are real and they are imperfect, two qualities that seem inescapably linked. Their messy hair, for instance, contrasts with the dummy's perfect coif. He seems to crave reality, even if it is unpredictable, and to savor humanity, even if it is flawed.

Chicken Dinner depicts dummies with identical features in a fully stocked bar. One is dressed casually in a white shirt. The other is dressed formally in a bow tie and black jacket. Both are absorbed in thought. Simmons exposes the desires that occupy their plaster heads. The unpretentious dummy dreams of a chicken dinner

"I realized early on that artifice attracted me to an image more than any other quality—"

success, which appear to be by-products of an insipid lifestyle. He yearns for Mexican-styled merrymaking. The dummy envisions himself in such unlikely roles as a spangled rancho, a twirling señorita, a dancing skeleton. His secret longings would seem scandalous to the human counterparts of this dummy's acquaintances: fraternity brothers, golf partners, or business associates who conform to the decorum of the establishment.

as common as the mass-produced meals in microwavable dinner packages. The desires of this meat-and-potatoes dummy are easily fulfilled. This is not true of the second dummy. His formal attire indicates that he leads a genteel existence, yet he is not content. His circle of thought is occupied by a cowboy. But the cowboy of his dreams does not chew tobacco, or smell of sweat, or carry dust from the range. He is as handsome as the Marlboro man and as

LAURIE SIMMONS
Chicken Dinner, 1994
Cibachrome, 35 x 53 in.
Courtesy the artist and Metro
Pictures, New York

immaculate as Garth Brooks. For this dummy, deliverance requires being transformed into a media star, a figure just as artificial and lifeless as he is.

The process of defining today's reality requires investigating its fictions. These fictions are not products of the artist's personal imagination. Simmons explains that her goal is to externalize society's collective memories. *"I'm making work about memory. And not my own personal autobiographical memory, but more like an exploration of memory and history. It's not as an exorcism of the past, but rather as an honest point to begin an external dialogue."*[4]

Television looms as the unrivaled generator of contemporary culture's images and values. As a member of the first generation to grow up in front of the television set, Simmons knows that sitcoms, Saturday morning cartoons, and commercials dominate childhood memories. Her work demonstrates that their impact extends

into adulthood. The stiff, plastic figures in synthetic environments that serve as the subject of Simmons's photographs are themselves derived from these early memories of television. Their fastidious dress, polished hair, and perpetual grins evoke the scrubbed look of Perry Como, Ozzie and Harriet, Mary Tyler Moore, and the Brady Bunch. These actors and actresses were so contrived, their gestures so posed, their behavior so predictable, their expressions so frozen, they resembled dolls and dummies

> **"I'm making work about memory. And not my own personal autobiographical memory, but more like an exploration of memory and history."**

even before Simmons chose these items as human surrogates. Their images, perpetuated through neverending reruns of programs from the archives of television history, continue to serve as form-givers and reality-markers. Simmons's art suggests that they and subsequent generations of media personalities provide the models we emulate.

In style as well as theme Simmons captures the era of the 1950s as it was described in media representations. Her work recapitulates a reality defined by that specific brand of artifice invented by television broadcasters.

SPACE: Simmons's tableaux limit the space in which activities are staged and enacted. Her miniature dramas occur within compressed rectangles that resemble television screens. Organized in narrow, parallel planes, they restage the relationship between the television set and a seated, passive viewer. The multidimensionality of life is eliminated.

LIGHT: An interruption in electrical service is known as a blackout. The term suggests that the loss of artificial light constitutes a total loss of illumination. This fallacy reflects a poignant psychological truth: we have become so accustomed to the cold glare of fluorescent fixtures and the brilliance of high-wattage neon displays that we are no longer acclimated to the nuanced and variable light from natural sources. The illumination of Simmons's tableaux confirms this fact. It is as harsh, focused, and dramatic as the lights used in stage sets and photography studios.

COLOR: Simmons's work also suggests the disappearance of nature's hues from our visual field. Most objects today are either dyed, bleached, injected, printed, or otherwise artificially colored. Simmons's palette belongs to the aesthetic of the marketplace, which bombards the eye with saturated pigments like those applied to billboards and packaging.

Through these devices, Simmons not only gives visual form to our cultural role models, she traces them to their sources in the media. Many of these roles are gender-specific. Simmons identifies them as *"the strong athlete, the successful businessman, the graceful dancer, the nurturing homemaker, even the artist."* She continues, *"It is often difficult to get these roles right in terms of our own expectations ... We try very hard to get it right."*[5]

Simmons's photographs of pseudo-people in pseudo-settings are not personal inventions. They are portraits of the masses of people for whom fantasies and realities are equally artificial. Viewers are awakened from their TV torpor. Through her work, they confront fabrications that distinguish the contemporary environment from previous eras in history. Simmons's pseudo-dramas warn us of the seduction of media offerings and expose the detachment of contemporary experience from natural experience.

SIMMONS POSTSCRIPT:[6]

Both nature and human nature are wounded by the relentless paving and bulldozing of the earth, the extracting of its resources, and the dumping of nondegradable waste. Artists' responses to this crisis vary and can be compared to magnifying glasses, telescopes, deflecting lenses, or mirrors. For example, Laurie Simmons magnifies the experiences of urban dwellers who may never have seen shadows cast by moonlight, drunk water from a stream, or walked where no path has been laid. Donald Sultan and Joseph Beuys telescope viewers' awareness that progress in technology may retard human values. The former renews the dignity of manual effort. The latter elevates animals to models of virtuous behavior. Carolee Schneemann deflects the effects of alienation from nature by realigning the viewer with cycles of nature that endure, unaffected by human interference. Mel Chin and Ericson and Ziegler mirror the urgency of rescuing nature—Chin by reclaiming tainted land, Ericson and Ziegler by promoting habits of proper waste disposal.

Wolfgang Laib

2

ALTHOUGH THE SHELVES OF ART supply stores in Germany are fully tocked, Wolfgang Laib does not avail himself of this convenience. He nstead devotes incalculable hours to

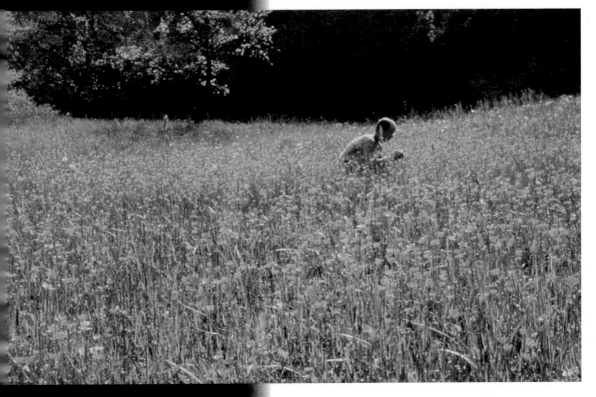

In the Buttercup Field. Wolfgang Laib gathering pollen
Courtesy the artist and Sperone Westwater, New York

preparing the materials out of which he fabricates his art. Three components of Laib's work—material, pigment, and theme—are dentical. They all consist of pollen. It can take him an entire season to gather enough of this very special medium for a single work of art.

AFFINITY WITH NATURE

Wolfgang Laib

Born 1950, Metzingen, West Germany
Tübingen Medical School
Studied in India
Lives in southern Germany

I INITIALLY PLANNED to begin this essay with the words "Barefoot, Wolfgang Laib slowly traverses the fields surrounding his home in rural Germany, stopping at one flower blossom after another, tenderly flicking grains of pollen into a jar." Unfortunately, there is a common misconception in this statement. Laib does not work barefoot. *"Do you have any idea how many*

WOLFGANG LAIB
Pollen from Hazelnut, 1991
90$\frac{1}{2}$ x 98$\frac{1}{2}$ in.
Installation at Galerie Chantal Crousel, Paris
Courtesy the artist and Sperone Westwater, New York

thorns you would have in your feet? Nature is not what most city people think. Nature is not romantic."[1] This error, however, is informative. It accurately reveals the mystique that surrounds Laib's enterprise. His painstaking process seems incomprehensibly inefficient within an economy replete with ingenious laborsaving schemes.

Moreover, Laib's laborious activity is conducted without the pretext of generating a practical outcome. His pollen-collecting is not undertaken to improve a crop or generate income. Effort is divorced from production and profit. He collects pollen to make art.

In the modern workplace, procedures that are routine and prolonged are often considered tedious. Laib's singleminded, singlehanded dedication to the harvesting process transmits an unanticipated revelation: that such laborious effort can be gratifying. This impression is reinforced by his subsequent formation of the pollen into sculpture. Laib sieves it, a few specks at a time, onto the bare floor of the exhibition space, where it forms a velvety, glimmering, golden cone.

Laib's studio is a sanctuary from the clamor of technology and commerce, and even from the demands of the art market. Punch clocks, evening news programs, and commuter schedules do not mark his time. Laib's activities are measured by rotations of the earth and cycles of growth. The process commences in mid-February and continues through September. The earliest pollen is produced by hazelnut trees; in June by dandelions; in summer, by pines; in autumn, by mosses. *"With dandelion, for instance, which blossoms in June for about a month I get two big jars. Pines have so much pollen and dandelion or buttercup, so little . . . There are warm days with a lot of sun and I collect much pollen, and there are cool days, windy days, when I collect very little . . . After all these months I then have four, five or six jars of three or four different kinds of pollen."[2]*

Laib's artistic activity mimics the pollen-gathering of bees. He enacts their rites of survival and procreation by participating in nature's cycles. In this way Laib immerses himself in the emanations of his environment, surrenders to its conditions, and delivers himself to its dictates. *"Several months each year I gather pollen from the land around my house. It is not important to me to use another kind of pollen or to find another color. The experience is what is important. I have enough pollen to make my art. I don't need more pollen. Once March and April come, it is an essential process, something I feel I must do, not to get material."[3]*

The survival of bees depends upon a symbiotic rapport with the plant kingdom. Laib's efforts suggest that such symbiosis may be equally essential to the survival of humanity. His art addresses a source of discontent that is not physical, but soulful. By relating to the flowers of the field, Laib celebrates an organic unity of all living things.

Such deference to nature is rare in Western culture. Pollen is remote from most people's experience. Excepting beekeepers and orchard owners, it is not difficult to imagine entire lives passing without ever touching or appreciating the substance. Pollen's popular reputation is largely a negative one linked to allergies, remedies, and avoidance.

Laib's pollen-alert is of a different order. He applies a prospector's patience to the gleaning of pollen, a gemcutter's deftness to its configuration, and a priest's dignity to its presentation. Thus cast in a reverential light, pollen's neglected quality—its amazing life-giving force—is resuscitated. In a secular, practical age, Laib's work appeals to our long-dormant capacity for wonder: *"Today, in our culture everything . . . has to be accessible, touchable and available. And before, . . . in all 'primitive cultures,' things were handled with much reverence. Many things were too precious to be touched . . . And now I think it can change again."[4]*

Pollen provides a compelling example of the opportunity for change. It serves as a microcosm of the established tendency in Western culture to approach nature as a resource capable of ameliorating human life. Those who treat nature as a source of energy and a storehouse of supplies "touch" it with impunity. Objective observation and experimentation facilitate the process of mastering the natural environment and appropriating its products. Laib's work suggests two alternative approaches. Physically, his presence is based on personal and sensual contact. Mentally, his paradigm is acquiescence. Laib releases pollen from its role as a utilitarian commodity and presents it for aesthetic and symbolic contemplation.

Laib has a scientific background. He attended medical school for six years, applying the scientific maxim to the study of life and death. But Laib came to doubt its premises. *"I got more and more dissatisfied . . . There must be something else besides the purity of limits in time*

WOLFGANG LAIB
Milkstone, 1987/1989
Milk and marble,
48 x 51³/₁₆ x ³/₄ in.
Installation in the
artist's studio

Courtesy the artist and
Sperone Westwater,
New York

and space of the body to suffering, illness, death. On one hand I was observing operations and on the other I was reading the scripts of Buddhism— the compassion of Buddha—and the scripts of the Jains: I was fascinated by this extreme purity and non-violence—ahimsa—the extreme meaning of things too precious to be touched. Out of this situation, out of the extreme opposites, out of this contradiction, I made my first milk stones."[5]

On the day he passed his exams, Laib declared himself an artist, not a doctor. He began to create sculpture out of an unlikely combination of materials: milk and marble. Laib first polished a block of white marble, a task as labor-intensive and time-consuming as gathering pollen. Day after day he patiently ground the top surface of the block until, eventually, a slight indentation was formed. He then poured milk into this shallow crevice, filling it to the rim and, thus, returning the marble to a state of perfect geometry. Identical in color, milk and marble fused into an uninterrupted visual unit. The block of marble relinquished its density, opacity, and inertia. It shimmered and quivered as if it were alive. Its wondrous vitality is sensed before its material sources can be discerned, before the viewer

perceives two materials—one liquid and one solid, one biotic and the other inert, one enduring and the other perishable—merged in a union that denies such dichotomies. Marble became, for Laib, *"a living being like milk."*[6] His work substitutes the Buddhist sense of wonder for the common Western premise that nothing in nature is "too precious to be touched" by the intrusions of empirical analysis.

Laib's milk-stone sculpture challenges the very existence of contradictory states of being. These contradictions were institutionalized when nature was divided into autonomous, specialized fields for the purpose of expediting scientific research. This divide-to-conquer approach exists on university campuses, where physical sciences, biological sciences, the social sciences, and political science occupy separate buildings. Laib's unification of milk and marble confirms a recent trend within the scientific community to seek intrinsic connections and to reunite disciplines—biophysics, chemical geology, and psychoeconomics are just a few examples. Even these merge in the science of ecology. Growing acknowledgment that all the realms of nature are codependent confirms Laib's search for organic wholeness.

The act of collecting pollen or polishing stone cultivates a correspondence between the human body and all that surrounds it. This immersion in the physical world exceeds scientific models. Laib likens his art-making to religious practice. Nature is not his studio, it is his monastery. *"It is St. Francis preaching to the birds . . . like human beings—the vision and realization of unity—it is so simple and so beautiful."*[7] But Laib also defines the difference between his practice and religion. *"I do not hang on historical religions. I am an artist, not a Buddhist, not a Zen Monk, because this would close it. When I studied medicine, I also studied Sanskrit and Indian religion and philosophy at an institute near the medical school. I spent more time there than in the hospital. I admire Saint Francis, but I am not a Franciscan. I became an artist, I did not enter a monastery. Art is a way to communicate to most people. Everyone is invited, but not everyone comes, and that's also good."*[8]

Laib creates nothing new. He does not use pollen as a raw material to produce an invented

reality. Untainted by pretense or artifice, it is placed directly on the ground, in the simplest of shapes, where it retains its own identity and its own meaning. *"I was fascinated with what pollen is in itself. Pollen has incredible colors, which you never could paint, but it is not a pigment and its color is only one quality out of many, like a hand has a color, or blood is red . . . but it is not a red liquid and milk is white, but it is not a white liquid. It is the difference between a blue pigment and the sky . . . All of these materials are full of symbols—and still they exist in themselves—they are what they are. So, it is not so important what I think about them. It is more participating than creating, for everyone, not only for me. These materials have incredible energies and power which I never could create."*[9] Thus, Laib imposes no opinions, expresses no emotions, draws no conclusions. By withdrawing his ego, he resurrects the accepting and respecting attitudes that have lain dormant in our lifetimes. Not all peoples compete with nature.

Laib's humility is responsible for two essential qualities of his work. First, his sculptures are unabashedly beautiful. Laib recognizes that beauty is often denigrated by critics of contemporary art. *"(Art) had to be as ugly and as brutal as possible. Beauty was bourgeois—what a strange idea. Maybe it was easier for me (to accept beauty) since I didn't have to paint a beautiful painting or make a beautiful sculpture."*[10] Thus he feels no uneasiness regarding his works' beauty. Nature created them. He can neither be credited nor blamed.

Second, there is no fiction in Laib's work. No material is transformed. No new reality is cre-

"(It) is very beautiful to live now because I feel it is a time when a lot of new things are beginning and so it is ours to do it."

ated. Implying that symbols are mental postures whose creation is an act of arrogance, he has abandoned the principle of inventing symbolic representations and imposing them onto the materials of art.

Laib's dream to extend his activities beyond museum walls originated in his exhibition of a chamber made of wax at the Carnegie Museum in Pittsburgh in 1988. *"I saw there was one step*

more. I began to look for a site to do a wax chamber in a natural rock setting . . . I have it now. It is in the Pyrenees. I did not choose the top of a mountain. I chose a modest mountain on a ridge of five rocks facing a major mountain. It is above a low forest, the last mountain range near the Mediterranean . . . My plan is to carve out a chapel . . . It is something to give to the world. It is not my property . . . It will have a small wooden door to protect it. There will be a key kept in the village. Anyone can pick up the key and visit the chapel. The Chamber of Certainty may be constructed in 1997. People will enter one at a time. I don't know what it will look like. I have no pre-fixed ideas. I will do it as the rock goes . . . Being surrounded by wax . . . is a world in its own. It has a presence, which no person experienced before. Compare this material with any common building material. It is so different. What materials are used for our walls, our floors? Wax comes from another planet. It is transcendent. These pieces are visually so different from my other pieces, but they are so close to the other materials. It's all the same—wax and stone are like milk and stone."[11]

Laib resists the triumphal model of the artist as genius. Instead of producing his own creations, he presents nature's creations. His ceremonial deportment elevates this act to a ritual that counters the ingrained precept that humans should strive to master the world. Similarly, he eliminates the pretensions of the pedestal. Within Western society, an exalted position is one that is elevated off the ground. Within nature's frame of reference, the ground is an honorable setting. When Laib places his sculptures directly on the floor, he submits to an order far grander than his own artistic ego or the conventions of Western art. His submission is not confined to art. "My life is on the floor . . . I don't have a table or a bench. I sit on the floor, I sleep on the floor, I have my works on the floor."[12]

Laib's use of material offers a model of harmony, silence, and clarity. The simplicity of his shapes is a reprieve from the clutter of contemporary life. The intrinsic relationship between his medium and his subject is an escape from the superfluity of manufactured items. In sum, he embodies the possibility of being both alive and at peace at the same time. "(It) is very beautiful to live now because I feel it is a time when a lot of new things are beginning and so it is ours to do it."[13] By restoring nature's wonder-inducing powers, Laib demonstrates that the act of trespassing is as much an attitude as it is a walk across private property. Participation is an alternative to possession. "If you believe only in the individual, in what you are, then life is a tragedy that ends in death. But if you feel part of a whole, that what you are doing is not just you, the individual, but something bigger, then all these problems are not there anymore. Everything is totally different."[14]

LAIB POSTSCRIPT:

Dualism has colored Western thought for many centuries. It simplifies the complexity of the world by seeking to explain all phenomena in terms of two distinct and irreducible opposites. Ultimate dualisms include being and nonbeing, mind and matter, body and soul, good and evil, man and woman, black and white, nature and technology, rich and poor, old and young. In recent years, two alternative "isms" have challenged the authority of dualism. One is pluralism, the theory that sees the universe controlled by numerous principles and substances. The other is monism, the theory that seeks to explain the universe with all its phenomena according to a single principle. Gerhard Richter's career, which encompasses multiple styles of expression, is an apparent confirmation of pluralism. Wolfgang Laib, who merges with the plant and animal realms, manifests a form of monism. His work unifies the whole of reality so that space and all the things that fill it unfold in a oneness of spirit.

Mel Chin

IN THE PAST, WESTERN ARTISTS limited their involvement with nature to observation and depiction. Mel Chin has expanded the artist's role to

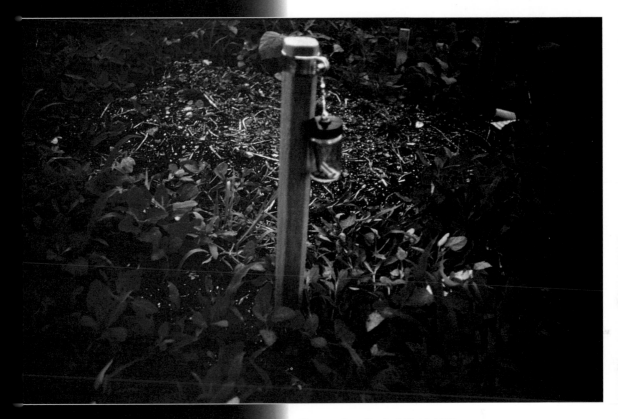

Plot marker, *Revival Field*, 1991
Courtesy the artist. Photo: Mel Chin

incorporate nature's management and rescue. His creative process is described by two sets of verbs. One derives from farming: plowing, tilling, planting, and harvesting.

REINSTATEMENT OF NATURE

The other belongs to scientific research: controlled testing, data collecting, and analyzing. The product of his efforts is real, reclaimed earth.

Mel Chin

Born 1951, Houston, Texas
George Peabody College for Teachers, Nashville,
 Tennessee
Lives in New York City

See colorplate 8, page 24

MEL CHIN directs his creative energy toward urgent problems that must be resolved if life on earth is to survive. His artistic medium is land that has become so laden with toxins that it is incapable of sustaining life or generating edible vegetation. Chin describes his artistic method as a *"plausible method of leaching heavy metals out of tainted soil, safely trapping the toxins in the vascular structure of the plant and mining the ash (after proper incineration) to provide a beneficial and economic potential."*[1] His *Revival Field* (1990-present), located at the Pig's Eye landfill dumping ground near St. Paul, Minnesota, is an example of landscape art for an era that can't afford to indulge in leisurely aesthetic contemplations of nature.

Chin revives the polluted field by growing and harvesting special plants that thrive on the heavy metals in the soil. These leaching plants are called "hyperaccumulators." At the end of each growth cycle they are incinerated so that the cadmium, zinc, and lead they absorbed can be extracted from their ashes and recycled. With each harvest, more and more toxic metals are removed from the soil, bringing Chin closer to his goal—creating purified earth.

This unconventional solution to a major environmental problem was developed by the artist in collaboration with the scientific community, government agencies, and community residents. Chin's primary collaborator is Dr. Rufus Chaney, Senior Research Agronomist with the Agricultural Research Service of the U.S. Department of Agriculture. Their research and planning were conducted in strict adherence to scientific testing of hypotheses and controlled procedures. The results are rigorously measured and documented.

Current technology and regulatory approaches require that land ravaged by industrial pollution be removed, mixed with a stabilizer such as concrete, and moved to federally licensed hazardous waste sites where it is sealed in airtight, watertight containers. These methods

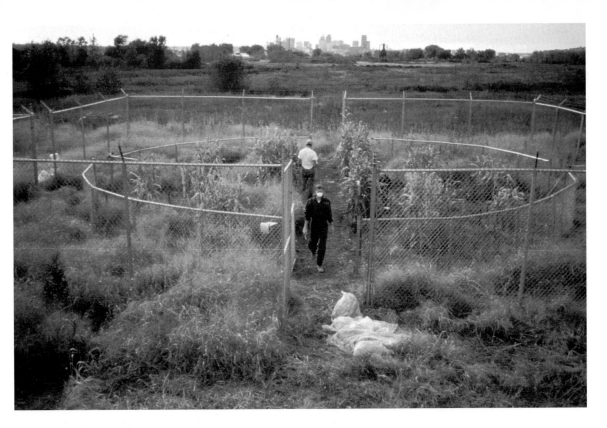

MEL CHIN
Revival Field,
Pig's Eye Landfill,
St. Paul, Minnesota,
1993
Harvest
Courtesy the artist
Photo: The Walker Art
Center

are extremely expensive. When official government agencies were reluctant to fund the implementation of an alternative approach that utilized the healing forces of nature, Chin transferred the experiment from the domain of science to the domain of art, because art is exempt from regulations, certificates, and authorizations.

Chin invented the term "Sniper Viral Attitude" to serve as a metaphor for his artistic efforts. The artist, he says, is like a sniper because *"his activities are covert, but carried out with a purpose and with discipline."* The sniper-artist creates art-viruses: *"mechanical, affective, and not necessarily negative phenomena which need a system to recreate themselves. I explore how we go about infecting each other. This is another way of discussing education. Art creates a condition where one can foresee the possibility of change. Art does not exist for its own sake."*

Mel Chin is a sniper-artist because he invents strategies for solving real-life problems.

Largely unencumbered by institutional procedures and bureaucratic protocol, artists can quietly interject unconventional programs into the stream of life. Chin intends that his efforts will multiply like viruses and infiltrate the system from within. The success of his work is measured in terms of real, not metaphoric, change. In defining a work of art's pragmatic potential, Chin has stated: *"Rather than making a metaphorical work to express a problem, a work can employ the same creative urge to tackle a problem head-on. As an art form it extends the notion of art beyond a familiar object-commodity status into the realm of process and public service."*

Nature once provided sustenance. Now it is in need of rehabilitation. Chin's efforts to reverse the effects of man's abuse of nature are directed at a single plot of land, but they carry greater meaning. Unlike a botanist or farmer, when an artist mediates the land, he also mediates public awareness. *"My work takes difficult political and ecological dilemmas and expresses such topics in symbolic forms. I am interested in the mechanics of ideas. The most interesting turf is the psychological. This does not only apply to art. I explore*

ideas and how we live, what kind of society we have. I look for a game plan, a possibility."

In the West, the merits of a work of art are often judged according to the artist's ability to take inert materials and create the illusion of space, or life, or movement. In *Revival Field*, Chin has dedicated himself just as ardently to a far different understanding of art's process and purpose. Confronting nature on its own terms in order to produce a pragmatic result, he dispels seven illusion-generating conditions of art.

"Art is not static, it is catalytic. Art is not just a language, it is useful, it makes things function. It has a critical relationship in society."

1. Instead of producing a painting that represents the state of the natural environment, Chin literally transforms a hazardous waste site. He makes no attempt in *Revival Field* to imitate the appearance of nature.

2. Instead of producing a sculpture by representing a living form through a neutral medium like marble, Chin allows nature to retain its own identity. The medium and the subject of *Revival Field* consist of the toxic earth and the dwarf corn, romaine lettuce, alpine pennythrift, and bladder campion planted in it.

3. Instead of employing techniques taught in art schools, Chin utilizes actual botanical processes known as "green remediation." Likewise, function, not aesthetics, dictated many of the decisions regarding this environmental artwork. Plants were not selected on the basis of such aesthetic qualities as size, shape, or color. Their inclusion depended upon their vascular systems' capacity to sponge up the toxins in the earth. Furthermore, function and scientific strictures influenced the configuration of the piece. Two standard chainlink fences protect the garden. A square contains a circle. The circular area, planted with the detoxifying vegetation, serves as the test site. The square, unplanted and of equal area, serves as the control. The area within the circle is divided into 96 equal plots, each treated with a different combination of plant and fertilizer. Access to the site is through paths that intersect in the center. Indeed, the artist confirms, *"the work, in its most complete incarnation, after the fences are removed and the*

toxic-ladened weeds harvested, will offer minimal visual and formal effects."

4. Instead of artificially preserving a work of art in conformity with museum procedures, Chin allows the duration of *Revival Field* to be determined by the natural life cycles of plants and the actual recycling of extracted metals. The work will be completed when the earth is cleansed and the land is again capable of sustaining normal plant growth. A foundation has been established to assure that the project will be completed even if it extends beyond the artist's lifetime. Chin's embrace of nature's own powers of dynamic reclamation nullifies dependence on a human creator.

Indeed, Chin does not assume the demeanor of a virtuoso, and he minimizes the importance of his role within the creative process. He acknowledges that the procedures utilized in *Revival Field* are dictated by the advanced methods of the Soil-Microbial Systems Laboratory at the USDA's Agricultural Research Service. *"I claim nothing original. The concept used in* Revival Field *has been known for a long while. It occurs naturally, for instance, in old mine washes. It is an ancient way of relating plants to soils."* He is the work's instigator more than its creator.

5. Instead of expressing the personality of the artist, Chin's imagination and energy are committed to wider social concerns. He argues that in an era when nature and life are in jeopardy, ethical responsibility supersedes individual thoughts and desires. Viewers of *Revival Field* pass immediately from art to life, bypassing the subjective commentaries of the artist.

6. Instead of creating art objects to sell to wealthy individuals, Chin creates a work that cleanses the environment for the benefit of all living beings. Nor is it segregated in museums and galleries where its audience would be confined to art collectors and museum visitors. *Revival Field* directly impacts nature and society. Chin not only generates new data on bio-remediation, he also disseminates this data by issuing press releases, giving lectures, and attending scientific conferences. He participates as well in traveling exhibitions, commonly installing drawings, blueprints, and models in town halls and

city libraries. By not restricting himself to the traditional museum venue, Chin aims to reach all citizens with the news about this gentle, economical, and promising solution to an intractable ecological problem.

7. Instead of its success being measured by professional art critics or individual taste, *Revival Field* is measured objectively. It is successful if the earth is renewed. The results are as incontestable as those of any well-conducted scientific experiment. In fact, the work is so aligned with science that stories about this project have appeared in science magazines as often as in art publications. Bridging these fields of inquiry provoked a well-documented controversy with the National Endowment for the Arts. In 1990, Endowment Chairman John E. Frohnmayer rejected a proposal to fund *Revival Field* because he insisted it pertained to the EPA, the Environmental Protection Agency, not the NEA.

Chin's appeal to Chairman Frohnmayer provides an opportunity to explore the ways in which *Revival Field* qualifies as art. *"I explained to Chairman Frohnmayer how I saw the poetics of [Revival Field], how this idea can be an art possibility. Call it science or art. There is an invisible aesthetic that applies to molecular exchanges too. It is manifested in nature as well as in art. How else can the work be described?"*

He explained that like a traditional sculptor, he began with an idea, approached his material, and fashioned it into a concrete reality. *"Soil is*

MEAN DTPA-EXTRACTABLE CD AND ZN, AND SOIL pH IN MN REVIVAL FIELD SOILS AT HARVEST IN 1992 (Homer, Chaney and Chin, unpub.)

TREATMENTS		Soil	DTPA-Extractable	
Sulfur	N	pH	Cd	Zn
			$-\mu g$ extd./g DW-	
Sulfur Treatments:				
No	All	7.80 a	5.1 a	33.7 a
Yes	All	7.36 b	5.9 a	40.4 a
Nitrogen Treatments:				
All	NH4	7.59 a	5.2 a	36.1 a
All	NO3	7.56 a	5.8 a	38.0 a
Both Treatments:				
No	NH4	7.86	4.9	32.9
No	NO3	7.74	5.3	34.6
Yes	NH4	7.32	5.5	39.3
Yes	NO3	7.39	6.3	41.4

REVIVAL FIELD : PALMERTON 1993

Diagram of Plant Layout : Plan E

I. MAIN PLOT DIVISIONS

SUB PLOT

A. 'Prayon' *Thlaspi caerulescens*
B. 'Merlin' red fescue
C. 'Rebel' tall fescue
D. Recommended Kentucky Bluegrass
E. 'Kentucky-31' tall fescue

MEL CHIN
Scientific data from *Revival Field*, DTPA Cd and Zn Harvest, 1992

Courtesy the artist. Photo: Dr. Rufus Chaney

my marble. Plants are my chisel. Revived nature is my product ... This is responsibility and poetry." Ecosystem sculpture resembles traditional wood or stone carving. *"Here, unseen*

materials (heavy metals) were to be chipped away by new tools (biochemistry and agriculture) to reveal the aesthetic product (a decontaminated piece of ground.)" [2]

All phenomena evolve. Chin includes art among them by subscribing to a "neo-evolutionary theory." This theory contradicts the Darwinian model of linear change proceeding toward ever more complex and advanced forms of life. The post-Darwinian outlook purports that nature leaps from one system to another just like thoughts in the human mind. It implies that constriction is as debilitating to nature as it is to art and humanity. All are vitalized when they are allowed to shift and mutate.

Chin's art embodies this notion of mutability. The changes he instigates apply to all three categories—nature, the human mind, and art—and can affect reform throughout culture. Natural changes are physical: *Revival Field* transforms tainted ground into pure ground. Mental changes are psychological: *Revival Field* transmutes despair over terrestrial despoilment into rays of hope. Artistic changes are symbolic: *Revival Field* is a prototype for converting many forms of careless behavior into responsible action.

Chin reports that in 1995 the scientific community was beginning to recognize his artistic effort at remediation. The EPA had visited his site, and a team of scientists from the Department of Energy had written a recommendation to fund the project. It required an artist to demonstrate that *"the earth could be healed from within and its potential to sustain life revealed. The community will be empowered by connecting them, art and science."*

Assessing this new attitude can only be measured by comparing Chin to predecessors who faithfully recorded the appearance of nature. Their reverential approach implied that altering nature's forms was an arrogant presumption. Nature supplied proof of the glory of creation and the existence of God. This attitude prevailed in landscape paintings from the eighteenth century until the Industrial Revolution, when artists joined scientists and industrialists in boldly submitting nature to human volition. During this era, painters imposed upon nature a geometric structure, or abstracted it, or manipu-

lated it to reveal human emotions.

The crisis mentality that prevails at the end of the twentieth century has extinguished both the deference to nature's innate perfection and the indifference to nature's inherent mechanisms. Today, when nature is in jeopardy, it seems immoral to indulge in aesthetic contemplations. Chin's involvement with nature offers a compelling instance of changed artistic attitudes. His art takes the form of a rescue mission. It is both practical, in terms of its impact on the land, and educational, in terms of its impact on the viewer. *"My goal for art is to create a condition where one can see the possibility of change. Art is not static, it is catalytic. Art is not just a language, it is useful, it makes things function. It has a critical relationship in society. Artists are essential parts of society, not members of an elite. We have our function in society."*

CHIN POSTSCRIPT:

Mel Chin creates landscape art for the end of the twentieth century. In the past, nature served as a model of harmony, truth, and beauty. Now, the pristine environment no longer exists. It is rearranged, paved, engineered, and finally violated by human intrusion. Chin heals nature. Other healer-artists include Joseph Beuys, who mended the rift between humans, animals, and trees; Marina Abramovic, who rehabilitates the intuitive mind; Jeff Koons, who eliminates the conflict between actuality and morality; Gilbert and George, who pursue a soul for humankind; Christian Boltanski, who assumes the anguish of historic memories; and Andres Serrano, who restores the dignity of those forsaken by society.

4

On Kawara

ON KAWARA'S SELF-PORTRAITS eliminate self-analysis, physical likeness, idealization, spontaneity, feelings, and recollections. He ignores everything that is subject to conjecture. What remains? Only the verifiable facts of his existence.

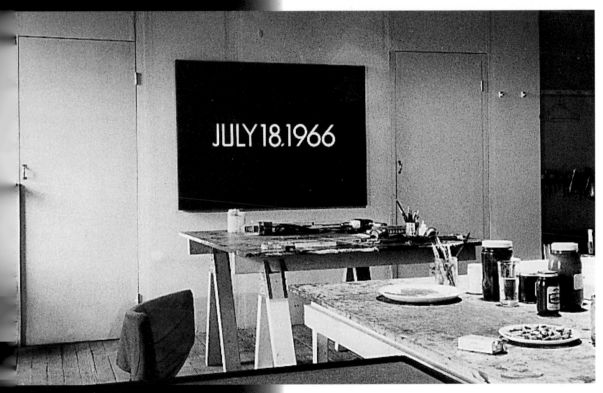

JULY 18.1966

The creation of a Date Painting. Studio view, New York, 1966
Courtesy the artist

SELF-DOCUMENTATION

On Kawara

23,056 days
(February 8, 1996)

THIS ESSAY contains no quotes by On Kawara. The artist resists interviews. He also refuses to be photographed. Despite these self-effacing acts, he is the exclusive subject of his art. He channels all disclosures about himself through his art.

Yet On Kawara discards the two pillars upon which self-portraiture has rested for centuries: physical likeness and self-expression. His self-disclosures are restricted by a determination to purge art of the vagaries of subjectivity. Physical likeness is shunned because it is subject to interpretation. Personality is omitted because it exists beyond the realm of certain knowledge. For thirty years Kawara has steadfastly explored the tiny domain of autobiography that remains when opinion, mimetic duplication, self-analysis, sensual responses, feelings, attitudes, ego, sentiments, memories, joys, terrors, dreams, and fantasies are eliminated from art.

On the production side of the art process, each Kawara portrait consists exclusively of a snippet of data about him. On the reception side, the information offered by the work of art, however objective, is so minimal it defies interpretation. Like musical phrases disengaged from compositions, this information carries little meaning until it is positioned within the larger context of his career.

Despite these novel characteristics, Kawara conforms to a point of view shared around the globe and across the span of history. He defines human life according to body and mind, flesh and spirit. Stripped bare of all extraneous baggage, he offers these as verifiable proofs of his existence. The elemental and indisputable experience of the body is space; Kawara ignores all other aspects of his physical organism. The elemental and indisputable experience of the mind

ON KAWARA
4 stages showing creation of a
Date Painting, Rome, 1990
Courtesy Barbara Gladstone Gallery, Thea Westreich

is time; Kawara dismisses all other elements of consciousness.

What remains are the two questions that perpetually challenge priests, scientists, poets, statesmen, and philosophers who pursue the nature of existence. These questions are also asked by ordinary people groping for a grounding in reality: "Where am I?" "What time is it?" Kawara's art manifests an approach that provides indisputable answers to these vexing questions. It is not theoretical, for theories can be wrong. It is not subjective, for subjectivity is conditional.

TIME: The perception of the passage of time depends on our moods, our life experiences, and our expectations. In moments of pleasure time races. In dreams it dissolves. For mystics it stands still. In myths it appears cloaked in eternity. Time defies comprehension.

Kawara hazards to dispel this conceptual confusion. He confers structure and legibility upon this elusive phenomenon by enlisting the objective temporal measures that exist in society. Thus, he employs seconds, hours, days, months, and years to organize his experience and clarify his consciousness. These premeasured units are integrated into preexisting formats like those of clocks, journals, and calendars. They too tame the transient and fugitive aspects of the temporal dimension.

An example is provided by Kawara's *Today Series*, which was initiated on January 4, 1966 and continues, unabated, to this day. The series consists of paintings of a day's date, articulated as month, day, and year. The date always appears in white on a uniform rectangular field of a dark color. The position of the date is unvarying. It forms a single horizontal line across the center of the canvas. The paintings' dimensions range from eight by ten inches to sixty-one by eight-nine inches. Each has a depth of two inches. Paintings that cannot be completed on the day of their inception are destroyed. The works in the *Today Series*, therefore, always reveal the true time.

In order to guarantee the objectivity of the statement, and thus the work, Kawara avoids writing the date in his own handwriting, which would disclose personal idiosyncrasies. He also rejects distinctive typefaces: a styled typeface reveals personal taste and could imply that his assertion was opinion, not fact. In all these works, Kawara affirms impartiality by using Futura, a standard typeface comparable in its utilitarianism to the basic units of time that determine the dates.

Kawara's paintings are so immaculate that they look stenciled and mechanically produced, but they are actually handpainted. Kawara is a disciplined painter whose labor-intensive technique conceals the capricious nature of human emotions. Starting with a coarse brush and concluding with very fine brushes, he applies four or five layers of paint to the background and six or seven layers of white to each date. Individualized brushwork is intentionally obscured so that the impersonality of the surface is scrupulously preserved.

Eight or more hours are required to execute a single painting. As a result, each date painting makes manifest the basic temporal measure of our lives: the work day. These paintings therefore not only record time, they consume time. They are a tangible record of a real day's work. The viewer knows precisely how On Kawara spent the day identified by the date. To confirm the veracity of his artistic statement, subtitles authenticate the date of its creation by identifying a national event that occurred on the day the work was painted, or the name of the day of the week of its creation. The latter is most common.

Kawara has produced over 1,900 such paintings in this series and apparently has no intention of relenting. But his preoccupation is not a sign of a neurotic fixation or arrested development. Longevity is essential to safeguard the project from the arbitrary aspects of personality. Choice, including the choice to abandon the project, is subject to mood and impulse. Kawara cannot permit himself this option if objectivity is to be preserved. His venture must be pursued until an unconditional event—death—forces its termination. Kawara's series of date paintings will then constitute a finite record of another, temporal unit: his lifetime.

SPACE: The certainty of the mind is revealed through time. But the self is also comprised of the body positioned in space. An accurate "picture" of the self emerges at the intersection of these two coordinates. For this reason Kawara

also reveals his physical location in his date paintings. His whereabouts are communicated by writing each date in the language of the country where the work was created. Both locale and date are further verified by Kawara's practice of placing each painting in a handmade box along with that day's local newspaper. As of February 1996, he had produced date paintings in 102 cities around the globe.

Kawara has further consolidated the time/space matrix by recording his output in notes collected in ring binders. These journals constitute an ongoing inventory of the date paintings. Journal entries provide data on the experiences of the artist's life, rendered exclusively in terms of place and time. They document the size, serial number, title, and date of each painting, along with samples of the pigments used. The language of the entry reveals the location in which it was produced. A calendar acquired in that country provides the temporal record. Thus, an entry identified first by inventory number uses a newspaper headline as its subtitle:

> +3 B (1) Feb. 2, 1972 "The United States command in Saigon announced this morning that American war planes conducted five bombing raids on antiaircraft sites in North Vietnam yesterday, bringing the number of such strikes to 11 in two days."

A painting created in Stockholm, which bears the day of the week as its subtitle, is noted as: +63 A (3) 31 Dec. 1972 "Sondag."

TIME/SPACE/DURATION: In another ongoing series, Kawara routinely sends telegrams to acquaintances. In 1970, the year of this project's inception, faxes, E-mail, and fiber-optic transmissions were not yet available. Telegrams were the standard means of communicating messages with speed. Significantly, telegrams are produced mechanically and electronically. Their impersonality guarantees the artist's emotional and physical detachment from his work of art. His telegrams present only the elemental, objective facts of his existence.

The cryptic style of telegram pronouncements imbues the news they contain with solemnity. Kawara exploits these associations. The message he sends is always the same. All read, "I am still alive." In this series it is the postmark that provides the elemental information of Kawara's continued existence by supplying incontrovertible proof about time (when they were sent) and place (where they originated).

The insertion of the word "still" within the phrase "I am alive" underscores the urgency of the message. "Still" implies that life is tenuous. It must seem excruciatingly so to an artist obsessed with the nature of existence. Telegram speed is required to assure the receiver of the reliability of this assertion. To anyone for whom death is imminent, the continuation of life is newsworthy. Kawara's undeviating telegram-sending is not a mindless routine; each is a reminder of the miracle of existence.

TIME/SPACE/DURATION/ACTIVITY: Kawara has additionally attempted to document his activities while adhering to a fundamentalist's faith in the infallibility of the space/time continuum and a statistician's faith in fact-bound disclosures. Every day from May of 1968 until his materials were stolen in Stockholm in 1984, he mailed postcards to two different people. Kawara's postcards, like his telegrams, transmitted a single unit of information over and over. Yet since postcards are a more personal form of communication, their content was correspondingly more personal. Factuality, however, was never compromised. The postcard series, titled *I Got Up*, literally announced the time of Kawara's awakening each day. Each postcard states: "I got up at" followed by the time—"9:03 A.M.," "5:14 A.M.," "1:30 P.M.," and so forth. These times charted the artist's successful return to consciousness from sleep. They document the instant he confirmed his continued existence.

The pictures on the postcards recorded his location. The temporal component of his assertions was confirmed by the postmark, and impersonality was preserved by substituting a rubber stamp for handwriting.

TIME/SPACE/DURATION/ACTIVITY/ SOCIETY: The *I Met* series, also undertaken in 1968, documents Kawara's social interactions. The format, again, is determined by the requirement of limiting the presentation to absolute facts. It excludes all nonverifiable information such as descriptions of the people he meets, his

subjective responses to them, or evidence of the nature of their exchange. Instead, they are identified exclusively according to their proper names, neatly typed and filed according to the location of the meeting.

TIME/SPACE/DURATION/ACTIVITY/ SOCIETY/TRAVEL: The *I Went* series consists of local maps marked with the daily routes traveled by the artist. The maps are collected and bound chronologically according to geographic location. They provide another example of the elemental truth of one's being—identifying the "where" and "when" of the artist's life, but resolutely eliminating the "how" and "why."

Kawara's determination to "picture" only the truth has compelled him to reject other sources of knowledge: morality, because it has no objective norm; philosophy, because it is not empirical; aesthetics, because it is based on personal taste; psychology, because it relies on subjective introspection; history, because it is beset with cultural biases; math, because it is based on invented structures.

In the twentieth century, it is science that has provided standards of accuracy and definitions of truth. Kawara's self-depictions are determined by science's measures of veracity. He integrates the fourth dimension into contemporary art. His process is analogous to the incorporation of the third dimension into art during the Renaissance. In the fifteenth century, information about the physical world was ascertained through observation and measurement. The eyes were considered credible receptors of material phenomena. Brunelleschi translated this standard of truth into art by inventing linear perspective, a system based on a vantage point that was fixed in time and space. From this static position, a geometric grid was laid upon a scene, magically transforming the flat surface of the painting into an illusion of depth, volume, and distance.

Likewise, Kawara's self-scrutiny is perfectly aligned with the new scientific scrutiny. Contemporary physics has reconceptualized the nature of the physical universe, which is no longer finite and unchanging. Events in space and time have replaced static objects; yet the Renaissance pictorial tradition is incapable of envisioning a world defined as a field of forces in perpetual motion. Kawara eliminates fixed space and suspended time and replaces them with dynamic space and transmutable time. In accordance with the contemporary conception of the physical universe,

ON KAWARA
I Am Still Alive,
February 17, 1996
Telegram to
Petur Arason in
Reykjavik, Iceland
Courtesy the artist and
Petur Arason

he is awhirl in space and time, continuously wandering from country to country. (He and his wife, Hiroko Hiraoka, are perpetual tourists.) Our knowledge of him is undifferentiated from our knowledge of the physical universe. Both depend upon identifying position and velocity. By plotting his course through time, Kawara applies the methods of science to his search for the "truth" of his existence.

Kawara's migrations apply recent science to human experience in two ways: first, by identifying himself with the dynamic units of matter; and second, by conforming to the Einsteinian rule that objects must be studied in their natural context. Kawara's self-portraits, therefore, cannot be created by posing between a mirror and an easel in a studio. The truths of his life can only be discerned in their natural settings. Kawara records his existence by buying newspapers,

sending telegrams, getting out of bed.

The conformity between the artist's examination of himself and the scientist's examination of the universe is further confirmed by their mutual distrust of surface appearance. Kawara's steadfast refusal to record his physical appearance is comparable to the physicist's acknowledgment that the unaided human eye cannot perceive the structure of the material universe. Nature and appearance are no longer equivalent to reality.

TIME/SPACE/DURATION/ACTIVITY/ SOCIETY/TRAVEL/TIME: Until the contemporary era, exceeding human-sized experiences and human-scaled time slots required switching from the banalities of life to the wonders of religion. At that juncture, knowledge became faith. Time became eternity. Space became infinity. In contrast, there seems to be no dimension that Kawara allocates to God. And yet he creates an art whose dimensions extend far beyond the scope of human life. In *One Million Years*, the work Kawara identifies as his most important, he locates himself within a vastness that supersedes earthbound measures of longitude and latitude, or years, or centuries. The universe he inhabits has swelled to encompass the orbits of stars and the intervals between galaxies. Kawara documents the boundaries of his life—birth and death—which in this piece transcend human comprehension because they are measured according to a number of such magnitude.

One Million Years takes the form of books of numbers that the artist typed with the exactitude of scientific data, in rows of ten sequential columns on white $8\frac{1}{2}$ x 11 inch paper. Each cluster of numbers on a page represents one century. There are two sets, each consisting of ten volumes. *One Million Years (Past)* (1970-71) is dedicated to "all those who have lived and died." It counts backwards and concludes with the number 998,031 B.C. *One Million Years (Future)* is in process. It is dedicated to "the last one." It counts forward to 1,001,980 A.D. and implies extension beyond civilization. Kawara has located himself, with characteristic precision, at the intersection between eternity and infinity.

PROCESS: Kawara has adopted a mind-set that seems the very antithesis of artistic thinking. He dissects the means of artistic production into definable acts that are totally preplanned. The execution is determined by set laws and is therefore neither inspired nor self-expressive. Once a series is initiated, its continuation is capable of infinite extension. It has no goal. It neither progresses nor declines. It merely accumulates.

Identifying causes, erecting explanations, engaging in analyses are processes bound by ideologies and theories. They are, therefore, deleted from Kawara's work as unreliable sources of information. Through these deletions Kawara offers a rare instance of absolute certainty. By limiting his work to pure description of space and time, he reveals only irrefutable information about himself. Each work of art offers definitive truth about a day in the artist's life. The works unfold year after year in an irreversible progression. Kawara will run out of art only when he runs out of time. Along the way he has created a chronicle of the meaning of life and mortality at the end of the twentieth century.

On Kawara's refusal to be photographed or interviewed does not indicate that he is noncommunicative. On a cold January day in 1996, Kawara asked to meet me in a downtown Manhattan bar, a setting conducive to uninterrupted hours of discussion. Both photography and written quotes, he told me, congeal events and thus belong to the desolate zone of the past. He prefers to activate the present. For the most part he spoke. As I listened I traveled through the vast galaxy of consciousness that comprises On Kawara's mind. My occasional comments and questions did not deflect him from the momentum of this oral trajectory. He ranged broadly: art, religion, the nature of matter and color, language. His thoughts spilled from a mental perch high above the one familiar to me. Was it a performance or a confession? Had he given me a gift or a responsibility?

Eventually I concluded that his discourse was not intended for his pleasure nor for my entertainment, but for the purpose of sharing with my readers. I offer it here as a supplement to the consideration of On Kawara's work and, perhaps, to the reader's more personal contemplations on the nature of consciousness.

l. On Kawara revels in codes. His focus is not on the rules that form them, but on the mystery

that surrounds them before they are broken, cracked wide, and deciphered.

2. On Kawara has had 100 one-person exhibitions. He has seen only fourteen. He prefers not knowing how his work is presented. He keeps no records of his postcard and telegram series. Once he creates these works of art, he sends them into the world to fulfill their own destinies.

3. On Kawara's father was Christian. His mother was Buddhist. They lived beside a Shinto shrine. His childhood experience made him aware that different religions offer separate codes but common premises.

4. Western thought is concerned with only one essence, the tangible world of objects in which things can be measured by the rational mind. In Islam, essence is a composite principle consisting of equal partners—the known and the unknown. Buddhists do not believe in essence.

5. There are five senses. Four are located on the face. Most people value these the most. But it is possible to survive without seeing, hearing, tasting, and smelling. The only sense upon which life depends is the sense of touch, and that is distributed throughout the body.

6. There are many ways to analyze color. In some color systems, three primary colors are

ON KAWARA
One Million Years Past, 1970-71. 2 views.
Type on paper assembled into 10 volumes
Courtesy the artist
Photo: Hiro Ihara

identified. But the color wheel reveals many elemental colors. Since all color is comprised of light, there is an infinite array of equally primary colors. At the same time, it is often presumed that red and green are complementary, and therefore equal. But this is not true because green contains more color components.

7. We are not very knowledgeable about death. We have never tried it. Westerners fear death. They fail to realize that death is an essential generator of energy. Sleep and meditation are forms of death. In the East, when a monk meditates upon a mountain, he persists until the

mountain disappears and the entirety of the world is perceived as uninterrupted sameness. The monk does not cease his travels when the tangible world of objects dissolves. He passes through this stage and returns to this world charged with energy. He has returned from a kind of death. Since we come into the world crying, we should go out of the world laughing.

8. On Kawara studied philosophy in school. In the beginning he worked intuitively, although he has always been interested in physics, astronomy, and mathematics. Scientists continually expand the beginning of life or the age of the earth. Each time they advance, God retreats and still cannot be known. Nothing has changed. The territory of mystery recedes as fast as knowledge advances.

9. Kawara relished the memory of one exhibition in which his dispassionate date paintings were paired with Alberto Giacometti's heartrending sculptures. These apparently contradictory works were exhibited in France, the homeland of René Descartes. Descartes is the seventeenth-century philosopher who celebrated consciousness as the essence of existence. This exhibition was an homage to Descartes.

10. Twelve years ago, in Stockholm, Kawara's case containing all of his stamps and other *I Got Up* material was stolen. He allowed this accidental event to terminate the series. He approached the mishap as an occasion for a vacation. He feels fully rested now and is considering resuming the series.

11. Artists almost never commit suicide. Writers often commit suicide. Words are deadly.

12. A deep chuckle concluded an anecdote about the well-known minimalist sculptor, Carl Andre. Kawara explained that many years ago, Andre was expounding on the glories of Marxism to a group of increasingly impatient French socialist intellectuals. They had all gathered in a café on a sweltering summer day. Kawara interrupted the monologue to remind Carl that Marx had no sympathy for art or for religion. Marx's prediction that all artists would become Sunday painters belonged to societies that no longer believed that Sundays were holy days of sabbath.

13. On Kawara believes there is quantum biology, which correlates with quantum mechanics and demonstrates that the world is an integrated unity.

14. The only way we know things is to examine them at their edges. For instance, defining shapes of objects depends on identifying their edges. Likewise, defining units of time depends on establishing edges. On Kawara does not believe in past and future. Time is a continuum unfolding in the present. There are no beginnings and endings.

15. He delighted in reporting that Greenland is icy and barren, but Iceland is green and fertile. Their names are reversed to discourage people from coming to Iceland and spoiling its natural beauty.

16. Kawara's honeymoon lasted exactly a year. It began on April 1st, his favorite day of the year, and ended on March 31st. During that year he and his bride, Hiroko, traveled throughout South America. They have been married thirty years.

17. Life is a pursuit of consciousness.

KAWARA POSTSCRIPT:

One measure of art's involvement in the affairs of the world is the frequency with which today's artists forsake the studio and the museum and relocate their works within the unpredictable circumstances of everyday life. Some of these artists include On Kawara—global travels; Mel Chin—toxic waste site; Joseph Beuys—schools and lecture halls; Marina Abramovic—deserts; Wolfgang Laib—fields; Felix Gonzalez-Torres—urban neighborhoods; Sophie Calle—bedrooms; Orlan—surgical operating rooms; Haim Steinbach—stores.

Marina Abramovic

MARINA ABRAMOVIC subjects herself to extreme physical and mental stress. Sometimes her activities result in a loss of consciousness. In Western societies, such acts are commonly cited as evidence of insanity. But in other cultures, they are respected as holy. Abramovic calls them art. Spiritual transcendence is her goal.

Waiting for an Idea, 1991
Amethyst Mine, Santa Catherina, Brazil
Courtesy Sean Kelly, New York
Photo: Paco Delgado

SELF-TRANSCENDENCE

Marina Abramovic

Born 1946, Belgrade, Yugoslavia
Academy of Fine Arts, Belgrade, Yugoslavia
Academy of Fine Arts, Zagreb, Yugoslavia
Lives in Amsterdam, The Netherlands and
 Berlin, Germany

MARINA ABRAMOVIC
Breathing In/Breathing Out, 1977
Collaboration with Ulay
Performance, duration 19 minutes
Student Cultural Center, Belgrade

Courtesy Sean Kelly Gallery, New York
Photo: Rudi Monster

Rhythm V, 1974
Performance, duration 90 minutes
Student Cultural Center, Belgrade

Courtesy Sean Kelly Gallery, New York
Photo: Nebojsa Cankovic

A QUESTION this author posed to thirty acquaintances generated the following answers:

> Seat belts.
> Insurance policies.
> Money in the bank.
> Mouth wash and deodorant.
> Vitamins.
> Water filters.
> IRAs.
> Sun-block lotion.
> Condoms and the pill.
> Burglar alarms.
> Well-lit parking lots.
> Shatterproof glass.
> Smoke detectors.

The question was "What are the sources of protection and security in your life?" When confronting the vagaries of life, these respondents appealed to services and commodities that can be purchased in the marketplace. This manner of alleviating anxiety discloses our reliance on solutions and forms of guidance that are profane and, therefore, provisional. Yet alternative approaches to achieving security have prevailed in societies occupying the furthest expanses of time and place. These approaches are rooted in the sacred and the eternal. In these cultures, decrees carry the supremacy of the gods. Explanations for natural phenomena are invested with the commanding power of totemic spirits. Social behavior is ordered by inviolable rituals. Faith is placed in the potency of prayer, fasting, and ritual. People seek assurance by placating angry gods, petitioning the blessings of benevolent beings, or pursuing the interventions of ancestral spirits.

What is significant about this little survey is that although most of the respondents identified themselves as "religious," their trust nevertheless remains rooted in the profane world. It is vested in the products of a detached attitude, in a search for verifiable facts, and in the methodi-

cal processing of data. Problem-solving is considered a human affair, dependent on those who occupy professions in government, medicine, law, and science. Even explanations for the origin of the world, the enigma of death, the nature of life here on earth, have fallen within their purview. Religion persists in technologically advanced societies, but God must coexist with holograms, Hubble telescopes, and test-tube babies.

Some contemporary artists regret that art is among the many categories of human endeavor that have become secularized. They seek ways to return it to the sacred realm. Their work is designed to heal the spirit, dissolve the duality between humanity and nature, protect the community from evil, furnish knowledge of death, and serve as a conduit between the divine and the profane worlds. Marina Abramovic is such an artist. The aspect of her work that is the subject of this essay is removed from the sphere of private ownership. Nonmonetary measures of artistic merit prevail. Abramovic is our guide into the orb of the spirit. Her art provides vivid testimony of a form of awareness that is as immaterial as breath and as resplendent as a vision. It has no material counterpart and therefore cannot be sculpted or painted. It can only be experienced.

Abramovic molds her spirit. Her art activities, grueling and often perilous, propel her to an altered plane of consciousness. She persists until her physical condition is so depleted that earthbound sensibilities cease to function and mundane thoughts are silenced. In this silence, spiritual states of being arise. Her work awakens neglected mental faculties.

Abramovic's "Biography" begins with a simple statement of fact:

1946 Born in Belgrade
Mother and father partisans

Further on, she enumerates her first self-imposed ordeals:

1972 Start using body as material
Blood, pain
Watching major surgical
Operations in hospitals
Pushing my body to its physical
And mental limits

Other entries provide examples of these trials:

1973 Burning the hair
Cutting a star in the stomach
With Razorblade
Lying naked on an ice cross

The year 1981 states:

Experiments without eating and
Talking for long periods of time . . .
Eating honey ants, lizards,
Desert rats, grasshoppers

Marina Abramovic has enacted many of these activities with her partner, Uwe F. Laysiepen (known as Ulay), whom she met in 1975. They discovered that they not only shared artistic goals, they also shared physiognomies. Both have strong, sculpted facial features and full heads of dark hair. They even have the same birthday, although Ulay is three years older. They became lovers and collaborators on a series of remarkable art events.

Relation Works refers to a group of pieces in which the couple invented forms of nonsexual union that fulfill the mystical desire to dissolve physical and psychic boundaries. In *Breathing In/Breathing Out* (1977), for instance, the couple literally relinquished their autonomy and became united by sharing the most elementary unit of life—a single breath. They blocked their nostrils, locked their mouths together, and synchronized their breathing. She inhaled the air expelled by him. He breathed only the air exhaled by her. Each received ever higher concentrations of carbon dioxide. They persisted nineteen minutes, to the brink of asphyxiation.

Between 1980 and 1985, in a work entitled *Modus Vivendi*, the couple made frequent voyages to the central Australian desert. They were not tourists. In fact, they intentionally exchanged the pleasures of travel for painful ordeals that lasted months at a time. The unbearable temperatures by day and night made such elementary tasks as sleeping, eating, and walking extremely arduous. Survival in the desert meant withstanding thirst, windstorms, bandits, rats, illness. But instead of attempting to diminish this discomfort, the artists chose to intensify it by spending their time sitting silent and motionless in the sweltering heat. What was gained by these

physical tribulations? Abramovic and Ulay sojourned in the desert like prophets on a spiritual quest. Immobile and mute, they broke the patterns of behavior that prevail in advanced technological societies. Their activities had no pragmatic purpose, nor did they provide comfort, earn money, or entertain. By disjoining themselves from the habits of their upbringing, they learned that monotony need not be boring. Indeed, monotony revives extraordinary, inner-directed experiences. Those who attempt to describe the feelings that ensue use such uplifting words as joy, light, peace, warmth, unity, certainty, confidence, rebirth.

How can a painful ordeal become a form of art? It is difficult to find a place for *Modus Vivendi* within conventional categories of Western art. The artists' activity did not involve representing it by shaping matter into a tangible object. Their enterprise cannot even be called a performance because there was no audience, no rehearsal, and no element of make-believe. It is, instead, a real-life experience of people who call themselves artists. Yet art historians and critics have willingly broadened art's domain to incorporate Abramovic's digressions. Perhaps it is because these incongruous acts are propelled by the same force that has been motivating change in art since Neolithic artists abandoned the realistic renderings of their Paleolithic predecessors. Art ceased being an accurate record of animal anatomy when hunting, which relies on keen observation of animal behavior, ceased to be the primary means of survival. Then as now, evolution from one art form to the next occurs when pre-existing forms are inadequate to convey a new experience or accomplish a new goal. Accordingly, Abramovic invented a medium (physical ordeals) to accommodate her message (that depriving the body restores the spirit).

Modus Vivendi, for instance, addresses a populace that has been pampered by material abundance. The work suggests that metaphysical fulfillment doesn't thrive amid air-conditioned cars, padded toilet seats, and a profusion of other physical comforts. Achieving spiritual good fortune may require reversing the engines that drive our acquisitive impulses. Perhaps we should strive as eagerly for deprivation as we normally strive for plenty.

A series of ceremonial meditations called *Nightsea Crossing* amplified these themes. Between 1981 and 1986 Abramovic and Ulay endured periods of fasting and silence that lasted up to sixteen days at a time. Each day the artists occupied seats at opposite ends of a long table installed in a museum. They spent all the hours the museum was open staring transfixed into each other's eyes. They were the work of art.

MARINA ABRAMOVIC
AND ULAY
Nightsea Crossing, 1985
Duration 2 days
São Paulo
Courtesy Sean Kelly Gallery, New York

Sometimes they emphasized their trance-like state by placing a particularly distracting object, for example a large snake, on the table between them. Visitors observed two people who had passed beyond normal consciousness. Instead of relying on words and gestures, Abramovic and Ulay engaged in a form of communication rarely employed in the West—pure psychic energy. Abramovic describes the experience:

> *Presence*
> *Being present, over long stretches of time,*
> *Till presence rises and falls, from*
> *Material to immaterial, from*
> *Form to formless, from*
> *Instrumental to mental, from*
> *Time to Timeless*

Outside of the museum as well as within, the two severed their ties to conventional modes of living and working. Throughout the period of *Nightsea Crossing* they lived and traveled in an old truck, stopping to perform the work in Düsseldorf, Berlin, Cologne, Amsterdam, Kassel, Helsinki, Ghent, Furka, Bonn, Lisbon, Lyons.

It was also performed in Ushimado, São Paulo, New South Wales, Chicago, Toronto, and New York. A total of ninety days was spent absorbed in telepathic connection. During each of these days, Abramovic and Ulay subsisted on water alone and maintained total silence.

Abramovic's works provide evidence that the human mind is capable of operating on a number of different wavelengths. Every world

MARINA ABRAMOVIC
AND ULAY
Rest Energy, 1980
Performance
ROSC Festival, Dublin

has its own frequency. We communicate with the worlds that share our wavelength. Monks, for instance, relate to the world mystically, through "prior-dimensional" means that unify the conscious and the unconscious minds. As a result, whatever their specific religion or language, they freely commune with each other. This truth is dramatized in a version of *Nightsea Crossing* in which Abramovic and Ulay were joined by an Australian aborigine and a Tibetan monk. Visitors observed four disparate people conversing in silence and stillness.

In 1988, the Great Wall of China, an ancient, crumbling ruin that meanders and zigzags over one-twentieth of the earth's circumference, became the site of a work entitled *The Lovers: The Great Wall Walk*. The artists walked the wall for ninety days, covering 2,400 miles. Abramovic started at the sea, in the zone of cold liquid. Ulay started in the desert, the zone of dry heat. They walked in the manner of a prolonged meditation, with no purpose but to achieve awareness. When they met on June 27, male/female, fire/water, hot/cold, dry/wet were symbolically united.

Intentional risk and discomfort are the distinguishing characteristics of Abramovic's performance works. For *Rhythm V* (1974), she constructed the outline of a large wooden five-pointed star, which was placed on the floor and then set on fire. To Yugoslavians like Abramovic, the red star carries powerful symbolism. It served as the official emblem of the Communist state, which made it compulsory to plaster stars on stores, restaurants, nurseries, schools, etc. But the same five-pointed star appears in hermetic traditions, where it is linked to life, health, and Mother Earth. Abramovic resurrected the star's ancient life-enhancing associations by including a traditional purification ritual in her performance. She chopped off her hair, cut her nails, and then lay down in the center of the flames. She waited patiently for the fire to consume all of the oxygen and usher her into a state of unconsciousness. The audience did not know that she was unconscious until flames touched her leg and she did not respond.

In *Rest/Energy* (1980), Abramovic and Ulay gambled with her life, as if heightening the risk also heightens the state of consciousness it generates. She held the wooden shaft of a great bow fitted with an arrow. Ulay faced her, holding the arrow against the string of the bow. He was blindfolded. Marina's eyes were open. Gradually, they leaned back, the weight of their bodies pulling the string taut. The arrow was aimed at Marina's heart and poised for release. They maintained this precarious balance until fatigue overwhelmed them.

In *Dragon Heads* (1995), Abramovic sat for an hour inside a ring of ice with five pythons and boas. The snakes sought the warmth of her body. They writhed across her face, tangled her hair, and even copulated on her head. Any trace of tension would have triggered their biting and strangling instincts. Thus the piece required Abramovic's utter surrender to the sacred role serpents played in prehistory. She merged with Ouroborus, Quetzalcoatl, and Atum, the cosmic serpents in the cosmogonies of Africa, Mexico, and the Mediterranean countries.

In all of these works Abramovic is passive. She exposes herself to elements that, to the typical Western mind, are agents of danger. But at

other times and in other places, these very same elements were respected as valuable human resources. Abramovic returns them to their ancient origins. *"I think that we live in an age which faces emergency: our consciousness has completely separated from our sources of energy. I want to reproduce this consciousness."*[1]

Individuals who believe that subjecting oneself to such forms of danger is a sign of mental disturbance constitute Abramovic's ideal audience. Her work jangles the tether that lashes viewers to the belief systems of Western culture. She asserts that artists need not be object-fabricators. They can act as ceremonial voyagers who travel into the forbidden territories of consciousness. To Abramovic, this journey is urgent: *"It is too late, the destruction is already such that the world can no longer be 'cured,' . . . Its destruction will continue, inevitably. I only want to prepare people for the fact that we are all living on a dying planet and that we will all be destroyed. I see a chance or a possibility of at least dying in union with the earth, at least grasping reality one single time."*

In addition to her performance works, Abramovic provides opportunities for others to enter the consciousness she engages. She arranges chunks of copper, iron, and crystals in gallery settings in specific configurations that visitors can place to their foreheads, their hearts, their genitals. In the stillness, many report they have been stirred, for the first time, by the energies these materials contain. *"This awareness,"* she hopes, *"may at least lead man to a state of unity with himself."*

The extreme nature of Abramovic's activities runs counter to Judeo-Christian religious beliefs. Instead, it closely parallels the practices of traditional shamanistic leaders for whom danger and pain serve as catalysts for spiritual transport. Shamans master fire, endure solitude or self-mutilation, subject themselves to fatigue or fasts to learn the mysteries of life.

In eschewing Western patterns of communication, Abramovic stills the mind and stirs the consciousness. In this way, she demonstrates that the analytic functions of the brain are not the only means to process experience. Thoughts must be quieted in order to pass to a higher plane of awareness. Presumed separations between the self and the world must be restored to unity.

Abramovic's work suggests that the word "illogical" is not synonymous with "nonsensical." A wondrous world is disclosed when we relinquish the habit of forming practical applications or drawing rational conclusions. This reward is relayed in her description of *Nightsea Crossing*:

> *Be quiet still and solitary*
> *The world will roll in ecstasy*
> *At your feet*

ABRAMOVIC POSTSCRIPT:

The fast-forward button is a symbol of the pace of contemporary life. People clamor for a place in the express lane on highways and at supermarket checkouts. They rush faxes and E-mail messages, microwave food, buy instant coffee, and demand millisecond responses from computers. Sustained activity and patience are anachronistic to our time, yet they appear frequently in contemporary art. Tempo is commonly associated with art forms that transpire in time like music, dance, film, and theater. Yet tempo is also an aesthetic ingredient of today's visual art. For instance, Marina Abramovic settles into stasis to resist earthbound tempos and enter a suspended, liminal state. James Luna freezes time when he transforms himself into an object for display. Mel Chin's art is dictated by the growth rate of plants. Chuck Close applies paint to canvas at a pace that seems inhumanly methodical and slow. All of these artists reject the hip-hop syncopations that characterize the velocity of contemporary urban life. They slow their lives' metronomes to a near halt.

Sophie Calle

SOPHIE CALLE trespasses onto personal territories. The information she gathers—secrets that usually remain hidden in diaries or behind bedroom doors—is divulged in the form of art. Most artists explore their own lives. Calle explores the lives of others.

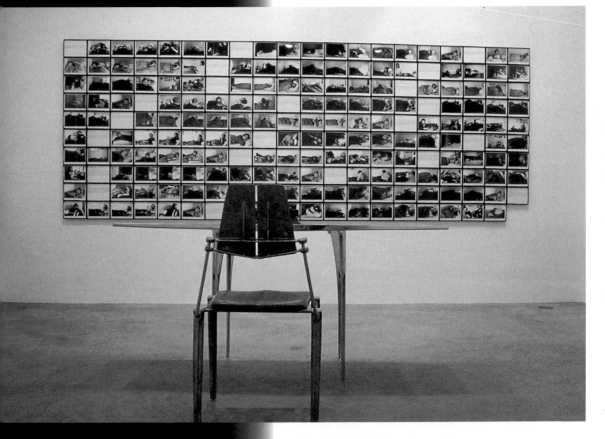

The Sleepers, 1979. Black-and-white photographs, each 5 $^7/_8$ x 7 $^7/_8$ in., and text

Courtesy the artist and Luhring Augustine Gallery, New York

ERADI SELF- CATION

Sophie Calle

Born 1953, Paris, France
Lives in Paris, France

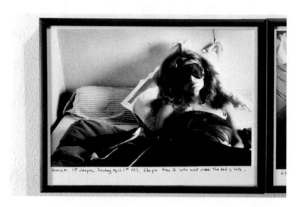

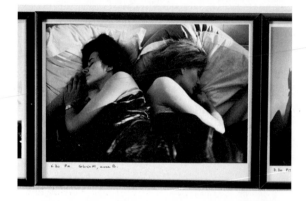

SOPHIE CALLE
The Sleepers, 1979. Details of Gloria K., first sleeper;
Gloria K. and Ann B.; and Gerard Maillot, fifth sleeper
Black-and-white photographs, each 5⁷/₈ x 7⁷/₈ in.
Courtesy the artist and Luhring Augustine Gallery, New York

IF A STRANGER APPROACHED

you and asked if you would lie in her bed for
eight hours so that she could observe you sleep-
ing, would you agree? Twenty-four people did.
They became collaborators in Sophie Calle's art,
an ongoing exploration of the private lives of
strangers. Their experiences compensate for the
loss of her own. Calle neither loves nor hates,
fears nor yearns, grieves nor rejoices. She gives
form to the void within her. Her barren state is
revealed by relying on others to supply the
emotional and narrative content of her work.
Through them she describes the mental tenor
of the times. Most artists who envision life's
misfortunes are expressionists. Calle, however, is
a non-expressionist. No spark of emotion ignites
her creative process. No personal feelings are
evident in her completed work.

Calle exposes the causes and symptoms
of today's soullessness by identifying various
professions that serve as proxies for personal
relationships. For instance, psychologists plumb
the private contents of psyches and souls while
meticulously preserving "professional distance."
Memories, motives, passions, fears, and obses-
sions are ferreted out utilizing the dispassionate
tools of science and cognition. In her best-known
work, Calle dramatizes how psychological
research has replaced love and affection as the
means to access intimate aspects of personality.

In planning a work of art that reveals how
psychological investigation obstructs human
interactions, Calle sought an activity that elicits
intense personal and social responses. It is evi-
dent why sleep became her subject. Sharing a
bed with a partner divulges intimate social
behavior, while dreams elicit unsocialized pro-
clivities. Calle describes the resulting work, enti-
tled *The Sleepers* (1979): *"I wanted my bed to be
occupied all the time, so I asked people I didn't
know to come and sleep in it. Each of them would
sleep for eight hours and be awakened by some-
one who would take their place, and so on, for
eight days. For the day shift I asked mainly people*

who normally slept in the day, like bakers, to come. I stayed at the bedside for the eight days." [1] Forty-five individuals were contacted by phone. Most of the names were suggested by acquaintances. Of these, twenty-nine accepted. Twenty-four actually appeared, arriving one after the other at eight-hour shifts around the clock. Calle summarizes her activity with them: *"I photographed them every hour and wrote down everything they said."* [2]

Determining the setting for this experiment constituted another artistic decision. Calle rejected the emotionally sterile territory of a psychologist's laboratory or office. She conducted her sleep experiment where personal relationships are expected to prevail, at home. Within her home she selected the room in which relationships are private, the bedroom. Within the bedroom, she identified the place that is reserved for intimacy, the bed.

A third decision involved her relationship with the sleepers, strangers who entered the emotionally charged environment of her bedroom. Calle's theme required that she assume the role of a scientist conducting an experiment. Her indifference was dramatized by the expectation of attachment within this setting. She remained as disengaged as if she were standing behind a one-way glass in the controlled setting of a laboratory. Nothing personal transpired between her and the occupants of her bed. The location and her demeanor pitted professionalism against familiarity, objectivity against affection, and anonymity against intimacy. The neutrality that infiltrated her bedroom was a metaphor for the paralyzed state of love in contemporary society.

The men and women who participated in Calle's experiment provided the content of her work. They contributed an aspect of their lives that is normally off-limits to strangers—their sleeping habits. Most were unaware that their actions and their words were going to be recorded through photographs and text. Few realized these documents would be displayed as art for the scrutiny of museum visitors.

The apprehension the subjects must have felt upon entering a stranger's bedroom, climbing into a stranger's bed, and sleeping in a stranger's presence evaporated in the clinical atmosphere that Calle contrived. Once installed in bed, they yielded to her objective gaze. She described what she observed. Verbal exchanges thwarted personal contact by eliminating spontaneous conversation and confining discourse to the rigid structure of a questionnaire: *"I put questions to those who allowed me; nothing to do with knowledge or fact-gathering, but rather to establish a neutral and distant contact."* [3] The work's unemotional accountings record answers to such questions as:

> *Is sleeping a source of pleasure?*
> *Should the door be left open or closed?*
> *Do you talk during sleep?*
> *How do you think you sleep?*
> *Do you use an alarm clock?*
> *Does my presence in this room risk disturbing your sleep?*

The report on the sixteenth sleeper, Patrick X, provides a sample of her scientific tone. *"He gets into bed without changing the sheets. He agrees to answer my questions. He tells me he came because he thought it had to do with an orgy. He isn't sorry about the way things turned out."* [4]

Calle's choice of the camera as the medium through which she would present her findings confirms the emotional distance that is at the core of her efforts. Her guests and her work of art are as "untouched" by her hand as they are by her emotions. *"Photography can help me to get inside a story, to get closer to my subject. It's a way of approaching people."* [5] In Calle's hands, the camera is an uncongenial tool. She exploits its intrusive lens and accedes to its mechanistic anonymity. Through it she formalizes her role as an observer, not a friend or lover, of her bedroom partners. Her photographic style renounces artful aesthetics. Calle's photographs are black-and-white, frontal, neutral. Devoid of feelings to express, she has no use for mood-emitting colors, forms, or textures.

The Sleepers is presented in the form of rows of photographs of the sleeping subjects and an entire book of interviews with them. The museum visitor sees and reads evidence of a profusion of bedroom activity that is neither romantic nor titillating. A clinician's disengagement characterizes the interactions enacted there. By luring strangers into her bedroom, but

shunning familiarity, Calle provides an unsettling indication that the loss of affection in contemporary life often pervades the bedroom.

Calle never attended art school or a university, and she never imagined being an artist. Her sleuth-like activities began in 1979 when she had no job, no goals, no desires. *"I had come back to France after seven years of travelling, and when I arrived in Paris, I felt completely lost in my own town. I no longer wanted to do the things I used to do before, I no longer knew how to occupy myself each day, so I decided that I would follow people in the street. My only reason for doing this was that since I had lost the ability to know what to do myself, I would choose the energy of anybody in the street and their imagination and just do what they did. I didn't take photographs or write texts, I just thought every morning that I would see where they went and let them decide what my day would be, since alone I could not decide."*[6] How then did Calle's schemes become known as art?

Ironically, it was not her creative vitality, but her lethargy that attracted the attention of the art world. Calle might have remained just a confused and lonely woman had it not been for an art critic who heard about her activities, recognized in them the characteristics of recent art, and invited her to participate in the Paris art exhibition, "Biennale des Jeunes," in 1980. In this way her art career was launched. She admits, *"I wasn't the one who thought I was an artist."* Her pre-art activities have been retroactively classified as art.

"I wanted my bed to be occupied all the time, so I asked people I didn't know to come and sleep in it."

Although it is a fluke that Calle entered the art context, her reputation in Europe and the United States developed because she went on to produce an original and coherent body of work. She explores a theme that has already produced great art by such luminaries as Edward Hopper, Egon Schiele, Pablo Picasso, Alberto Giacometti, Jean Dubuffet, and Käthe Kollwitz, to name a few. They have all given visible form to melancholy and despair. In their work, subject and style merge to provide a vivid record of their feelings. Viewers empathize. What differentiates Calle's work from theirs is that she doesn't feel anything at all. By directing a harsh, inquisitor's light into her own soul, she exposes a hollow interior. Viewers feel the chill of isolation. They sympathize.

In each work of art, Calle enacts a role in which personal dealings are conducted in an impersonal manner. For *Sleepers*, she assumed the guise of an experimental psychologist. Likewise, when she followed strangers, she became a stalker, someone who trespasses on an individual's privacy without interacting with that person. The following works of art dramatize other "imperson-to-imperson" relationships.

STALKER: *Suite Venitienne* (1980) is a work in which Calle's sleuthing activities intensified to incorporate full-scale surveillance tactics, all conducted to yield a portrait of a complete stranger. Calle followed a stranger through the streets of Paris and then pursued him all the way to Venice. *"Monday. February 11, 1980, 10:00 pm. Gare de Lyon. Platform H. Venice boarding area . . . In my suitcase: a make-up kit so I can disguise myself; a blond bobbed wig; hats, veils, gloves, sunglasses, a Leica and a Squintar (a lens attachment equipped with a set of mirrors so I can take photos without aiming at the subject)."*

Thus equipped with the detective paraphernalia of a Grade-B movie, Calle embarked on a thirteen-day escapade that mimicked a romantic melodrama but was devoid of its most essential ingredient—passion. Calle spied on a man in whom she had no interest. Her obsession was feigned. *"I did things for him that I would never do for someone I really loved. I would never spend ten hours outside in the cold waiting for someone—I've never been jealous enough or in love enough—but for him I did it . . . (These works are) a way of creating emotion. I'm not in love, but I have all the . . . signs."*[7]

After thirteen days, Henri B. discovered he was being followed. He confronted Calle. What was the tale's climax? An embrace? A showdown? Neither. As Calle reports, *"Henri B. did nothing. I discovered nothing. A banal ending to this banal story."* Her romance collapses at the moment of a face-to-face confrontation with her

imaginary lover. *"Nothing (was) to happen, not one event that might establish any contact or relationship between (us). That is the price of seduction. The secret must not be broken."* [8] The narrative reverberates with the ache of a loveless life. It is a reminder that the only romantic adventure in many people's lives is contrived. *Suite Venitienne* is an artistic fabrication, but it tells the true story of people whose erotic sensations depend on fantasy.

CHAMBERMAID: Chambermaids comprise another profession in which privileged views of people's private activities are gained without personal associations being formed. Calle took a job as a chambermaid in a hotel and pried into the private lives of the guests by sifting through their belongings while she cleaned. She read diaries, opened suitcases, eavesdropped at their doors. She remained anonymous while the hotel guests yielded their bathroom and bedroom habits to her. Calle recorded her findings with a cheap, auto-focus camera and a tape recorder. These documents comprise the work entitled *Hotel* (1986).

INVESTIGATIVE REPORTER: In *The Notebook Man* (1983) Calle behaved like an investigative reporter ferreting out secrets without the consent of her subject. *"I made a work for the newspaper* Liberation. *They offered me half a page a day during the whole summer to do whatever I wanted. I tried to find a project which included the old newspapers' idea of a serial. I had recently found an address book in the street. I photocopied it and I sent it back to the owner. Then I went to see, one by one, the people mentioned in the book and asked them to talk to me about the man, trying to piece together a portrait of him, like a puzzle, through everybody's opinion of him."* [9]

Interviewing and photographing the individuals listed in Pierre D.'s address book, Calle gathered information about his professional, social, and personal life. The results comprise an artwork that took the form of thirty installments published in the Paris daily newspaper between August and September 1983. The newspaper setting escalated the power of this intrusion. Art

SOPHIE CALLE
The Hotel, Room 29, 1986. Photographs and text, 41 1/8 x 57 1/2 in.
Courtesy the artist and Luhring Augustine Gallery, New York

may be a fiction, but newspaper reports are assumed to be factual. Furthermore, the intimate details of this unsuspecting citizen's life were

revealed to a far greater number of people than if the work were presented in a museum.

TOURIST: Tourists are outsiders, observers, picture-takers. Like journalists, psychologists, and chambermaids, they form relationships that are temporary, superficial, and impersonal. Calle experienced tourism in its extreme form in a work entitled *The Trans-Siberian* (1987). *"I decided to take the trans-Siberian train. For the whole journey you are in a compartment with someone you don't know and you have to live like a couple. The space is four meters square, and there you are for fifteen days, face to face."*[10] The man with whom Calle shared her compartment spoke only Russian. They could not converse and felt no emotional involvement, yet together they conducted the intimate functions of cohabitation. They arranged when to eat, when to sleep, when to wake.

DETECTIVE: Calle's contribution to an exhibition titled "Self-Portrait," organized by the Centre Pompidou in 1981, provides heart-wrenching evidence of her depleted state of being. Instead of producing her own self-portrait, she relied on a second party to determine the portrayal. *"I asked my mother to hire a private detective to follow me, without him knowing that I had arranged it; and to provide photographic evidence of my existence. I knew he would follow me during a certain week, but I didn't know on which day of that week. I was not trying to do weird things, I wanted to show him what my life was really like."*[11] The detective produced a written chronicle of Calle's day, which she exhibited along with her own diary account as *La Filature (The Shadow)*. Calle relinquished the role of artist to the detective. He created her portrait. Thus the range of her emotional disengagement was not confined to her relationship with others. It included her relationship to herself.

Blind (1986) provides further testimony of the depletion of her creative resources by publicly abdicating the classical role of artist as a depicter of beauty. Calle demonstrated that individuals presumed to be incapable of supplying this vision were more capable than she. She depended on people who were blind since birth to identify things that were beautiful for her artwork. She photographed the participants and the objects they described. The final work of art consisted of these photographs and the verbal descriptions of beauty on which they were based.

In all of these projects, Calle's imagination depends on emotions other people feel and material other people furnish. She admits, however, that she usually introduces into the final work one element all her own. One photograph of a hotel room, one response of a blind person, etc.: *"... every time there is a lie, and generally there is only one in each work: it is what I would have liked to find and didn't."*[12]

Today's workplace and home life often deprive people of opportunities for human interaction. Surveys report that social disintegration is rampant. Community bonds are rarely established because we move frequently. Our network of acquaintances is dominated by work, not family. Single-person households proliferate. Home is often a refuge from danger and not a center of congenial social exchange. Televisions supply mealtime conversation. Hallmark cards express our intimate communications. The computer, bureaucracy, and the media impersonalize life. We can dial for shrinks, sex, jokes, and horoscopes. These are some of the causes. Sophie Calle documents their effects.

CALLE POSTSCRIPT:

Sophie Calle, along with On Kawara, Chuck Close, and Sherrie Levine, purges art of anger, envy, hate, love, joy, sorrow, zeal. Marina Abramovic, the Gerlovins, and Paul Thek transcend these emotions. It is ironic that a full expression of human emotions is found in Laurie Simmons's puppets, Mike Kelley's dolls, Meyer Vaisman's stuffed turkeys, and two human automatons named Gilbert and George.

7

Gilbert & George

GILBERT AND GEORGE are not personal names. They are an entity like Procter & Gamble or Sears Roebuck. Instead of presenting themselves as living sculptors, Gilbert and George is a living sculpture. Both members of the team have lavished great care upon their appearance (the aesthetic component of their art) and their actions (the content of their art). Every moment, awake or asleep,

Design for Foreheads, 1990
Courtesy the artist

in the privacy of their home or in the public forum, is devoted to their artistic mission. Gilbert and George, the artwork, suffers for the benefit of humankind.

SELF-SACRIFICE

GILBERT & GEORGE/THE ARTIST

71

Gilbert & George

See colorplate 14, page 30

Gilbert
Born 1943, Dolomites, Italy
Wolkenstein School of Art
Hallein School of Art, Austria
Munich Academy, Germany
St. Martin's School of Art, London, England
Lives in London, England

George
Born 1942, Devon, England
Darlington Adult Education Center, England
Darlington College of Art, England
Oxford School, England
St. Martin's School of Art, London, England
Lives in London, England

GILBERT AND GEORGE had become a sculpture by the time they graduated from St. Martin's School of Art in London in 1967. As students, they produced statements, pamphlets, novels, postcards, and photographs and made public appearances. Although these activities are usually identified as the work of writers, performers, and photographers, Gilbert and George classify themselves as sculptors. They assert that because they are a work of art, everything they do, or think, or feel is sculpture.

After graduation, Gilbert and George moved into a London townhouse where they still live. Devoting the entirety of their lives' experience to their art, they have established a rigid daily routine that exempts them from all activities unrelated to this artistic calling. They never cook, clean, or shop. Every waking moment is required, they say, *"to give us time and space to feel our way to our purpose. Every day we have to be sure that the purpose is set in the right direction. It needs redefining every day, every second."*[1] And what constitutes their purpose? *"We try to find ourselves a soul."*[2]

This soul-seeking sculpture is always dressed in the prissy, prim, and proper attire characteristic of the Edwardian period. At home and in public, the artists don identical tweed suits and ties, immaculate white shirts, polished shoes, and often gloves. Sometimes they carry walking sticks to complete their dandyish demeanor. No

stubble is ever detected on their chins. No errant hair disturbs their flawless appearance. Gilbert and George's starched, bleached, and pressed attire is particularly startling because it contradicts contemporary clothing trends. Today, comfort-inspired jeans, sneakers, T-shirts, and sweatshirts are worn to laundromats and sports events as well as to concert halls and churches. Gilbert and George appear conspicuous in all these settings. Their mannequin-like perfection dispels the notion that they are human and supports the impression that they are a work of art. So too does their uncanny resemblance. Although Gilbert's features are darker and more angular than George's, they seem more a mirror reflection of one person than two people who are similarly dressed. Their contrived likeness extends beyond appearance and includes posture, facial expression, and gesture. Being one work of art necessitates that they abandon individuality along with their humanity.

Half of the time, Gilbert and George's deportment is just as starched as their shirts, and just as anachronistic to popular norms of behavior. Adherence to the most stringent rules of etiquette segregates them from a social milieu that tolerates belching, yelling, and grabbing. Gilbert and George enact flawless grace, poise, and courtesy. Their uncommon calm is startling amidst the brusque pace of contemporary human affairs. In this way too, they relinquish familiar human behavior to attain the status of art. Their most acclaimed work, *The Singing Sculpture*, is an example of such undeviating perfection. It has been repeated many times since its inception in 1969. For each performance the artists cover their exposed skin with a glistening bronze powder to verify their status as art. Standing on a pedestal in the middle of a gallery space, they become two bronze sculptures cast from the same mold.

The work is deceptively simple. It consists of Gilbert and George singing "Underneath the Arches" over and over again. Originally popularized by Flanagan and Allan, a team of English music hall performers, "Underneath the Arches" dates to the Edwardian era and thus coincides with the vintage of Gilbert and George's clothing. The artists are accompanied by a recording of the song played on an Edwardian gramophone. Each time the song ends, they exchange glove and cane, reset the record, and begin again. In Düsseldorf, for instance, they repeated this unblinking, rigid, impassive performance for eight hours.

The lyrics to "Underneath the Arches" are written from the point of view of a tramp dubious about the rewards of wealth and content to sleep under a railroad bridge. He prefers his

GILBERT AND GEORGE
The Singing Sculpture, 1970
Courtesy the artist

simple, impoverished state to the complicated lifestyle of wage earners and homeowners:

The Ritz we never sign for, the Carlton they can keep
There's the only place we know and that is where we sleep
Underneath the arches we dream our dreams away
Underneath the arches on cobblestones we lay
Every night you'll find us tired out and worn
Happy when the day-light comes creeping, heralding the dawn

*Sleeping when it's raining and sleeping
when it's fine
We hear trains rattling by above
Pavement is our pillow no matter where
we stray
Underneath the arches we dream our
dreams away.*

Gilbert and George's appearance is utterly anomalous to these lyrics. The artists are immaculate, whereas hoboes are soiled, unkempt, and ragged. Perhaps Gilbert and George are seeking a different form of correspondence. Like tramps, they too are misfits, enduring discomforts in pursuit of an unconventional lifestyle.

In this performance piece, Gilbert and George reverse the qualities commonly celebrated in Western art traditions. Instead of imbuing inert matter (e.g., marble and bronze) with the qualities of life, they devote equal effort to imbuing life with the attributes of inanimate matter. The work is machine-like despite the interjection of three forms of vitality into their aesthetic repertoire—song introduces real sound, dance introduces real movement, and their own living flesh introduces real animation. The work's resulting predictability eliminates signs of life where they could easily be achieved, and thus punctuates the lack of soulful vitality.

Is the performance boring? The crowds that congregate and remain transfixed for hours at a time indicate it is not. In fact, it is riveting. Gilbert and George offer the unique opportunity to witness living perfection, which, of necessity, exceeds human capacity. Like dolls on a mechanical music box, their movements are prescribed and undeviating, their faces vacant and detached. They are oblivious to the crowds who wait in anticipation that these lobotomized vaudevillians will eventually reveal their humanity by making a mistake. They never do. Gilbert and George, together, always constitute a sculpture. Robotic demeanor is maintained when they are singing as when they are not, when they are on stage as when they are off. Their bronze rigidity, their lack of personality, and their loss of spontaneity are total. The search for a soul is their life and their life is art.

The undeviating formula of perfection in *The Singing Sculpture* represents only one extreme of Gilbert and George's behavior. The artists contribute the entirety of their experience to their art. *"We often realize that what people have in mind is having a beautiful life, a happy, peaceful, comfortable life . . . , but happiness has its other side, there are other aspects . . . We don't want to look at only one side of reality, but at all possible sides . . . Our daily life is full of multiple elements such as murders, bombs, and all the rest. Each event provides us with a clue to the meaning of the world, this mysterious, complex world we scan looking up to these remote heights which stir our inspiration . . . We turn each experience into images which we offer to the public."*[3] Thus, the other half of Gilbert and George's art represents sordid scenes of loathsome behaviors. Here, in the service of art, they explore the tragedy of the human condition. Each pole of experience is intensified by proximity to its opposite. Against a backdrop of civility, Gilbert and George behave like louts and philistines. The effect is unsettling. What traits does this aspect of their work display? *"Our weaknesses, our thinking, our suffering, our sexual behavior and all that belongs to this species called mankind."*[4] And what purpose does it serve? *"We want to find and accept all the good and bad in ourselves. Civilization has always depended for advancement on the 'giving person.' We want to spill our blood, brains and seed in our life-search for new meanings and purpose to give to life."*[5] Why must they probe degradation as well as devotion, vulgarity as well as civility, in order to present viewers with the complexity of the human condition? *"We want Our Art to speak across the barriers of knowledge directly to People about their Life and not about their knowledge of art."*[6] *"It is for this reason that we have dedicated our hands, legs, pens, speech and our own dear heads to progress and understanding in art."*[7]

In other words, their artistic quest is conducted for the betterment of society. Gilbert and George have sacrificed normality, comfort, and moderation not only to find themselves a soul, but to save the soul of humankind. They can only accomplish this mission by enacting the best and the worst of human behaviors.

Gilbert and George's behaviors are recorded in photographs, drawings, and paintings. Their hallmark work consists of multiple black-and-white photographs of the artists in harsh,

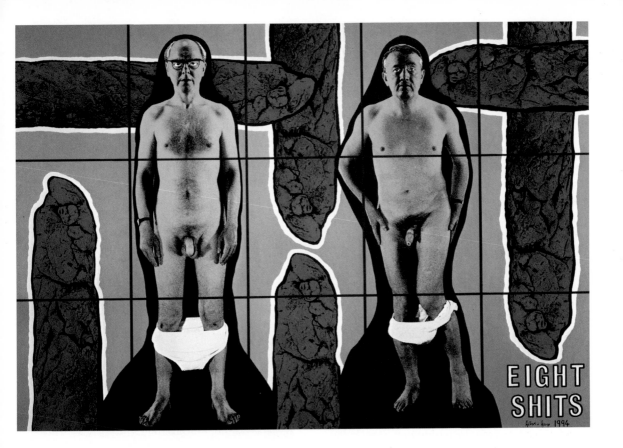

EIGHT
SHITS

GILBERT AND GEORGE
Eight Shits, 1994
99³/₅ x 139⁴/₅ in.
Courtesy Jablonka Gallery,
Cologne

uncompromising situations, together with cryptic, often obscene texts. Commonly, the photographs are hand-painted with brilliant green or red. Each panel is individually framed in black, the units arranged in grids that glow with the intensity of stained glass windows. The walls on which their work is hung are radiant with evidence of the vile impulses that grip humankind. They conjure a sanctified context for the artists' unsavory cavortings. In this manner, the lives of these reverse saints is announced with a fervor worthy of Ezekiel.

Even drunkenness becomes part of the burden that must be borne by a living sculpture. Gilbert and George subject themselves to excessive alcohol consumption, stating that *"it is our job to be involved with drunkenness. Not pleasure, a duty to explore."*[8] The large multipanel photographs that record these experiences reverberate with the sensations of intoxication. The artists' clever manipulation of paradox is in evidence. Dressed in their proper Edwardian suits, they spill liquor, stagger, or collapse in drunken stupors. These outward signs of drunkenness are accompanied by the stomach-turning vertigo associated with nausea. The camera mimics an inebriated eye. Images slip out of focus, tumble out of alignment, and appear in double vision. Viewers actually observe the thick, gin-induced haze of an all-night binge. The disorientation is augmented by an accompanying text that recounts the senseless ramblings of a drunk:

> *. . . wobbly, old chums, intoxication, easy going, tinkling bells, all the grub, well away, damnation!, dog off, supp off, bleeding away, tilting, simpsons, first offence, rushing past quiet-looking, tipsy . . .*[9]

In other works, Gilbert and George, the sculpture, probes sexual deviance, physical violence, weakness, confusion, and self-loathing. Fists, chains, blood, swastikas, fire, penetrations, and excrement appear in works with titles such as *Morning Gin in the Abercorn Bar, Falling,* and

Staggering of 1972; *Human Bondage* (1974); *The Alcoholic, Piss,* and *Prick Ass* of 1977-78; and *Dark Bondage* and *Eight Shits* of 1994. If Gilbert and George, wandering these mean streets, had not transformed themselves into a sculpture, they would remain indistinguishable from the depravity that surrounds them. But by becoming a work of art, they expose human offense and shame, and the need for redemption. Their confessions are metaphors for the universal human condition, their perversions are philosophical discussions of will, their religious experiences are explorations of spirituality in the modern world, their sadness is a mirror of the afflictions of all humankind, their dealings with nature are allegories concerning the entirety of civilization. This inventory of human experience is disclosed by two robots. Dressed invariably in their "responsibility suits," they employ modesty to illuminate the world's crassness, civility to highlight its vulgarity, rigidity to illuminate its uncertainty.

In sum, Gilbert and George assign art the crucial function of serving as a catalyst for change. *"Our reason for making pictures is to change people and not to congratulate them on being how they are."*[10] They never sanitize or censor their depictions. Multiple forms of catastrophe are depicted in their photographs, from murders and bombings to fires and mayhem. Cities are sinister. Animals are savage. Nature is barren. It is through art that this apocalypse might be averted. Two men have relinquished their lives and become a work of art in the hopes of rekindling the spirit.

An invitation to performances of *The Singing Sculpture* included "A Guide to Singing Sculpture." Recipients were invited to assume the vantage point of art and interpret the artists' mechanized and predictable actions as a lament for humanity's loss of freedom:

> *Essentially a sculpture*
> *we carve our desires in the air.*
>
> *Together with you this sculpture presents*
> *as much contact for experiencing as is*
> *possible.*
>
> *Human sculpture*
> *makes available every feeling you can*
> *think of.*

> *It is significant that this sculpture*
> *is able to sing its message with words*
> *and music.*
>
> *The sculptors, in their sculpture,*
> *are given over to feeling the life of the*
> *world of art.*
>
> *It is intended that this sculpture brings*
> *to us all a more light*
> *generous and general art feeling.*

GILBERT AND GEORGE POSTSCRIPT:

Because some artists are ironic and some are forthright, art that appears different may in fact convey common concerns. For instance, Wolfgang Laib, Toni Dove, and Gilbert and George all explore the impact of technology upon humanity. In the first instance a natural substance is the artwork, in the second advanced technology is the artwork, in the third the artists are the artwork. Wolfgang Laib retreats from the technological environment and restores humanity by absorbing the rhythms and processes of nature. Toni Dove employs high technology to envision people's wholesale assimilation of the automatized traits of technology. Gilbert and George combine Laib's goal with Dove's approach. They attempt to restore humanity by repressing their own personalities and becoming automatons. In that form they enact frailties that are distinctly human.

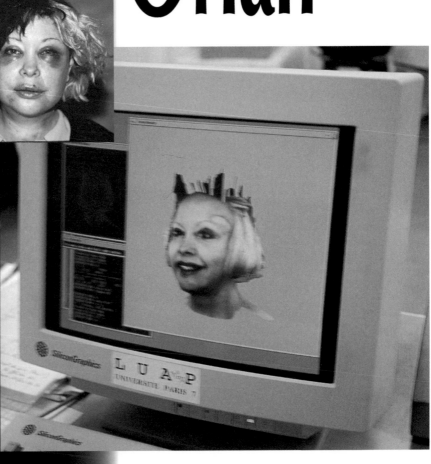

Omnipresence, 1993
Orlan, 1st day after
7th operation
Photograph,
55 1/8 x 57 1/2 in.
Courtesy the artist and
Sipa Press
Photo: Sichov

ORLAN'S GOAL is to "pose a legal problem," but the interface between her art and the law is anything but typical. Instead of addressing issues of free speech, censorship, and copyright, Orlan has introduced a legal issue that is perhaps without precedent. Her goal is to transform herself so fundamentally that she legally warrants a new identity. This change is actual, and it is permanent. She works on her internal self through intense psychoanalysis. At the same time, she reconstructs her outer self through elective surgical operations. Together these procedures constitute an art performance that she titles *Image/New Image(s) or the Re-incarnation of Saint-Orlan.*

My Face with Two Bumps Fabricated by Cyberware (Debut of the Clone), 1992
Université de Jussieu, Paris, France
Researchers: Monique Nahas, Herve Huitric
Film: Joel Ducoroy

SELF-SANCTIFICATION

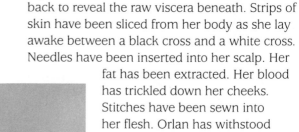

Orlan

Born 1947, France
Lives in Ivry-sur-Seine, France

See colorplate 4, page 20

BEHOLD! The reincarnation of a saint.

Beware! Earning sainthood is often a bloody affair. Orlan has endured more than mere burning at the stake. Her flesh has been clamped back to reveal the raw viscera beneath. Strips of skin have been sliced from her body as she lay awake between a black cross and a white cross. Needles have been inserted into her scalp. Her fat has been extracted. Her blood has trickled down her cheeks. Stitches have been sewn into her flesh. Orlan has withstood this ordeal not just once, but nine times. She endures it as an artist who believes the body is merely a surface covering that can be shed or transformed as readily as a costume.

Like Joan of Arc, Orlan is French. Both were born in humble circumstances. The fifteenth-century maid of Orleans rose from shepherdess to sainthood; Orlan is the daughter of a housewife and an electrician. But unlike Joan, who met a sacrificial death at the stake after a witch trial, today's saint is very much alive. In 1962, when she was fifteen, she relinquished her natural identity and adopted a new persona and a new name, Orlan. In 1971 she canonized herself Saint-Orlan and began carrying a crucifix. She donned the attributes of female saints as they are represented in Baroque paintings by posing in billowing costumes that revealed one breast. In a work of 1983, which mimed Giovanni Bernini's *Ecstasy of St. Teresa* of 1644-52, Orlan surrounded herself with fabric that rose around her like clouds. Always eager to integrate the latest technology into her divine vision of herself, she had the costume constructed of contemporary vinyl materials. Small video monitors placed on the floor projected a tape of inmates from a psychiatric hospital. They were posed in the manner

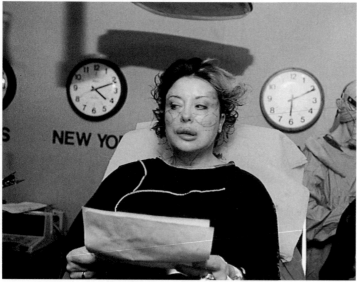

ORLAN
Omnipresence—Reading FAXes, 1993
7th operation/performance
Cibachrome in diasec vacuum, 43 3/8 x 65 in.

Operation conducted by Dr. Marjorie Cramer in New York. Costume by Lan Vu. Performance transmitted by satellite. Courtesy the artist and SIPA-Press. Photo: Vladimir Sochov

of the elders reaching upward toward the ascending "Virgin."

What miracle has been attributed to this saint? Orlan has undertaken a complete metamorphosis of herself. By what miraculous means? Neither fasting nor good works, neither prayer nor pious deeds, are responsible for Orlan's acquisition of the divine power of transformation. She is quintessentially a product of her era, defining sainthood in terms that were not invented when Joan of Arc faced her accusers. Orlan's reembodiment is conducted by plastic surgeons who usually contribute their services free in the name of artistic sainthood. The hospital operating room is the site of her reconfiguration. It also serves as the artist's studio. There she directs the repositioning of her fat deposits, the realigning of her facial bones, and the redesigning of her flesh. At the same time, she works with psychoanalysts to sculpt the elements of her personality, excavating traits that lie buried beneath the surface.

Bypassing both natural and unnatural conception, Orlan performs the ultimate creative act by willing her own rebirth. She describes herself as *"a daughter born without a mother."* Her birth is *"from woman to woman."* Billions of particles of DNA and an entire lifetime of conditioning have ceased to be hurdles to self-transformation: *"Life is a recoverable aesthetic phenomenon and I am at the strongest points of the confrontation. We no longer need to accept the body God and genetics have given us."*[1] Orlan is permanently altering her own identity.

The goal of reconstructing her outer self through elective surgical operations and forming her inner self through intense psychoanalysis constitutes an ongoing art performance. Initiated on May 30, 1990 in Newcastle, England, it bears the title *Image/New Image(s) or the Re-incarnation of Saint-Orlan.* The artist explains that the "Reincarnation of Saint-Orlan" *"refers to a character who was created gradually by assuming the images of religious madonnas, virgins and saints."*[2] "Image/New Image(s)" *"refers to Hindu gods and goddesses who change their appearance to undertake new works or new exploits (in my case it is a matter of changing referents, of moving from the Judeo-Christian religious iconography to Greek mythology)."*[3] Orlan's artistic endeavor is to recreate herself by inscribing her portrait directly into her carnal self. This process elevates her art beyond the secular, the decorative, and the self-expressive. She is becoming a saint and her representations are, therefore, religious icons.

Orlan's process of physical transformation may be identical to that employed by Joan Rivers to conform to socially inscribed definitions of beauty, by Ivana Trump to halt the march of time, by Cindy Crawford to become a breathing Barbie look-alike, by Michael Jackson to make himself into a creature with no distinguishable race, gender, or age, and by Jackson's sister La Toya to synthesize a family resemblance to her altered brother. Yet they are all mortals with mere human-sized goals. Orlan's desire to become a saint alters the category of her physical transformation. As she announces, *"It is no longer plastic surgery, but revelation."* In one of her operations she borrows the words of Christ: *"In a short while you will no longer see me . . . then a short time later . . . you will see me again."* She fulfills these words by disembodying herself from herself in order to make room for a new soul and a new body.

This new-age saint employs new-age means to accomplish an age-old goal. Her ultimate objective is to conform to an image that has no living counterpart and corresponds to no existing model. Indeed, it currently exists only as a computer printout. This morphed image of her future self combines the facial features of great mythological goddesses as they have been depicted in masterpieces of Renaissance and post-Renaissance art. Eventually, Orlan will possess the chin of Botticelli's Venus, the nose of Gérôme's Psyche, the lips of François Boucher's Europa, and the eyes of Diana from a sixteenth-century French School of Fontainebleau painting. In addition, she aspires to the forehead of Leonardo da Vinci's *Mona Lisa,* whose androgynous mystique surpasses mortal status.

These physical characteristics are intimately correlated to aspects of the female spirit Orlan admires. *"I chose them not for the canons of beauty they are supposed to represent . . . , but rather on account of the stories associated with them."*[4] Venus is lascivious and is connected to fertility and creativity. Psyche represents the soul

and its need for love and spiritual beauty. Europa is the giver of law, the mother of judges, souls, and kings. *"Diana was chosen because she refuses to submit to the gods or to men, she is active and even aggressive, she directs a group; Mona Lisa was chosen as a beacon figure in the history of art, a key reference, not because she is beautiful according to contemporary criteria of beauty, since beneath this woman there is a man, who we now know is Leonardo da Vinci, a self-portrait hiding in the image of the 'Mona Lisa' (which brings us back to the questions of identity). After having mixed my image with these other images I reworked the whole as any painter might, until a final portrait emerged and it was possible to come to a halt and to sign it."*[5]

Orlan's transformation is thus rooted in models that are hallowed by the passage of time. Instead of dallying with trivial prototypes derived from fashion, film, and television, she revives images that are consecrated by what they *are* (masterworks of art) and what most of them *depict* (goddesses from ancient Greek and Roman mythology). Orlan not only plunders the creations of revered male artists, she seizes her incarnation from the gods. If successful, she will achieve a paragon of femininity that is both super-natural (beyond a human) and super-supernatural (beyond a goddess).

It is in the hospital setting that the pomp and circumstance of this celebratory canonization ritual are enacted. Under Orlan's direction, the operating room becomes an operatic theater complete with elaborate sets, costumes, performers, music, scripts, and props. Each surgery has a theme, often determined by the character of the goddess whose features are being duplicated. Sterility applies only to the room's certifiable cleanliness. Orlan and her surgeons are dressed for these occasions in outfits by such renowned designers as Paco Rabanne, Alain Van de Verle, Isey Miyake. In the fifth operation, for example, the artist wore a black strapless gown, red gloves, and a harlequin hat conceived by Frank Sorbier. Grinning triumphantly as she was wheeled into the operating room, she waved a skull and trident at the camera. The surgeon's assistants wore black wet suits. The room was festooned with plastic fruit and flowers. A rap-singing dancer appeared in a black cape and

green wig. During his performance, he removed the cape to reveal a gold bustier and peeled off his wig to display his shaven head, delivering an instantaneous parody of a sex-change transformation.

All the while, Orlan's blood and fat flowed through an inserted tube while she read aloud from a text written by Michel Serres: *"What can he do to us now, the tattooed running monster, an ambidextrous, hermaphrodite, mixed race monster? Yes, blood and flesh. Science speaks of organs, of functions, of cells and of molecules, finally admitting that it is high time that we stop speaking about life in laboratories, but it never speaks about flesh . . . "* A videocameraman recording the event then sharpened the focus and shot in detail the fat being injected above her eyelids, into her upper lip, and below her cheekbones.

Orlan is the director who casts herself as the star and chooses the surgeons as her supporting actors. She is the set designer, the scriptwriter, and the choreographer. She selects the soundtracks, the costumers who outfit the performers, the publicist who produces posters and billboards, and the advertising companies who promote her efforts. Orlan is, therefore, both the catalyst and the recipient of her efforts.

Saints are commonly accompanied by angels who herald the news of their transformation. For Orlan, that role is filled by a bank of technologically sophisticated communications equipment, which broadcasts information about her reincarnation across oceans and continents. *Omnipresence* (1993), her seventh operation, reveals Orlan's godly aim to be known everywhere all at once to all people. Surgical acts—typically concealed behind the closed doors of operating rooms—were transmitted live via satellite to audiences in Nice, Lyons, Paris, Antwerp, Banff, Quebec, Toronto, Hamburg, Cologne, and Geneva. Fax machines and videophones established interactive communication networks between these cities and the operating room. People not only witnessed the reincarnation of a saint, they conversed with her. Questions, accusations, and congratulations were sent from around the globe. And Orlan responded to them even as the surgical procedures were being performed. She is a saint for the Age of Information,

when tempos are controlled by technology and sensibilities are tuned to the media.

Those not plugged in to the real-time communication network are given other opportunities to observe the proceedings. Signers translated the proceedings for the deaf. Videos of the operations and bloodied surgeons' gowns comprise gallery exhibitions. Orlan also dutifully

ORLAN
Omnipresence, 1993
Photograph of Orlan, 41st day after 7th operation
Centre Georges Pompidou exhibition, "Hors Limites"
Courtesy the artist and SIPA-Press
Photo: Georges Meguerditchian

records the healing process. For the exhibition associated with *Omnipresence*, she ritualistically photographed her bruised, discolored, swollen, and bandaged postoperative face every morning for forty-one days, the standard length of time that cosmetic surgery patients keep themselves hidden from public scrutiny. These brutal and shocking images were paired with the computer-generated printouts that picture Orlan's ultimate goal. Her disfigurement powerfully attests to the relationship between beauty and pain experienced by typical plastic surgery patients.

Orlan also exploits low-tech strategies to promote her omnipresence. In India in 1990, she commissioned a series of movie billboards that look like kitsch advertisements for Hollywood blockbusters. Although none of the films have actually been made, each billboard advertisement features Saint-Orlan as the star. Credits for the supporting cast and production crew mix members of the art world with names of actual film celebrities. Some billboards feature Orlan with her surgeons and operating room technicians. *Orlan before Saint-Orlan* is a triple portrait depicting Saint-Orlan's own private trinity: Orlan as she is today midway through her transformation, as she once was, and as she will become. Other billboards refer to sacred Hindu texts surrounding the Cult of Kali, in which the body is described as a costume to be shed. Presumably this is why snakes are revered by this cult. Kali is primarily the black goddess of death. She is the consort of Shiva, the destroyer, although she has benign forms as well. These billboards brandish the convergence of religious symbolism, showbiz hype, and fine art.

Miraculous power is attributed to the mortal remains of saints, whose earthly bodies are imbued with eternal grace. Shrines are built as repositories for these reliquaries. This tradition provides an opportunity for Orlan to support her project financially in a manner consistent with her sainthood. She sells relics of herself. Fat, flesh, and blood-soaked gauze collected from her operations are placed in preserving liquids, framed in soldered metal frames, and sealed with bulletproof glass. For $1,000 it is possible to purchase a fragment of Orlan's body inscribed *"This is my body, this is my software."*

The discomfort, danger, and expense of plastic surgery are sanctioned by society when it is used to achieve clichés of beauty and youth. Orlan's work disturbs in part because she is actually making herself progressively less attractive by conventional Western standards. In fact, she recently developed exaggerated lobes on either side of her forehead to silence those who accuse her of vanity. And her next scheduled operation is intended to invert the typical "nose job" by elongating her naturally small, upturned nose. Saying that she wants *"the biggest nose technically possible"* as an homage to Psyche,[6] she has chosen Japan, a land of small-nosed people, as the site of this intervention.

Orlan has described her work as *"a struggle against the innate, the inexorable, the programmed nature, DNA (which is our direct rival as artists of representation) and God! My work is blasphemous."*[7] Although images of her transformation consistently evoke repulsion and even terror, their real shock value stems from their

profoundly heretical premise. It is not surprising that her career has been inflammatory. Orlan has been ridiculed, arrested, and fired from jobs. Her atypical embrace of plastic surgery has led to pronouncements that she must be afflicted with a catalogue of mental disorders: self-fetishism, narcissism, masochism, hysteria, schizophrenia, perversion, histrionics, mystical delusions, and auto-mutilation. An entire issue of the French psychoanalytic journal *VST* (September-December 1991) dedicated to determining her mental state ultimately judged her sane. Most recently, an extensive and heated debate erupted over the Internet in the wake of her appearance at New York University in the spring of 1995.

Yet Orlan is a heretic with a mission that exceeds her own career. The media attention that is perpetually showered upon her also directs attention to issues within and beyond the world of art. *"My body has become a site of public debate that poses crucial questions for our time . . . Our era hates the flesh and works of art cannot enter certain networks and certain galleries except according to pre-established molds. Among others, the parodic style, the grotesque, and the ironic are irritating, judged to be in bad taste and often scorned."*[8]

Saints undergo humiliation, pain, even death for the sake of a higher purpose. But Orlan is no masochist. Although she accepts the risks associated with repeated surgical procedures, she minimizes the discomfort by using epidural blocks. Nor is she a sadist. She actually apologizes to her viewers by stating, *"I am sorry to make you suffer, but remember, I am not suffering, except like you, when I look at the images. Only a few kinds of images force you to shut your eyes: death, suffering, the opening of the body, some aspects of pornography for some people, and for others, giving birth.*

"In this case, eyes become black holes in which the image is absorbed willingly or unwillingly, these images are swallowed up and hit just where it hurts, without passing through the usual filters . . .

"In showing these images, I propose an exercise which you probably enact when you watch the news on TV; not to be fooled by the images but to keep thinking about what is behind them."[9]

Nor is Saint-Orlan an ascetic who abstains from worldly ambitions. She wears expensive high-fashion black dresses and gold-studded sunglasses. Her hair is two-toned, one tone often being bright blue. Her life is not lived in seclusion or devoted to penitence. Indeed, she is so busy meeting with the press, pursuing her art activities, and making money any way she can that she has little time for the soulful contemplation of celestial goals.

What sign will be offered to prove that her transformation belongs to a holy, not a secular, order of magnitude? Orlan has devised a scheme that mirrors the church's official process of canonization. Conferring sainthood requires a formal trial. According to church custom, the defense of sainthood is presented by "God's advocate." This evidence is attacked by someone appointed to serve as a "devil's advocate." Orlan explains her updated version of this hearing: *"When the operations are finished, I will employ an advertising agency to find me a first and second name and an artist name, then I will get a lawyer to appeal to the Public Prosecutor to accept my new identities with my new face. This is a performance inscribed within the social fabric, a performance which goes as far as the law . . . as far as a complete change of identity. In any case, if it proves to be impossible, the attempt and the lawyer's appeal will be a part of the work."*[10]

Orlan is likely to be less concerned whether this performance amuses or disgusts you as long as it also alerts you to the fact that everyone possesses the means of self-transformation. Her art both reflects and anticipates behaviors in society. *"My work and its ideas incarnated in my flesh pose questions about the status of the body in our society and its evolution in future generations via new technologies and upcoming genetic manipulations."*[11] Technology has converted the body from a sacred ground into a playground. Body piercing, bodybuilding, face-lifts, breast implants, tummy tucks, tattooing, hair dying, pumping up, slimming down, skin toners, are all common transforming agents. Plastic surgery reshapes the body. Prostheses offer an array of spare parts. Organ and limb transplants, surgical augmentations and reductions, steroids, silicone injections, and fetal implants are all reforming instruments. Psychological transformations and personality

manipulations are available through analysis, stimulants, sedatives, hypnosis, electronic brain gyms. At the same time, advances in applied science and engineering, electronic technologies, and telecommunications have supercharged mental capabilities and catapulted our bodies beyond their biological limitations. And genetic manipulations are no longer confined to the realm of speculation.

Those who submit to the scalpel share the artist's belief that the body and identity are mutable. Orlan's particular means of creating her facial ideal is now being used as a marketing device. In September 1995, "Betty Crocker" announced that she was getting a total face-lift. This paragon of the white, middle-American female is being replaced by an image digitally "morphed" from pictures of seventy-five real women of all races and all ages. The super-Orlan will someday take her place beside a hybrid homemaker, the super-Betty.

The success of such television shows as "ER" indicates that Orlan has also plugged into the population's fascination with medical procedures. The media has discovered high drama in the operating room. It is exploiting the public's appetite for full disclosure of the medical rituals that occur there.

Thus the forces of advanced technology have joined those of the media to challenge the old notion that the natural person is determined at the moment of conception. An audacious assertion has replaced that notion: we possess the means to vanquish the tyranny of our inheritance. Everyone can become supernatural. Orlan focuses on the resulting dilemmas. What should our bodies look like? What should our personalities be? What differentiates self-improvement from self-mutilation?

"For me, art which is interesting is related to and belongs to resistance. It must upset our assumptions, overwhelm our thoughts, be outside norms and outside of the law. It should be against bourgeois art; it is not there to comfort, nor to give us what we already know. It must take risks, at the risk of not being accepted, at least initially. It should be deviant and involve a project for society. And even if this declaration seems very romantic, I say: art can, art must, change the world, for that is its only justification."[12]

By stating *"this is my body, this is my software,"* the artist revises several saintly notions. She indicates that the body, once thought an inviolable entity, has been reclassified as a crude form of machinery. The soul, the essence of the spirit, has been displaced by psychoanalytic and pharmaceutical tampering. Orlan even determines her own destiny. She has arranged for her body to be mummified and donated to a museum, proclaiming, *"I have given my body to art."*[13]

ORLAN POSTSCRIPT:

One of the risks undertaken by an artist who subjects herself to the hazards of paralysis associated with spinal anesthesia and to the discomfort of nine elected surgeries is that she will be dismissed as insane. Sanity is commonly associated with activities geared toward reducing danger, maximizing comfort, and seeking security. Art that comes into being according to a different model is likely to be discredited as the product of a person in need of guidance, not one who is capable of giving it. Other risk-taking artists include Marina Abramovic, Joseph Beuys, Carolee Schneemann, Sophie Calle, Gilbert and George, James Luna, Christian Boltanski, and Vito Acconci. By violating standards of normal behavior, they demonstrate the many emotions, thoughts, and insights that are suppressed by social strictures.

David
Hammons

9

THE MATERIALS OUT OF WHICH
DAVID HAMMONS assembles his art
are the discarded vestiges of life in
the streets of Harlem or reminders
of his African heritage. White
Americans are likely to catego-
rize these objects as debris.
African-Americans are likely to
associate them with the visceral
power of fetish figures. Some
of the well-known collectors of
Hammons's works are Bill
Cosby, Stevie Wonder, Herbie
Hancock, and A. C. Hudgins.

Elephant Dung Sculpture, 1978
Elephant dung, chain, tin foil, 7$\frac{1}{4}$ x 7 in.
Courtesy Jack Tilton Gallery, New York
Photo: Erma Estwick

An African-American Man

David Hammons

See colorplate 8, page 24

Born 1943, Springfield, Illinois
Los Angeles City College, California
Los Angeles Trade Technical College, California
The Otis Art Institute, Los Angeles, California
The Chouinard Art Institute, Los Angeles, California
Lives in Harlem, New York

I WAS AMONG THE MANY followers of contemporary art in the 1970s who took note of the haunting self-portraits created by a young African-American artist named David Hammons. These works were prints, but instead of using wood, linoleum, or copper as his printing plates, Hammons used his face and his body. Each print was created by smearing himself with grease and lying upon a sheet of paper. He then sprinkled powdered pigment over the entire sheet. The pigment adhered to the grease, creating eerie, ghost-like imprints of the artist. The process recorded the configuration of his body and amplified the textures of his flesh, hair, and clothing.

After this auspicious beginning, Hammons vanished from the art scene. His career seemed to ignite and expire, more like a shooting star than a rising star. Then, after a twenty-year absence, Hammons's name reappeared in art reviews and exhibition announcements. Instead of his elegant and acclaimed body prints, however, they described bizarre constructions made out of chicken bones, barber shop sweepings, dried-out barbecue ribs, discarded wine bottles, bottle caps, and greasy paper bags found on the city streets. Many wondered, "Had this once promising artist squandered his talent?"

Curiously, both types of work are autobiographical. Their disparity is evidence that Hammons's definition of "self" underwent a radical overhaul during his hiatus from the art scene. In his earliest works his expressive parameters were confined to his own body; he identified himself in terms of the first-person singular. In the 1990s, his concept of "person" expanded until it assumed the dimensions of "spokesperson" for a collective identity—African-Americans.

During the years Hammons was absent from the art world, he never ceased producing art. His creative efforts, however, were directed toward art that was faithful to his African

DAVID HAMMONS
Higher Goals, 1986
Mixed media, 20 ft., 20 ft.,
30 ft., 30 ft., 35 ft.
Courtesy Jack Tilton Gallery, New York
Photo: Dawoud Bey

ancestors and to the unique sensibilities, economic conditions, and social status of their American descendants. He even abandoned painting and printmaking because they belonged to a white, European art tradition. African-American history stocked his imagination and African-American forms of work served as his artistic processes. Objects that his neighbors consumed and discarded became the material of his new art. The rhythms of his people's music became the basis of his aesthetic. His artistic precedents were furnished by the fetish objects of voodoo practices, the ritualistic instruments of African shamanic ceremonies, and the idiosyncratic accumulations of humble materials that characterize black folk art.

Likewise, the environs where African-Americans lived and labored became his sites of display. Hammons preferred an audience that shared his race and culture to the predominantly white, Euro-American collectors, board members, and administrators in museums and galleries. Those who have never commuted to Harlem on the A-train are likely to assume the role of unassimilated "others" when viewing Hammons's work.

The book, *The Psychology of the Afro-American: A Humanistic Approach*, charts the progression of five identifiable political attitudes experienced by many African-Americans as they reclaim African-American pride and identity.[1] The stages commence with a desire for integration, proceed through militant separatism, and culminate in racial reconciliation. Although Hammons's career does not strictly conform to this model, it serves to frame the profound sociological significance of his art.

STAGE 1. PRE-ENCOUNTER: Black racial identity is deemphasized in the hope of conforming to Euro-American determinants of success. The individual's goal is integration into white-controlled economic and social structures. Individual talent and effort take precedence over group identity.

Hammons's childhood provided minimal opportunity for identification with his African-American roots. He grew up in Springfield, Illinois. Abraham Lincoln was his hero. He remained in the Midwest from his birth in 1943 until he graduated from high school.

Hammons then moved to California to pursue his education.

The body prints Hammons produced during the late sixties and early seventies conformed to the expectations of the white art establishment. Although they made innovative use of the print medium, they were marketable and exhibitable works of art that found immediate acceptance in the clean spaces of mainstream galleries and museums.

STAGE 2. ENCOUNTER: At this stage the individual begins to interpret his/her self-esteem and circumstances as being conditioned by race and class. A new sense of self emerges which takes its reference points explicitly from a perspective of African-American history and consciousness. This stage is accompanied by a "frantic and obsessive" search for black identity.

Hammons's black consciousness was aroused during his years at the Otis Art Institute, where he formed an apprentice-like association with Charles White, an older African-American printmaker whose work documented the struggles of the African-American community. Political content soon appeared in Hammons's work. The civil rights struggle and the trial of the Chicago Seven were dominating the national news at the time. Hammons's *Injustice Case* (1973) is a powerful and disturbing work inspired by Bobby Seale, a leading black activist. It is a body print showing the artist bound and gagged.

Hammons moved to Harlem in the mid-1970s and steeped himself in the black, urban, ghetto experience. Instead of working with costly art materials that obliged him to create sellable art, he created idiosyncratic objects with litter collected from gutters, sidewalks, and vacant lots. Without asking for permission, he installed these works throughout the neighborhood as offerings to his "brothers and sisters" of Harlem. In this manner he made art and had shows that were seen by an immense audience. Hammons's course assured his neglect by official art world gallery owners, museum curators, collectors, and reviewers, an effect he apparently elected: *"The art audience is the worst audience in the world. It's overly educated, it's conservative, it's out to criticize not to understand, and it never has any fun. Why should I spend my time playing to that*

audience? The street audience is much more human, and their opinion is from the heart." [2]

The streets were Hammons's living sourcebook of black consciousness. He wandered, absorbing the boom-box rhythms, the hip-hop beats, and the scattershot thumps of Bushwick, Harlem, Flatbush. He registered the glitter of gold chains and gold teeth, the taste of collard greens and grits, the smell of soup kitchens and soul kitchens. He breathed his blackness: Ornette, Sun Ra, Marcus, Malcolm, squatters, park people, homeless people, street people, street merchants, street musicians. He dug elbow deep into the litter and plucked out emblems of black urban life: tinted wine bottles, tin cans, sneakers, chicken bones, condoms. In these perambulations, Hammons discovered the raw energy of the ghetto. Its anarchy, clutter, and filth became symbols of his rejection of the tidy, sanitary decorum of white cultural values. The streets of Harlem had become his home, his studio, his inspiration, and his museum: *"I think I spend 85% of my time on the streets as opposed to in the studio. So when I go to the studio I expect to regurgitate what I see socially—the social conditions of racism come out like a sweat."* [3]

His protest took the form of art stripped of niceties and decorum. Derelict materials were assembled into art objects that were both uncensored and unkempt. Bodily functions, excretions, and gestures that would shock the refined sensibilities of downtown art viewers were his favored subjects. Some pieces grabbed racial slurs and hurled them back at bigots. One such counterattack was waged by *Laughing Magic* (1973), a sculpture in which a "spade's" metaphoric meaning—a derogatory term for a person as black as a spade playing card—was first neutralized (it appeared in the form of an actual shovel) and then empowered within black culture (the shovel was transformed into an African mask). The sculpture resonated with the supernatural power of an African talisman. Hammons literally called a spade, a spade.

Structures that rose like obelisks from vacant lots provide another example of Hammons's Stage 2 attitudes. They commemorated African-American achievements neglected by the official history of this country. Some, for example, were strategically erected on the corner where Malcolm X conducted street orations. The urban neighborhood provided the material for these obelisks: they were made of telephone poles and covered with beer and soda bottle caps. This debris was arranged on the poles in diamond, zigzag, chevron designs that resembled the dazzling mosaics of Islamic decoration, African textiles, and black southern folk art. In this way Hammons's obelisks synthesized the four major components of black culture: Islam, rural/south, urban/north, Africa.

"So my assignment in that situation as a black man is very clear. My defense against this offense is to deal with racism and how racism is destroying our country internally."

At the top of each pole Hammons attached a hoop and net that were also made of the residue of the streets. Titles such as *High Falutin'* and *Higher Goals* proclaim their reference to basketball, which for African-American males is synonymous with opportunity. These gorgeous basketball monuments are symbols of triumph over adversity and bigotry. They serve as visual pep talks directed at youths hanging out on the very streets where these sculptures are installed. They are encouragement to aim straight and high.

STAGE 3. IMMERSION-EMERSION: The individual glorifies African heritage and black people. Black Power is zealously espoused. White culture is scorned. Individuals at this stage exult in their status as outcasts. They prefer exclusion from white society to betrayal of their own culture. Self-definition coincides with an identification with blacks, especially those who are impoverished. Pride replaces humility and subservience.

When Hammons withdrew from the white-run art world, he also rejected the cultural mores that dominate white society. He chose to live simply, even without a telephone. This self-induced deprivation fostered racial pride by emancipating him from the need to participate in an economy that limits most African-Americans to menial work. Although Hammons continued to create hoop sculptures, he added to his repertoire work that manifests this third

stage of disdain for whites and for African-Americans who aspire to white lifestyles.

Insubordination is evident in a series entitled *Elephant Dung Sculptures*, which Hammons produced by recycling the same sample of

DAVID HAMMONS
Whose Ice is Colder?, 1990
Installation at Jack Tilton
Gallery, New York
Flags, oil cans, and ice
Courtesy Jack Tilton
Gallery, New York
Photo: Ellen Wilson

elephant dung four times between 1978 and 1984. Hammons gathered the dung from a circus company and made it into fetish-like objects by attaching not only peanuts, leaves, and wheels but also miniature elephants, which made the dung appear as grandiose as Mt. Kilimanjaro. In one example Hammons sheathed the dung in gold leaf and painted it the colors of the African liberation flag.

Elephants evoke the exotic splendor of the African continent. But using elephant excrement seems an odd way for an artist to pay tribute to his African heritage. Hammons's decision was predicated on the fact that the work was destined for the Wall Street desk of a specific African-American stockbroker. In this setting, the

magical power of African spiritual practices clashed with the forces of capitalism. Hammons used the language of their common ancestors to remind the financier of his African heritage.

The white art establishment was the target of a vitriolic piece in which Hammons joined those whose hostility toward Richard Serra's federally funded sculpture, *Tilted Arc*, precipitated a highly publicized court battle. Richard Serra is a prominent white artist. His site-specific sculpture consisted of a long, unadorned, impenetrable steel wall planted across the Federal Plaza in Lower Manhattan. People working in the neighborhood protested that it blocked pedestrian traffic and imposed its austere facade upon the public space. It took eight years, but ultimately their will prevailed. The work was demolished, and the scrap was removed from its location at 4:30 A.M. on March 15, 1989.

As an early participant in this protest, Hammons created *Pissed Off* (1981), a work that confirmed the belligerence of its title: he urinated directly on Serra's sculpture. His act was discussed in art catalogues and art magazines and analyzed utilizing the conventional tools of art criticism. Once again Hammons's artistic language pitted the disenfranchised, whom he represents, against the empowered, whom Serra epitomizes. Hammons adopted a means of protest available to those who are excluded from culture, government, business, the media, and the law. *Pissed Off* fulfilled his carefully calculated goal: *"It is my belief that artists should disturb, upset, criticize, make fun of the establishment."*[4]

STAGE 4. INTERNALIZATION: Hostility, assertiveness, and defensiveness dissipate as critical appraisal is directed at the totality of factors that constitute social identity. Individuals become aware of the ambiguities and complexities inherent in race relations. As self-confidence develops, a pluralistic, non-racist perspective of humanity is espoused.

Whose Ice is Colder? (1990) coincided with the highly publicized confrontations in Brooklyn between Korean and Arab grocery store owners and their African-American customers. A contest of trilingual namecalling was broadcast throughout the media. Accusations of shoplifting from the shopkeepers collided with charges of price-

DAVID HAMMONS
A House for the Future, 1991
Charleston,
South Carolina

Courtesy Jack Tilton
Gallery, New York
Photo: John McWilliams

gouging from the customers. The situation incited ugly displays of ethnic distrust and racial hatred. Hammons attempted to reconcile the conflict by creating a gallery installation consisting of three large flags. One flag was South Korean. One was Yemeni. The third was American; but instead of red, white, and blue, it bore the colors of the black nationalist flag: red, green, and black. The flags identified the parties in the conflict as three American minorities: Arab-, Asian-, and African-Americans. Each flag was suspended over a tub containing a huge, three-hundred pound block of ice. The title of the work introduces the issue of competition and conflict. Racial and ethnic animosity produces the heat. Although no one's

ice is coldest, those who are the most vitriolic will melt the fastest. Hatred is self-destructive. Hammons explained that his mission involved long-term reconciliation, not short-term defusion: *"So my assignment in that situation as a black man is very clear. My defense against this offense is to deal with racism and how racism is destroying our country internally. It's such a joke to see America spending so much energy looking for the communist red demon on the outside, a demon that doesn't even exist. We're dealing with the illusion of someone outside threatening our security when the real threat is happening within our own borders. Blacks and whites are being played against each other for the capitalist gains of a few individuals."*[5]

STAGE 5. INTERNALIZATION-COMMITMENT: At this stage the individual translates personal identity into activities that are meaning-

ful to the group. Creative strategies for dealing with racism are generated.

A new attitude characterized by sympathy and support is evident in Hammons's contribution to the 1991 Spoleto Festival in Charleston, South Carolina, a festival in which artists consider the entire city as a potential site for their art. Hammons's sculpture took the form of a functional building that conformed to the long, narrow, vernacular architectural style of historic Charleston. Physically, A House for the Future differed from other houses in the neighborhood only in that it was fabricated with scrap material and sited on an empty lot at a ninety-degree angle to the others.

To construct the house, Hammons enlisted unskilled local residents as workers and a local contractor as their supervisor. In this way he involved in the festival those who are usually excluded from Charleston's cultural life. Moreover, the result of their involvement was practical. First, the workers themselves learned marketable building trade skills. Second, labels attached to the columns, doors, and windows instructed visitors about the architectural heritage of Charleston. Finally, the completed house functioned as a learning center for neighborhood youth.

Self-esteem was further promoted in the second part of this project. A vacant lot across the street from the house was converted into a small park. A cigarette advertisement was removed from the billboard on the lot and replaced with an image of area children looking up at a red, green, and black American flag. In demonstrating how to transform scraps into structures through community effort, A House for the Future served as a model of achievement.

Hammons, like others who arrive at the fifth stage of social interaction, quietly assumed an ethical posture. The house project is populist (not elitist), functional (not purely aesthetic), and motivated by civic duty (not individual ego). This piece reduces conflict, invites participation, and contributes to the betterment of ordinary people. The congeniality between the artist and the community that characterized Hammons's house/sculpture is antithetical to the resentment that surrounded Richard Serra's Tilted Arc. Hammons's work protests an all too common attitude he refers to as *"'I got mine and fuck everybody else.' People don't want to work together. We have no leaders to rally around . . . I'm not interested in spending the rest of my life in that Mickey Mouse, Donald Duck, fast food, McDonald's mentality."*[6]

Amalia Mesa-Bains

THE BORDERS surrounding most countries respect neither natural geographical features nor homogeneous populations. They are fictions created by laws. Like the arbitrary perimeters separating Pakistan from India, Israel from its Arab neighbors, Bosnia from Herzegovina, those between the United States and Canada and Mexico are acts of human contrivance. Amalia Mesa-Bains explores the intermingling of Spanish, Indian, and Anglo legacies around our southern borders.

Vanity from *Venus Envy Chapter One or the First Holy Communion Moments Before the End Installation*, 1993. Mixed media
Courtesy Steinbaum Krauss Gallery, New York
Photo: George Hirose

A Chicano Woman

Amalia Mesa-Bains

Born 1950, Santa Clara, California
San Jose State University, California: BA painting
San Francisco State University, California: MA
 Interdisciplinary Education
Wright Institute, Berkeley, California: MA and
 Ph.D. Clinical Psychology
Lives in San Francisco, California

AMALIA MESA-BAINS in
collaboration with VICTOR
ZAMUDIO-TAYLOR
*Emblems of the Decade:
Borders and Numbers*, 1990
Detail of dresser from
mixed media installation

Courtesy Steinbaum Krauss
Gallery, New York
Photo: George Hirose

AMALIA MESA-BAINS has
received a bachelor degree in art, a
master's degree in history and edu-
cation, and a doctoral degree in psy-
chology. Her manifold professional
endeavors mirror the depth and
breadth of her education. She is an
artist, critic, author, psychologist, lec-
turer, political activist, cultural histo-
rian, teacher, and researcher. What
unites her efforts in all of these
capacities is her advocacy for the
Mexican population in the United
States. Mesa-Bains's dedication to
chronicling and validating the lives of
her people coalesces in an explicitly
partisan art. Her elaborate, often
room-sized sculptural constructions
are fashioned by mixing text, fabri-
cated elements, found objects and,
frequently, sound. The result is an art
form that is as informative as it is
emotionally stirring.

Mesa-Bains documents Chicano
traditions, but her activities disavow
the detached objectivity of Western-
styled scholarship. For her, scholar-
ship coexists with the emotive and
savory nature of Chicano culture. She
relies heavily on the residue of her
3,000-year-old Mexican lineage and
on memories of growing up in a
home in which transplanted values were pre-
served and an abiding pride in her heritage was
instilled. Mesa-Bains's father crossed the border
between Mexico and California as a child during
the Mexican Revolution in 1916. Her mother
came on a day pass in the 1920s. Undocu-
mented throughout the artist's childhood, they
have since become resident aliens. Born in Cali-
fornia, Mesa-Baines thus developed an insider's

perspective on the outsider's existence. A powerful thread of continuity winds through her work, crocheting intricate patterns of contemporary Chicano life in the United States.

Mesa-Bains seeks to synthesize the collective experience of Mexican-Americans, a vast and disparate population represented by Hispanics, Spaniards, Indians, blacks, mestizos, and mulattos. She traces their communal identity to a rich legacy defined by language, religion, and national origin. But the past in which she glories is never sentimentalized. At the same time that her work celebrates the complex ingredients and traditions of Chicano life, it protests the remains of three centuries of colonialism and resolutely demands the empowerment of Chicano people in the United States. And although it conjures the trials of migration and social transplantation, it never allows the preservation of native Mexican traditions to imply alienation from mainstream life. Politically and artistically, Mesa-Bains campaigns for cultural exclusivity as long as it is accompanied by political equality and social respect. Her work sets an example by operating between tradition and innovation.

Generations of Mexican and Chicano mothers, aunts, and grandmothers have been the faithful preservers of their culture's folklore and customs. Their practices comprise a lavish storehouse from which Mesa-Bains draws artistic inspiration. She garners the material ingredients of their traditional creations, employs their original processes, shares their healing beliefs, and retains the devotional and commemorative function of their activities. In this way she pays tribute to the neglected accomplishments of women whose creative expressions were forcibly repressed by the Catholic church or denigrated as household crafts by the official purveyors of culture.

For centuries, folk ceremonies honoring household saints and deceased relatives have inspired the creative imaginations of Mexican women whose artistic vitality is still manifested in their construction of portable reliquaries, yard shrines, and domestic altars displayed on kitchen tables, dresser tops, and television sets. Mesa-Bains honors her ethnicity and her gender by reenacting these ceremonial centers in her art. Their ephemeral nature derives from Mexican custom, according to which these assemblages were made to commemorate specific events and were then dismantled. Their creators made no attempt to preserve evidence of their personal efforts. In a like manner, Mesa-Bains's work usually lasts only for the duration of an exhibition.

The components of these altars are transformed in the manner of traditional ceremonial centers and reflect the double source of Chicano identity. Some are sanctioned by tradition and derive from ancient culture; they include skulls, hearts, crosses, saddles, and virgins. Others are artifacts drawn from contemporary life and are no different for Chicanos than for others. All become icons, talismans, amulets, and effigies.

Extensive preliminary sketches document Mesa-Bains's fabrication of these ritual centers. Her creative process combines deliberation and improvisation. The former derives from her training. The latter perpetuates traditional procedures. Professional art-making and domestic altar-making merge. *"In my work, I follow traditional Mexican altar-making practices: I do my own papercuts, screen my own altar cloths, and make my own paper flowers as well as create my own 'nichos' and 'retablo' boxes (with the help of a carpenter). In addition, I am preparing to do my own bread and candy-making."*[1] A "nichos" is a recess in a wall commonly used to house an image of a saint. A "retablos" is a raised shelf (for lights, flowers, figures of saints, and other articles) above a table in an altar. Adopting these centuries-old practices, Mesa-Bains bestows upon traditional artifacts the honorable designation, "art."

The residue of many centuries of Mexican history evolving in tandem with current events characterizes the rich melange of traditions that comprise Chicano experience. Mesa-Bains's artwork and her writings identify some sustaining tendencies within this complexity. Each weighs against the pragmatism, materialism, and competition that dominate Anglo culture. Each offers, therefore, the means to achieve a more balanced society.

Chicanos tend to nurture faith and spirituality. One of Mesa-Bains's themes is the dichotomy between the Mexican mind—which tends to dwell on inference and imagination—and the Anglo mind, which inclines toward cognitive

thought processes and data. This contrast is made explicit in her elaborate installation piece *Emblems of the Decade: Borders & Numbers*, produced collaboratively with Victor Zamudio-Taylor in 1990. Zamudio-Taylor is a scholar and friend who introduced Mesa-Bains to the sixteenth- and seventeenth-century Hispanic tradition of creating highly charged emblems

AMALIA MESA-BAINS
in collaboration
with VICTOR
ZAMUDIO-TAYLOR
Emblems of the
Decade: Borders
and Numbers, 1990
Detail of dresser
from mixed media
installation

Courtesy Steinbaum Krauss
Gallery, New York.
Photo: George Hirose

combining text and images. *In Emblems of the Decade*, one side of a long room presented "emblems" of a quantitatively oriented culture. They took the form of counting devices, maps, printed text, graffiti, and statistics that recounted the average life span, education, and incomes of Chicano populations. Visitors learned, for instance, how many Chicanos are afflicted with AIDS, the numbers of illegal entrants, and the dates of Mexico's conquest, annexation, liberation, and independence. Clustered on the opposite side of the room were magical tokens of fortune honored in traditional Hispanic emblems. Visitors experienced the clash of contrasting mental postures: one a validation of facts and statistics, the other a refuge for ritual and talismans. The former describes. The latter transforms.

Mesa-Bains asserts that both groups benefit from an interchange of values. Anglo culture can offer Mexican-Americans greater access to its political and economic resources, and Chicanos are capable of infusing vitality into a culture dominated by secular concerns. Magic, myth, and ceremony can coexist with computer arcades, television, and engineering. *"In an increasingly technological society the division between experience and ritual grows more vast. When rockets reach the moon, the mysteries of the lunar religion lose their power. Where death can be delayed by injections . . . the liturgy of mourning declines . . . The everyday life experiences upon which rituals are built finally diminish as a shared observance."*[2]

Chicano society tends to be collective. The family is the nucleus in Chicano communities. And within the family, maternal forces prevail. By suffusing her work with these sources of love and devotion, Mesa-Bains reinforces the supportive qualities of Chicano culture. Concurrently, she invites non-Chicano viewers to experience an alternative to individualism. *"Chicano art is based on respecting your family and your community. That doesn't mean you don't get to question or provoke or even satire them every once in a while, but we love them. And I don't see a lot of love and passion in the work that I see in museums. I see a lot of people who think that love and passion are sort of corny, something that happens to people who just aren't intelligent enough to survive any other way."*[3]

For Mesa-Baines, connecting with the past is life-affirming. Reenacting the ritualistic art forms established by past generations of female Mexicans yields soul-fulfilling benefits in the present. *"It is important to recognize the influence of the Chicano movement as a critical juncture of identity. The emphasis is on (re)claiming our history and our culture."*[4] *Grotto of the Virgins* (1987), for example, consisted of three altars in which accumulations of mementos elicit the particular qualities and achievements of the women they honor, all heroines of Mexican descent. Visitors first entered a cave-like form that might have served as a setting for pre-Christian religious ceremonies. There they encountered three altars. In one, the Mexican painter Frida Kahlo presided over an array of Mexican popular arts, Precolom-

bian ceramic fragments, dead leaves, and rocks. They served as reminders of the ancient and current folk traditions she honored and preserved. Kahlo's emotional and physical afflictions were disclosed through reproductions of her paintings, a skeleton, and pictures of Saint Sebastian. In the second altar, the celebrated Mexican movie star Dolores del Rio is evoked with mirrors, tinsel, and satin suggesting the glamorous dressing room of a movie idol. Del Rio earned her status as a heroine by merging Anglo-Saxon and Mexican ideals.

The third altar is dedicated to Mesa Bains's own grandmother, a remarkable woman who raised seven children and provided for them by working in the fields. This work confers the respect that society never granted her. It includes a confessional booth created out of her personal memorabilia. Supplicants seeking absolution kneel before emblems of Mesa-Bains's grandmother rather than a white male priest. The piece has special significance for Anglo audiences. By participating in this ritual of absolution, they acknowledge the prejudice, persecution, humiliation, injustice, and other indignities that beset aliens in this country.

Thus Mesa-Bains's installations draw strength from their roots in traditional practice. *"On the personal level, my altars serve as ceremonial centers, enabling me to reach a spiritual sensibility through aesthetic form. They are not directly religious, but have served to pay homage to ancestors as well as other historical figures I find important."*[5] By coalescing specifics of her ethnic inheritance with evidence of its universally recognized accomplishments, Mesa-Bains addresses dual audiences, affirming community pride for the Chicano population while challenging the disrespect often displayed by the Anglo population. *"I wanted the viewer to be able to pass into another time, to feel the residue of rituals and beliefs from the past and through that encounter, gain an experience from the hearts."*[6]

Chicanos honor the dead. In Mexican culture, death is not considered a mournful terminus. It is accepted, like birth, as a corollary of life. The death rituals that so horrified the conquistadores when they arrived in 1519 were essential to nature's creative renewal and served as a means for humans to repay the favors of the gods. Celebrating death assured the continuation of life. These traditions survive today in the Day of Dead festivities, which culminate each year on November 2. The observance is based on a belief that the dead miss the living, that the living love the dead, and that the dead and the living communicate. Honoring the dead in Mexico provides amusement for children and a form of entertainment for adults. Bands dress in skeleton costumes and wear skull masks. Dancing, singing, drinking, carousing skeletons are carved for the occasion. Tombs are decorated,

> *"It is important to recognize the influence of the Chicano movement as a critical juncture of identity. The emphasis is on (re)claiming our history and our culture."*

and special dishes are prepared to please their occupants. Bones appear as brightly colored decorations, skulls as sugar candies, skeletons as toys. It is a day that emphasizes whimsy and humor over solemnity and morbidity.

Mesa-Bains defines this aspect of Chicano culture in the form of a dichotomy: *"There is in America a distinct fear of death, a distancing between it and life; people don't deal with it, would never dream of honoring it; because they don't see its relationship to life. They just see it as some sort of terrible tragedy, some failure of life. In fact it's not. It's absolutely syncretic."*[7] Not content to merely legitimize a marginalized culture by commemorating the Mexican concept of death, Mesa-Bains demonstrated its viability in Anglo culture in a work entitled *Emblems of the Decade: Body + Time = Live/Death* (1991). Those who had died of AIDS were commemorated in an altar that offered the general public an opportunity to experience an alternative approach to disease and departure. *"When you remember people in the act of making an altar, they're absolutely alive for you again, and you're given back all that they embodied. I feel there has not been enough of that kind of thinking about the results of AIDS . . . I really wanted to commit to doing a piece that would honor life by respecting death."*[8]

The Chicano aesthetic is exuberant. The abundance displayed in Mesa-Bains's work perpetuates the custom of surrounding saints

and ancestors with lavish quantities of offerings. Food, chilies, toys, religious figures, photographs, flowers, votive candles, incense, icons, and personal mementos are presented along with articles favored by the dead such as toys, candy, clothing, shoes, cigarettes, and tequila. The tables on which this abundance is arranged are covered with colored embroidered cloth, bordered with lace, and rimmed with cut-paper decorations. The entire array is tiered and layered in glorious profusion. Even the surrounding floor, ceiling, and walls are frequently decorated with palm leaves, flowers, and hanging adornments.

Mesa-Bains brandishes the spectacle of ornamentation that is integral to Chicano taste, despite the fact that Anglos commonly deride it as kitsch excess inappropriate within the refined setting of fine art. She traces this fondness for lavish display to the acclaimed sixth-century codices created by Maya painters to record both religious and historical events. These codices were characterized by a similar propensity for intricacy and profusion. Mesa-Baines further draws parallels to the Mexican Baroque tradition of the eighteenth and nineteenth centuries, when elaborate detailing prevailed in architecture, painting, literature, and sculpture.

In her own work, accumulation is augmented by the incorporation of such contemporary artistic devices as text, soundtracks, and videotapes. In this way her traditionally inspired altars acquire the range of multimedia and multisensory contemporary art. But accumulation alone does not define Chicano exuberance. Mesa-Bains describes it as "rasquachismo," which means presenting tattered materials with flair and dignity.

In a talk presented at the National Council of the Association of American Museum Directors, Mesa-Bains defended her aesthetic with a much quoted phrase: *"Quality is a euphemism for the familiar."* She proposed that quality, when applied to Chicano work, should be defined as *"a balance between sincerity and complexity. I like things that have a ceremonial nature, that imply an experience. It's important to be able to master your materials . . . And I look for a critical viewpoint. A work of art should help people learn something that would make their life somehow more understandable."*[9]

Mesa-Bains contributes to this cause by perpetuating the energy that ignited the Chicano movement in 1965. It originated during a strike of grape workers and evolved into a comprehensive campaign to preserve and legitimize the culture the protesters carried in their hearts. They campaigned for bilingual education, the establishment of Chicano Studies departments, and Chicano control over educational and cultural programs. Outdoor public murals provided their primary channels of communication. Mesa-Bains expands this mission into the present. Her altars serve as meeting grounds for the material and the spiritual, the past and the present, the personal and the communal, the divine and the mundane. They also address the conflict between kinship and nationhood. Mesa-Bains accepts the hybrid nature of Chicano status in the United States, convinced that by revitalizing Chicano traditions, the larger society will also be renewed.

MESA-BAINS POSTSCRIPT:

Amalia Mesa-Bains, Barbara Kruger, James Luna, and Joseph Beuys are artists who are committed to instigating social change. But that is not the only aspect of their work that is shared. They all have multiple careers. They straddle one course as artists and another as counselors, writers, teachers, or politicians. Because these professions all provide opportunities to guide, warn, and instruct, the services they offer are compatible with their art activities and in some cases are even categorized as such. Social duty also inclines these artists to welcome unconventional sites for the presentation of their art. These common characteristics conform to a common goal—to reach beyond the homogeneous audiences who typically visit museums and galleries.

James Luna

PREJUDICE is one cause of the plight of Native Americans, but idealization is another. James Luna is a Native American who believes that the mental health of his people depends on confronting such problems as alcohol

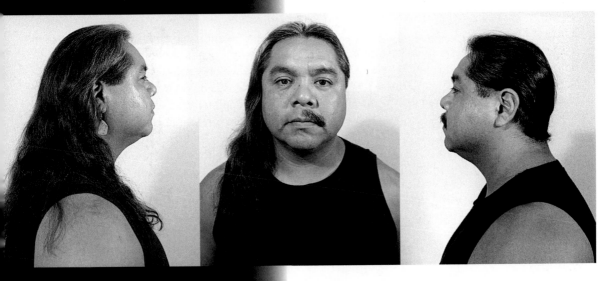

Half Indian/Half Mexican, 1990
Black-and-white photographs mounted on masonite board; triptych, each panel 24 x 39 in.
Courtesy the artist. Photo: Richard Lou

and drug abuse, crime, lack of education, unemployment, cultural apathy, and the intermixing of identities. Luna is both a psychological counselor and an artist. By applying therapeutic procedures to art, he exposes the suppressed truths and projected fantasies that afflict individuals and whole societies.

A NATIVE AMERICAN MAN

James Luna

Born 1950, La Jolla Indian Reservation, California
University of California, Irvine; BA art
San Diego State University, California; MA Science,
 Counselor Education
Lives in the La Jolla Indian Reservation, North San Diego,
 California

DOES IT BENEFIT OR HINDER

Native Americans to hear the speech attributed to Chief Seattle quoted endlessly in books, magazines, movies, political campaigns, and rallies? The speech is, reportedly, a fabrication. It is significant that its construction and perpetuation are due to the efforts of white environmentalists, not Native Americans. This example of the convoluted relationships between native and non-native Americans serves as the background against which James Luna's art is presented. Luna focuses on an immense tribe sometimes sarcastically referred to as the Wanabees. The redness in the Wanabees's blood is not attributed to race. They are white people who hold their own European culture in contempt. As an antidote to its secular, individualist, materialistic values, they espouse a romanticized vision of American Indian culture, seeking compensation for their own deficiencies in the indigenous people of this continent. Ironically, the result of their adulation is a suppression of opportunity. Wanabee Indians reproach authentic Indians who are educated, militant, enterprising, or Christian for degrading their sacred heritage.

Luna's work documents the strange perversion of prejudice that results when dissatisfied whites impose the prejudice of admiration upon Native Americans. Luna, a member of the Luiseno/Diegueno tribe, uses art as the means to undo this false projection. Residing on the La Jolla Reservation in North San Diego County, he is reminded daily of the contrast between the actual experiences of his neighbors and the idealization of things ancient, exotic, and indigenous. Juxtaposing these poles, Luna's art presents an unsentimentalized depiction of Indian life at the end of the twentieth century.

Luna says he regrets that the people who want to be Indians only *"want to be the 'good' part of the culture."* They ignore the fact that

JAMES LUNA
Artifact Piece, 1987
Dimensions variable
Courtesy the artist

native culture has been adulterated by contact with Europe since the 1600s when they purchase trinkets and participate in sweat-lodges, pipe ceremonies, and sun-dances. Some who have only a trace of Indian ancestry in their lineage even claim to be "cultural full-bloods." The U.S. Census Bureau reports that the number of Native Americans rose by seventy-two percent from 1970 to 1980, and by thirty-eight percent from 1980 to 1990, a growth too precipitous to be explained by an increase in Indian pregnancies. Meanwhile, real Native Americans are beset with health and unemployment problems, and they barely earn subsistence from public relief, government-supported programs, and menial jobs.

With a forthrightness that is often disarming, Luna articulates the discrepancy between the Indians who occupy the white imagination and those who occupy the Federal reservations. Even his means of communication—the oral and performance traditions of his ancestors—is disorienting to many museumgoers. In *Indian Tails* (1993), Luna simply speaks to an audience. Throughout the plaintive narration, his tone becomes progressively more anguished:

> *I don't want to be an Indian anymore.*
> *Everybody wants to be an Indian . . .*
> *I don't want to be an Indian anymore,*
> *I don't want to be an Indian anymore.*
> *I don't to be an Indian for historical*
> *reasons*
> *I don't want to be an Indian for commer-*
> *cial reasons*
> *I don't want to be an Indian for "Senti-*
> *mental Reasons"*
> *I don't want to . . .*

This lament seems designed to raise questions among white members of the audience. Why would a Native American reject his heritage? Is there a difference between "being" an Indian and "playing" Indian? At the same time, Native American members of the audience are confronted with the anguish associated with assimilation. The piece elicits the strange irony of two mutually dissatisfied cultures desiring to be each other.

The roots of Luna's oral testimony derive from alcohol support groups, tribal councils, and professional training in psychology. In all three settings, confession is promoted as a strategy for the healing and problem-solving at the core of his art. Luna, who received a Bachelor of Fine Arts degree from the University of California in Irvine in 1976, utilizes his art to purify and educate his people: *"I consider myself a social artist not a political artist. I consider myself an educational activist, not just an activist."*[1] He also received a Master's degree in Counseling from the same university and has worked with Indian students at Palomar Community College since 1982: *"My first interest is in working with Indian people to save themselves. My (counseling) job keeps me in touch with my feelings, with my people."*[2] Finally, Luna is an alcoholic. *"In my work, I'm not just criticizing a condition. I am in the condition."*[3] *Drinking Piece* is a confessional work of art consisting of a stack of six-pack cartons and empty beer bottles and cans spread on the floor. These objects provide tangible testimony to the pathetic admission mounted on the wall: *"I've never been able to handle my drinks, something always happens. I started drinking at thirteen . . . trying to dance but not very good . . . the fighting started, fell down, got pushed down . . . I staggered outside for air, looked up, there leaning against the car were two old men, watching, disgusted, they were 'Dreamers.' I felt ashamed, should have gone home, but got drunker and passed out."*

Viewers of *Artifact Piece* (1987) were often startled to discover that the title's artifact refers to Luna himself. Clothed only in a breechcloth, he lay prone on a large display case in a gallery devoted to American Indians at the Museum of Man in Balboa Park, San Diego. The gallery was otherwise given over to relics and dioramas honoring the revered aspects of Native American life. No part of its permanent display addressed the real problems that beset the living representatives of these people. Rather, the museum placed Indian life in the same category as dinosaur skeletons and plant fossils. Luna shattered the impression that Indians are extinct by presenting himself as a breathing artifact. Museumgoers saw a living Indian's maimed body. Labels written by Luna provided information about this "display." They documented the actuality of Indian life by citing his scars and describing the injuries that caused them:

Drunk beyond the point of being able to defend himself, he was jumped by people from another reservation. After being knocked down, he was kicked in the face and upper body. Saved by an old man, he awoke with a swollen face covered with dried blood. Thereafter, he made it a point not to be as trusting among relatives and other Indians.

The burns on the fore and upper arm were sustained during days of excessive drinking. Having passed out on a campground table, trying to walk, he fell into a campfire. Not until several days later, when the drinking ceased, was the seriousness and pain of the burn realized.

Having been married less than two years, the sharing of emotional scars from alcoholic family backgrounds (was) cause for fears of giving, communicating, and mistrust. Skin callous on ring finger remains, along with assorted painful and happy memories.

In this context, Luna's scars are not only physical. They are monuments to the soulful wounds of his people. They dispel thoughts about the mythic past by confronting viewers with the living present. Further evidence of contemporary Indian life was provided by two adjoining display cases. One contained the personal effects and objects that pertain to Luna's native experience, things such as the sacred medicine objects used in rituals. The other documented his involvement in American culture: albums by Miles Davis, the Six Pistols, a miniature Volkswagen Beetle, a copy of Allen Ginsberg's *Kaddish and Other Poems*, Zap comics, a figurine of Willie Mays, Luna's master's degree diploma, his arrest record, tubes of paint. These display cases document the dual citizenship of Native Americans. *"Whether I like it or not this (non-native American) society is not going to go away, so I (and my culture) must learn to survive in it."*[4] Viewers are notified that pure Indian culture is a fiction.

The compound nature of Indian identity is frequently the focus of Luna's art projects. Intermarriage is the subject of *Half Indian/Half Mexi-*

can (1990). In it Luna demonstrates that he is the product of a Mexican father and a Luiseno Indian mother. His double genetic strain is made explicit in three photographs mounted on a wall. In the left photograph, Luna appears in profile as a "pure" Indian; his hair is long and he wears an Indian earring. In the right photograph he is shown in the opposite profile, equally convincing

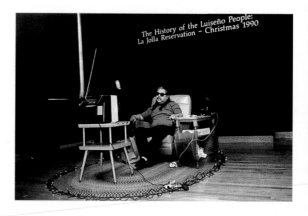

JAMES LUNA
History of the Luiseno People/La Jolla Reservation, Christmas, 1990
Installation, performance, video.
Television, chair,
Christmas tree,
and miscellaneous objects
Courtesy the artist

as a Mexican; he has cropped his hair, removed his earring, and grown a mustache. The middle photograph is a composite frontal close-up of Luna's face comically divided in half; the right half is Mexican and the left half is Native American. These deadpan mug shots reveal that this "most wanted Indian" has been genetically encoded with an alias and a disguise. Racial mixing-and-matching renders identities too deceptive to support stereotyping, be it positive or negative.

The duality of Luna's origins is confirmed in the circle of artifacts laid on the floor under the photographic triptych: Indian baskets, moccasins, and corn grinding stones are juxtaposed with Mexican votive candles, heavy shoes, and identifying photographs. Musical expressions of both cultures play simultaneously. The text extends the metaphor:

I'm half Indian and half Mexican.
I'm half many things.
I'm half compassionate / I'm half unfeeling.

I'm half happy / I'm half angry
I'm half educated / I'm half ignorant.
I'm half drunk / I'm half sober.
I'm half giving / I'm half selfish ...[5]

Dual citizenship likewise provides the heartwrenching theme in *History of the Luiseno People/La Jolla Reservation, Christmas* (1990), in which a gallery is transformed into an ordinary living room. It contains a television, an armchair, a telephone, a braided rug and, in the very center, a Christmas tree that is unadorned except for a single beer can at the top, replacing the traditional star of Bethlehem. Again, two points of view collide. The treetop symbol represents rebirth and celebration to Christians. But placed within the context of a work created by a Native American, it is also a symbol of Indian assimilation of Western customs. *"This piece is sort of chipping away at the illusion of Christmas ... It looks at Christianity on the reservation and the use of the tree in an Indian way."*[6]

The setting of *History of the Luiseno People* is the site of a performance in which Luna enacts the grief of being alone on Christmas eve. The audience witnesses a private scene in which the artist seeks comfort by getting drunk and telephoning friends. Although both activities are real, not playacted, Luna ensures that his pitiful situation is not merely autobiographical; it is a metaphor for a shared form of distress. Meaning is expanded because he has painted each of the room's four walls a different color—red, yellow, black, and white—thus delineating it as a native ritual space by marking the four directions with colors sacred to his people. The piece evokes the estrangement of Native Americans from their own forms of celebration. Both native and non-native audiences are given the opportunity to *"leave thinking about who, how, and why they celebrate. The meanings are different for everyone, and yet popular culture asks that we celebrate in a certain way; it's commercialized and defined for us."*[7]

Native Americans often counter the ill-effects of misfortune with laughter. *"In Indian humor, you can make fun of anything and even at the worst times, ... but I think what I came to realize is that it's a way of easing the pain, that laughter is a good cure and that maybe if we didn't laugh so much, we would be depressed."*[8]

Indian humor is typically educational. While the viewer learns a moral, the artist does the laughing in Luna's *Take a Picture With a Real Indian* (1991). Luna, wearing only a breechcloth and a pendant around his neck, is present together with two life-size photographic likenesses of himself. In one he is dressed in the ordinary attire of a white male: slacks and a cotton shirt. In the

JAMES LUNA
Take a Picture With a Real Indian, 1991
Life-sized figures
Black-and-white photographs mounted on foam core
Courtesy the artist

other he appears in full Indian attire: feathered headdress, beaded breastplate, and arm bands. As a cassette tape announces, *"Take a picture with a real Indian tonight!"* the audience becomes implicated in an amusing circumstance. Luna's invitation provides three competing options. Each viewer must determine what dress code constitutes his or her version of a "real" Indian: the assimilated, the mythic, or the vernacular. The work pokes fun at vacationing white tourists who descend on Indian reservations armed with Kodaks and the desire to record a culture uncorrupted by their own urban and suburban materialism. Furthermore, it is amusing to think that a photographic representation might seem more real than the living Indian. At the same time, the piece demonstrates the pressure on Indians to dress and act in accordance with white imaginations. Such behavior relegates Indians to mascots. The tape continues, *"America likes to say, her Indian. America loves to see us dance. America loves our religions. America likes to name cars after our peoples. Take a*

picture with a real Indian. Love one. Take one home."

Luna's art is also intended to encourage self-reflection among Indians who are suppliers and producers of "Mc-Indianism." This reference to wholesale commercialization describes Native craftspersons and entertainers who market the commercialized versions of their powwow/wigwam/wampum heritage. This is the heritage that the media, the marketplace, and New Age Wanabees so eagerly consume. *Take a Picture* exposes both the Indian's charade and the white person's gullibility.

Reality is undisguised in Luna's work. He discloses his real vulnerability, shattering the stereotype of the proud and stoic Indian. In *Artifact Piece*, for instance, his own body lay on the display case. Similarly, there was no acting or pretense in *History of the Luiseno People*; the artist actually got drunk, and he really telephoned acquaintances. Likewise, the audience undergoes a true search for the authentic Indian in *Take a Picture*. Each of these works establishes an inquiry that Luna hopes will prevail beyond the confines of art. His work sensitizes Native Americans to the commercialization of their ethnic essence, acknowledging that those who stand guard over the surviving remnants of their heritage are isolated from science, business, and technology. At the same time it alerts whites to their delusions regarding a lost golden age.

Luna confesses that he is unable to reconcile these bewildering dilemmas. *"I give people choices—I don't tell them how to think . . . Sometimes I hit people over the head with information they may not understand at first glance. It's different than hitting them over the head with an appeal for them to think my way."*[9] The role he has chosen to play is that of a catalyst for change, not a dictator. His projects urge academics, environmentalists, cultists, and tourists to stop neglecting Indians who are overweight, poor, uneducated, angry, drunk, and confused, who do not conform to idealized "Dances With Wolves" portrayals. But he also inspires recognition of the growing ranks of assertive Indians who present their grievances in Washington, the Vatican, and the United Nations; who write petitions; who form coalitions and alliances of tribal constituencies; who know their way through the executive branch of government and through the courts; who run gambling casinos and bingo parlors. Luna lays the groundwork to renegotiate the moral charters and psychological treaties between whites and Native Americans.

> *Everybody wants to be an Indian so they can say they have culture.*
> *Everybody wants to be an Indian so they can be spiritual.*
> *Everybody wants to be an Indian so they can be funded.*
> *Everybody wants to be an Indian so they can be a victim.*
> *Everybody wants to be an Indian so they can be multicultural.*[10]

LUNA POSTSCRIPT:

Art-making at the end of the twentieth century may or may not be manual, physical, aesthetic, emotional, and technical, but it invariably involves the activity of choosing an audience from among the diverse groups who comprise the total population. James Luna, like Tomie Arai and Amalia Mesa-Bains, addresses two audiences: hyphenated Americans, who share their use of the pronoun "we," and members of the predominantly white museum audience who belong to the "other." In contrast, David Hammons for many years selected an exclusive audience; it consisted of his neighbors. Donald Sultan, Chuck Close, and Gerhard Richter are among the many artists who target museumgoers. Felix Gonzalez-Torres, Mel Chin, Joseph Beuys, Jeff Koons, and Ericson and Ziegler create art specifically designed to embrace people across the social spectrum: those who are rich, sophisticated, and educated, and those who are not.

Tomie Arai

12

TOMIE ARAI is the great-granddaughter of Japanese farmers who settled in America in the early 1900s. Despite her family's roots in this country, few would maintain that her art is created by an American. She herself states, *"I continue to be defined by the immigrant experience and remain, like many other Asian-Americans, forever foreign, uprooted, and marginal."*[1]

Portrait of a Young Girl, 1993
Detail of installation: mixed media

Courtesy the artist

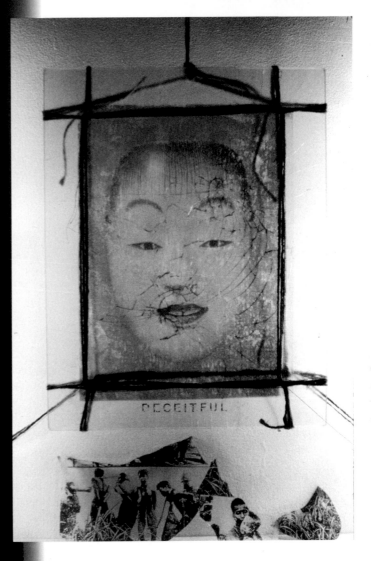

A JAPANESE- AMERICAN WOMAN

Born 1949, New York City
Lives in New York City

See colorplate 6, page 22

TOMIE ARAI'S STUDIO is located on the border between Chinatown and the multiethnic neighborhoods that surround it in lower Manhattan. Appreciation of her work is enhanced by imagining this location. Traffic hurtles through the streets day and night. The sidewalks team with shoppers buying imported produce and fish from distant seas, foreign-made electronic gadgets, and an array of international trinkets. Pedestrians are barraged with whiffs of exotic cuisines, the chatter of innumerable languages, and a collage of people whose skins, hair, bodies, and dress offer a multiplicity of colors and shapes. It would be difficult to ignore identity amid this profusion.

A desire to define and give visual form to her gender, ethnicity, and race has occupied Arai since the late 1960s. Without doubt, these three aspects of an artist's birthright influence professional opportunities. Art has traditionally been assigned to one of three implicitly hierarchical categories. Fine art is made by professional artists, exhibited in prestigious settings, and purchased by sophisticated collectors.

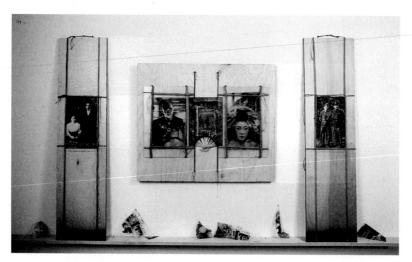

TOMIE ARAI
Self-Portrait, Framing an American Identity, 1992
Installation view: mixed media, glass, silkscreen, 8 ¹/₂ x 12 ft.
Courtesy the artist

Work in this category tends to emphasize innovation and form over tradition and theme. It is honored in history books and preserved in museum collections. In art made for the masses, message dominates form. Style is simple. Meaning is obvious. Impact is broad and instant. This category of art-making is often labeled popular art, propaganda, or kitsch. Finally, there is the category of art made by members of the masses for their own enjoyment. It communicates in a vernacular visual language that tends to be subjective and narrative. This kind of art is commonly classified as "outsider" art, "ethnic" art, or "folk" art.

The position of Japanese-American artists within this hierarchy has oscillated due to political circumstances. They were largely excluded from fine art settings during World War II, when Asians were considered a threat to the security of the nation, and again during the Vietnam War, when images of Asians shooting U.S. soldiers dominated the evening news. In the 1980s, anti-Japanese sentiments developed in response to intense business competition from Japan. Countering negative stereotypes, the civil rights movement encouraged Asian activists to join other indignant minorities in protesting discriminatory practices. And the multicultural policies of recent decades have provided special encouragement for people of color.

In interviews conducted in her studio between May and October of 1994, Tomie Arai described her effort to reconcile her art activities with her collective identity within a field that continually fluctuated between prejudice and opportunity. Three quandaries confronted her. Does aspiring to a place within the mainstream art structure require the suppression of race and gender? Does making art for the general populace necessitate sacrificing recognition by a sophisticated audience? Is art that celebrates ethnic identity necessarily "folk" art?

"I always felt my experience different from other artists. I didn't go through academic experience—no college, only a few months in art school. I became disillusioned with art school. I didn't fit in. I learned a lot about making art not by studying, but from other artists. I am amused when writers say I am self-taught.

So in 1968 I dropped out. It was a time when many were dropping out. The war in Vietnam was raging. I was interested in political art, the uses of art to communicate ideas. I learned how to do paste-up, mechanicals, political work. I made banners, street theater, posters, and murals. I was hired by the City Arts Workshop and worked with them from 1973 to 1978. The premise of the program was for community groups to design and execute murals for their own neighborhoods. The people

made art relevant to them. At the same time, artists of color who felt excluded from the art world found murals were a viable alternative to galleries. In the early seventies there was support for that kind of activity. War. Feminism. People mobilized themselves as groups. They sought alternatives. Going out onto the street was something people were sympathetic to.

Participants were non-artists, many at-risk teens. I also did a women's mural. I worked with Black, Puerto Rican, Chinese, Italian women. They didn't know how to do research. There were no books in their houses. They wanted to dramatize their own histories. They initiated my interest in history, going back to our own experience, where we come from, our personal history. These murals were a blank page on which people wrote. Their titles are "Wall of Respect for the Working People of Chinatown," "Wall of Respect for Women," "Crear Una Sociedad Nueva," "Women Hold Up Half of the Sky."

The murals are not "my" work. They are signed by all the participants. Working with people from different cultures introduced me to "ethnic" art or "ghetto" art—not "real" art. We tried to subvert the idea that this "ghetto" was a negative label.

Peasant painters in China visited during the Cultural Revolution. They toured these murals. They were bewildered by our Western country. They could not understand the symbols. They would ask, "Why a tree?" To me it was so clear and obvious. It became apparent that there are real cultural differences in how people look at things. They made me sensitive to these differences.

The National Mural Network held a conference in 1975. Most artists who attended were artists of color. They came from all over the country. This became the basis of a community of artists and writers who were interested in a people's art and community art. There was obviously a great hunger to learn about

people's authentic experience. I admired Chicano and African-American artists who used autobiography. They celebrated their cultural heritages. They found alternative ways to make art. I learned that it was okay to do work about myself. There are so many options beyond the art school approach. You don't need to track into the mainstream.

In those days, revolution was romanticized. We were influenced by ideas that were coming out of the Third World countries. Socialist ideas. People's art. Serving people. In China and Cuba art had a clear function, a role, and a social meaning. It was a time when all kinds of institutions were being challenged: marriage, sexual relationships, education. My work connected with that. It related to community control issues. We wanted to control our own cultural, health, and educational institutions.

I don't think any art is produced in a vacuum. Social and political environments affect art. I was influenced by the Vietnam War and the art coming out of China. It produced a growing awareness of races. It made me aware of how my situation connected with the African-Americans and other people of color.

The murals had the potential to be a people's art movement. When the war ended, when Reagan got elected, the Left self-destructed. Money dried up. The connection with people was severed. The energy got diffused."

Arai's life has encompassed suppression, discrimination, identification, and activism. She remembers that as a child, people treated her like an unwelcome foreigner despite the fact that she and her parents were born in the United States. She was taunted. Her family was ostracized from the white communities where they sought housing. Arai's mother made a concerted effort to inculcate in her daughter the Western manners she had learned while working as a maid in a wealthy Boston home. Tomie was

encouraged to visit the Museum of Modern Art, not Asia House, and to read Charlotte Brontë, Thomas Hardy, and Emily Post, not Lady Murasaki. Her Japanese heritage was considered a hindrance to success and happiness.

Arai now honors the very aspects of her culture that her family repressed. She considers them a source of privilege and distinction. It is through art that she has overcome her early experiences.

"There was so much silence in my childhood. My parents did not speak. I wanted to retrieve them through talking to other Asian women. I spoke to mothers and their daughters. There are many different ways to work with people to make art. I received a New York State Council on the Arts grant for 1988-89. I used it to collect oral histories with Asian women and then to make prints based on them. I invited a hundred Asian women to submit photos, recipes, stories. I also utilized the archives in Chinatown, and I talked to community scholars.

The work that I do is a lot about memory, exploring the idea of community—based on conversations and family photographs and archives. I am interested in people's stories—not politics, wars, economics. I have lost confidence in social movements and facts. The world has changed. I value direct contact with people. In the grand search for alternatives, murals are one vehicle. But there are many ways to make connections with people."

Arai draws on her Western experience when she applies the tools of sociology or anthropology to the field of art. She interviews individuals, investigates their history, collects evidence of their current lifestyles, records her findings. But she has little interest in the objective account-taking that belongs to Western science. Arai is not a distanced observer, and the individuals she studies are not reduced to impersonal statistics. She is deeply and personally implicated in her research. Her work is conducted in the hope that it will assist in delineating her own identity.

It was difficult for Arai to differentiate fact from fiction in the tales told her by Asian women. But this proved to be an asset in her special type of research. She is less concerned with individual biographies than with cultural truths. Her narratives are entwined with myths and legends. They help her recover the mysterious spirit of the Orient and form links to this rich cultural continuum. Her subjective research is an exploration into gender and ethnic identity, searching for answers to such questions as: What do women of color have in common with each other? What do women of color have in common with white women? What do Asian women share with Asian men that differentiates them from the non-Asian community? What do Koreans, Chinese, Japanese, and Indochinese share as Asians? *"I am not interested in retelling the story (of the Japanese experience in America) as a corrective measure. Many artists tell the authentic story of their people as opposed to the story bantered in the media and textbooks. My work is not an attempt to correct prevailing stereotypes but an exploration of how stereotypes affect how one sees oneself. This is the common theme for all Asian-Americans. How much do we become what others project on us?"*

Arai's *Self-Portrait: Framing an American Identity* (1992) explores the issue of stereotypes. It charts a complicated labyrinth originating in her own personal experience and concluding with graphic representations of the negative traits that are often projected upon people of Japanese extraction. Arai integrates fictional elements, she edits in and edits out, in order to compose a comprehensive identity for all Americans of Japanese lineage. In this work the central position is occupied by a photograph of the artist as a child taken by her mother in the sculpture garden of New York's Museum of Modern Art. This perky little girl is oblivious to the two symbols of racial distortion that the artist has positioned on either side of her. They are images from popular culture, and appear to be stationed in the wings of Arai's life: *"I have a tough stance that I like. In the work I surround myself with things that create who I am. I am flanked by male and female stereotypes, not my father and mother. The mother image is of a Geisha girl, a woman who is passive, servile, and wears a mask-like face. She is a dehumanized object. The father image is from a war movie. He is a general who has a finger on the globe. He is a fanatic, intent on taking over the world. He is asexual, sinister, highly decorated. Both of these images*

TOMIE ARAI
Self-Portrait, Framing an American Identity, 1992
Installation view: mixed media, glass, silkscreen, 8 1/2 x 12 ft.
Courtesy the artist

are layered on me. They are imposed by others."

Glass fragments scattered on a shelf carry silkscreened images of events that shaped Japanese-American experience: Pearl Harbor, Hiroshima, internment during World War II, the Vietnam War, the civil rights movement. These shards serve as a metaphor for the psychological fracturing of a people who are made to feel like aliens in the country of their birth.

Portrait of a Young Girl (1993) confronts the viewer with the offensive stereotypes that underlie Caucasian attitudes toward Asians. Arai inscribed "inscrutable," "exotic," "deceitful," and "servile" onto photographic images of Asian women. Similarly, *At the Heart of this Narrative Lies a Human Life* (1991) consists of collages of defamatory material from the popular media, including tourist guides to Chinatown created by whites for white consumers and tourists, in which the racist implications of both texts and illustrations are glaring. The work establishes a chain of ethnic reversals: members of the white

art audience observe an Asian-American work that decries material produced by whites and disrespectful of Asians. Arai intensifies—and thus hopes to neutralize—the bigotry contained in this found material by personalizing its effect. In other works she replaces such stereotypes with positive alternatives. *"There is one woman who appears frequently in my work. It is Frances Chung. She is a poet. She looks back at you. She is an image of health and hope. I celebrate her human qualities. This counters those in the mainstream who see Asians as objects and not as humans. I bring out the human qualities so people can connect with that."*

To articulate the conflict between the two sides of her hyphenated identity, Arai pits the traditional Asian woman against the modern. As an American, she acknowledges gender imbalances and is attracted to feminism. As an Asian, however, she respects a woman's primary link to the family. *"I wasn't active in the movement. That doesn't mean I wasn't affected by the white feminist movement and its writings. It touched everybody. That is why I've concentrated on women's lives and autobiographies. But the institution of feminism, the organized movement didn't touch enough women—the working class and the minority communities. For Asian women, the discussion of feminism seemed to force women to make a choice between family and self. Coming out of a patriarchal society where the family is the central unit, to question this in a negative way made Asian women feel that a choice had to be made—it was difficult and awkward. It meant we had to deny our own culture."*

In terms of style and material preferences as well, Arai emphasizes her cultural roots. The manifestations of her soul-searchings evoke a specifically Asian approach to aesthetics and medium. Although she does not revive authentic Japanese traditions, her wood panels assume the dimensions of Japanese scrolls, and her arrangement of images conforms to this model. Similarly, she uses black ink in the manner of Japanese calligraphy and wraps twine around the panels in reference to traditional Asian packaging.

Most of the images in Arai's work derive from old family photographs, which have special significance to Japanese-Americans. Following

Pearl Harbor, many Japanese-Americans intentionally destroyed their family pictures, fearing that this evidence of loyalty to Japan would subject them to arrest. Furthermore, cameras were confiscated from Japanese-Americans lest they be used for spying. As a result, surviving photographs are rare and highly valued within this community. Arai's family album records a narrative relevant to all Japanese-Americans. Through its use, she perpetuates the populist missions of the collectives and the grassroots groups that formed her artistic sensibilities in the 1970s. *"Our mission was to create a new culture. We were not motivated by personal gain. We felt solidarity. There was great excitement then. There was a belief that we could change the world. This is where culture plays such a strong role. We believed we were cultural workers. I still feel tied to what I did then."*

ARAI POSTSCRIPT:

The memories that steer today's artists are likely to be collective, not individual, and historic, not personal. Art laden with shared memories proclaims that composite experiences influence our destinies as much as our own biographies do. Tomie Arai's memories are devoid of the ethnic-affirming experiences that Amalia Mesa-Bains is privileged to recall. Arai practices art as a means to furnish her memory with the repository of legends that derives from her ancestors but was withheld by her parents. Christian Boltanski's memories compel viewers to reckon with the repressed guilt surrounding the Holocaust. Ericson and Ziegler evoke memories of neglected values that were once part of America's national heritage. Laurie Simmons's memories derive from the pseudo-utopias broadcast during the early days of television.

Felix Gonzalez-Torres

SPANIC AND A HOMOSEXUAL,
LIX GONZALEZ-TORRES was a
er of two minorities. Through
ique way of practicing art, he
ce to their often marginalized

Untitled (Perfect Lovers), 1987-90. Commercial clocks, edition of 3, 13 1/2 x 27 x 1 in.

Courtesy Andrea Rosen Gallery, New York. Photo: Peter Muscato

ews. His dedication to opening
ls of communication involved
tending art's reach far beyond
ngoers, and eliciting the active
ement of this expanded audi-
"I need the public to help me,
esponsibility, to become part
ork, to join in." In pursuit of
blic, Gonzalez-Torres circum-
ented a trio of conditions that
cionally restrict art's reception
exclusive audience: personal
production, museum display,
upscale marketing strategies.

A HISPANIC HOMOSEXUAL MAN

Felix Gonzalez-Torres

See colorplate 3, page 19

Born 1957, Guaimaro, Cuba; died 1996,
 Miami Beach, Florida
Whitney Museum Independent Study Program
Pratt Institute, Brooklyn, New York: BFA
International Center for Photography and
 New York University: MFA

AN INVENTORY of works of art by Felix Gonzalez-Torres includes stacks of paper, mounds of wrapped candies, two common clocks, electric cords strung with tiny lights, and a billboard. This artist didn't have a studio. He was less a creator of objects than a maker of meanings. Yet meaning is not easily gleaned from a visual examination of his work. The artist's own words provide a clue to interpreting his enigmatic career: *"My work is all my personal history . . . I can't separate my art from my life."*[2] Although multiple factors affected his biography, this essay will explore two components of his identity. Gonzalez-Torres was a refugee from Cuba who emigrated to the United States in 1968 at the age of eleven. And he was a homosexual who lived precariously on the fault line of the AIDS epidemic.

The artist's birthplace provides compelling evidence for the impetus behind his remarkable candor. Communicating in terms of the first-person singular acquires a political charge when it originates in a Cuban-born artist. That artist moved from a society based on collective thinking to one in which the discrete person is the essential unit of order. Gonzalez-Torres's personal revelations celebrated the privileges of U.S. citizenship. He invented ways to practice art that manifested the individual rights guaranteed by the Constitution and opinions protected by the court. Opportunities for self-expression in art were not confined to manipulating paint or clay. Gonzalez-Torres actively reinvented the entire art system—including tactics for display, marketing, preservation, and distribution—as a public staging of neglected freedoms.

Gonzalez-Torres assigned such credence to an individual agenda that he intently resisted the multicultural rubric. He exclaimed, *"I'm not a good token,"*[3] and refused to submit to stereotypes by producing what he called *"maracas sculptures."* He expressed his subjectivity by

FELIX GONZALEZ-TORRES
Untitled (Portrait of the Wongs), 1991
Paint on wall, dimensions vary with installation.
Collection Lorrin and Deane Wong

Courtesy Andrea Rosen Gallery, New York
Photo: Brian Forest

"reinvesting everyday objects with my own meaning, trying to reinvent my surroundings, my language. I name according to what I need at a particular historical time."[4] Yet through his intimate expressions, he gave voice to an important sector of society.

The sculpture, *Untitled (Perfect Lovers)* (1987-90), for example, consists of two identical, battery-operated clocks hung on a wall and set to the same time. Even their second hands are synchronized. What do two clocks convey besides the time of day? Gonzalez-Torres provides a clue in the work's subtitle. The words "Perfect Lovers" catapult two ordinary clocks into the expanded realm of metaphor. Their side-by-side position assumes the power of a gesture; they touch. Their synchronization envisions their relationship, the unison of love. Their identical forms indicate alike lovers; they are homosexuals.

Gonzalez-Torres's daily confrontation with AIDS completes the symbolic narrative of the battery-operated clocks. This temporal context for love is derived from the emotional aftershock of watching his lover succumb to the HIV virus. *Perfect Lovers* resonates with Gonzalez-Torres's intimate involvement with a life that expired too quickly and sorrow that lasts too long. When *Untitled (Perfect Lovers)* was made, two lovers' hearts were still beating.

Gonzalez-Torres identified the dates of *Perfect Lovers* as 1987-90, the years his lover was sick. Time was running out. How many minutes remained? When would the lament begin? He confessed that he made the work because *"time is something that scares me . . . or used to. The piece I made with the two clocks was the scariest thing I have ever done. I wanted to face it. I wanted those two clocks right in front of me, ticking."*[5] Impending death is approached from the emotional vantage point of a lover's sickbed. The work's autobiographical context invests two wall clocks with the anguish of becoming what the artist terms *"a relentless survivor,"* a role Gonzalez-Torres shared with an appalling

number of people. The disease has such far-reaching political significance that those who mourn deal with much more than a personal grief.

"I don't want the public to feel . . . I want the public to be informed, moved to action. 'Feeling' is too easy."

In Cuba, barriers to self-expression are government-imposed. In the United States, they are self-imposed. Most U.S. citizens neglect their democratic right to free expression. They prefer to protect their privacy and to avoid public criticism. Gonzalez-Torres revamped the tradition of self-portraiture to exploit our constitutional opportunity for intimacy and self-disclosure. There are five reasons why his mission could not be fulfilled within the standard format of a painted representation. Painting concentrates on surface appearance and neglects nonvisible aspects of personality. It records a single moment instead of an entire lifetime. It presents the image from the artist's vantage point and neglects the multiple and varied impressions of others. It isolates the subject from the historic, cultural, political, and scientific events that influence that life. And finally, it tends to present the public persona and not the private one.

In Gonzalez-Torres's self-portraits and his commissioned portraits of others, the verbal aspects of art are not limited to interpretation and criticism. They actually constitute the work of art. These "Word Portraits" take the form of a string of dates and proper nouns that identify significant events in the life of the subject. They are usually positioned frieze-like along the upper portion of all four walls of a room in the subject's home or workplace, an ever present intermingling of memories. One of Gonzalez-Torres's (self) word-portraits depicts the artist in terms of his possessions, his travels, and his recollections, some joyful and some troublesome. They include his lover, Ross:

> Red Canoe 1987 Paris 1985 Blue Flowers 1984 Harry the Dog 1983 Blue Lake 1986 Interferon 1989 Ross 1983

Individuals who commissioned portraits from him never assumed a silent, static pose in front of an easel. They actively participated in their portrait's creation by recounting meaningful, intimate moments in their lives. *"I start a commission word portrait by asking the person to give me a list of important events in his or her life—intensively personal moments which outsiders have very little knowledge of or insight into. Then I add some relevant historical events that in more ways than one have probably altered the course of and the possibility for those supposedly private events."*[6]

In this way individuals provided the content of their own portraits; their contributions constitute the "subject." Gonzalez-Torres added the "background": facts about elections, civil conflicts, military actions, inventions, and fads that coincided with their lives. He cited occurrences that occupied the headlines as well as those that were too commonplace to be newsworthy. Anything was eligible for inclusion if it affected the subject:

> Alabama 1964, Safer Sex 1985, Disco Donuts 1979, Cardinal O'Connor 1987, Klaus Barbie 1944, Napalm 1972 C.O.D., Bitberg Cemetery 1985, Walkman 1979, Capetown 1985, Waterproof mascara 1971, computer 1981 TLC

After a word portrait's installation, the owner is granted the liberty of adding or removing facts and dates at his or her own discretion. The artwork, therefore, evolves parallel to the life of its subject, independent of the artist. Portraiture becomes an unfolding chronicle of a life, not a record of a single, frozen moment.

The word "flattering" is embedded in the meaning of conventional portraiture. Clients normally commission portraits to enhance their social status and their physical appearance. It might seem that transferring the decision-making power from the artist to the collector would augment portraiture's ego-boosting potential. But Gonzalez-Torres's portraits serve as confessions, not public relations. He quietly sabotaged opportunities for conceit by including accountings of failures and insecurities in these word friezes. Installed in their owners' homes or offices, and thus available to the scrutiny of visitors and family members alike, these portraits cultivate honesty and a humble demeanor.

In a similar vein, Gonzalez-Torres's art never brandishes his talents, but rather explores such issues as his acute anxiety about death, the final passage. He describes his art as *"a comment on the passing of time and the possibility of erasure or disappearance, which involves the poetics of space . . . [It] also touches upon life in its most radical definition, its limit: death. As with all artistic practices, it is related to the act of leaving one place for another, one which proves perhaps better than the first."*[7] This theme takes the form of passage in the sculpture *Untitled (Passport)* (1991), created when Gonzalez-Torres was anticipating the death of his lover. Normally, a passport contains a chronicle of a person's travels. But this passport, consisting of a 4-inch-high stack of plain white 23-inch-square paper sheets, is blank. It belongs to a traveler who is anticipating a journey across the ultimate border.

Untitled (Blue Cross) (1990) is another stack work that demonstrates the transformation of neutral objects into potent message-conveyors. It consists of four stacks of white paper set on the corners of a blue square mat spread out on the floor. The paper piles obliterate the corners of the mat, so that the uncovered area assumes the shape of a blue cross. A viewer, unfortified with biographical information about the artist, might conclude that this handsome work is an abstract, geometric sculpture. When connected to an artist whose lover is dying of AIDS, it acquires the context of hospitals, drugs, therapies, and doctors. A neutral blue cross is transformed into the logo of a major health insurance company. And the work most certainly addresses the precarious nature of medical insurance protection in light of the financial burden of caring for AIDS patients.

In another bold violation of art-world convention, Gonzalez-Torres urged gallery visitors to help themselves to a sheet from the paper stacks. No monetary exchange was required. The label stated *"please take one."* When an artist invites the audience to help themselves to his artwork, it is apparent that income is not his primary motive. Gonzalez-Torres effects social change. He infuses society with sympathy, kindness, honesty, and generosity. First, his giveaway strategy allowed the work's healing tonic to spread far and wide. When AIDS is the theme,

FELIX GONZALEZ-TORRES
Untitled (Blue Cross), 1990
Offset print on paper,
endless copies,
9 (ideal height) x 59 x 59 in.
Collection Camille and
Paul Oliver-Hoffmann

Courtesy Andrea Rosen
Gallery, New York
Photo: Peter Muscato

the work pursues the relentless course of the disease. Individuals who have taken a sheet of paper from his stacks are "carriers" who precipitate an epidemic of compassion. *"I don't want the public to feel . . . I want the public to be informed, moved to action. 'Feeling' is too easy."*[8]

But the invitation to possess the work sometimes obliges people to make a choice. In one piece, side-by-side paper stacks allow visitors to select either a sheet inscribed *"Nowhere better than this place"* or one that asserts *"Somewhere better than this place."* The artist explained, *"It's about two atheist lovers arguing about making this place the best of all because there is nothing else, no other place."*[9] Museumgoers do not merely encounter the dilemma, they are beckoned to help resolve it. Taking a sheet is a vote for or against the existence of an afterlife.

FELIX GONZALEZ-TORRES
Untitled (A Corner of Baci), 1990
Approximately 42 lbs. of Baci chocolates
Collection The Museum of Contemporary Art, Los Angeles, purchased with funds provided by the Ruth and Jake Bloom Young Artist Fund
Courtesy Andrea Rosen Gallery, New York
Photo: Peter Muscato

Although *Untitled (Passport)* and *Untitled (Blue Cross)* assert the reality of impending death, they are not devoid of comfort. In another innovative move, the artist requires that the stack sculptures be replenished as soon as they are depleted by those who accept his invitation to take a sheet. The sheets are produced in "endless copies." In this way, Gonzalez-Torres's stacks will last forever, either in memories of the victims they memorialize or, perhaps, in an eternal afterlife.

The stack sculptures are also available for sale to art collectors and museums. But Gonzalez-Torres utilized this conventional route unconventionally. His goal was not only personal gain, but the desire to deflect the acquisitiveness and competitiveness that are often endemic to collecting. Those who purchase a stack work are obliged to honor the artist's commitment to magnanimity. They must sign a certificate pledging to perpetuate its free distribution. The terms of this obligation can never be discharged; the piles must be replenished each time they are reduced. Thus these artworks impose a perpetual state of generosity upon their owners. The stack pieces serve as a call to action. Instead of equating art with the accumulation of wealth, purchasers become gift-givers, and art collecting becomes a lesson in assuming social responsibility. By extension, the altruism learned through art may spill over into business and personal relationships, where it is so often lacking.

The stack pieces were as uplifting and edifying for the artist as for those who acquire them. *"In a way, this letting go of the work, this refusal to make a static form, a monolithic sculpture, in favor of a disappearing, changing, unstable, and fragile form was an attempt on my part to rehearse my fears of having Ross disappear day by day right in front of my eyes. It's really a weird thing when you see the public come into the*

gallery and walk away with a piece of paper that is 'yours.'"[10] Thus, in order to fulfill the moral imperative of his work, Gonzalez-Torres relinquished exclusive control and authority to enable the audience to touch, possess, and alter the work as the work touches, possesses, and alters them. In the process, the artist rehearsed his impending loss.

Gonzalez-Torres promoted this giveaway program in another series of sculptures referred to as "spills." They consist of quantities of wrapped candies piled on a gallery floor. The spills appear as parodies of abstract, geometric sculpture. Gonzalez-Torres described them as subverting the neutrality of minimal sculpture by annexing issues that derive from his biography. Often their bulk was calculated to equal the artist's body weight or the combined weights of the artist and his lover. Thus the spills, too, are portraits. In this case, the offer of a free gift entails a metaphoric predicament. It confronts visitors with the issue of homophobia and their fear of contact with HIV carriers.

Untitled (USA Today) (1990) is a spill of red-, silver-, and blue-wrapped Fruits & Berries candies, whose name recalls slang terms for homosexuals. The subtitle amplifies the irony. Are you a reader of *USA Today*? Do you support its exclusionary politics and traditional family values? Will you receive a sweet from a homosexual?

Untitled (A Corner of Baci), also of 1990, is a spill of Italian chocolates. *Baci* refers to "kiss" in Italian. Each piece has a waxed paper strip under its foil wrapper that speaks of love. Will you accept a kiss from a gay man?

Untitled (Welcome Back Heroes) of 1991 is a 400-pound pile of pieces of Bazooka gum "memorializing" the Gulf War that occurred that year. The gum is wrapped in the colors of the American flag. Its name refers to a military weapon. These patriotic images, however, are proffered by a homosexual who may have other motives in celebrating the return of the soldiers. Will you join him in welcoming the boys home?

Instead of sloganeering and preaching, Gonzalez-Torres's stacks and spills erode biases by appealing to our acquisitiveness and our sweet tooth. But his offering is not merely an act of generosity. Nor is our acceptance really free. We compensate the artist by surrendering intolerance of gays and Hispanics. This artistic strategy is particularly evident in Gonzalez-Torres's 1991 exhibition, "Every Week There is Something Different." Again motivated by the desire to extend art's healing capacity, Gonzalez-Torres reinvented the very concept of an exhibition. During the course of the month-long show, he transformed the gallery each week. At first, it presented a conventional installation of tastefully framed photographs. These depicted carved inscriptions from the backdrop of the Teddy Roosevelt monument, located outside of the Museum of Natural History in New York. The inscriptions list the attributes that qualify Roosevelt as a national hero. They identify him as a humanitarian, a soldier, a historian, a patriot, a rancher, a scholar, a statesman, and a naturalist.

During the second week, Gonzalez-Torres placed a powder-blue wooden platform in the middle of the gallery. During the third week this platform became a dance stage where a professional male go-go dancer, garbed provocatively in a pair of silver briefs, performed for a while each day. The final week's transformation consisted of the addition of *Bloodworks*, a series of graphs depicting diagonal red lines. The title announces that these lines are not abstract compositions, but charts documenting the steady decline of an AIDS patient's T-cell count. Each graph thus depicts the relentless approach of death.

"In a way, . . . this refusal to make a static form, a monolithic sculpture, in favor of a disappearing, changing, unstable, and fragile form was an attempt on my part to rehearse my fears of having Ross disappear day by day right in front of my eyes."

It is the male stripper, not Theodore Roosevelt, who is the leading player in this narrative. Roosevelt assumes a supporting role by contributing the cultural definition of masculinity against which the stripper performs. *"(The exhibition) wasn't about making a spectacle of (Roosevelt)"*; it dealt with *"men who represent what we should aspire to be."* Despite their contrasting demeanors and social positions, an

interesting correspondence between the dancer and this American hero becomes apparent. The stripper, like Roosevelt, is engaged in a war, but his war is a civil conflict with straight Americans.

The battlefield has often been cited as a prototype for behavior in sports and the corporate sector. Gonzalez-Torres applied this metaphor to the life of homosexuals, raising awareness of the hostility and risk that beset gay lifestyles. At the same time, in this and all his work, he cultivated an alternative code of conduct. By exposing his love, desire, loss, mourning, fear, regret, and weakness, Gonzalez-Torres tipped the established equation of human relationships in the direction of kindness and laid the groundwork for a coalition between straights and gays.

A piece that epitomizes this mission is *Untitled (Bed)* (1991-92), an enlarged close-up, black-and-white photograph of the artist's own empty double bed. The image was displayed simultaneously at the Museum of Modern Art and on twenty-four billboards located in industrial, residential, and commercial neighborhoods around the city. The rumpled sheets and dented pillows of the unmade bed in the photograph evoked the ghostly impressions of two bodies— Gonzalez-Torres and his recently deceased lover. It is a wrenching, intimate depiction of his loss.

The billboard is a form of public address typically used to promote commercial products and political campaigns. Rarely is it a site for personal expression. By presenting his private loss in such a public forum, Gonzalez-Torres once again dissolved boundaries between spaces that are physical and mental, public and private. *"In a way I'm trying to negotiate my position within this culture by making this artwork . . . Above all else, it is about leaving a mark that I exist: I was here. I was hungry. I was defeated. I was happy. I was sad. I was in love. I was afraid. I was hopeful. I had an idea and I had a good purpose and that's why I made works of art."*[11]

By declaring his personal history and encouraging others to declare theirs, Gonzalez-Torres applied the persuasive power of art to overcoming a collection of commonly shared fears: of the power structure, of disease, of ridicule, of difference, of the terror of losing someone you love. In 1991 he declared, *"This may not be the best idea, but I'm still proposing the radical idea of trying to make this a better place for everyone. That's really what I'm all about. I trust that agenda. That's why I'm not afraid of power."*[12]

In January 1996, Felix Gonzalez-Torres died of AIDS. It is hoped that his passing was as gentle as the spirit that pervades his work and as brave as his long struggle with the inevitability and the imminence of death.

GONZALEZ-TORRES POSTSCRIPT:

Some artists are so loyal to subject and format that their careers resemble trips on one-lane highways. Others continually swerve across two or three different lanes. Felix Gonzalez-Torres's search-and-rescue missions, for instance, traverse many different routes. Other artists who work with manifold material and formal concerns include Mike Kelley (drawings, performance, video, constructions), Mel Chin (land reclamation, assemblages), David Hammons (sculpture, performance, public projects), David Salle (paintings, prints, film), Carolee Schneemann (paintings, performance, video, sculpture, mechanized sculptures), Joseph Beuys (drawings, sculpture, performance, lectures, political activism), Barbara Kruger (installations, billboards, books, critical writing, prints, merchandise), Ericson and Ziegler (sculpture, house painting, public art, manufacturing), Vito Acconci (installations, video, performance, drawings, sculpture, public art), and Gerhard Richter (sculpture, paintings, prints, drawings, charts, inventories).

David Salle

14

DAVID SALLE commonly dismisses the pornographic content of his work, preferring to emphasize the rmal and compositional aspects of his female subjects. By referring o their seductive poses as "abstract horeography," he reveals that they neither arouse his passions nor

isturb his conscience Salle applies ch ennui to a remarkable diversity subjects Nothing seems to engage n Yet his paint igs reflect more than his own psychological ate They offer a compelling portrait of the Baby-Boomer generation.

Epaulettes for Walt Kuhn, 1987. Acrylic and oil on canvas linen, 96 x 133½ in.

A WHITE HETEROSEXUAL MAN

David Salle

Born 1952, Norman, Oklahoma
California Institute of the Arts, Valencia: BFA and MFA
Lives in New York City

See colorplate 7, page 23

DAVID SALLE'S WORLD VIEW is projected from the summit, an impressive position for an artist descended from Russian Jewish immigrants who were in the junk business. The plenitude of subjects and styles informing Salle's work mirrors the cultural and material dominion of those who have earned wealth and renown. His proficiency in orchestrating this abundance reflects membership among the ruling minority. But Salle's paintings also reveal the mental disposition of this privileged group. Instead of contentment, they indicate that a plethora of consumer products and cultural advantages has yielded disillusionment. Salle's paintings document the apathy that besets the elite class at the end of the twentieth century. They testify to the derailment of the American dream.

This essay positions Salle's output within the multicultural fabric of American society. The communal identity with which he is identified is that of the "establishment." His paintings unveil the prerogatives that most often accrue to those who have successfully competed for honors in this country. These individuals tend to be white, heterosexual, and male. Traditionally, their activities define what is considered this nation's official culture and its norms of behavior.

Although white male privilege has a long history in Western art, the abbreviated narrative offered here begins approximately forty years before Salle was born. This period is identified as the time when art's tether to the physical world was broken by a generation of mostly male pioneers who usurped nature's dominion over form and subject. Kasimir Malevich, Piet Mondrian, and Wassily Kandinsky, for example, liberated painting from the constraints of gravity, from the eternal presence of the horizon line, from the opposition between up and down or close and far, from the association of color with texture and texture with form. They laid claim instead to the frontier of expressive possibility offered by abstraction.

David Salle is a leader among a group of painters of the 1980s and 1990s who renewed the pursuits of the first-generation abstractionists. Like his predecessors, Salle declared freedom. But instead of applying their liberating ventures to abstraction, he directed them to the field of representation. In his art, people and objects are treated in the unconstrained manner that was formerly reserved for abstract form and color.

Salle's work contradicts three traditional hallmarks of the masterpiece in Western art: harmony, unity, and consistency of style. In his painted world, matter sheds its normal attributes. It can float, resist light, abandon its spatial moorings, and cast no shadow. Objects placed side-by-side on a canvas occupy independent contexts; they exhibit autonomous points of view, reflect inconsistent sources of light, and defy rational scales of significance. Yet considerable acclaim is granted to Salle because of these violations. He began to attract the attention of critics soon after he graduated from college in the 1970s. Since then an expansive literature has analyzed his accomplishments. Some authors direct their analysis backwards from the finished product, pursuing the sources of his imagery. Others examine his completed works in an effort to identify a lucid scheme unifying their diverse styles and images. And a third group endorses the work's apparent randomness, correlating Salle's style with the fragmentation of television news programs, a walk down an urban street, surfing on the Internet, or the optical complexity of music videos. Observing that Salle's work mirrors these real-life situations, they praise his paintings as embodiments of a unique contemporary aesthetic.

Which critical approach is most productive? Salle seems to reject all three when he insists that *"There's no narrative. There really is none; there isn't one . . . It's assumed my work is a commentary on popular culture . . . For years I have been saying the opposite. At least in my mind, my work has absolutely nothing to do with popular culture. Not only does it have nothing to do with popular culture in any kind of didactic, deliberate way, it simply doesn't have popular culture on its mind."*[1]

There remains a fourth avenue of analysis that approaches Salle's work as a form of communal biography. It proposes that his paintings are as vernacular as the art made by African-Americans, Native Americans, Asian-Americans, and other "hyphenated" Americans, including European-Americans who are no longer credited with expressing "universal" values. Salle's decisions about what to paint, and how to arrange and render his images, all disclose the complacent materialism of the privileged class. In his paintings, fine art masterpieces, Disney cartoons, newspaper photos, comic books, nineteenth-century illustrations, and industrial designs are reformed, reversed, and multiplied. All the world seems to fall within Salle's grasp.

"I think much art that interests me is about getting outside of oneself."

In medium, technique, source, and subject, Salle prefers superfluity to selectivity. His works suggest that those who can have it all, should take it all. Individual paintings are aggregates of drawing, painting, sculpture, and photography. Some canvases are further enriched by the attachment of fabric, wood, lead, and plastic, or objects from the real world such as chairs, light bulbs, tables, and crockery. Salle also stakes claims on the annals of art history by appropriating illusionistic and expressionistic elements, linear renderings and tonal depictions, masterful draftsmanship and crude scrawls. Zooms, pans, splices, and close-ups are derived from film and photography. Similarly, his repertoire embraces transparent undertones and overtones that mimic a television screen's electronic transmission. In many cases these divergent techniques appear simultaneously on single canvases. Unrelated subjects depicted in divergent styles are superimposed in the manner of double-exposure photography. Their dissimilarity preserves their discrete presence and requires that the observing eye jump from component to component, constantly adjusting to the particular orientation, scale, and style of each part.

These variables do not, however, exhaust Salle's field of operation. He also favors multiple canvases, typically working in diptych or triptych format or inserting small paintings into larger

ones to double and triple the generation of ingredients in any given work. An empire of visual possibility is at the artist's command. This profusion mirrors not only his generation's penchant for consumption, but also its power to possess quality as well as quantity.

Signs of elite culture abound on Salle's canvases. Many of his references to the history of art derive from an inventory of European and American masterworks. An array of honored artists make guest appearances in his paintings: John Singer Sargent, José de Ribera, Andrea Mantegna, Walt Kuhn, Raphael Soyer, Reginald Marsh, Edward Hopper, Antoine Watteau, Edouard Manet, Francis Picabia, Otto Dix, Alberto Giacometti, René Magritte, Théodore Géricault, Oskar Kokoschka. Joining them are allusions to great Western dancers, composers, authors, filmmakers, and designers. Salle has claimed their renowned accomplishments as his cultural inheritance. He operates comfortably within an illustrious and exclusive fraternity.

Yet Salle's work also embraces American history and popular culture, suggesting that the gamut of possibility that falls within his purview is not confined to the exclusive and the expensive, but includes as well the familiar and the banal. Paintings carry allusions to such cultural icons as Abraham Lincoln, Santa Claus, Christopher Columbus, and Donald Duck. They incorporate references to common objects of consumption, hair and clothing styles, recent art and old films.

"I feel that my work might have gotten stuck in a minor key."

Such work is time-specific. Salle frequently cites the 1950s, the decade that supplied his—and all Baby Boomers'—childhood memories. But references to this era also connote the 1980s, the decade of Salle's prominence. It was then that the decorative arts of the 1950s became a craze among the sophisticated urbanites with whom Salle associated. As one would expect, his own interest in the era extends beyond fifties "moderne" furniture, fabrics, lamps, pulp fiction, and illustration. He also inherits the era's most acclaimed accomplishments. *"When people refer to the 50s aspect in my work, perhaps they're thinking in terms of the mass-produced aspect of the culture, like boomerang tables. When I think about the 50s, I think of Balanchine's abstract ballets, of great abstract paintings, of humanely innovative architecture, of improvisational comedy, and of Lolita."*[2]

Although Salle's paintings reveal his success, they seem to simultaneously disclose a cheerless state. Disinterest pervades his treatment of all subjects, which tend to be rendered in melancholy colors under a dim light. A specific example can be found in his images of female nudes positioned close-up and foreshortened, panties down, flaunting their buttocks and their genitalia. They are sumptuously proportioned and surrounded by such stock-in-trade props of titillation as stockings, high heels, sequins, brassieres, and costume jewelry. Typically, their heads are cropped or turned away from the viewer. These women are presented as depersonalized stimulants for the male libido.

It is significant that few of these images are appropriated from pornographic sources despite the frequently cited fact that Salle worked on a softcore porn magazine when he first arrived in New York. Live models pose for the artist in his studio. Thus, his work embraces yet another art historical tradition—that of the female body as a favored subject in high European art, a territory claimed by male artists. In Salle's work, girly poses overlap with fine art studies of the nude. The sanctioned relationship between the artist (male) and the model (female) is equated with the shameful act of the voyeur (male) and the nude (female). These cultural extremes are leveled by Salle's cool indifference to them both.

Three characteristics of his art suggest that Salle has achieved wealth and power, but not contentment. First, as in these paintings of female nudes, he seems strangely detached from the bounty he manipulates, demonstrating that lives lavished with stimuli can still be devoid of meaning. *"I saw that everything in this world is simultaneously itself and a representation of the idea of itself . . . But you also see the thing as more of an abstraction of itself. You see the thing as all of the ideas about it—as a representation."*[3] Second, his personal voice is muffled by the

din of his possessions, including the styles and images he borrows from past art. *"I think much art that interests me is about getting outside of oneself."*[4] And third, the popular heroes and cultural icons he depicts drift in the surfeit of stimuli. Salle claims to withhold *"any apparent intrusion of interpretive morality into the context."*[5]

Salle recently expanded his activities to include filmmaking. The 1995 release of a feature-length film entitled "Search and Destroy" has stimulated new critical controversy. The script involves the conflict between an inspirational filmmaker committed to uplifting people and one equally committed to producing lowbrow entertainment. Pretension is pitted against sincerity, artistry against schlock.

Many film critics report that "Search and Destroy" lacks adrenaline-producing action and vibrant characterizations, and that Salle overcompensates with clichéd visual effects. Since these very qualities are shared by his acclaimed paintings, perhaps they qualify as assets, not flaws. Likewise, both his paintings and the film demonstrate Salle's access to exclusive resources. In the former, he utilizes the monuments of art history. In "Search and Destroy," he assembles a star-studded cast: Dennis Hopper, Griffin Dunne, Rosanna Arquette, Ethan Hawke, John Turturro, Christopher Walken. The emotional flatness of these respected performers mirrors the dispassion of Salle's painted representations. Both portray the demoralization of the privileged class.

Salle's film, like his paintings, exhales a long sigh. It is evidence of the ennui that seems to afflict those members of the establishment who have come closest to garnering the promises of Western civilization. As Salle confesses, *"I feel that my work might have gotten stuck in a minor key."*[6]

Citing his use of the minor key does not disparage Salle's accomplishment. Eminent composers, like Beethoven, Mozart, and Haydn, have favored the minor key for its sonorous, melancholy qualities. Indeed, this musical reference provides a convenient analogy to assess the merits of Salle's work. His aesthetic choices resemble those made by distinguished twentieth-century composers. Charles Ives and Igor Stravinsky, for instance, favored polytonality in which at least two different keys transpire simultaneously. Arnold Schönberg completely abandoned key base and tonal center. By equalizing all twelve tones, he discarded the unifying effect of melody and harmony. Milton Babbitt and Karl-Heinz Stockhausen replaced tonality with volume, tempo, and pitch. John Cage welcomed nonmusical sounds from the everyday world into his compositions. All these distinguished innovators employ manifold, divergent, discrete, coexisting elements. A comparable profusion occupies Salle's canvases. Perhaps one measure of mastery in the twentieth century depends on augmenting the ingredients of art and mastering their orchestration.

SALLE POSTSCRIPT:

Contemporary art is a great republic encompassing representatives of multiple genders, ethnicities, and political agendas. It is also home to artists displaying greatly divergent temperaments. The two Davids in this section exemplify two extremes. David Salle is acclaimed for his ennui. David Hammons is lauded for his ardor. Salle's languor expresses the disinterest of people for whom most things are available but few things are enticing. Hammons's decisiveness derives from discontent that commonly arises when opportunities are both denied and coveted. Likewise, Janine Antoni abandons control with the same intensity that Chuck Close cultivates it, and Jeff Koons covets media attention with the ardor that Sophie Calle shuns it.

TWO SOME PROCESSES

THE LIFE OF A WORK OF ART does not commence when it leaves the studio. There is an engrossing narrative that evolves between a work's conception and its realization. Reconstructing the sequence of decisions that drove a work's evolution provides entry into the wondrous territory of the artist's mind. For many deceased artists, these indicators of intelligence and temperament might be lost to history were it not for the fact that works of art themselves congeal evidence of manners of manipulating materials. A work's surface reverberates forever with the passion or deliberation, the delicacy or aggression, of the creative act.

Current art, however, need not be subject to the conjectures and deductions applied to historic art. Enactments can be witnessed while they are occurring. Techniques and mediums can be explained by the artists themselves. Tempos and durations can be recorded on location. This is a crucial asset because, in many cases, devices are being used that have never before appeared within the field of art.

Today, there are no proficiency tests to qualify an individual to become an artist, no licensing mechanisms to govern admittance, no rules for remaining a member in good standing. Artists confront a limitless exploratorium of possibilities. As a result, they can precisely calibrate their operational choices to the larger mission of their art.

This chapter will explore a few examples of procedures currently being conducted in artists' studios or, in the case of works even more remote from convention, in the shopping malls, factories, and other unlikely sites that have replaced studios. It will explore the role of process as the connecting link between intention and realization.

The significance of this pursuit far exceeds revealing an artist's temperament. Making art decisions and fabricating art materials also disclose the collective temperament of the society in which these acts occurred. This is because the mediums and techniques favored by artists often synchronize an era's dominant technology. At the same time, they manifest the culture's less tangible attributes—its preference for intuitive or rational thought, for conservative or experimental efforts, for playful or solemn expression. Thus an artwork's meaning is amplified by its evolution and its resolution.

Janine Antoni

CAN A WOMAN BE INTELLIGENT, imaginative, honest, creative, caring, amiable, generous, and sensitive, and yet suffer from low self-esteem? The answer is "yes" if that woman is exposed to the mass media, where virtues of womanhood are measured according to the dimensions of a woman's torso and the smoothness of her skin. Janine Antoni turns this emphasis on appearance inside out. Her artistic stance is located within the female psyche. She explores the neuroses that erupt from unattainable standards of youth, beauty, and proportion.

Lick and Lather, 1993–94
Detail of installation: self-portrait bust. Soap
Private collection, New York
Photo: John Bessler

COMPULSIVE ACTIVITY

Born 1964, Freeport, Bahamas
Camberwell Art College, London, England
Sarah Lawrence College, Bronxville, New York: BA
Rhode Island School of Design, Providence: MFA
Lives in New York City

JANINE ANTONI
Lick and Lather, 1993-94 (detail)
Self-portrait bust. Chocolate

Private collection, New York
Photo: John Bessler

FOR THE PAST HOUR

I have been engaged in two activities. One was purposeful: I arranged my notes to write this essay. The other was purpose-less: I nibbled on crackers from a large box that is perched beside my computer. I am not hungry and the crackers are not particularly nutritious. *Gnaw,* the work of art that is the subject of this essay, makes me self-conscious about rote snacking. I find myself contemplating, with anxiety, the pleasure/guilt quotient involved in eating. Janine Antoni enacts a triumvirate of phobias that afflict many American women. In fact, these phobias are so prevalent they are often categorized as social, not personal problems. Specifically, they include the phobia concerning fat and its compulsion, to diet; the phobia concerning aging and its compulsion, to retain a youthful appearance; and the phobia concerning loss of sex appeal and its compulsion, to seek romance.

These widespread female disorders constitute Janine Antoni's artistic process. Yet in life, Antoni herself reveals no symptoms of these afflictions. She is an attractive young woman who is neither overweight nor overlooked by friends and suitors. Nevertheless, from inception to conclusion, her work is permeated with psychological disequilibrium between the natural state of the body and

the cultural definition of beauty. Antoni intercepts the stress common among women living in a competitive, media-permeated environment. She rebroadcasts it in the form of art.

It is a challenge to convey through art the debilitating effects of biologically remote standards of beauty. This is not a subject that lends itself to representation in paint on canvas. In fact, the subject is itself a process. In order to nudge it out of the privacy of women's homes and into the public sphere of art, Antoni actually enacts the obsessive and self-punishing aspects of the eating disorders that afflict many women today. Her artistic endeavors involve manic, obsessive, and sometimes self-abusive behavior. She devises situations in which a neurosis possesses her and functions as her creative process. It even determines its outcome. In large measure, this well-adjusted, rational woman loses control of her own art activities. Forfeiting control is an enactment of the compulsive behavior that is her theme. It serves as an example of an artistic process revealing an artistic theme.

Antoni's work, like the lives of many women, lies between the gratification of libidinal impulses and the guilt attached to them. *"I want to put myself in a situation and have the situation create the meaning of the work. I'm discovering something through the process."*[1] Despite the avoidance of preconceived results, her diverse activities follow two consistent patterns. They are conducted in private. And they are carried to obsessive extremes.

In the work poignantly titled *Gnaw* (1992), food is Antoni's sculptural medium. She chose the most tempting and hence most forbidden foods: sugar and fat. In moderation, they represent many people's preferences. But Antoni is concerned with oral fixations, not inclinations. Fixations come in one size only: enormous. In *Gnaw*, calorie-laden chocolate and lard are presented in two 600-pound cubes, huge (sickening) quantities (portions).

Tedious effort is required to produce these blocks of lard and chocolate. Because the content of the work resides in compulsive activity, Antoni rarely employs assistants. She enacts the process alone. Producing the chocolate cube requires building up thin layers of chocolate, which must cool and harden before the process can continue. The lard presents the opposite problem, for at room temperature it is viscous. Each layer must be cooled with dry ice to maintain a cubic shape. Forming both blocks requires repetitive, monotonous, compulsive activity.

This arduous process marks only the first of *Gnaw*'s three phases. The lard and chocolate cubes serve as the raw material for the second phase. Assuming the role of a sculptor, Antoni removes portions of the chocolate and the lard.

"Maybe we're a bulimic society—we are addicted to that fast fix and then throw it away."

Both her tool and her working method convey women's emotional cravings and society's inability to fulfill them. Her tool is her mouth. Carving is conducted by gnawing. Antoni bites and chews the chocolate and lard.

Like cheese that has been attacked by rats in the larder, the cubes clearly display the marks of the artist's lips and teeth. They provide visual evidence of the means, the duration, and the intensity of her sculpting process. Viewers can observe that in order to create this sculpture, the artist has indulged in the ultimate binge.

Does this sugar and fat spree evoke pleasure? Antoni reminds the viewer that eating provides *"a wonderful indulgence in the process . . . The most pleasurable moments in life are chewing."* But *Gnaw* involves gluttony, not simple eating. It seeks to fill a void far greater than the one located in a stomach. Compulsive nibbling on forbidden foods is as disconnected from the mechanics of normal art production as it is from the nutritional needs of the body. The extent of Antoni's perversion can be deduced from the marks left on the cubes. She confessed that she nearly vomited when chewing the lard, and her mouth developed deep, painful sores from the chocolate. Her creative process became a grueling procedure. *"I try to push my body to physical limits. I want the viewer to imagine the obsessive labor involved in removing so much chocolate from the large cube. I gnawed at the form for a month and a half in an effort to communicate this. I made the lard sculpture knowing that when the viewers imagined me*

chewing on the lard they would share my disgust."[2]

Antoni reports that *Gnaw* commenced as a desire to create art utilizing the mouth as a sculptural tool. *"I am interested in the bite because it's both intimate and destructive."*[3] The presence of the mouth naturally suggested the process of chewing. Chewing led to the use of food. Of all the foodstuffs in the market, Antoni chose lard because it epitomizes the dread of fat, and

JANINE ANTONI
Chocolate Gnaw, 1992
600 lbs. of chocolate,
24 x 24 x 24 in.

Courtesy Saatchi
Collection, London
Photo: Scott Cohen

chocolate because it embodies desire. She describes her process as one intended to reveal itself. *"As I was pouring, I knew I would chew, but I did not know how (the work) would look. I did not have an aesthetic end in mind. What I did know is that I wanted to make an object that revealed its history on its surface."*[4]

But the work did not end at this point. *"I took the first bite and then whether I swallowed it or spit it out decided the meaning. When I spit it out, I knew I wanted to make the spit-out parts into something else. Then it occurred to me that*

this (work of art) was related to bulimia."[5] By binging and purging, Antoni integrates the bulimic cycle into her art. Her actions couple indulgence with self-punishment and shame.

The lard and chocolate that were bitten off the cubes became the raw material for the next stage of this sculptural installation. Antoni remelted the expectorated chocolate and poured it into molds shaped like heart-shaped candy boxes. The chewed-up lard was colored red, poured into lipstick molds, and inserted in readymade lipstick cases. In this manner great quantities of chocolate boxes and lard lipsticks were fabricated. Although this mechanistic task could easily have been streamlined, Antoni performed it using a cumbersome and inefficient procedure. Alone, by hand, she poured the lard and the chocolate into handmade molds, waited for them to harden, removed them, and repeated the process again and again. This third form of obsessive behavior transformed these regurgitated materials into enticing symbols of romance and love. Eventually Antoni accumulated enough items to fill a glittering boutique that she constructed for this purpose. Installed in proximity to the cubes, the boutique completed the work, *Gnaw*.

The elaborate display of chocolate boxes and lard lipsticks directed attention to packaging as a manipulative force that applies equally to product design and to people who contrive their appearance to attract attention and fabricate desire. According to Antoni, *"Packaging is a symbol of our times. It is a seduction—unwrapping is like undressing. The stuff around the object is often more signifying than the object it contains."* She goes on to observe that in a consumer society, bulimic relationships are formed with all kinds of material objects. Evidence of this psychological addiction is found in refuse bins that

are jammed with items that were consumed in excess and hastily disposed of. She comments, *"Maybe we're a bulimic society—we are addicted to that fast fix and then throw it away. Maybe that's what packaging is; it's all for immediate satisfaction, then discarded."*

The full title of the boutique in *Gnaw* is "Lipstick/Phenylethylamine Display." Phenylethylamine, a primary ingredient of chocolate, is purportedly an aphrodisiac. It makes eating chocolate approximate the sensation of being in love. This illusion of love, as much as its pleasant taste, may account for chocolate's addictive power. Chocolate appeases a form of hunger that persists in an age of plenty. It resides in the spirit and is exacerbated by artificially manufactured desires and media-synthesized passions.

Chocolate in a heart-shaped box is a classic gift from an admirer. Lipstick belongs to the beautifying process; it is a tool of seduction. Antoni presents these items as prettily as luxury consumer goods in an upscale department store. But viewers cannot see these symbols of longing and pleasure without also observing evidence—in the mauled lard and chocolate cubes—of the physical abuse and psychological duress that achieving them entailed. In addition, mirrors on the backs of the display cases not only multiply the visual profusion of the items on display, but also reflect the viewers themselves. No one can escape without becoming implicated in a tangle of guilt, shame, fantasy, and insecurity.

Antoni reports that members of the audience tend to respond to *Gnaw* according to gender dispositions. Men are aroused by the erotic implications of obsessive nibbling and licking. Women, on the other hand, respond with repulsion. For them, the work apparently triggers sensitivity to the multimedia assault on female

egos and their lifelong struggle to shape up and slim down to wafer-thin proportions. Even young women respond this way. Many are already programmed to approach their bodies as territories under siege by time and genetics. Each flaw is viewed as a threat to their romantic and professional well-being.

For Antoni, her work offers a means to conquer insecurities. *"I am not angry,"* she insists. *"I am looking at the split between my mother's gen-*

JANINE ANTONI
Lard Gnaw, 1992
600 lbs. of lard,
24 x 24 x 24 in.

Courtesy Saatchi
Collection, London
Photo: Scott Cohen

eration and mine . . . She was a victim of certain ideas of beauty. I am trying to dispel them because they are a problem in my life." In another context she has said that *"There is something hilarious about making sculpture 'tongue-in-cheek,' with the mouth. It is through humor that I become self-reflective about my work. I satirize the women at home binging. I laugh at myself. It is important to release that . . . I'm enacting what I'm worried about in society."*[6] Nevertheless, she insists this work is not about personal trauma. *"It's too easy to have the focus on me . . . I want the viewer to*

have a relationship with the object and imagine the process."[7]

Abandoning her will to her process is so essential to the intent of this work that it persisted even after *Gnaw* was installed in the museum. A bulimic's compulsive behavior is not confined to timetables and schedules. The artist succumbed to its relentless momentum and did not even halt the binging and purging when the exhibition opened. She continued gnawing on the lard and chocolate in the evenings, in private, after the public left. Furthermore, some time after the lard cube was installed at the museum it unexpectedly lost its shape and oozed off its pedestal. Rather than impose her artistic will by reforming it, Antoni decided to integrate this unanticipated circumstance into her work as further evidence of the loss of willpower. She explains, *"Lord, this is how we experience fat in our own bodies. We can't control it. But perhaps we can learn to see this, too, as a beautiful gesture, the aging process as beautiful."*

Gnaw establishes a sculptural approach that is repeated in Antoni's other pieces. Each work of art originates with an obsessive/compulsive behavior common among females. This activity dictates the method, the materials, and the theme of the artwork. Visual evidence allows the viewer to deduce Antoni's creative process. This, in turn, elicits the work's sociological/psychological theme. Some examples include:

Lick and Lather (1993)
Activity: obsessive bathing
Material: soap
Phobia: fear of germs
Art project: Antoni forms busts of herself by creating a mold of her image and casting it in soap. She washes herself obsessively, simultaneously cleansing her body and dissolving the molded image of herself.

Loving Care (1993)
Activity: obsessive mopping
Material: hair
Compulsion: to be desirable a woman must be beautiful and subservient
Art project: Hair replaces a

Courtesy Anthony d'Offay Gallery, London
Photo: Prudence Cumming Associates, Ltd.

paint brush. Hair dye replaces paint. The gallery floor replaces the canvas. Antoni mops the entire floor of a gallery with her long hair, which she repeatedly plunges into a bucket of black hair dye. This activity is carried out on her knees with her head bowed to the ground. The artist's self-beautification is linked to the servile domestic chore of mopping. Both degrade women.

Cover Girl Thick Lash (1993)
Activity: obsessive fluttering of eyelashes while applying cosmetics
Material: mascara
Compulsion: primping and flirting
Art project: Eyelashes replace hairbrushes. Mascara replaces paint. Antoni obsessively applies mascara and then blinks, transferring the wet mascara to a sheet of paper. Each blink is counted. Over 1,000 flutters of the eyelashes comprise each drawing. They are presented as diptychs drawn by the left eye and the right eye.

ANTONI POSTSCRIPT:

Extended duration of the creative process is common among contemporary artists. It unleashes a variety of meanings. Janine Antoni's use of long duration permits her to abandon herself to an obsession and enact the distress shared by many women today. For On Kawara, art-making confirms living and therefore must continue as long as he survives. Duration is determined by the process of land reclamation for Mel Chin and that of surgical transformation for Orlan. The innumerable hours invested in creating art are a measure of the value of work for Donald Sultan and the pervasiveness of data-gathering for Chuck Close.

16

Donald Sultan

DONALD SULTAN toils where effort could be spared. Evidence of his elaborate and time-consuming painting process is barely discernible in the completed work of art. But the investment of labor is not wasted. This invisible agent transforms his still lifes and cityscapes into compelling social critiques about the nature of work in contemporary society.

Lemons April 9 1984, 1984
Oil, plaster, and tar on vinyl
composite tile on masonite,
96 x 96 in.
Courtesy the artist

LABOR

Donald Sultan

See colorplate 2, page 18

Born Asheville, North Carolina, 1951
University of North Carolina, Chapel Hill: BFA
School of the Art Institute of Chicago, Illinois: MFA
Lives in New York City

THE POPULARITY of push-button, labor-saving, automated conveniences suggests that most people equate work with drudgery. Donald Sultan's paintings carry a message intended for those whose relationship with work is summed up in the word "avoidance." He seeks opportunities to work where no work is required. The effort invested in his art-making serves no practical purpose and exceeds its aesthetic goals. It directs attention to itself and thereby stimulates consideration of the relationship between labor, function, and achievement.

DONALD SULTAN
Process: 8 stages of creating *Lemon*, 1995
Latex, spackle, and tar on tile over
masonite, each 12 x 12 in.
Courtesy the artist

There are two opposing ways of defining work. It can be described as the thing one does in order to earn an income. In this instance, monetary payment is its goal and spending power its reward. But it is also possible to think of work as the thing one does in enjoyment of an activity. In this case, the reward is imbedded within the process. Which of these attitudes is more likely to generate pleasure and self-esteem? The answer may lie in examining four means to acquire a peanut-butter-and-jelly sandwich:

> Pick berries and make the jelly; shell peanuts and grind peanut butter; knead the dough and bake bread; slice, spread, assemble.

> Purchase jars of prepared peanut butter and jelly and a loaf of bread. Slice bread, spread, assemble.

> Purchase peanut butter preswirled with

jelly and a package of presliced bread. Assemble.

Purchase preassembled peanut-butter-and-jelly crackers.

In the last example, the purchaser is spared the necessity of spreading; thus there is no knife to wash. The crackers are often small enough to eliminate even the work of biting.

Our culture is not alone in doubting the pleasurable aspects of work. Ancient Greeks owned slaves so that they could be free to enjoy work's antithesis—leisure. The Hebrews equated work with bondage. Early Christians found work for profit offensive until St. Aquinas praised it as a source of grace. The work ethic that became institutionalized in the United States Constitution is based on the Reformation's credo that happiness is contingent on effort and wealth is proof of godliness. The U.S. economy, its educational system, and its social mores are founded on the virtue of work. But has this tradition survived?

Commonly cited criteria for happiness include love, dignity, and self-respect. Commonly identified feelings about the workplace involve humiliation, frustration, and anxiety. Donald Sultan reconciles labor and happiness. He and his assistants expend time, money, and effort to perform jobs that—in addition to being noisy, dirty, and sometimes smelly—serve no practical purpose whatsoever. Yet these jobs provide opportunities for self-gratification that are rarely experienced within today's labor force. They involve manual labor.

Physical contact with materials is an endangered form of work in the advanced technologies of the West. As inanimate machines replace animate exertion, humans are progressively removed from direct involvement with materials. First due to the introduction of the assembly line and remote sensing devices, most recently due to computer-assisted manufacturing and robotics, work has lost its artisanal nature. Speed has replaced skill as the measure of merit. This factory mentality has spread to the office and the home, and even to activities designed for entertainment. Kits reduce the effort involved in crafting model airplanes, moccasins, and hooked rugs.

Banks, insurance companies, real estate agencies, government bureaus, and personal and professional services have outstripped the sectors of the work force that produce tangible goods. The physical effort involved in postindustrial technology is often expended in pushing "start" and "stop" buttons. But does the ability to serve microwavable dinners from ready-to-serve, disposable trays, to rotate a dial for heat, to turn on the television for entertainment, constitute a worthy dream? By honoring the edict, "work is its own reward," Sultan suggests that plenty without toil rarely yields true enjoyment because it omits a primary source of human fulfillment—physical effort.

In his studio, different people carry out different tasks, a respected tradition practiced by esteemed artists in the past. But the nature of the activities that occur in Sultan's studio is decidedly untraditional. Integrating procedures used for the construction of buildings, not for the production of art, Sultan embraces a trade that provides one of the few surviving opportunities for physical labor in today's workplace.

Sultan's paintings pose a dilemma for critics whose discussion of an artwork relies on evocative metaphors and poetic phrases. Literal descriptions identifying material and structure are suitable for ordinary labor. One would hardly describe the efforts of house-builders by referring to "the rhythmic procession of the studs in the framing," "the glacial smoothness of the spackling," "the staccato accents of the nails," or "the turbid tones of the roofing tar."

Likewise, processes utilized in building a house are not conducive to the free reign of the imagination or to inspiration. And yet Donald Sultan and his assistants incorporate the activities of framers, roofers, spacklers, and painters into his works of art. Such labor is routine and meticulous; and its means and results are predetermined. Art, on the other hand, still carries the romantic notion of spontaneity and unpredictability. In addition to technical and material know-how, true artists are expected to employ insight and vision. It is commonly believed that art is exalted above the everyday world because it embodies the magic of an inspired moment. Donald Sultan's art emerges from blue-collar procedures and thereby defends the value of work itself. In the end, its surfaces are dense and its images highly evocative. But the manner of

arriving at the finished product is responsible for investing his works with social and psychological significance.

The following statement written by the artist might be titled, "The Problem of Painting." It describes the current exhaustion of the two major avenues of painting—abstraction and nar-

DONALD SULTAN
Factory Fire Aug 8 1985, 1985
Latex and tar on tile over masonite,
96⅝ x 96¾ in.
Courtesy the artist

rative work. *"The language of abstraction is our modern legacy . . . Pure abstraction is in crisis. After 70 years, much of what abstraction has to say about itself is done."* Regarding narrative painting, *"Images are so pervasive, however, that eventually they blur into abstraction. This is the fundamental visual truth of our time."* What is Sultan's solution to this dilemma? *"Painting is foremost a handmade, or individual made object. As long as humans have an interest in themselves, painting can avoid being corraled into an irrelevant world . . . It is therefore essential that the painter fling his mind into the middle of the muck. After all, the hand-madeness of the painting alone would make it no better than a chair."*[1]

Sultan's effort to retain painting's vitality and relevance takes the form of an elaborate creative process.

STEPS 1 AND 2: Instead of painting on canvas, Sultan "constructs" his paintings, embracing the materials, tools, and skills commonly used in the construction trade. For his large paintings, he uses three-inch steel rods to bolt a heavy plywood backing to stretchers made of standard pine two-by-fours. His woodworking techniques are not those of an artist or craftsman, but a carpenter. Other fabricating materials include linoleum tiles, tar, rubber, pine boards, plaster, and spackle purchased from a typical building supply store. Sultan's tool inventory lists blowtorches, chisels, hammers, scrapers, and knives. His studio techniques involve gouging, rasping, pouring, and sanding.

STEPS 3 AND 4: Vinyl tile is glued to the wood in the manner of laying a floor in a typical house. A second layer of vinyl is then applied over the first.

STEP 5: A thick layer of butyl rubber is laid over the vinyl and left to dry for several weeks. Butyl rubber is a sticky, unpleasant mixture that forms a thick, smooth surface and is used for roofing. Painterly impulses are delayed until this elaborate supporting structure is complete.

STEP 6: Sultan makes a chalk drawing on the dried butyl rubber surface. He always creates this drawing himself.

STEP 7: The drawn image is heated with a blowtorch, then cut and scraped away to reveal the underlying vinyl tile. Sultan's shopping list for art supplies includes Kryloh Interior/Exterior Spray Paint, Grip Primer Sealer, Fuller O'Brien Latex Flat Wall Paint, Regal Wall Stain, DAP Vinyl Spackling, Pitfire Propane Fuel, Elmer's Carpenter's Wood Filler, Red Devil Blacktop and Roof Repair, and UGL Safe Grip Contact Cement. He even uses premixed colors. Tradesmen don't need custom-made materials.

STEPS 8 AND 9: Once the butyl rubber is removed, plaster is added to build up the surface.

The surface is then sanded down. An inventory of tools in Donald Sultan's studio includes a Silver Knight shop vac, a Stanley sander, a Makita finishing sander, De Walt stationary power tools, a power miter box, hammers, electric drills, wire cutters, goggles, spackling tools, hacksaws, clamps, screws, and nails.

STEP 10: Color is added, applied with a sponge or rag.

Sultan's paintings often apply the means of construction to the theme of nature. But instead of celebrating nature's beauty, purity, freshness, and healthfulness, Sultan's fruits and flowers seem suffused with industrial effluence. They are flattened, expanded to abnormal proportions, and surrounded by a scabrous black substance. Sometimes these industrial references are depicted directly as belching smokestacks and blazing industrial sites. These works are discomfiting reminders that even our organic edibles are products of a hands-off, industrialized agricultural system. They evoke the smell of diesel fuel, the sound of engines, the presence of black smoke—all integral to life on today's industrial farms.

The divergent activities of making art, farming, and building coalesce in Sultan's work. Their unification demonstrates the extent to which nature has succumbed to industry. But it is also true that manufacturing in turn is succumbing to newer technologies. *"I began to see the smokestacks like the poplars, that these things were going to go away soon too. I think of them as our forest . . . It's another play on the idea that even these things are like plants."*[2] Thus advanced technologies are threatening both nature's way of growing things and people's ways of constructing things. Sultan goes on to state that *"Industry is part of the past and there is only electronics. It's a pretty desperate situation . . . The industrial revolution had a very different impact on people than the nuclear age and the hyper-electronic age did (and do). The first provoked humanitarianism whereas the latter, in the case of electronics, causes a disenfranchisement."*[3]

Sultan is distressed by our diminishing opportunities for gratification. *"The country is being destroyed in order to amass wealth. The country has moved that way because television and the media convince people that the older eco-nomic structure, that is making and producing things, is collapsing. People are turning toward mediating and moving sums of money rather than making things. We're losing the ability to make things."*[4] In reaction, he invests inordinate time and effort in the construction of his paintings. He enacts tasks that machines are capable of handling. He even selects chores that are not necessary at all. Efficiency is not Sultan's ruling stricture. By welcoming into his studio such processes as spackling, roofing, and studding, he ensures that these routine and labor-intensive activities acquire the esteem of art. In this new context they communicate the satisfaction, the dignity, and the sensuous pleasure of physical toil. Sultan reclaims traditional sources of pride that are lost when muscles and hands are replaced by machines and convenience goods. He reverses values entrenched in culture and assumptions ingrained in minds by proposing that we replace labor-saving with labor-savoring.

SULTAN POSTSCRIPT:

Donald Sultan and Rosemarie Trockel both ennoble forms of labor that are obsolete or that survive only as vestiges of preautomated eras. Trockel focuses on female-related domestic activities, Sultan on male-dominated construction trades. The clicking of knitting needles and the pounding of hammers are sounds that announce deeply inscribed cultural assumptions about gender and production. Sultan and Trockel make these messages audible. Mike Kelley enters this arena by appropriating cast-off toys made by women at home. They, too, shed their humble origins by becoming the material components of Kelley's art, which is displayed in prestigious galleries and the homes of sophisticated art patrons.

Haim Steinbach

REPORTS ON THE ORIGINS OF SHOPPING extend all the way back to Babylon. King Solomon and the Queen of Sheba indulged in the acquisition of goods on a biblical scale. But it is only at the end of the twentieth century that exchanging money for goods has been included within the repertoire of an artist's creative endeavors. Haim Steinbach is one of a number of artists who equate art-making with shopping. The objects he purchases and then displays are his works of art. Often, the shelves on which they are placed are the only components of his work that are newly fabricated.

Shelf with Annie Figurine, 1981
Wood, plastic masks, contact paper, and plaster figurine, 25 x 22 x 14 in.
Courtesy Jay Gorney Modern Art and Sonnabend Gallery, New York

shopping

Haim Steinbach

See colorplate 11, page 27

Born 1944, Rechevot, Israel
Pratt Institute, Brooklyn, New York: BFA
Université d'Aix, Marseilles, France
Yale University School of Art and Architecture, New Haven, Connecticut: MFA

Bumper sticker: "When the going gets tough, the tough go shopping"

T-shirts: "The difference between men and boys is the price of their toys"; "Shop-a-holic"; "He who dies with the most toys wins"

Greeting cards: "Work to live, live to love, love to shop"; "Born to shop"; "I shop, therefore I am"

Apron: "A woman's place is in the mall"

Coffee mug: "Mall rats"

HAIM STEINBACH
charm of tradition, 1985
Mixed media construction, 38 x 66 x 13 in.
Courtesy Jay Gorney Modern Art and Sonnabend Gallery, New York

Merchandisers and advertising executives are often accused of preying upon an unsuspecting public, conjuring schemes to unleash bouts of impulse-buying. But this impression is contradicted by the mottoes emblazoned on the goods listed above. Such items are purchased by thousands of individuals who identify with their slogans. These objects brandish the fun and fulfillment offered by participating in the climax of the marketing process—the moment of sale. Their owners have pledged allegiance to a lifestyle of consumption.

Haim Steinbach partakes of the merchandising doctrines that rule most contemporary lives. He roams the streets and the commercial strips searching for things to buy, instead of isolating himself in his studio. Then he arranges his purchases on shelves he constructs, instead of painting, carving, or casting. Thus his work consists of displays of merchandise available to anyone able to pay the price.

Steinbach's creative process reflects prevailing social values as intrinsically as the methods employed by Benjamin West, John Singleton Copley, and Charles Willson Peale conveyed the values upon which this country was founded. The labor-intensive paintings created by these eighteenth-century artists proclaimed an ethic based on hard work, temperance, and discipline. Steinbach's adoption of shopping as art is equally valid because it announces the unapologetic pursuit of consumption, extravagance, and indulgence that is characteristic of these final decades of the twentieth century.

Just as artists in previous generations honed their skills in carving, casting, and painting, Steinbach develops his skills in buying. This endeavor draws attention to the new kind of proficiency that determines survival. Well-being no longer requires tools and dexterity; it is a function of culling the marketplace for the best item at the lowest price. Similarly, social status depends more on spending power than on beauty, talent, intelligence, or spirituality. Shopping is a serious endeavor. Steinbach has designated it an artistic one as well.

But shopping is more than a functional affair. Even window-shopping is a leisure-time activity, and shopping sprees are common antidotes to frustration and depression. Infomercials are a form of entertainment. Going to a mall cheers people up. It also cheers the country up. It is shopping, not parades or festivals, that comprises our culture's primary mode of celebration. Price-slashing sales define the manner in which we commemorate Veteran's Day, President's Day, Memorial Day, Labor Day, Martin Luther King Day. We honor our nation's heritage by spending money.

If art provides material evidence of the artist's keenest perceptions and finest sensibilities, Steinbach suggests that purchased commodities fulfill this role for him. This seemingly curious assertion is confirmed by the observation that shoppers behave like artists. Market choices manifest their tastes and desires. Shopping thereby bestows meaning on life and grants the psychological rewards that once resulted from producing things.

Furthermore, buying is empowering. Each decision involves exertion, suspense, self-assertion, and creative problem-solving. Like art, shopping provides the means for achieving self-expression and aesthetic pleasure. Steinbach thus argues that *"Objects, commodity products, or art works have functions for us that are not unlike words, language. We invented them for our own use and we communicate through them, thereby getting into self-realization."*[1]

Steinbach seems to revel in the regenerative thrill-seeking of being an avid consumer. Like sex and eating, it is never wholly fulfilled. No product is too paltry to consecrate his delight in material plenty. Greed, squandering, crassness, infantile demands for gratification, all of these derogatory terms are expunged from his definition of the verb "to consume." In his work, the purchasing of objects offers visual exultation and pride in having disposable income. He methodically explores the components of consumption, which he identifies as *"the commonly shared social ritual[s] of collecting, arranging, and presenting objects."*[2]

COLLECTING AS ART: Steinbach systematically examines the manifold sites where consumer desires are stimulated and assuaged: thrift shops and boutiques, supermarkets and furniture stores, museum gift stores and design emporiums, J.C. Penney's and Nordstrom's. He even goes prospecting through the bins of disorderly, cut-rate merchandise that line the aisles in Job Lot Trading establishments. Other explorations take place amid the make-believe tropics in Banana Republics. All marketed goods are candidates for inclusion in his assemblages. He is as likely to return with a rare antique as a mass-produced utensil.

Unlike a wife or husband conducting the weekly chores, Steinbach sustains the delight of a tourist encountering the glittering sights of a great bazaar. He avidly searches for souvenirs of his journeys, perpetually eager to reenact the rite of impulse-buying. His works are not preconceived. Each purchase is the result of a chance encounter with an object that leaps from the congestion of the merchandising arena. Exhibitions of Steinbach's work abroad are initiated when he goes shopping on location. Thus each is a tangible record of goods available in the immediate locale. Museumgoers see their own lives reflected in his efforts.

In the late 1970s, before his work began to command high prices, Steinbach confined his purchases to cheap objects found in flea markets, yard sales, and secondhand shops. When the price of his work escalated, so did the value of its ingredients. Pieces made between 1979 and 1983 included a child's plastic ball, a T-shirt, a copy of a Precolombian sculpture, Ajax cleanser, a cereal box, a plastic clock, a stuffed raccoon, and a Frisbee. In 1985 he combined BOLD detergent boxes with new enamel teapots, and a year later he introduced wooden owls carved by a professional artisan. By 1987 Steinbach was purchasing authentic eighteenth-century Dutch carved figures and Universal weight-lifting machines. In 1988 he acquired a rare French walnut armoire and a Mies Van der Rohe chaise. In 1989 he bought museum-quality ancient Israeli pottery; and in 1990 a work included an original sculpture by the well-known artist, Pol Bury.

Although set prices are determined according to overall size, the buyer additionally absorbs the cost of the objects incorporated into the work. Occasionally, objects are sold by themselves; in these cases, Steinbach charges only the price he paid. Once the objects have been assigned places on the shelves that become their sculptural support, however, they are considered artworks and command the hefty price of fine art. This pricing structure demonstrates the importance Steinbach attaches to display. Objects are granted the privileged status of art only after they become elements in his assemblages.

ARRANGING PURCHASED OBJECTS: Steinbach differentiates between two phases of the ritual of commerce. This ritual is initiated when merchandise is presented on the counters and display cases of stores. These point-of-purchase displays are often designed by professionals who are trained in the techniques of high-powered marketing. The second stage begins when the objects leave the turbulent domain of the marketplace and enter the private sphere of a home or workplace. Once the objects are purchased, personalized relationships are established between them and their owners. Steinbach comments that many commodities are purchased by people simply *"to build their own*

cathedral inside their house. They select the objects that they like to live with, and they make a shell for themselves. They cultivate their little domain."*[3]

Having made his purchases, Steinbach neither manipulates nor transforms them in any way. *"What I do with objects is what anyone can do, what anyone does anyway with objects, which is talk and communicate through a socially shared ritual of moving, placing and arranging them."*[4] The formula of acquisition ordinarily

> **"All commodities are made with the intention of eliciting desire ... We live in a culture of 'pornography,' we are engulfed by it, contained in it."**

ends when items are given a place on their owner's turf. But Steinbach returns them to the commercial sector in the form of art. In this context these purchased commodities relinquish their intended use and assume a new role within the artist's assemblage. Steinbach states that they become *"disenfranchised of personalized, ritualized and qualitative associations which may have been attributed to them at another time."*[5] When an artist configures utensils, antiques, animal specimens, and prosthetic devices, their meaning is recalibrated. A new order is devised. They become art. Thus recently purchased objects are reinstalled in an art gallery to be repurchased by art collectors. *"Everyday objects produced by our society may be turned into objects of desire more than one time. I am trying to demonstrate that an object may be consumed more than one time and desired in more than one way."*[6]

His collectors assign them a place amid their artworks, furnishings, and personal mementos. Steinbach describes the irony of this process: *"I make an arrangement of shelf and objects which (is) a fragment of my collection from my living room and send it off to someone else's living room (or bedroom, kitchen, hallway). Once reinstalled, my arrangement of objects will face my host's arrangement of objects, putting the issues of choice in focus."*[7]

Steinbach's art often asserts a paradoxical presence in collectors' typically refined and sophisticated homes. Pieces that include BOLD detergent, AJAX cleanser, and Corn Flakes grant

objects normally hidden in broom closets and kitchen cabinets the privileges of public display. In the process, they shed their association with laundries, sinks, and cereal bowls and become sources of aesthetic and symbolic contemplation.

The commodities themselves are exalted by the sheer force of Steinbach's scrutiny. Like a poet choosing and then combining simple words until they are resonant with new meaning, he meticulously contrives the combinations and

HAIM STEINBACH
Spirit I, 1987
Mixed media construction, 83 x 96 x 91 in. (gym set), 49 1/4 x 170 7/8 x 27 1/2 in. (shelf)
Courtesy the artist and Sonnabend Gallery, New York.
Photo: Lawrence Beck

positions of his visual units and presents them in the new syntax of his tableaux. Relocated in this manner, their latent formal qualities and thematic content are released.

Mythology: *charm of tradition* (1985) consists of two pairs of Nike sneakers and a lamp. The lamp's base is made of deer legs; its shade depicts a hunting scene. Both sneakers and the deer legs imply fleetness of foot. A race between a human and an animal is further suggested by the reference to Nike, the Greek goddess of victory.

Portrait of a Place: For the Israel Museum in Jerusalem, Steinbach displayed locally produced Corn Flakes boxes with pre-Christian jugs that once held cereal grains, reenacting Israel's vast history by pairing current and ancient means of supplying food.

Aesthetic Abstraction: *Supremely Black* (1985) is a stunning assemblage of two wedge-shaped shelves, one solid red, the other tar

black. The red shelf holds two black pitchers. The black shelf holds three BOLD Detergent boxes whose red background and black letters contribute to the dazzling optical scheme. *Supremely Black* reinterprets a great monument of Russian Suprematist art for the 1980s.

Social Commentary: *Spirit I* (1987) pairs two immense steel weight-lifting machines and a set of lava lamps. The passivity of the 1960s drug culture becomes the counterpoint for the fitness prized in the 1980s.

Social Narrative: A shelf of 1981-83 displays a Little Orphan Annie figurine and inverted Halloween Spiderman masks. Like a visual fairy tale, the work recreates the common scenario of the hostile male confronting the innocent female.

THE POLITICS OF DISPLAY: The shelf—the prototypical emblem of aggressive marketing and conspicuous consumption—is central to Steinbach's scrupulous analysis of the role of commodities in contemporary society. The popularity of shelves as facilitators of display has risen and fallen with the fate of the middle class. It is reported that they first appeared in the eighteenth century to flaunt the wealth of the bourgeoisie.[8] They fell out of vogue during the French Revolution when material ostentation contradicted the populist ideals of the times. They reappeared during the Restoration and have proliferated ever since, infiltrating both the public sphere, where they announce an object's availability for sale, and the domestic sphere, where they manifest the taste and affluence of their owners. In both contexts, shelves confer special status on objects.

In Steinbach's work, the design of shelves is as diverse as the kinds of objects arrayed upon them. He exploits the shelf's varied formal and associative meanings by fashioning special supports for his purchased objects. His first shelves were standard lumber planks hung with common hardware metal brackets. Around 1982 he began to construct handmade shelves out of eccentric assortments of discarded home-decorating materials, fragments from nature, scraps of lumber, furniture parts, plastics, and junk. In 1985 he converted to geometric, wedge-shaped shelves made of plastic laminate over wood.

The shelf swells to new proportions in *Untitled (French walnut armoire, Cuban mahogany*

armoire) (1988). This work consists of two similar armoires placed back-to-back and framed by a larger cabinet. An armoire is a piece of furniture in which collections of objects are stored. Large enough to provide tangible signs of wealth, they were favored by the bourgeoisie in the nineteenth century. By framing these two armoires, Steinbach isolates them from their domestic function and presents them as metaphors for crass materialism.

Steinbach first became aware of the way in which shelves announce lifestyles when he was growing up in Tel Aviv. There, he says, *"you have all these Jews who were coming in from Europe and different countries, speaking different languages and having different cultural backgrounds. As a child I was really fascinated by the dramatic difference between the cultural milieu of one household and another . . . My father was a kind of pioneer of a 'modern' look in our neighborhood—Scandinavian-style furniture and so on. I remember the first time I went from my modern house to visit a friend whose house was all chintz/rococo and heavy glass . . . In a sense my work is precisely about those distinctions between one household and the next."*[9] His initial reaction was to avoid displaying or even acquiring objects for his own home. *"I realized that I had developed an incredible bias toward objects, probably as a result of a resistance to an ideology of 'commodity fetishism.'"*[10] Ultimately, however, Steinbach abandoned himself to objects with the fervor of an unabated shopping spree. *"One day I decided to open up, to fill my house with objects and let myself experience and familiarize myself with them again."*[11] In this manner, he evolved his tripartite operation to articulate the relationship between the commodity-glutted environment and our collective ideals and yearnings.

Detractors accuse Steinbach of complicity in the mindless frenzy of consumption. They insist that elevating shopping to an art form dignifies excessive consumption of wasteful products. Arguing that art's influence would be better used to reduce the congestion of the marketplace and relieve the pressure on garbage dumps, they reprove him for reinforcing an addiction that, like junk food, nourishes neither our bodies nor our souls. Defenders assert that Steinbach ingeniously manifests the shift in industrialized societies from fashioning to purchasing and the yuppy's delight in commodity acquisition.

The artist himself uses the word "pornography" to describe the enticement and procurement of objects in the marketplace. *"Pornography is seductive, it is comprised of formal elements designed, manipulated and registered to attain high states of stimulation. All commodities are made with the intention of eliciting desire . . . We live in a culture of 'pornography,' we are engulfed by it, contained in it."*[12] Steinbach's immersion, however, corresponds more to a warden than a prostitute. He describes his mission by asserting, *"If this state of things is 'pornographic' we must look at it and ask ourselves how we partake in it."*[13] Since we are unavoidably entangled in the promotion, procurement, and consumption of objects, viewing a Haim Steinbach assemblage provides an occasion to scrutinize the manner in which objects govern our lives.

STEINBACH POSTSCRIPT:

Foraging, once the means of survival for our earliest ancestors, has been revived by many of today's most vanguard artists. Their hunting and gathering excursions take them into common sites of procurement, but uncommon sites of artistic activity. The material they collect often serves as their medium, their product, and their subject matter. Haim Steinbach scavenges in stores, Wolfgang Laib in fields, David Hammons in ghetto streets, Amalia Mesa-Bains in trinket and memento shops, Mike Kelley in thrift shops, Sherrie Levine in art books, Barbara Kruger in old magazines, Christian Boltanski in rummage bins, Tomie Arai in media depictions of Asians.

Rosemarie Trockel

GENDER ROLES may be overt, as in sports and family settings, or subliminal, as in language. In both categories they are coercive, molding patterns of thought, dictating behavior, and delineating opportunity. By relying on mechanics and electronics to produce her art, Rosemarie Trockel enlists process to delineate a world free of gender differences.

Untitled, 1987
Wool, fabric, and mannequin,
48 x 21 x 15$\frac{1}{2}$ in.
Courtesy Barbara Gladstone Gallery, New York

MECHANICS
AND
ELECTRONICS

Rosemarie Trockel

Born 1952, Schwerte, West Germany
Werkkunsteschule, Cologne, West Germany
Lives in Cologne, Germany

See colorplate 2, page 18

ROSEMARIE TROCKEL
Untitled ("Endless" Stockings), 1987
Stocking, glass, and wood, 94$\frac{1}{2}$ x 22 x 1$\frac{3}{8}$ in.
Courtesy Monika Spruth Gallery, Cologne
Photo: Bernard Schaub

WOULD YOU PREFER a sweater with a perfect mass-produced weave, an imperfect mass-produced weave, or an imperfect hand-made weave? The people I canvassed unhesitatingly selected the imperfect handmade sweater. Apparently, a century and a half of industrially produced abundance has not diminished respect for manual dexterity. Nevertheless, Rosemarie Trockel withholds evidence of her hand from her works of art. She invites the machine to be her collaborator by serving as fabricator and designer. This choice is dramatized by her involvement with knitting, an activity long associated with manual effort. Trockel thereby disrupts the commonly accepted distinction between craft and art, which asserts that craft cannot be art because it stresses technique, practical knowledge, and preconceived results. Fine art is not supposed to submit to rules in a "how to" manual. By integrating machine-knitting into the lexicon of art techniques, Trockel enlarges art's territory to encompass not only craft skills but mechanical production.

Skill in knitting is commonly assessed according to the regularity of the weave. Great care is invested in maintaining even tension in the yarn and equal spacing between the stitches. Although knitting machines automatically execute the regular weave to which handknitters aspire, sweater manufacturers often program machines to mirror the irregularities of a hand-made product. A paradoxical exchange of goals occurs: while knitters strive to be as precise as machines, machines are sometimes manipulated to be flawed like people.

Rosemarie Trockel pries open these cultural peculiarities and exposes the assumptions they suggest. She operates within the resulting cracks and fissures in social values. Take for example her *Untitled* (1987), which consists of knitted fabric made into long underwear. The underwear is fitted over the bottom half of a mannequin, which is then placed on a pedestal and presented as sculpture. The artist herself did not

fabricate this knitted work of art, nor did she hire others to perform the manual task for her. The knitting was carried out mechanically.

In technologically advanced nations, objects produced via automation usually carry less esteem than those made by hand. Presumably, this is because machine-made goods lack three valued attributes: individuality, inspiration, and rarity. By mechanically producing her work,

ROSEMARIE TROCKEL
Untitled, 1986
Wool; dress worn by
Monika Spruth

Courtesy Monika Spruth
Gallery, Cologne
Photo: Bernard Schaub

Trockel dismisses two of the three requirements for fine art: her leggings are impersonal, and they are not the outcome of an inspired moment. Ironically, however, they retain the prerequisite of rarity. For although machines in the textile industry typically churn out quantities of identical units, Trockel's machine produced only one pair of leggings. As unique as a handmade object, they recoup an essential characteristic of both craft and more conventional art.

Yet another irony underlies the leggings' construction. Although they were created with the techniques of mass production, they lack the two qualities by which machine-made goods are judged: they are decidedly uneconomical and inefficient.

These knitted leggings unravel two additional strands of fine art's legacy. By looking and behaving like clothing, they upset the presumed segregation of art from function. Trockel further nudges complacent distinctions between art and craft from their positions of authority by designing this knitted work on a computer. Computer-aided design is even more remote from the creative processes commonly associated with art. It is methodical instead of emotional, preconceived instead of spontaneous.

Trockel thus tampers with the four aspects of art-making that traditionally confer status upon art. Machine fabrication replaces manual fabrication, eliminating the personal touch of the artist. Routine procedures displace expressive freedom, thus excluding spontaneity. Computer-aided design supplants intuition, erasing inspiration from the creative process. And fourth, utility compromises the aesthetic purity of art, which loses its disassociation from mundane affairs.

This brainteasing narrative of the genesis of Trockel's leggings is not yet complete. I have so far dealt only with the issue of "how" the work was produced, neglecting postulates about "who" did the producing. *Untitled* directs attention to the inequities between men's and women's work. A centuries-old tradition honors the former as professional, but degrades the latter as amateur and domestic. Male jobs are granted status when names are bestowed upon them: mason, mechanic, butcher, carpenter, tailor, trucker, cobbler, even chef. Women's tasks lack professional names and are thus typically referred to with verbs: ironing, baking, cooking, mending, sweeping, quilting. Trockel invents intriguing schemes to reconcile these gender inequities. *"Materials, procedures and motives are meaningful aspects of the female and are, accordingly, looked upon as inferior and taboo ... Women have historically been left out. And that's why I'm interested not only in the history of the victor, but also in that of the weaker party."*[1] Her approach is that of a feminist Marxist. She assigns to the household the dignity of a place of business.

Trockel might be considered the Martha Stewart of the art world. Stewart has built a media empire by reviving domestic skills that

were lost when mothers hung up their aprons and donned business suits. Daughters who grow up in homes where dinner is microwaved and clothing is ready-to-wear lack the opportunity to learn traditional women's skills. Stewart's books, videos, and magazines resurrect knowledge about food and clothing, window treatments and brunch menus, preserving fruits, planting tomatoes, polishing silverware, sewing stuffed dolls, making Christmas decorations, and concocting salad dressings.

Like Stewart, Trockel resuscitates traditional sources of female pride and empowerment, but she takes an unlikely route by inviting a machine to produce her knitted art. How can mechanical knitting elevate the stature of women's domestic work? Machines harness power, extend control, command authority, and increase force. By implicitly assigning these metaphors for virility to the standard feminine job of knitting, Trockel enhances the stature of a woman's task. The involvement of a machine removes knitting from the category of domestic craft and elevates it to a stereotypically male professional activity. At the same time, by assigning a machine the woman's task of knitting, she diminishes the machine's association with brute force and, by implication, masculine power. Trockel plays with these incongruities that are programmed into Western culture, ultimately equalizing the inequities built into society's gender equation.

A parallel situation explains why Trockel relies on computers to design her art. While machines relate the *physical* aspects of labor to male stereotypes, computers relate the *mental* aspects of labor to male stereotypes. Their objective, precise, and methodical functions contrast with women's intuitive, variable, and emotional ways of working. Once again, Trockel subverts habitual attitudes about gender by merging a feminine activity with a masculine process.

Any gender inequalities that linger are eliminated in a profoundly original manner. Instead of attempting to abolish them, Trockel eliminates gender itself. Her sculpture is essentially androgynous. There are, for instance, no telltale buttons and zippers on the underwear. At the same time the mannequin's hips, buttocks, and thighs equivocate between masculine and feminine qualities. Moreover, sexual equivalence is confirmed by the pattern on the leggings. The left leg displays a design of minuses, the right leg one of pluses. The two, like vaginas and phalluses, cancel each other out. Unisex apparel is matched with a unisex mannequin. Thus, this work of art's challenge to convention includes

"Women have historically been left out. And that's why I'm interested not only in the history of the victor, but also in that of the weaker party."

the audacious dismissal of three fundamental laws of nature that were presumed to be irrefutable: every creature is either male or female; no one can be both male and female; no one can be neither male nor female.

The mannequin wearing the knitted underwear is as powerful a symbol of social values as a bronze monument. But bronze monuments typically depict soldiers or statesmen who embody masculine attributes. This sculpture presents a sexless form on which male and female characteristics are rendered null and void.

Trockel defies society's established power discrepancies by making a machine function like a housewife, by claiming that a mechanically produced object is art, by equating the fabricator standing at an assembly line with a knitter sitting in a rocking chair. In all these ways she reverses the viewer's expectations and appeals for the neutralization of dominant/masculine and subordinate/feminine values. Trockel has also assigned these complex themes to other articles of clothing.

In *Balaklava* (1986), Trockel fabricated a cap modeled after those traditionally worn in the Crimea to protect against extreme cold. Popular as fashionable ski apparel, such caps have also been adopted by terrorists because they cover the entire face. A single garment worn by both sexes, therefore, signals such disparate associations as protection, fashion, and crime. It suggests that men and women are equal in seeking comfort, being fashionable, and breaking the law.

Dress (1986) is a witty act of insubordination against the manipulative power of emblems:

here a commercial logo that, like the cross and the swastika, is laden with associations. Trockel programmed the knitting machine to make a dress according to a generic pattern. The dress differed from this pattern only in the imposition of two Woolrich logos precisely over the wearer's breasts. In this location, they evoke amusing and provocative associations. Ad campaigns displaying the Woolrich sign refer to purity, reliability, and quality. *Dress* releases a flood of subversive questions about who can lay claim to the Woolrich logo and thus these attributes. Is a woman wearing the dress virtuous? Is a man examining the woman's breasts virtuous? Is the capitalist pandering wool's purity virtuous? Is the artwork virtuous?

Untitled ("Endless" Stockings) (1987) is a sculpture that consists of abnormally long stockings meant to satirize the lean bodies epitomized on the pages of women's fashion magazines. These stockings exaggerate the socially inscribed ideals of the female body. But Trockel's artistic statements are never so reductive. She reverses the stockings' connection to luxury and elegance by manufacturing them out of heavy, opaque material. These stockings are produced for warmth, not seduction. Their material suggests buxom old ladies, while their form suggests stylish young girls. Trockel merges two categories of stockings: those designed for female comfort that conceal the body and those designed for male titillation that display the body. As in her other works, she shuffles social values, dislodging them from their hiding places and exposing them to review. Is a skinny, shapeless woman a candidate for Trockel's genderless utopia? Should women select comfort or beauty? Do men prefer comfort or beauty? Which gender determines what women wear?

Throughout her work, Trockel diminishes the traditional female roles—goddess, mother, virgin, whore — because these accentuate the differences between women and men. She emphasizes the one role that empowers women to assert their equality with men: that of worker. In sculptures that do not involve clothing, Trockel typically assigns to women's tools—ladles, irons, stoves, scrub brushes, and other home appliances—the dignity, prerogatives, and significance of male activities.

Trockel's reconciliation of sexual dichotomies far exceeds equal pay for equal work. The workplace is a territory in which gender roles and social values originate and are perpetuated. Changes in production inevitably shuffle cultural systems differentiating art and function, machine-made and handmade, art and craft, male and female. By scrambling these habits, Trockel dislodges society's tendency to concentrate power around characteristics seen as traditionally male: technology, rationality, and professional status. Concurrently, she promotes the merits of women's stereotypical attributes: craft, intuition, and amateurism.

TROCKEL POSTSCRIPT:

Full appreciation of a work of art, whether it is historic or contemporary, can rarely be derived from the visual experience alone. But contemporary art places the eyes at a particular disadvantage. Visual scrutiny, however intense, cannot decipher the relationship between On Kawara's date paintings and his life's mission; the sources of Serrano's yellow liquid; the origin of the material in Antoni's lipsticks, the biographical references in Felix Gonzalez-Torres's candy spills; or the elaborate construction techniques used in Donald Sultan's paintings. Likewise, observation alone cannot discern that Rosemarie Trockel's commentary deals with the gender implications of the distribution and conditions of labor. In all these cases, visual perception requires bolstering with information about cultural settings, artists' biographies, technical procedures, and theoretical frameworks.

Chuck Close
19

CHUCK CLOSE may seem an unlikely candidate for inclusion in a book devoted to artists who radically transgress the limits of artistic norms. He is a portrait painter whose work is realistic. He applies paint to canvas. His paintings offer visual pleasure.

Within this conventional format, however, Close registers the seismic tremors of the cybernetic revolution. His atomized method of applying paint to canvas confirms that the computer's intrusion into human affairs extends far beyond the prosaics of banking, research, poll-taking, and space travel. It jolts our definitions of humanity.

Self-Portrait, 1973
Ink and pencil on paper,
$70^{1}/_{2}$ x 58 in.
Courtesy the artist and Pace/Wildenstein
Photo: Bevan Davies

DATA
COLLECTING

Chuck Close

See colorplate 5, page 21

Born 1941, Monroe, Washington
Everett Community College, Washington
University of Washington School of Art, Seattle
Yale University School of Art and Architecture,
 New Haven, Connecticut: BFA and MFA
Lives in New York City

CHUCK CLOSE
Self-Portrait—White Ink, 1978
Hardground etching and aquatint on black
paper, edition of 35, 54 x 40 ½ in.
Courtesy the artist and Pace/Wildenstein

CULTURAL CLIMATES
and technological achieve-
ments have always been
linked. The Stone Age, the
Bronze Age, and the Iron Age
are historic eras identified by
their primary forms of technol-
ogy. In our own century, the
relationship between techno-
logical and artistic innovation
is equally apparent. During the
first decades of the twentieth
century, the human environ-
ment was dramatically trans-
formed when the industrial
revolution drove machines
and machine-made goods
into every facet of life. Art
changed in tandem as it
absorbed the unprecedented
sensations of speed, power,
and flight. It became as
brilliant as electricity, as
dispassionate as machines,
as cool as steel.

A parallel revolution is
under way today. If the current
era is to be named for the tech-
nology that distinguishes it
from all previous times in his-
tory, it will most likely be
known as the Computer Age. We are inexorably
tied to this electronic apparatus. Our lives are
inundated with the bounty of its product—infor-
mation. Data is the fuel that keeps these infor-
mation turbines running. Their voracious
processing systems have transformed the atom,
the galaxies, and human behavior into manifold
bits of information.

The computer's influence on art is not lim-
ited to artists who use it as a tool for generating

images or conducting calculations. Artists are equally affected by the computer's psychological and philosophical implications. Chuck Close, for instance, apparently defines knowledge in the computer's terms—as the dissection of objects or events into their absolute numerical equivalents. He has invented a way of applying paint to canvas that implicitly discredits less rigorous forms of knowledge.

Close equates truth and reality with visual facts, the kind of data that can be fed into an electronic network, sorted, stored, and retrieved. His art-making process involves receiving and dispensing visual information. Accuracy is its goal. In this way, his paintings submit to the same criterion that guides today's computer culture. Although Close does not directly refer to the impact of the computer on his work, he acknowledges, *"I am more concerned with the process of transmitting information than in filling out a check list of the ingredients a portrait painting is supposed to contain. I . . . want to strip the viewer of the comfort of thinking that the traditional concepts of art are automatically going to make him understand what art today is all about."*[1]

Since the 1970s, Close has tackled the complex and intricate details of the human face. His images are so fact-filled they neither look like paintings nor like products of the human hand. To be sure, painters in the past have achieved impressive likenesses. Such nineteenth-century American masters of the still life as William Harnett even fooled the eye of the beholder into believing that what was being perceived was actual, not represented. But Close's realism belongs to an entirely new order of magnitude. His compulsively detailed portraits duplicate each individual follicle, wrinkle, hair, pore, freckle, and blemish. It is this dogged pursuit of visual data that reveals the cybernetic implications of Close's endeavors. Behaving like a computer enables him to escape two former imperatives: the anatomy of visual perception and the personality of the artist.

The eye serves as our primary link to the world, supplying approximately eighty-five percent of the information we receive from our surroundings. Yet the task of recording pure visual data is severely hampered by the human optical apparatus. Vision is not a factual affair. A complicated sequence of events intervenes between the external world as it exists and as it is perceived. It has been estimated that images enter the eye in the form of light rays at a velocity of ten snapshots per second. With every impression, tens of thousands of cells in the eye are stimulated. They respond independently, each registering the image's specific details. This deluge of visual information far exceeds the human capacity to absorb it. We would surely collapse from the overload if our bodies didn't have a built-in protective device: our brains intervene and guard us from confusion. They automatically process the continuous flow of disconnected stimuli from the eyes, grouping those that have similar characteristics and feeding us visual information in manageable clusters. In this way we discern a chair, or a tree, or a person.

The brain also economizes on the effort involved in visual perception by informing us that an object illuminated by moonlight is the same object we saw under electric light although its colors have changed, or that the tree in the distance is as large as the tree nearby although their perceived sizes vary, or that the odd object on the table is merely a half-eaten apple. In other words, our brains emphasize relativity over absolutes. They spontaneously untangle the deviation from the norm. What they extract are the global aspects of an object, not its individual details.

The brain thus reconstructs the order of the physical environment that was lost during lightwave transmission. Seeing according to qualities, not quantities, is built into the human organism and lies beyond human will and consciousness. Sense emerges from sensations because the brain simplifies and generalizes.

In comparison, the computer begins by transforming an image into a field of electrical signals. Each signal registers a finite measure of brightness and location. This process mirrors the first phase of human perception. But here the similarity ends. The computer never proceeds to the generalizing phase. Its immense processing capabilities enable it to digest the manifold bits of raw visual data comprised of absolute size, absolute shape, absolute color, and absolute location.

Emulating computer perception, Close has undertaken the seemingly impossible task of escaping the involuntary functions of the brain. In lieu of generalization, he aims for the incorporation of each discrete and quantified stimulus.

Close rejects drawing, the conventional way to begin a portrait, because drawings register the overall structure of the face. They simplify by

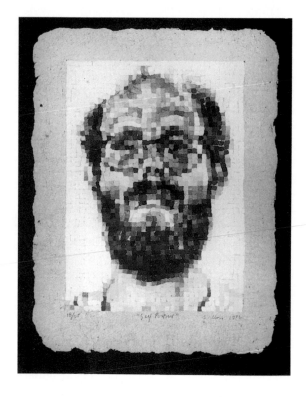

CHUCK CLOSE
Self-Portrait/
Manipulated, 1982
Handmade gray paper,
¹/₂-inch grid manipu-
lated and air dried,
edition of 25, 38 ¹/₂ x
28 ¹/₂ in.
Courtesy the artist
Photo: Courtesy Pace/
Wildenstein

concentrating on wholes instead of parts. In fact, drawn sketches organize an impression of a face in the same manner that brains do. Both identify such general qualities as slimness, straightness, and roundness. These generalizations compromise the exactness of a depiction.

Instead of drawing, Close summons the camera to furnish a mechanical record free of the distorting effects of human sight. Close's photographs emphasize documentation; they are flat, frontal, and explicit. Taken with the assistance of a professional photographer, they serve

as icons of truth for the next phase of his creative process, which involves transferring the image from the photograph to the canvas.

Close's goal is absolute verisimilitude. He begins by drawing a grid over the photograph of a face and then dividing his canvas into an equal number of squares. The size of the grids and the size of the canvases vary: small paintings are 36 by 30 inches; large ones are 108 by 84 inches. Close then proceeds from square to square across the canvas, methodically reproducing the visual configuration he observes in each comparable square on the photograph. *"I work very close and seldom step back as I'm not interested in the gestalt of the whole head but rather in getting involved in the process of translating parts into paint and blowing it up."*[2]

The grid has long been employed by painters as a means of faithfully enlarging a drawing. But for Close it dominates the entire painting process. His relationship with his subject, from inception to completion, entails itemized bits of visual information. This process nullifies the biological imperative of seeing in terms of generalities. It also enables him to bypass the creative, abstracting elements built into human sight and the tradition of painting.

"In order to come up with a mark-making technique which would make painting information stack up with photographic information, I tried to purge my work of as much of the baggage of traditional portrait painting as I could. To avoid a painterly brush stroke and surface, I use some pretty devious means . . . "[3] These means involve rigorously mimicking the photographic process. A black-and-white image is reproduced with black paint applied in varying densities. Close never uses white paint. White is supplied by the unpainted canvas, just as white in a black-and-white photograph derives from the paper. He substitutes a motorized airbrush for a manual paintbrush in order to produce a neutral, photographic surface. The application is so thin that only a couple of tablespoons of black paint are required to cover the surface of a 9-by-7-foot canvas.

In 1971 Close developed a method to reproduce a color photograph with the same inhuman accuracy. Cameras record color as fields of varying lengths of light waves. Light is translated onto

the photograph as mixtures of red, blue, and yellow. As they overlap in varying densities, they replicate the subject in full color. At Close's request, the lab separates each of his color photographs into three separate images. One registers the location and density of the red, one the blue, and one the yellow. Close then proceeds to replicate the process that occurs in the photogra-

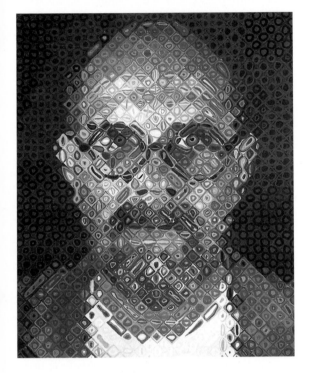

CHUCK CLOSE
Self-Portrait I, 1995
Oil on canvas,
72 x 60 in.

Courtesy the artist
Photo: Ellen Page Wilson,
Courtesy Pace/Wildenstein

pher's developing solution. First he reproduces the amount of blue in each square of the grid on his photograph. Next he repaints the entire surface, placing the red on top of the blue. Finally, he superimposes the yellow. The three primaries mix directly on the canvas. When these meaningless areas of color overlap, a remarkably accurate image emerges.

Close's loyalty to photography extends to his preferred means of representing the third dimension on a two-dimensional surface. Not surprisingly, he rejects the tradition derived from Renaissance painting, in which converging parallel lines are laid upon the scene to create the illusion of objects in space. That scheme accomplishes for space what outlining accomplishes for form; both register the overall organization of the image and therefore hinder the pursuit of accuracy. More radical is Close's rejection of the process of perception inscribed in his anatomy. He instead embraces the more fact-bound alternative inherent to the camera.

Spatial information is conveyed photographically through focal variations. The plane in focus establishes a ground. The progressive blurring of things in front of or behind this plane conveys their locations. When a photograph of a face is enlarged to monumental proportions, the blurring of the parts that lie behind the plane of the eyes (like the hair), and those that lie in front of it (like the nose), is as precisely calibrated as a map depicting the undulating topography of a mountain range. In comparison, the human eye focuses automatically on whatever is being examined. We cannot observe the blurred periphery. Viewing his model through the intervention of the camera's lens and the photograph's flatness allows Close to represent space in a manner that is mechanically determined and therefore objectively true.

Although Close creates paintings of the human face, he abandons the tradition of portraiture as a revelation of the sitter's character. *"It is useless to try and revive figurative art by pumping it full of outworn humanist notions. It seems to me that the figure can be used as a source of new information, but only if new devices and techniques are formed which will bring another focus on it through new ways of realizing form."*[4] Close successfully eliminates "outworn humanist notions" from his art and replaces them with the primary commodity of the Computer Age—information. The model supplies this information; the audience receives it; the artist generates it.

MODEL: Close strips faces of emotions and personality. Their identity is calculated according to two quantifiable visual qualities: the size of his paintings and the size of the grids. In mural-sized paintings with very small grids, the faces are so enlarged and so itemized that viewers standing a normal distance from them can't absorb their totality. They are perceived as abstract protrusions, orifices, and textures, not faces. In paintings in which the size of the

canvas is diminished and the size of the grid is increased, the bits of information occupying each square never congeal into a composite person. In a series of paintings of *Robert* (1974), for instance, Close varied the number of squares in his grids from 154 to 104,072. In both formats, the face is classified as visual data.

AUDIENCE: Viewers of a Chuck Close painting are confronted with a cluster of discrete bits of information, wreaking havoc with the normal process of perceiving in terms of generalities. Either canvases are too large to be perceived as totalities, or the lines of the grid are too apparent to unify the individual units into a perceptual whole. In the first instance, a complete field of vision is occupied by a single follicle, tear duct, or pore. In the second, the process of perceiving universals before particulars is reversed. Observers are required to abandon their inherited perceptual process and adopt digital decoding. Close is explicit about his intention of making the viewer acutely aware of these elements. *"It's what I call an 'invention of means' rather than an invention in the way (painting) is normally thought of. You're not inventing the shape, you're not inventing the color, you're not inventing the texture. All that is inherent in the original. What you're doing is inventing the means to reconstruct that, in its own terms."*[5]

"In order to come up with a mark-making technique which would make painting information stack up with photographic information, I tried to purge my work of as much of the baggage of traditional portrait painting as I could."

ARTIST: Close dispenses with the catalogue of traits often associated with the artistic temperament; he is not inspired, emotional, self-expressive, sensitive, creative. At the same time he seeks to eliminate the subjective import of habit, bias, mood, and memory. Like the computer, he processes tiny inputs, each defined according to quantifiable measures. His subjects' faces supply visual information, not human meaning. Like the computer, he is a disinterested accumulator of facts. *"Looking at the eye is one thing, and looking at the cheek another, but I have always tried to have the same attitude toward*

both of them—by breaking (the image) down this way, I can make the act of painting exactly the same all the way through . . . I was never happy inventing interesting shapes and interesting color combinations because all I could think of was how other people had done it . . . Now there is no invention at all; I simply accept the subject matter. I accept the situation . . . I'm not concerned with painting people or with making humanistic paintings."[6]

Not only does Close eliminate such signs of the human mind as judgment, soul, and emotion, he also removes signs of the human hand. The glacial smoothness of his paintings is produced by using an airbrush instead of a paintbrush. Even with one's nose to the surface, there is no visible evidence that this is the product of the human hand or that the mental effort required to produce it is the product of the human mind. Only in the dimension of speed does Close remain bound by his human capabilities. He is slow. Computers are fast. Two weeks are spent just applying the grid of pencil lines to a canvas. At times there has been a waiting list among his collectors, who reserve paintings that have not yet been created.

Some might wonder why Close persists in so tedious a process, particularly one that might seem replicable by computer. The artist's response provides crucial insights into his work. *"The way you choose to do something is as important as what you choose to do."*[7] In other words, it is his investment of human effort that directs attention to the computer/human interface, and to the fact that this interface is growing ever more entwined. Without comment, Close's art mirrors the many human functions that are being reduced to quantifiable data and fed into electronic networks where they are shuffled, sorted, and formed into statistics. At the same time, computers are encroaching on human territory. They are equipped to gather their own data from the environment. Supplied with photo-electric cells they see, with thermocouples they feel, with acoustical devices they hear. They remember what they learn. Some devise their own programs. Are they creative? conscious? intelligent? Will they win the chess game? Do they have free will?

Close has continually invented new means to divide human faces into fractions of data. In 1970 he transferred his activity to film and created "Slow Pan/Bob," a ten-minute scan in extreme close-up. The screen presents sequential details of Bob's face. In the mid-1980s, Close adopted an ironic alternative to the airbrush—his fingerprint; employing this ultimately personal impression, he dabbed black ink in varying densities to create the illusion of the planes and shadows of the human face. Pastels provided an antithetical approach to Close's original color scheme. He collected all possible colors of pastels from all the brands produced worldwide; then, instead of constructing colors out of three primaries, he chose from thousands of pastels. In another series he abandoned painting and exhibited photographs; a single work consisted of a grid of numerous photographs, each delivering a discrete unit of visual information.

An illness struck Close in 1988, leaving him partially paralyzed and confined to a wheelchair. Still, he has persisted in redefining the portrait's constituent elements. In recent works, information contained within each square of the grid is distributed in a playful manner so that it appears, simultaneously, as a tiny abstract painting and as a component of the total portrait. And, in an acclaimed exhibition for New York's Museum of Modern Art in 1991, Close assembled dozens of paintings and sculptures of human heads from the museum's collection and arranged them side-by-side on walls or shelves so that they approximated the nonhierarchical configuration of a grid. In this way, masterpieces of twentieth-century art replaced individual squares of painted marks.

In all of these instances, the three distinguishing aspects of Close's paintings were maintained. The creative process involved assembling masses of data. Visual components consisted of discrete data. Viewers scanned the scene, absorbing disconnected bits of information instead of an aggregate. How does Close judge his own effort? *"The paintings looked more like people than the photographs did. No matter what degree of likeness existed in the photograph, I always ended up putting more into the painting. Consciously, I was trying not to. I was trying to be very flat-flooted, and effect this translation, and not editorialize, and not crank anything up for greater effect. But unconsciously, I couldn't help do it."*[8]

CLOSE POSTSCRIPT:

Artists creating self-portraits today tend to revamp portraiture's traditional format (creating a physical likeness) and purpose (to expose the inner self). They have invented alternatives that may or may not present a visual impression of the face, express a mental state, or describe personal experiences. Chuck Close renders the face in excruciating detail, but his portraits are devoid of soulful or emotional content; they are accumulations of surface phenomena that resemble topographical maps. Gonzalez-Torres's involvement in intimacy cannot be satisfied by creating visual representations of faces; he probes beyond surfaces to locate personal events, secrets, and humbling life episodes that he conveys through words. On Kawara eliminates both the face and subjective disclosures, but his self-portrait is nonetheless personal; it tabulates and records two quantifiable aspects of his life—space and time. Sophie Calle eliminates her face, her voice, her attitudes, and her history, but still discloses her emotional state; her ennui is revealed through her dependence on projections from other people. Orlan brandishes her face, but this face is continually changing; it identifies her as a malleable substance in the process of being formed.

THREE SOME MEDIUMS

PAINT is a neutral agent waiting to be fashioned into expressive forms. It may record the passion and grace of an artistic act, but the material itself has no latent meaning. In contrast, fresh-picked cotton elicits the ordeal of slavery. Tar intensifies industrial themes. Caviar connotes luxury. Milk invokes purity. Raw meat is gruesome. Barbie dolls proclaim popular culture. Discarded tires dramatize the ecological crisis.

Many artists clarify the themes of their works by exploiting the associations elicited by substance. Perhaps artists are driven to gather unlikely materials because they recognize that art has lost its exclusivity as a source of invented images. It is not necessary to step into a museum to be exposed to pictures. Two-dimensional images are emitted from multiple, competing sources, conveying information and providing entertainment. The result is a cacophony of optical stimulation. Pictures are stamped on placemats, tissue boxes, billboards, napkins, T-shirts. They decorate packages selling CDs, toiletries, medicines, foods, housewares, tools, and myriad other consumer items. Technology has provided ever more sophisticated means to transmit them. Images are projected, xeroxed, photographed, faxed, digitized, and scanned. Film, video, and computers have contributed motion and tempo. High resolution television, fiber optics, CD-ROMs, and virtual reality have further accelerated their proliferation. Other burgeoning forms of transmission are digital, infrared, ultrasonic, thermal, sonar, and stroboscopic. Each waking hour, visual messages race into our field of vision. Most are rebuffed because they exceed the capacity of our bodies' sensory apparatus to absorb and process them.

Nontraditional art materials resuscitate images and arouse optically exhausted viewers. This chapter explores a few examples of the alternatives employed by artists who proclaim all the world of matter eligible for art-making. The multiple physical substances they embrace not only contribute color, shape, and texture, they also serve as potent agents of expression.

Medium replenishes the power and immediacy of art in an age of unprecedented image proliferation. For the artist it offers an exhilarating frontier of artistic exploration. For the art observer, exploring medium offers a key to unlock the enigma of many contemporary works of art.

~ristian Boltanski

20

)SSIBLE to deliver an inspira-
essage using gutter slang, or
roduce uplifting art by using

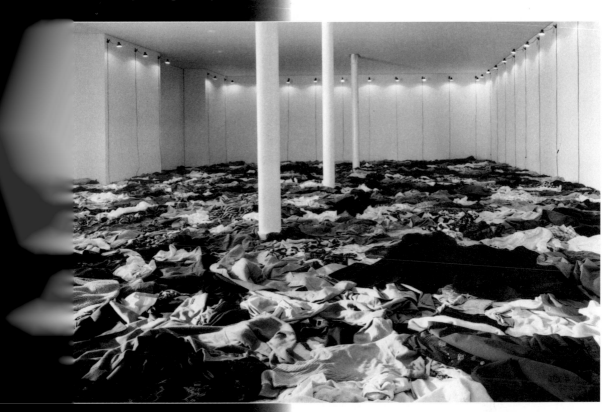

Réserve (Reserve), 1989. Installed at the Museum für
Gegenwartskunst, Detective Magazine

Courtesy Marian Goodman Gallery, New York

naterials? Christian Boltanski
1,000 pounds of soiled, foul-
ing clothing onto a museum
ssigned it a title, and pro-
t a work of art. His inten-
not related to a rummage
e. It was to create a visual
The artist explains, *"Even*
am in the art world, I try to
things to people, important
s that can change or at least
lify people, like a preacher."

RUMMAGE

Christian Boltanski

Born 1944, Paris, France
Home-educated after age eleven
Lives in Malakoff, France

CHRISTIAN BOLTANSKI
Monument Odessa, 1991
Photographs, lights, tin boxes, wire, 118 x 48 x 9 in.
Courtesy Marian Goodman Gallery, New York

THE FOLLOWING anecdote helps explain why an artist might select a debased medium to convey an exalted mission. Christian Boltanski was present at a special screening of a film by director Roman Polanski. Afterward, several members of the audience became confused by the similarities between the names Boltanski and Polanski. Mistakenly, they congratulated the artist for directing such a beautiful film. Boltanski made no attempt to correct them. His reaction reveals a conviction that helps explain the mystifying inversion of material and spiritual value that pervades his work. *"The function of the artist is not to transmit news or information, but rather to ask questions, postulate problems, or posit situations."*[1] Boltanski felt no compunction to correct the factual error because, to him, understanding is less a matter of gathering facts than intimations.

On first encounter, Boltanski's work may appear more intimidating than intimating. *Reserve* (1989), for instance, consists of a half ton of used clothes. The clothing is not artfully arranged into compositions of color and form. It is heaped in disarray and strewn about the entire floor of the gallery. Standard barriers between the viewer and art are abolished. Physical immersion in a 360-degree surround of textures and smells replaces

observation of a static work of art from a respectful distance. Pedestals, stanchions, frames, and wall labels are eliminated, as is the taboo against touching. In fact, visitors to this exhibition not only touch the work of art, they step all over it. Navigating through the gallery requires walking on top of the clothes and disturbing their arrangement.

Material transformation is not the essence of a work of art made of worthless items carelessly presented. Boltanski enlists two nonmaterial alternatives: the artist's intention, and the audience's acceptance of the experience as an art experience. Once these conditions are met, old clothes dumped in a museum relinquish their identity as banal objects. They become metaphors, bearers of significant meaning.

Situating people within and upon a sea of clothing initiates the process of communicating through intimations, not facts. Viewers cannot remain disengaged. Physical contact with the clothing stimulates all their bodily senses—sight, smell, touch. These, in turn, converge to arouse less tangible responses—memories and emotions. The search for meaning is kindled by these sensations. It provokes an internal dialogue:

Who wore these clothes?
The clothing is small. It must have been worn by children.

What kind of children?
The garments are of cheap materials and show signs of long use. They must have belonged to poor children.

Where?
The style of the clothing is European.

When?
The clothes are typical of those worn in the 1940s. Their intense, stale odor makes palpable the passing of decades.

The clothing fills the gallery from wall to wall. It lies in a massive heap, motionless, silent, eerie, deathlike. In this form, this quantity, and this disarray, it evokes the ghostly presence of thousands of dead youngsters, or the terrible jumble of a mass grave. Who are these missing children? The clues suggest they are among the ill-fated who were sent to the death camps during World War II.

Visitors to *Reserve* have variously described the experience as "sinking into the clothing"; "being forced to walk on bodies"; feeling like they were "brutalizing helpless victims"; like "murdering." Boltanski chose decaying material whose form is forever being altered to erect a monument to lost children. Its enduring aspect is

"I want to make people cry . . . That is exactly what I would hope for."

not its material form, but the sorrow etched in the hearts of its visitors. This affect is startlingly different from the one anticipated by the Nazis, who undertook a similar project. During the occupation of Czechoslovakia, they collected the possessions of deported Jews for the purpose of creating a museum of an extinct race.

The single word that Boltanski chose for the title has multiple synonyms, each elucidating a facet of the work's message. "Reserve" as a verb means both to engage (a memory) and to conserve (feelings associated with this historic event). As a noun, "reserve" refers to a stockpile (evidence of an atrocity within the context of this artwork) and to emotional detachment (from war crimes).

Reserve (Pourim) (1989) shares the poignant historic references of *Reserve* although it is remarkably dissimilar in form. Instead of the sea of clothing, many black-and-white photographs conjure the ghostly presence of anonymous people, often children, from the World War II period. Boltanski has been rephotographing images of Jewish children since 1971. He intentionally blurs them to contribute a patina as evocative of dark memories as are the musty smells of old clothing. Both constitute a haunting afterimage of an entire population. Sometimes his collection mixes the faces of those who were doomed with those who became their persecutors. In each case, the images are destabilized and invested with intimations of times passed.

Typically Boltanski hangs the photographs on a wall in close proximity to each other. They are interspersed with numerous old-fashioned biscuit tins, the kind that were popular in the 1940s. Children often used them for storing secret treasures after the biscuits were eaten.

Small lamps installed among these tins and photographs comprise a third sculptural element. In the eerie light these components renounce their banal identities and become a shrine to a

"An artist plays with life and no longer lives it."

lost generation. The lamps cast a glow of other-worldly radiance. Each child's face seems as exalted as an icon. Each biscuit tin becomes a reliquary. Each victim, a saint.

Here too the title contributes to the metaphoric meaning of its medium. It refers to the Jewish holiday of Purim. Purim was originally the New Year festival of the Babylonians. It marked the day on which the fate of each individual, for good or ill, was determined in a celestial lottery conducted by the gods. The Babylonian word for "lot" was "pur" (plural purim). Purim was the "Feast of Lots."

The Biblical account of Purim reverses this narrative. Instead of the gods deciding the fate of human beings, it was Haman, the favorite minister to the Persian king, who determined the fate of the Jews. He cast lots to divine what day would be most propitious for exterminating all the Jews in the empire, from India to Ethiopia. The plot was foiled by Queen Esther, who urged the Jews to take up arms, defend themselves, and rout their enemies.

For twenty-two centuries, the hateful image of Haman has been summoned as the embodiment of the criminally obsessed anti-Semite. Adolph Hitler is often referred to as Haman's cohort in genocidal mania and diabolical scheming. In fact, Haman's pronouncements have an uncanny resemblance to the Nazi leader's: "There is a certain people scattered abroad and dispersed among the peoples in all the provinces of thy kingdom; and their laws are diverse from those of every people, neither keep they the king's laws; therefore, it profiteth not the king to suffer them. If it please the king, let it be written that they be destroyed" (Esther 3.8-9).

The Holocaust is a crime many would prefer to forget. These tins and photographs, like the clothes, propel this repressed and fading memory into the palpable present. They are too real to be dismissed. At the same time, Boltanski's

title signifies the regrettable continuation of victimization and persecution that originated in Biblical days. Connecting events that occurred in the 1930s and 1940s with events that transpired around 150 B.C. is a reminder of the Jewish people's affliction and their God-given destiny. The children whose faces appear here were victims of a terrible crime that conforms to a lamentable tradition.

Boltanski is Jewish. He was born in Paris on August 25, 1944, the very day the city was liber-

CHRISTIAN BOLTANSKI
Reserve (Pourim), 1989
Black-and-white photographs, metal box, electric light and wire, 95 1/4 x 54 1/2 x 18 1/4 in.
Courtesy Marian Goodman Gallery, New York

ated from the Nazis. On this day his father emerged from the basement that had been his hiding place, despite his conversion to Catholicism, throughout the four-year occupation. Boltanski's father celebrated the occasion by giving his infant son a middle name, Liberté, to fuse this historic moment with his child's identity.

The perspective of Boltanski's Jewish origins is revealed in his resolute concern for history and his longing for the refuge of a Holy Land. *"There is a whole Jewish mythology around the idea that there was a marvelous world, the Holy Land, Jerusalem, which was lost and to which we hope to return . . . My work is bound to a certain world that is bordered by the White Sea and the Black Sea, a mythic world that doesn't exist and I never knew."*[2] At the same time, his work reenacts Catholicism's preoccupations. *"I had a Christian upbringing, there are many things in my thinking that are bound up with Christianity. The idea of guilt, for instance, weighs very heavily in my work, and the idea of the corruption of the body, which is bound up with Jansenism, the almost physical rot of the body."*[3] Thus, while reenacting the collective memory of the Jewish people, Boltanski assumes the shame of unspeakable Christian crimes. His work is a plea for grace. It applies to victims and aggressors.

Odessa Monument (1990) is another fragile installation of photographs, tins, and lights. Instead of hiding the electrical wires, Boltanski exploits the expressive potential of long, black cables that form an ominous, spidery web across the field of faces. The piece earned the title "monument" because it keeps a memory alive. Only the forgotten actually die. *"I want to make people cry . . . That is exactly what I would hope for . . . I want to elicit emotion. This is difficult to say; it sounds ridiculous, unfashionable, but I am for an art that is sentimental."*

In 1994 Boltanski rephotographed images taken in 1938 at a Jewish School in Berlin. They became the basis for three installations. One group of photographs was illuminated from behind a shroud made of bed sheets. A second group fluttered in a breeze created by a ceiling fan. Still others were covered with a transparent black mantle. Each group impels viewers to encounter staring children from half a century ago. No longer the subject of detached statistical narratives or of the factual accounts recorded in history books, their passing is mourned anew.

Why did Boltanski use old clothing, snapshots, and biscuit tins as his medium instead of paint on canvas? The artist suggests an answer: *"to avoid the vagaries of the brush stroke."*[4]

CHRISTIAN BOLTANSKI
Jewish School of Grosse Hamburgerstrasse in Berlin in 1938, 1994
Sheet, photograph, fluorescent lamp, nails, 77 x 30 x 2³/₄ in.
Courtesy Marian Goodman Gallery, New York
Photo: Tom Powel

These objects cannot be dismissed as a fiction or a fabrication. Old clothing and old photographs are ghostly records of missing people. They are literally imprinted with the forms of the victims. Clothing and biscuit tins are both containers. One actually enclosed people's bodies. The other held their treasures. Both are empty now. Art created out of artifacts resonates with a palpable truth.

Despite its specific autobiographic and historic roots, Boltanski ascribes broader historic

meaning to his work. *"My work is really not about the Holocaust, it's about death in general, about all of our deaths."*[5] In May 1995, the artist spread his melancholy message all across Manhattan. The project, called *Lost: New York Projects*, dealt with the literal and abstract aspects of loss. In the Church of the Intercession in Harlem, for just two dollars, people went home with brown bags filled with clothing they had selected from his heaps. At Grand Central Terminal, he displayed 5,000 personal items lost by commuters. The New York Historical Society participated by exhibiting all the belongings of an anonymous New Yorker. Finally, the Eldridge Street Synagogue on the Lower East Side presented interviews with Jewish youngsters chronicling "what they remember," thus connecting the living with the dead. In each case these losses cease to be abstractions, and the audience ceases to be indifferent to them. These material inventories, like photographs, are imprinted with real people's lives. Boltanski guards the flame symbolizing those who are now lost, or dead, or missing. Remembering is the only way to assure their immortality.

Boltanski's artistic mission was first undertaken when he was contemplating suicide. *"One of the first things that I did as an artist was to send a hand-written letter to fifteen people I didn't know. It was a suicide letter from someone who was very unhappy, half-crazy, and going to kill himself. I was very unhappy at the time and I think that if I hadn't been an artist, if I had written only one letter, I probably would have killed myself. But since I was an artist, I wrote fifteen. I played with death, with the idea of suicide. I displaced it from personal to collective terms. I was no longer unhappy, I represented unhappiness. When you represent, you no longer live."*[6]

The artist's personal depression became art, and since art is not reality but a representation of reality, he became progressively more distanced from himself—first from his emotions and then from his biography. The preceding description of his near-suicide provides a poignant example. In it, Boltanski says he wrote fifteen letters. But he has told some interviewers that he wrote thirty, and others that he wrote sixty. The facts of his life do not matter, confirming his belief that *"an artist plays with life and no longer lives it."*[7]

Dissolving the chronicle of his personal life makes his work relevant to all people. As a generic being, unencumbered by his own experience, he becomes a universal force guiding the transformation of cynicism into sympathy. *"There is nothing left of me. I am nothing more than what others hope for, I am their desire. I died a long time ago . . . I think that I became an artist so that I would no longer have to live. That is a very Christian idea, to give yourself entirely to others, that you are nothing but their image."*[8] In symbolically dying, Boltanski consecrates life.

BOLTANSKI POSTSCRIPT:

Scale is a powerful propellent of meaning in art. Yet works that cluster at a single end of the spectrum can exhibit remarkably divergent meanings. Christian Boltanski equates bigness with horror. He assembles enormous quantities of discarded clothing and old photographs to escalate the implications of horror: from murder, to serial killing, to genocide. The magnitude of his sculptures matches the inhumanity they describe. In contrast, Laurie Simmons's photographic enlargements of miniature dolls transform them from innocuous playthings into troublesome symbols of media-conditioning. The bigness of Janine Antoni's *Gnaw* describes obsession, a psychological affliction that only exists as an oversized phenomenon. Bigness means grandeur for Jeff Koons; it describes the scale of his ego, his aspirations, and his ambitions.

Andres Serrano

ANDRES SERRANO creates radiant, monumental photographs. But the controversy surrounding his work is more closely allied with the medium of his subject than the medium of his process. The subject of Serrano's most famous photograph is a three-dimensional representation of Christ on the cross. But few would say that this Catholic artist is upholding the tradition of Christian art, for the crucifix was submerged in a dispute-provoking medium—urine.

Piss Christ, 1987. Cibachrome, silicone, plexiglas, and wood frame, edition of 4, 60 x 40 in.

Courtesy the artist and Paula Cooper, Inc., New York

URINE

Andres Serrano

Born 1950, New York
Brooklyn Museum Art School, New York
Lives in Brooklyn, New York

See colorplate 1, page 17

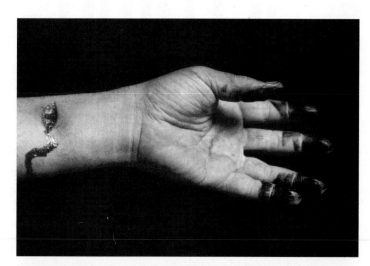

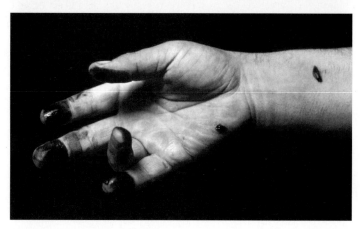

ANDRES SERRANO
The Morgue (Knifed To Death I), 1992
Diptych: Cibachrome, silicone, plexiglas,
and wood frame, edition of 3, 49 1/2 x 60 in.
Courtesy the artist and Paula Cooper, Inc., New York

The Morgue (Knifed To Death II), 1992
Diptych: Cibachrome, silicone, plexiglas,
and wood frame, edition of 3, 49 1/2 x 60 in.
Courtesy the artist and Paula Cooper, Inc., New York

ON 18 MAY 1989, Senator Alphonse D'Amato of New York stood before Congress and denounced a work of art by Andres Serrano, exclaiming, "This so-called piece of art is a deplorable, despicable display of vulgarity." Then, in front of the entire chamber, he tore up the catalogue for Serrano's exhibition. D'Amato's condemnation resonated through the halls of Congress and echoed over the airwaves. The public scandal that ensued was provoked by Serrano's color photograph of a statuette of the Savior on a cross. The photograph contains no offensive imagery. It is as radiant as a medieval mosaic. The furor was caused by the substance producing this resplendent light—the artist's own urine.

Government funding had supported Serrano's art project through the National Endowment for the Arts. His pairing of the sacred and the profane pitted upholders of freedom of expression against those who decry obscenity. The discord originated when a Mississippi-based right-wing Christian group called the American Family Association issued a complaint to Jesse Helms, a conservative senator. Indignant, Helms proposed prohibiting Endowment funding for any works that "advertise, endorse or create offensive or indecent objects." Helms concluded his pronouncement by bellowing, "I do not know Mr. Andres Serrano and I hope I never meet him because he is not an artist, he is a jerk . . . Let him be a jerk on his own time and with his own sources. Do not dishonor the Lord!"

Congressmen were deluged with mail from constituents whose ire was aroused although few had seen Serrano's work, and many had never previously contemplated the relationship

between art and moral rectitude. The maelstrom that ensued was fueled by three different factions. Monitors of taxpayers' money accused Serrano of squandering national funds. Supporters of family values condemned the artist as a demoralizing influence on society. Defenders of the First Amendment extended the guarantee of free speech to the artist.

This essay will not promote any of these crusades. Responses are individual affairs. It will, however, document Serrano's choice of this inflammatory medium and consider the role of urine as an expressive device in art. This exploration is initiated by seeking an answer to a fundamental question. Did the artist anticipate that his photograph would become a rallying cry for some and a heresy to others?

Published interviews with the artist suggest that his motivation was to reconcile his own conflicted feelings regarding the Catholic church and not, primarily, to arouse the public. *To this day, I am the artist but I'm the audience first, I do it for me. But I've realized that I don't simply work in a vacuum: the work does go out there to the real world and people will react to it, but at the time I was just concerned with photographing the ideas and images in my head.*[1]

What were these ideas and images? *To redefine and personalize my relationship with God.*[2] Did Serrano intend to tamper with issues of faith? *I've always understood the nature of conflict and duality, so I don't have a problem with the duality of images and the fact that they can blow hot and cold or be seductive and critical at the same time.*[3] Was he distressed by the uproar the work incited? *I've always felt that I wanted my work to be more or less open to interpretation and so even though some of the work has got people riled up, my attitude has always been I didn't mean to offend you but if I did, fuck it, I'm not going to apologize.*[4] Is it possible to reconcile adult desires with a Catholic upbringing and avoid provocation? *There's nothing wrong with provocative art work: I even look forward to the day when I can take pictures which will disturb even me.*[5]

Other evidence of the artist's intentions is derived from the work itself. The crucifix in the controversial photograph glows in a golden light analogous to the vision of heavenly splendor that suffuses over 500 years of religious paintings, from medieval times through the Renaissance. Ginger ale, honey, and many other mediums could have produced this effect without inciting scandal. Even after choosing urine, Serrano could have avoided accusations of sacrilege. Since the medium cannot be identified visually,

> *"The fluids, besides being symbolic of life's vital fluids, loaded with meaning—also give me beautiful light."*

he took a decisive step by announcing in the work's title his use of this stigmatized substance. Furthermore, he chose an emotionally charged slang word—piss—over the clinical designation, urine, and the euphemism, pee. To "be pissed" and to "be pissed upon" are vernacular phrases for anger and insult.

Viewers' responses to *Piss Christ* (1987) depend on whether or not they identify urine as a foul excretion of the mortal body. But urine is not always associated with bodily waste. To Serrano, it is a rich source of color and visual effect. The artist traces his use of this medium to his early involvement with abstractions, when actual liquids like blood and milk supplied the fields of color that he photographed. *Since the work is about abstraction, I was also amazed and pleased that the fluids had a life of their own and I had no control over the final image . . . Since I had been doing religious imagery before the fluids, I thought nothing of combining the two directions in my work in one image. This is called* Piss Christ *from 1987. People ask why I use fluids. First of all, I feel I'm painting with light, and the fluids, besides being symbolic of life's vital fluids, loaded with meaning—also give me beautiful light.*[6]

Serrano's accent on *"life's vital fluids"* and *"beautiful light"* demonstrates that he does not share our culturally inscribed disgust toward bodily waste. It is precisely this indoctrination that the work investigates. Urine tampers with two issues that fray the nerves of most people: squeamishness about their own bodies' fluids; and anxiety about bodily fluids as disease-transmitters, especially in the midst of the AIDS epidemic. Combining urine and the crucifix aggravates other sensitive issues: the role of the church in

producing stigmas against the normal functions of the healthy body; and the relationship between the carnal body and spiritual practice.

Piss Christ challenges the authority of the Roman Catholic Church to dictate individuals' attitudes about their own bodies. Yet Serrano continually reminds his accusers that he is a

ANDRES SERRANO
Nomads (Bertha), 1990
Cibachrome, silicone, plexiglas, and wood frame, edition of 4, 60 x 49 ½ in.

Courtesy the artist and Paula Cooper, Inc., New York

Catholic—one who is seeking a more personal Christianity—and not a heretic. Church policies, he complains, are *"at least indifferent to human need and at worst malicious and intolerant."* [7] As tempers flare around him, Serrano contemplates human desire and personal piety. He creates images that explore both. *"To me they're icons, I've never felt that I destroy icons, I just feel as if I'm developing new ones."* [8]

Piss Christ might have been called the "Yellow Christ," which happens to be the title of a painting that occupies an honored place in the history of Western art. It was created by Paul Gauguin in 1889, exactly a century before Serrano's undertaking.[9] This work anticipates Gauguin's renunciation of his European home, family, and occupation, and his impending departure for the remote South Sea islands. His escape from the confines of naturalism in art was made manifest when he painted Christ's flesh a brilliant yellow.

Serrano, like Gauguin, rejects the polite world of manners and decorum. He is an obsessive collector of the godly and the grotesque. He surrounds himself with bleached animal skulls, human brains, stuffed trophy heads, and bats suspended upside down in bell jars. But his apartment is also described as an ecclesiastic wonderland brimming with priestly vestments, a bishop's throne, church candelabra, stained glass, holy pictures, and crucifixes. *Piss Christ* exists at the intersection between these divergent symbols of faith. Serrano describes himself as a religious artist. *"Religion depends largely on symbols, and as an artist, my job is to explore the possibilities in deliberate manipulation of that symbolism."* [10]

Symbolism also describes Paul Gauguin's association with a group of nineteenth-century artists who pioneered new means of giving visible form to invisible realities. In *Yellow Christ* for instance, Gauguin explored unorthodox coloration to heighten the drama of the Crucifixion. Serrano seems to share Gauguin's motive, but rejects Gauguin's means. In the intervening century, the liberation of color has become so commonplace in both fine art and the everyday environment that color has lost its emotive potency. Serrano reinvigorates art by introducing a scandalous material to supply his colorant.

Both Gauguin and Serrano employ popular representations of Christ as the models for their works of art, but the contrast between the two is dramatic. Gauguin's rejection of European cultural norms led him to prefer the work of folk artists to those with academic training. The crucifix in his painting is modeled after a polychromed carving created by an anonymous French peasant. This simple form is imbued with heartfelt piety. Serrano's figure of Christ, on the other hand, is a tawdry, mass-produced statuette.

Its production was motivated by work-for-pay, not devotion.

The deterioration of religious sentiments represented by this factory-produced crucifix is one of the sensitive issues brandished by *Piss Christ*. In place of polemics, the work elicits reactions that are as varied as personal religious and political convictions. Six common interpretations are noted below. Serrano comments on some of them.

1. The presence of a disagreeable bodily fluid indicates that the artist intended to desanctify Christ. Serrano denies the accusation that *Piss Christ* is blasphemous: *"You can't have the sacred without the profane. I wouldn't be so obsessed with Christianity if I didn't have a feeling for it, and I find it strange when people call me an anti-Christian bigot. What is wrong is to make something that isn't beautiful."*[11]

2. The Bible relays that Christ was betrayed, demeaned, tormented. Today's lethargic populace no longer empathizes with His suffering. Serrano's symbolic reenactment of Christ's humiliation reawakens religious ardor and renews faith. Serrano confirms this interpretation. *"I think about the people who have a problem with* Piss Christ, *the photograph, and how they lose sight of what it symbolizes, the crucifix. Crucifixion is a very ugly and painful way to die, but we see the crucifix as a very aestheticized object which has lost its meaning. So I think about the people who have been upset by the photograph: how would they react to a real crucifix?"*[12]

3. Contemporary society defiles Christ's saintliness by marketing tawdry religious artifacts as surrogates for faith. *Piss Christ* defiles the figurine and not the figure represented. Thus the work purges religious practice of this kind of material sentimentality. It alerts the populace to the difference between true devotion and superficial expressions of faith offered for sale. *"My work addresses the public specifically on the roles of religion, worship, dreams, death, change, and spirit in our individual lives, as well as collectively in contemporary culture."*[13]

4. *Piss Christ* tests public tolerance and challenges the government's commitment to freedom of expression.

5. *Piss Christ* questions the sincerity of the

public's reverence for art, not religion. The objects Serrano submerges in unconventional liquids are often kitsch representations of the hallmarks of Western art—the Pietà, the Thinker, the Discus Thrower, the Winged Victory. His purpose may be to sensitize viewers to the debase-

ANDRES SERRANO
Klansman (Imperial Wizard), 1990
Cibachrome, silicone, plexiglas, and wood frame, edition of 4, 60 x 49 ½ in.
Courtesy the artist and Paula Cooper, Inc., New York

ment of art through plaster replicas, gaudy prints, night lights, car trinkets, advertising imagery, T-shirt designs, and lamp bases.

6. Whether it is viewed as offensive or inspirational, *Piss Christ* is a splendorous image. Even incensed viewers are likely to be seduced by its luxuriance. Its monumental scale (five feet in height), saturated color, and brilliant light are characteristic of Cibachromes, photographs printed in a process commonly used in advertis-

ing. *Piss Christ* may demonstrate that in order for artists to inspire religious feelings in contemporary audiences, images must display the flamboyance that derives specifically from glossy magazines.

Serrano's response to the *Piss Christ* controversy took the form of a work entitled *White Christ* (1989). It consists of a bust of Christ submerged in milk and water, symbols of purity, wholesomeness, and mother love. The work confirms the artist's search for a personal and consoling relationship with religion, rather than one based on institutions and dogma.

Anxiety-producing, unresolved, politically sensitive—these are the characteristics that unify the subjects of other series by Andrés Serrano. Violence and death are confronted in two series from 1992. In *Objects of Desire*, he focused his camera on guns. And in *The Morgue (Cause of Death)*, he created unflinching photographs of cadavers accompanied by labels identifying the causes of death: drowning, stabbing, asphyxiation, etc. Most viewers recoil from these stark confrontations with the grim face of death. Serrano, however, insists that his interest is not morbid and that the images are not gruesome. *"I took these pictures out of desire to find some humanity and love."* [14]

Humanity and love are equally incongruous when applied to the urban poor and the Ku Klux Klan, but these are the subjects of two other series. *Nomads* of 1990 consists of photographs of homeless men and women in the streets and subways of New York City late at night. Their strong, proud, and defiant faces contradict their desperate circumstances. Even the scale of the photographs (five feet by four feet) is heroic. *Klansmen*, also of 1990, is a series of portraits of members of the Ku Klux Klan. Merely choosing to interact with these white supremacists subjected the artist to criticism. But it also subjected him to danger. Serrano is half Afro-Cuban and half Honduran and therefore a likely target of bigotry. Still, he persuaded the Imperial Wizard to don his hooded regalia and pose for him. What was Serrano's motivation? *"Being who I am, racially and culturally, it was a challenge for me to work with the Klan, as much for me as for them, that's why I did it."* [15]

Throughout the photographic process, Klan members discovered that this candidate for their contempt was intelligent and respectful, a likable person. For Serrano, art is a tool of reconciliation. *Nomads* brought viewers face-to-face with the anonymous bodies they ignore on the street. Both series provide occasions for Christian love, compassion, and forgiveness. The artist, so notorious for his presumed sacrilege, in fact asserts a very different agenda. *"For me, art is a moral and spiritual obligation that cuts across all manner of pretense and speaks directly to the soul."* [16]

SERRANO POSTSCRIPT:

The outcry instigated by the exhibition of Andres Serrano's photograph of a religious emblem submerged in urine qualified him to join an impressive roster of artists who have provoked censure and debate. It includes Gilbert and George, Carolee Schneemann, Janine Antoni, Orlan, Barbara Kruger, Jeff Koons, Mike Kelley, Vito Acconci, and Meyer Vaisman. Why do artists choose to irritate when they possess the means to delight? Why do they strip away comforting delusions and present the naked world in a harsh and uncompromising light? Artists working in an era of crisis seem to feel compelled to give tangible form to our predicaments. The clarity of their vision is both a measure of their integrity and a cause of provocation. Getting to the truth necessitates violating decorum, rules of propriety, and the expectation that art must please the senses. It irritates those who prefer being charmed, flattered, entertained — and deluded.

Carolee Schneemann

22

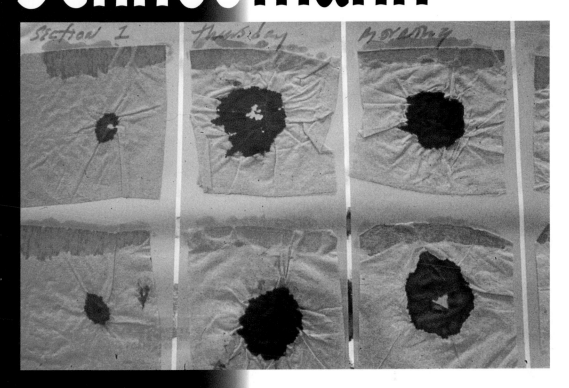

Blood Work Diary (detail), 1971. Blood on tissue with egg yolk

Courtesy the artist

CAROLEE SCHNEEMANN asserts the sensual, intellectual, and physical essence of experience from a woman's perspective. Her endeavor involves the undisguised presentation of female dreams, female body functions, and female genitalia. The stigmas that surround her work uncover the patriarchal credos that continue to influence the behavior of women as well as men. In particular, her use of menstrual blood as a medium of expression dramatizes deeply ingrained cultural taboos.

BLOOD

Carolee Schneemann

See colorplate 13, page 29

Born 1939, Fox Chase, Pennsylvania
Bard College, Annandale-on-Hudson, New York: BA
University of Illinois, Urbana: MFA
Columbia University, School of Painting and
 Sculpture, New York
The New School for Social Research, New York
La Universidad de Puebla, Puebla, Mexico
Lives in Manhattan and Springtown, New York

THE MALE MONOPOLY on Western culture has denied successive generations of women the opportunity to confirm their own physical and spiritual natures through art. In fine art, the female nude has been an object of aesthetic contemplation. In pornography, it is a source of voyeuristic stimulation. In both instances, women submit to the scrutiny of the male gaze and are represented exclusively by their surface appearance.

But for women, the body is a mosaic of sensations and functions, nerves and fluids, cycles and forces. Carolee Schneemann has interjected these womanly sensations into the tradition of the female nude in Western art. Her work originates in her body's urges and is created out of its functions. Through these actions Schneemann has, for the past three decades, campaigned for the reappraisal of gendered value, substituting feminine experience for masculine desire. Her depictions of carnal, mental, and mystical charges are the products of an interior contemplation, a woman's kind of research into a realm where the rhythms of creation and the seeds of life reside. *"It was in the body that the energy and the confirmation of what I'd seen and lived was coherent. That was an area that hadn't been colonized."*[1] Schneemann's perspective is from the inside out.

Blood Work Diary (1971) provides an example of this pursuit. At first glance, this work appears to consist of a series of delicate abstrac-

CAROLEE SCHNEEMANN
Blood Work Diary (installation),
1971. Blood on tissue with egg yolk
Courtesy the artist

tions created out of the neutral medium of paint. Their modest scale, deep tones, rich burnt sienna colors, and fragility easily lull viewers into a state of restful contemplation. Once the medium of these tiny paintings is identified, however, repose is abruptly transformed into astonishment. The colorations are blottings of menstrual blood on toilet paper.

Schneemann carefully calculates this sequence of responses into the work's conception. *"The piece does not hit people over the head with my own principles. I can make something taboo so formally compelling the taboo becomes an aftereffect. That makes it much more powerful."* She has described the process of creating *Blood Work Diary* as one in which time is as important a factor as the medium itself. *"The collection of blood took place over a seven-day period. The work is an investigation in process to see what were the changes, variations, the manifest visual imagery of the sequence of blottings . . . I started with small blots and then the density of the blood increases and diminishes. Finally, I'm left with a record of this painterly suffusion. Each blot is a moment in time. I decided to construct the blots to represent a diary in time. They manifest a visceral process. I wanted the blottings to be able to represent a mathematical idea of marking time, the interiority of time . . . My own body is a source of variation, of permutation, of trace. Instead of taking the paint from somewhere else, my body is giving me my own painterly material. What I get is a record of my interiority."*

She then explains the delicate problem of adhering the bloodstained toilet tissue to a backing for display purposes. *"The first thing that occurred to me was that I wanted to use something very elegant, as contrast to blood. I chose silvered paper as a support. Then, once I laid them out, the question was, how to attach them? I did not want to use glue because it is not implicitly connected to the process. Then it occurred to me that egg yolk was the correct adhering substance."* In the completed work, the adhering egg yolk is visually apparent on the tissues. It suggests the artist's focus on life forces, not bathroom refuse.

By arranging the stains on a grid, Schneemann accorded menstruation the formal pattern of a calendar. The biological sequence it records links contemporary women with their ancestors, who also marked their bodies' processes and passages. Schneemann terms this activity "time factoring." *"I related womb and vagina to primary knowledge, recorded as earliest history with strokes and cuts on bone and rock. By these marks, I believe, my ancestor measured her menstrual cycles, pregnancies, lunar observations, agricultural notations—the origins of time factoring of mathematical equivalences, of abstract relations."* *Blood Work Diary* revives an age-old custom. It derives from societies in which depicting female functions was not taboo.

Blood is not the first—or only—medium with which Schneemann has worked. She also creates art using paint, photography, drawing, performance, and video, all of which provide opportunities for materializing her visceral energy. Schneemann's decision in the 1970s to incorporate blood in her works of art arose from her progressive exploration of the relationship between the artist's body and the work produced. She pushes even paint, a medium she has been employing since the 1960s, beyond its conventional application, which relies on an alliance of eye, hand, and head. Schneemann channels it along a trajectory determined by her body's impulses. It is thrown, layered, blown, poured, rolled, splattered, dripped, spilled, and blotted, and then enriched with shattered glass, sawdust, crushed Dixie cups, tangled audiotapes, styrofoam packing, snarled wire, tailor's scraps, cotton puffs, kitty litter, kitty turds, newspapers, gauze, dust, ashes, raw pigments, mica, syrup, and ink. She has included even mechanized mops and broken umbrellas in her paintings, where their swaying and writhing movements are unsettling surrogates for seductive female bodies.

In the 1960s, Schneemann's repertoire of gestures and marks swelled as she engaged more and more of her body in the creative process. Manual dabbing and stroking expanded to include clawing and shredding the canvas. Film also enters her work at this time, not merely as a recorder of images, but as a substance susceptible to being marked by the artist's physical presence. Schneemann burns, scratches, and stains it. The resulting works echo her procedures. They are as palpitating, as ingesting and

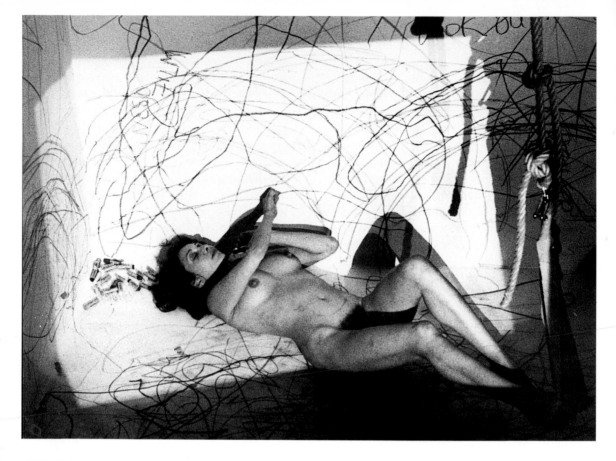

CAROLEE
SCHNEEMANN
*Up To and Including
Her Limits*, 1976
Trance drawing, crayon
on paper, 8 x 6 ft.
Courtesy the artist
Photo: Mary Harding

discharging, as complex and as muscular, as the body itself. The words she uses to describe womanly experience— *"personal, intuitive, volcanic, messy, bloody, eruptions, visceral, blatant"*[2]—also describe her art.

By the 1970s, Schneemann's excursion with her body led her to insert her own image into her art. *"As I hacked at the excluding vital surfaces of Abstract Expressionism, my entire body ripped through the canvas to emerge on the other side in actual time and space as an active and activating form."* At first she substituted her body for the canvas, making it the living recipient of her painterly impulses. Then Schneemann substituted material from her body for the paint: she utilized her menstrual blood as medium.

Although Schneemann's exploration into womanhood has been directed at her own corporeal nature, her work is neither a denial of the intellect nor a condemnation of masculine values. She seeks mergers, not hostile takeovers. Wisdom emerges from physical as well as intellectual sources: *"The body is integrated to conceptual processes."* It is not necessary to destroy the present in order to improve the future: *"(Society) remains within Western traditions but addresses suppressed content."* Abstract theorizing and experience are partners, not competitors: *"Conceptual processes (are) enriched by lived processes."*[3]

Furthermore, Schneemann's body explorations are neither narcissistic nor even self-expressive. She summons aspects of being that have been stifled for far longer than her own lifetime, preceding the time in history when men assumed ruling positions in society. Since then, she states, *"we have endured 3,000 years of complete distortions against what women know and experience."*[4]

An uncanny series of chance occurrences supplies evidence of correspondences between the content of Schneemann's dreams and

ancient artifacts connected with goddess worship. The imagery of her subconscious seems linked to primeval cultures and confirms their validity. In these societies women, not men, provided the symbols of power and resplendence. Schneemann reintroduces their forms and images into the tradition of Western art. She identifies them as representing *"the source of sacred knowledge, ecstasy, birth passage, transformation."*

Schneemann also tunes in to the intimate functions of her anatomy. What she discovers there is the mathematic regularity of nature's cycles. Her chronicle of menstruation honors the way female bodies participate in the ebb and flow of nature's emissions. This interior wisdom reunites women with their alienated natures, in both spirit and flesh.

Schneemann presents menstrual blood as a substance of beauty. She is untouched by the squeamishness that the sight of blood routinely evokes in our society. She is also exempt from the common association of blood with violence. The visual delicacy of *Blood Work Diary* seems irreconcilable with a culture that speaks of "spilling blood," "blood revenge," "blood lust," "bad blood," "being bloodthirsty." Schneemann's work suggests that the association between blood and revulsion derives from masculine experience, where it evokes carnage and injury. To men, blood is a dreaded reminder of mortality. While blood thus alienates men from their bodies, it unites women with their bodies. Its flow signals harmony with nature's rhythms. As a symbol of life-giving functions, it affirms health and fertility. *Blood Work Diary* contrasts female experience with the blood-related taboos that classify menstruation as "a curse" and menstruating women as "impure."

Blood as a neglected symbol of feminine power appears in other works by Schneemann. *Meat Joy* (1964) was performed by Schneemann and a group of nearly naked men and women who—amidst carcasses of fish and chicken, chunks of raw meat, and sausages—writhed on top of each other, upon wet paint, transparent plastic, and rope brushes. As if engaged in a Neolithic fertility rite, they smeared themselves with animal blood in an ecstatic celebration of flesh. A page in Schneemann's book, *Parts of a*

Body House Book (1972), instructed her lover to use the vagina as a paint box. *Interior Scroll* (1975 and 1977) was a performance in which the artist read a feminist diatribe against male filmmakers; the text was written on a scroll that she gradually pulled, stained with menstrual

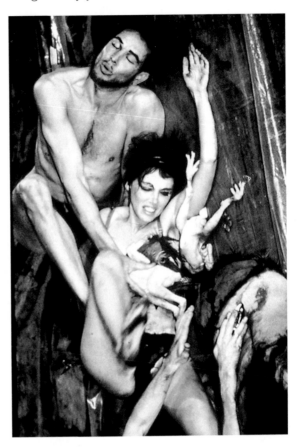

CAROLEE
SCHNEEMANN
Meat Joy, 1964
Performance
Courtesy the artist

blood, from her vagina. *Fresh Blood—A Dream Morphology* (1981-86) was a performance and installation inspired by a dream that contrasts male and female associations with blood. *Venus Vectors* (1988) is a sculpture consisting of ten eight-by-ten-foot acrylic panels radiating from a central point like a star. In it, statements like *"The power of blood made overt has the risk of social censure"* are played on continuously running tapes. *Hand/Heart for Ana Mendieta* (1986), an homage to that renowned artist, is a triptych in which two paintings bracket a chromoprint of Schneemann "painting" by pouring blood, syrup, and ashes onto fresh-fallen snow. Mendieta shared

Schneemann's commitment to releasing the female body from male attitudes.

Most images of women in Western media, education, and religion depict the female body as bloodless and sanitized, while most of our socially accepted symbols of power are phallic. Since the 1960s, Schneemann has consistently challenged these taboos against feminine alternatives to the masculine bias imbedded in both the norms of art history and popular culture. Her transgressions have earned her a respected position within the history of twentieth-century vanguard art, but she has simultaneously been penalized with denunciations and censorship from non-art audiences. Emancipating herself from male-centered subject matter, media standards of excellence, and permissible areas of sensuality has been costly. Even works created twenty years ago continue to provoke scandal. Schneemann has been denied shows, publicity, and grants because her work is considered too controversial. Her pieces have been removed from exhibitions by United States Information Agency authorities, the fire department, the police, and museum trustees. Evidently, her effort to reconcile the discrepancy between learned attitudes and felt sensations bares deep-seated taboos. It is ironic that her continual assertion of the body's innocence should provoke such hostility in a culture in which demeaning representations of the female form are rampant. *"My sexuality was idealized, fetishized, but the organic experience of my own body was referred to as defiling, stinking, contaminating."*

Schneemann's four-decade effort to reclaim her sexuality, her thoughts, and her dreams from zones of masculine influence has transpired within divergent social climates. During the 1960s and 1970s, it coincided with a broad-based spirit of protest against the status quo. The era engendered woman's caucuses, civil rights riots, student protests, and gay liberation rallies. The 1980s brought a more repressive atmosphere in which issues of abortion, censorship, and AIDs associated the body, both male and female, with issues of morality, illness, and death. In the 1990s, female perspectives in news reporting, lawmaking, and business practices may signal more balanced gender depictions. Schneemann is anticipating the day when *"the simplicity and the vital integral character of (women's sexual) organs can be seen the way fruit is or sea shells, or the cup or the keys. The body is innocent and these objects are innocent."*

Although she prefigured the sexual assertiveness that characterized the burgeoning feminist movement, Schneemann has never been a member of any particular feminist group. She avoids appearing programmatic or confrontational and offers, instead, a means of *"healing and mending and bringing forth the denied and lost meanings that are essential for vision and spirit."* Just as she unites current and ancient forms of art, she integrates qualities of mind with those of body, and qualities of men with those of women.

SCHNEEMANN POSTSCRIPT:

Frequently, species of artistic expression are altered by cross-pollinations. Both Carolee Schneemann and David Salle contribute to this process of hybridization by reaching across the divide that separates abstract art from representational art. This process both enriches their art and confuses art historians. Schneemann's *Blood Work Diary*, for instance, introduces elements of representational art into the tradition of abstract art; her medium, menstrual blood, is laden with social taboos and gender experiences and therefore relays a specific narrative. On the other hand, Salle contributes elements of abstraction to the legacy of representational art by equating trivia and treasures; in this way he neutralizes the content of the objects depicted and curtails their ability to erect a narrative.

ENCE between computers
space has been compared
erence between riding in a
tomed boat and snorkling.
ngers observe sealife while
ing strapped in their seats;
plunge into the ocean. Like
g, art in cyberspace invites
abandon their moorings in

23 Toni Dove

TONI DOVE and MICHAEL MACKENZIE
Archeology of a Mother Tongue, 1993. Digital media
Courtesy the artists and Banff Centre for the Arts, Canada

miliar, tangible world. The
dives into an environment
ultisensory (not limited to
tidimensional (spatial and
l), and interactive (viewers
te in the creative
s). It is also pure
This new reality
out any material
counterpart.

TECHCYBERNOLOGY

DOVE/SOME MEDIUMS

171

Toni Dove

Born Queens, New York
Rhode Island School of Design, Providence: BFA
Lives in New York City

PRESS THE REWIND button on the history of Western art. You are likely to observe conventional art materials making their first appearance as innovations. Then witness how these innovations in turn supplanted earlier traditions that had once been innovations. Even the simple act of painting provides an example of this progression. Inserting paint into tubes was a nineteenth-century invention; it made paint portable and turned the entire world into an art studio. Oil paints had been introduced three hundred years earlier; painting with oils supplanted the fresco technique of applying colored plaster directly to the wall, releasing painting from its attachment to architecture. Even the paintbrush was once a new technological invention; it augmented the control and delicacy of the human hand.

Similar progressions have been instigated by the discovery of clay, glass, iron, bronze, steel, plastic, photography, and so forth. Most of these materials were introduced as solutions to practical problems. The aesthetic opportunities they afforded soon became apparent. Art history books abound with examples of venturesome artists who explored each generation's frontiers of material possibility. But no era's technological innovations seem as precipitous and as comprehensive as today's. The revolution wrought by computers is of such magnitude that in a flash Edison's synchronization of film and sound and Zworykin's

TONI DOVE
Short Term Memory Construct, 1993
Digital media
Courtesy the artist and Banff Centre for the Arts, Canada

television become as outdated as Gutenberg's printing press and Marconi's radio. This is because printing, radio, television, and film all function in only one direction, from active sender to passive receiver. They were rendered passé the instant technology became interactive.

Societal chromosomes are scurrying to rearrange themselves according to this post-industrial order. New breeds have emerged—with names like "borgs," "cyberdelics," "technopagans," and "cyberhippies"—that are crosses between the organic and the technological. Muscles and dexterity are irrelevant to their functions. Their collaborations entail mind and machine. They thrive on information and dialogues with natural and artificial forms of intelligence. These new crossbreeds are plugged into global networks that dissolve time and national boundaries and collapse space. They are capable of intercepting data that streak by at transistor and microchip speeds. The ranks of these cyborg-like creatures are swelling by the hour. They include everyone who has gone "on-line," who receives E-mail, who joins news groups, who engages in video conferencing, who uses cellular phones, or who shops over interactive television networks.

But the use of technology is hardly confined to accessing information and conducting work. Post-industrial societies engage the computer in leisure-time activities too. Video arcades, computer games, and simulations are designed for fun. Computers are even being summoned to contribute to the spiritual well-being of the populace. Technopagans regard the computer as a vehicle to commune with God. Rave parlors produce electronically instigated euphoria, and commercial producers of "gray-matter tune-ups" market digital programming devices, headsets, and optical apparatuses that alter brain wave frequency and produce new states of consciousness. The term "joystick" indicates that the new technology does not function only as a task facilitator. It abounds as well with aesthetic, emotional, and spiritual opportunities.

Each entry in the following inventory of technology's effects has a corollary in art. As a result, manifold new aesthetic and emotive devices have recently been annexed to artists' expressive repertoires.

MEDIUM: Computer technology has revolutionized the means by which tasks are conducted. Artists can engage the same high-velocity information networks that have transformed the way we work, study, publish, teach, play, and converse.

SUBJECT: Electronically sophisticated hardware not only precipitates revolutions in procedures. It also reconstitutes tastes, molds moralities, manipulates senses, and explodes parameters of time, space, and scale. Technology has generated a vast new corpus of subjects for artists to explore, from the new perceptions it arouses to the unprecedented experiences it impels.

AESTHETICS: Electronic technology explodes the parameters of the visual world. It culminates in a free-for-all for the imagination, offering artists a cornucopia of colors and a dizzying array of shapes, textures, patterns, and motions. Artists who enroll in its devices revel in unprecedented aesthetic thrills and adventures. Like intergalactic travelers, they relinquish the restraints of the physical universe and conjure a mental universe to replace it.

AUDIENCE: Audiences not only observe this world, they embody it. In fact, they not only embody it, they invent it. Devices for interacting with virtual worlds include head-mounted displays, computerized clothing, joysticks, gloves, and wands. These apparatuses are capable of sensing the wearer's gestures. Movement is converted into digital information, which is then relayed in the form of commands. These commands generate the participant's subsequent experiences. In this way the audience actually participates in the creative process.

This essay examines the work of one pioneer who has staked a claim on the advanced interactive computer systems in which human brains and artificial intelligence interface. Toni Dove is a member of the first generation of artists born into a digital environment and reared on PCs, VCRs, and MTV. Dove has graduated beyond such conventional technological gadgets as the preprogrammed computer. Although she engages in a variety of technologies, her production in virtual reality is the focus of this essay.

In *Archeology of a Mother Tongue* (1993), Toni Dove and her collaborator Michael Mackenzie

close the divide between user and used. This piece immerses its participants in conditions as remote from the daily environment as Earth is from Oz. They dive into a multidimensional environment created out of pure information. The objects in this cyberworld can be seen, heard, and touched. They offer a full complement of sensations although they are digital not tangible, virtual not actual. The work consists of a theater-sized rear-projection screen onto which

> **"I have created an environment of sound and projected animated images which usher you into a world of ecstasy, irony and perversity."**

interactive computer graphics are projected. Three-dimensional scrims are erected on either side of the screen for images from computer-programmed slide projectors. A succession of such images creates the impression of animated characters hovering in space. At the same time a powerful, quadrophonic soundtrack is played. The forty-minute work is like a multimedia theater presentation for a small number of observers. But there is one significant difference—the action is controlled by one participant who wears a "power glove" and holds a camera. By "touching" the projected objects, this participant triggers sound and makes the visuals stop and start and move. At the same time, the camera with a tracking device enables the participant to navigate throughout the fictional graphic environment. This person becomes the cinematographer, dictating the sequence, the tempo, and the perspective of the narrative.

The member of the audience who dons the power glove and becomes the co-creator of the work of art reaches out to grasp *"and in that act a willing, desiring being invents itself."* In this way the narrative constructed by Dove and Mackenzie is subjected to the infinitely varied responses of the participant, who experiences *"a wandering accretion in a three-dimensional cube, . . . a movie sprung free from the screen."*[1] In *Archeology*, the wearer of the glove moves through a dense labyrinth of towers, arches, vaults, bridges, and columns comprised of taut wires and naked scaffolding. This is a futuristic city from which, we are told, there is no escape. The architecture is strung like the nerves of a

psychopath. Eerie music spirals around, reinforcing the directionless confusion. The camera shifts back and forth, capturing the agitation of a traveler in an unfamiliar and hostile setting. It intercepts children dressed in corsets, hoop skirts, and bustles that are wire-framed like the architectural structures they inhabit. Their forms are obscured by the blinding, irradiated light they emit. Some appear to be running on air. As the participant maneuvers through the virtual space, the voice of a female coroner is heard describing chaos and panic. She recounts a dream about her adoption as a child from the city to which she has now returned. She remembers being naked and dirty and wanting to murder the authorities.

Dove's statement that *"I have created an environment of sound and projected animated images which usher you into a world of ecstasy, irony and perversity"*[2] enumerates three thematic categories explored in *Archeology:*

PERVERSITY: The city in *Archeology* is crumbling. Its disintegration seems perverse because it is not old. In fact, it doesn't yet exist. Viewers are archeological explorers of a site in which current ominous trends come to fruition in the future. The narrator reports that inflation is mounting, the gross national product is plummeting, and the deficit is spiraling. Trafficking in abandoned children, prostitution, and the black market are the only viable businesses that sustain the faltering economy. Off-shore waste treatment and disposal are in crisis. Few people live beyond the age of forty. Furthermore, warnings of contamination mark the imminent collapse of civilization:

> *"Pollution index is 102% toxicity."* Face mask is recommended.
> *"Ultra-violet index is 4-5."* Sunscreen is required.
> *"Heavy metal content of smog."* Breathing mask is critical.

This distressing report is suddenly interrupted. The screen goes blank. Voices are silenced. Is civilization doomed? Tension mounts. At last, red words flash on screen: *"EMERGENCY POWER ON."* The end has been averted, barely.

IRONY: The male voice in *Archeology* belongs to the pathologist. He describes an

"imaginary space where we can reach for our memories." But his recollections have become so vivid that they obliterate the present. *"The past has become like some alien predator. Memories have taken on life of their own . . . The mind is detonating remembrances."* He is forced to rely on *"a short-term memory storage program to access the present."*

ECSTACY: A whirling, vaporous, colorless vortex appears. The participant is sucked into its fulcrum and transported into the beyond.

Because virtual reality sensations are computer-generated, computer-sustained, and computer-accessed, they have no relationship to tangible matter. Dimensions are boundless. Velocities are limitless. Shapes are malleable. Attributes can be added or deleted at will. Those who enter cyberspace enter an ethereal domain that is naturally aligned with the characteristics of mystical experience. Virtual reality technology makes this immersion particularly compelling because the technology itself is invisible and because no training is required to use it. No screen circumscribes the image, and there are no levers to manipulate, gears to shift, or buttons to press. Dove is intent that her work neither *"interrupts [n]or breaks down the illusion of the world you have chosen to enter. The interface needs to be transparent."*[3] Cyberspace is a natural conduit through which the sublime can be accessed.

Technology, like paint and marble, is a neutral medium capable of conveying a wide range of themes. Some artists present it as a marvel, others as a calamity. The stunning imagery in *Archeology* confirms the power of the medium to enrich aesthetic experience and provide a route to metaphysical experience. But evidence of this expansion of human potential is only half of Dove's story. She also asserts that technology's awesome power can be summoned on behalf of subversion, abuse, and coercion to imperil the health of the planet and stifle the growth of the spirit.

Artists' use of advanced technology also presents dilemmas within the field of art. When museum visitors become cybernauts, when they are strapped into sensory input devices and allowed to navigate alien spaces on their own volition, many art conventions crumble. For instance, the artist relinquishes the monopoly on decision-making. Furthermore, pressing keys on an electronic synthesizer leaves no trace of the artist's physical presence. This method of registering images makes it as difficult to determine the work's authenticity as it is easy to plagiarize. Finally, sensations in the "virtual" world are created out of a matrix of data that has no tangible counterpart. Art that utilizes this technology is not rooted in the gravity-bound, three-dimensional world. It can be dismantled and stored as information. With a touch on the keyboard, it can be recreated and cloned. The potential for limitless originals disrupts normal measures for determining an artwork's value.

DOVE POSTSCRIPT:

Art is capable of incarnating a multiplicity of time zones. For instance, Marina Abramovic, Joseph Beuys, and Carolee Schneemann reawaken impulses that originated at the dawn of history. The expanded past inhabited by James Luna, Tomie Arai, and Amalia Mesa-Bains is shared with their ancestors. Sherrie Levine draws on artistic rather than tribal predecessors, referring to early twentieth-century modernist artists. Laurie Simmons and David Salle draw on their personal histories; thus their work commences in the 1950s. Haim Steinbach, Meyer Vaisman, and Jeff Koons manifest the present tense. Toni Dove projects the present into the anticipated future. On Kawara positions his life within the context of incomprehensible units of time—one million years past and one million years forward.

FOUR SOME PURPOSES

VISUAL BEAUTY, sensual enjoyment, emotional release, self-expression, and accurate representation are rarely the goals that motivate acclaimed artists at the end of the twentieth century. Apparently, conditions of life appear so grave and the need to discover solutions so urgent, that clogging channels of communication with poetic references or personal reflections has come to seem irresponsible. Artists have become dedicated social workers. They not only expose problems, they act upon them.

The artists included in this section desist from taking a circuitous course in which art reveals its purpose through intimation, allusion, and evocation. They strip art of such pretense and direct their efforts into territories that have not previously been included within the domain of Western art. Their constructions and activities engage in the operations of the environment, often innovating ways to accomplish the business of life. They have put art to work solving problems, conducting experiments, altering lives, and transmitting knowledge.

Joseph Beuys

24

JOSEPH BEUYS was an artist who organized political parties and ran for office. His political activities did not constitute a separate part of his life; they are his works of art. His career was dedicated to jettisoning the bulwark of oppressive values in order to clear the decks for a new social

order. The function of his art was to tip the ballast that keeps old ships of state afloat.

Save the Woods, 1973. Detail of photo offset, edition of 200, 19³/₈ x 19⁵/₈ in.

Courtesy Ronald Feldman Fine Arts Inc., New York
Photo: D. James Dee

POLITICAL REFORMATION

Joseph Beuys

Born 1921, Krefeld, Germany; died 1986, Düsseldorf
Kunstakademie, Düsseldorf

AN INVENTORY of artworks by Joseph Beuys includes profoundly evocative drawings, paintings, and sculptures, real political activities, and ritual-like performances called "actions." In an action enacted in 1965, Beuys smeared gold leaf and honey on his skin, cradled a dead hare in his arms, and then toured an art gallery explaining to the hare everything that was to be seen. He later explained, *"I think this hare can achieve more for the political development of the world than a human being. By that I mean that some of the elementary strength of animals should be added to the positivist thinking which is prevalent today. I would like to elevate the status of animals to that of humans."*[1] That humans are superior to animals was but one of the many assumptions dismantled by Beuys in his effort to redeem society. Another addressed the limits of art. Beuys expanded art's conventional definitions to incorporate the goals and the means of politics.

JOSEPH BEUYS
Creativity—Capital, 1983
Silkscreen and lithograph,
edition of 120, 11 x 27³/₄ in.
Courtesy Ronald Feldman Fine Arts
Inc., New York
Photo: D. James Dee

There are politicians who enter politics to prescribe the course of history, and those who enter to transfer power. Likewise, there are artists who create art to express their personal identities, and those who create art to address universal concerns. Joseph Beuys represents all four categories. As an agent of political change, he campaigned for the broad and equal distribution of wealth and influence. As a charismatic personality, he provided evidence of the creative potential of all humankind. Beuys led an international crusade on political thought and art practice from the 1960s until his death in 1986.

In writing the manifesto-like document, *Organization for Direct Democracy through Referendum (Free People's Initiative) June, 1971*, Beuys applied his artistic vision to political motives, discourse, and devices. This document, quoted in bolder italics, provides the framework for a discussion of Beuys's intricately integrated efforts.

"Only art is capable of dismantling the repressive effects of a senile social system that continues to totter along the deathline: to dismantle in order to build A SOCIAL ORGANISM AS A WORK OF ART." Joseph Beuys, a native of Germany, was disillusioned with the West's efforts to control the vagaries of nature—including human nature—and to establish a utopian world. Daily headlines confirm that we remain victims of drought, flood, disease, poverty, violence, crime, war, drudgery, and insecurity. Beuys identified two sources of these afflictions: one, the soullessness produced by the unchallenged dominion of materialistic goals; the other, the psychological disequilibrium caused by dependence on analytic thought.

In today's society, intuitive understanding and spiritual practice have tenuous relationships with science, education, and even religion. Beuys suggested that if it hadn't been for art, society would have completely squandered these life-affirming forces. He defined art as the warden of metaphysical awareness. It alone is capable of rescuing civilization.

"This most modern art discipline—Social Sculpture/Social Architecture—... will only reach fruition when every living person becomes a creator, a sculptor or architect of the social organism. Only then ... would democracy be fully realized." Art can only assure salvation if its functions are extended beyond its conventional role. Instead of representing life, art must actually fashion life. Beuys believed that artists are shapers. Anything that can be formed is eligible to enter their repertoire of sculptural mediums. In addition to using traditional materials (metal, clay, and stone), and untraditional mediums (animal fat, felt, tar, pianos, sleds, soap, and erasers), Beuys employed nonmaterial phenomena (sound, language, and gesture) in his art. These intangible mediums were molded and shaped into "social structures": systems of economics,

education, agriculture, manufacturing, and politics.

As art projects, Beuys formed such radical political organizations as the DSP (The German Student Party), founded in 1967; the Organization for Non-Voters and Free Referendum in 1970; the Organization of Direct Democracy Through Referendum in 1971; the AUD (Action Community of Independent Germans for the German Bundestag) in 1976; and the Free International University for Creativity and Interdisciplinary Research in 1973. These organizations provided the forms of his sculptures. World problems provided their themes. Thus Beuys integrated into art such grave and imposing problems as: the domination of advanced nations over Third World countries; nuclear energy and its alternatives; the control of world news by American corporations; urban decay; unemployment and the exploitation of workers; repression, violence, terrorism, and human rights abuses. And he advocated through his art the empowerment of communities for self-government; the establishment of a people's media network; and the development of alternatives to capitalism and socialism.

Beuys argued that in its concentration of authority, the pyramid structure of Western institutions of education, government, religion, and economics invited exploitation, repression, and abuse. He believed that society's ills could not be rectified as long as the disenfranchised majority accedes to the empowered minority. Democracy could only be protected if full powers of self-determination were restored to the populace.

But Beuys also recognized that guaranteeing consummate freedom would not enhance humanity unless people possessed imagination and the will to activate it. Along with breaking dependence on minority decision makers, it was necessary to break the dependence on rationality and objectivity. Beuys strove to resuscitate the creative powers of the average European, powers that had been neglected for centuries.

"Only a conception of art revolutionized to this degree can turn it into a politically productive force, coursing through each person and shaping history." At the same time that Beuys nurtured a utopian vision, he pursued the day-to-day operation of civil revolution. He strove

to arm each person with the force of his or her own reinvigorated creative resources. A meaningful transformation of the social order could only be achieved gradually, the "organic way." *"We could tell man that he has the power to determine his own life, to change the repressive*

systems, but in respect of freedom, man is at a loss and doesn't know what to do. He must be shown gradually how to make use of his freedom; he must understand that he is allowed to do this."[2]

"We must probe (theory of knowledge) . . . the origin of free individual productive potency (creativity)." Beuys often said that *"to be a teacher was his greatest work of art. The rest is the waste product, a demonstration."*[3] In 1961 he was appointed Professor of Sculpture at the Düsseldorf Academy of Art, but his official teaching career was abruptly terminated in 1968 when his radical approach to education precipitated his dismissal. The furor that ensued took the form of sit-ins and student strikes and had all the marks of the political unrest of the sixties and seventies. In 1973 Beuys founded an alternative institution named the Free International University for Creativity and Interdisciplinary Research. There, the dispensing of facts and rules was rejected, as was the cultivation of disciplined thought. *"I am not a teacher who tells his students only to think. I say act; do something: I ask for a result."*[4] Beuys entreated his students to proclaim independence not allegiance, to forge not follow.

The Free International University (FIU) expanded traditional academic boundaries. It urged the replacement of society's three destructive modes of operation (materialism, positivist philosophy, and mechanistic thought) with three untapped reservoirs of productivity (love, warmth, and freedom). In order to transmit this radical agenda to the widest possible audience, classrooms were supplemented with pirate radio stations, independent films, small printing presses, and open forums that were in permanent session and available to everyone. FIU programs also entered the actual arenas where agriculture, pollution control, nuclear disarmament, and educational reform were being conducted. Beuys ran unsuccessfully as a candidate for the Action Community of Independent Germans for the German Bundestag in 1976 and again for the European Parliament on the Green Party platform in 1979.

The FIU was modeled after an energy center. It was a generator of creative solutions, a conduit through which insights could flow, a battery for storing the powers of the human race, a tower to transmit ideas. There is little doubt, however, that Beuys's most effective tool was Beuys himself. After his dismissal from the Academy he became an itinerant lecturer/debater, appearing in hundreds of auditoriums and on countless street corners throughout Europe, Scandinavia, and the United States. Throngs gathered to hear him. One example of how these activities has entered the annals of contemporary art is a work entitled *100 Days* (1972). For one hundred days, Beuys managed an information bureau for the "Organization for Direct Democracy through Plebiscite" at Documenta, Germany's annual, international art fair. Here he conducted a marathon debate

with the public, whose latent creative powers were unleashed as they exchanged ideas with the artist.

In Beuys's ideal society, anyone who develops such creative facility earns the designation "artist." Thus, the concept of art can be applied to all forms of human endeavor: *"I advocate an aesthetic involvement from science, from economics, from politics, from religion—every sphere of human activity. Even the act of peeling a potato can be a work of art if it is a conscious act."*[5]

The diversity of his own activities exemplifies this proposition. Beuys classified as art any activity that broke through barriers isolating people from spiritual experience. As habits of thought represent the most stubborn barriers, he embraced public speaking to erode old-world thinking and to promote a new social vision. Beuys illustrated his lectures by sketching arrows, phrases, figures, diagrams, and charts on blackboards. Meticulously preserved as works of art, these boards are displayed in museums and purchased by collectors.

Another body of drawings is less obviously related to Beuys's political agenda. Honey, fruit juice, blood, fat, and clay frequently substitute for pencil and paint. Out of the blottings and bleedings of these natural substances, Beuys coaxed enigmatic human, animal, and plant forms. Their extraordinary mystery confirms the presence of a reality that is irrelevant to the rational processing of information. By releasing the viewer from dependence on intellectual systems, they too advance Beuys's political and instructive missions.

Beuys sought to demonstrate that becoming disengaged from rationality spurs the genesis of a new soul. And he identified trauma as a powerful, untapped source of *"free individual productive potency."* People typically fear trauma because it is accompanied by a loss of rationality and control. Beuys's art demonstrates its bene-

fits. He himself had experienced a transforming traumatic experience as a fighter pilot in the German air force during World War II. In the midst of a severe snowstorm his plane was shot down in a desolate region of the Crimea. Stranded and unconscious, Beuys lay helpless in the frigid wreckage and would certainly have died if a group of native Tatar tribesmen hadn't discov-

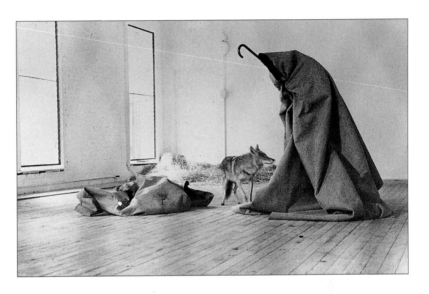

JOSEPH BEUYS
I Like America and America Likes Me, 1974
Duration 1 week

Courtesy Ronald Feldman Fine Arts Inc., New York
Photo: © 1974 Caroline Tisdall

ered him. They nursed him with their traditional folk remedies by wrapping him in animal fat and felt to help his body regenerate warmth. After eight days he was rescued by German search troops. Beuys had symbolically died. His recovery was like a resurrection. Abandoning the scientific studies he had pursued as a youth, he resumed his life as an artist.

Beuys's wounds and his recovery are referred to throughout his work as an allegory representing the maimed state of society and its ultimate rehabilitation. Injury, disease, darkness, and solitude are opportunities for rebirth. Moving from cold to warm charts the passage from the rigidity of rational thought to the flexibility of creative action.

"We then reach the threshold where the human being experiences himself primarily as a spiritual being, . . ." At the dawn of time, spirit

and intuition dictated the processes of agriculture, healing, government, and ethics. In the twentieth century these processes have been rationalized. Bureaucracy banishes intuition. Mass culture and consumerism ravage the imagination. Competition crushes the spirit. Beuys despaired that *"In our times, thinking has become so positivist that people only appreciate what can be controlled by reason, what can be used, what furthers your career. The need for questions that go beyond that has pretty much died out of our culture. That's why I feel it's necessary to present something more than mere objects. By doing that people may begin to understand man is not only a rational being."*[6]

In choosing materials for his sculpture, Beuys privileged those whose physical properties are metaphors for the spiritual potential of the human race. He utilized felt not only because it saved his life in the Crimea, but also because it challenges materialist habits (felt has negligible commercial or aesthetic value in bourgeois society) and because it fosters metaphysical growth (it absorbs and muffles the sensations of the physical environment, insulating against tangible experience). He used fat to demonstrate the principle of self-transformation because it never assumes a final shape: its form is fixed when cold but fluid, and therefore chaotic, when warm. Furthermore, when it burns, it produces energy. Its malleability manifests the human potential to move from rigid materiality to dynamic creativity. Its fetid smell and appearance repudiate the bourgeois fixation on cleanliness and order. Like felt, fat too had helped save Beuys's life.

Beuys also embraced foul chemical reactions—fermentations, oxidations, rot, and corrosion—as formative processes for his sculptures. In Beuys's credo, these naturally occurring processes represent constructive evolutionary development: transformation rather than rigidity or stasis.

In Beuys's inventory of materials, copper represents the culminating state of spirituality because it transports an electrical charge and produces warmth. It therefore epitomizes the human brain, with open pathways for receiving and transmitting ideas. Beuys applied these material metaphors for spiritual metamorphosis to psychology, government, economics, science,

religion, and every other human endeavor, especially pure thought.

". . . where his supreme achievements (work of art), his active thinking, his active will, and their higher forms, can be apprehended as sculptural generative means, corresponding to the exploded concepts of sculpture divided into its elements: indefinite—movement— definite, . . ." The "sculptural generative means" refers to an all-encompassing creativity that is neither limited to artists nor even to people. In Beuys's world view, all living creatures possess creative potential. Animals, for instance, can help people reactivate their repressed creativity. In a work entitled *I Like America and America Likes Me* (1974), Beuys communed with a representative of the animal realm. Entering a cage that had been fabricated in an art gallery, he remained confined with a wild coyote for an entire week.

I Like America took place in the René Block Gallery on West 57th Street in Manhattan, a street lined with luxury boutiques and sophisticated art galleries. Exemplifying the material affluence of Western civilization, this context served as the ideal backdrop for a work that pitted human reason against animal instinct, civilization against nature.

Beuys accentuated the antagonistic nature of human/animal duality by assuming the guise of a shepherd, the protector of domesticated animals. To shepherds, coyotes are predators. Beuys therefore roused the animal's aggressive behavior by jabbing him with his crook. The animal was further agitated by the periodic roar of a turbine engine—the deafening sound of human achievement—blasting from a tape recorder.

Beuys and the coyote survived their confinement. But it is less the outcome than the means of self-protection that is the key to this parable. The artist dispensed with civilization's usual devices for dealing with a beast (taming, isolating, or killing). He protected himself by adopting the coyote's behavior and the coyote's mode of communication. Each time the animal's snarling grew ferocious, Beuys fell to the ground, prone and vulnerable, and assumed the position of defeat used among animal adversaries. Not once was he attacked. The coyote displayed what in humans would be called moral consciousness,

although it is often lacking in farmers, hunters, and shepherds. *I Like America* dislodged preconceptions about the coyote as victim or aggressor. Realization of a new and different possibility brought each member of the audience a little closer to creative freedom.

"*. . . and are then recognized as flowing in the direction that is shaping the content of the world right through into the future.*" Like animals, trees can direct humanity toward a future "Sun State" in which instinct, ancient lore, mysticism, and union with nature are integrated. This message is conveyed in an artwork in which Beuys orchestrated the planting of 7,000 oaks. Oak trees are linked to the adjective "mighty." Like gods, these "creature trees" embody strength and the power of self-regeneration and here provide an inspiring model for human behavior. Seven thousand of them comprise an enduring proclamation of hope.

"*This is the concept of art that carries within itself the revolutionizing not only of the historic bourgeois concept of knowledge (materialism, positivism) but also of religious activity.*" Beuys is frequently compared to a shaman, a mender of souls. His activities were conducted in the intense, trance-like state of a religious rite. In his drawings, he even depicted himself as a shaman teaching truths he learned from trees, plants, and animals. These mystical reverberations invested Beuys's name with the aura of a sage or a prophet.

"*EVERY HUMAN BEING IS AN ARTIST who—from his state of freedom . . . —learns to determine the other positions in the TOTAL Artwork OF THE FUTURE SOCIAL ORDER. Self-determination and participation in the cultural sphere (freedom), in the structuring of laws (democracy); and in the sphere of economics (socialism). Self-administration and decentralization (three-fold structure) occurs: FREE DEMOCRATIC SOCIALISM.*" Beuys's platform describes a new social order. Capital is no longer determined by the accumulation of goods but by the sum of people's self-awareness. Value is measured according to their dignity, not wealth. Economic interests are determined by the balanced participation of all people. Laws and the constitution are realized by plebiscite. In a society that operates through cooperation among self-realized individuals, everyone earns the designation "artist," and all human efforts are works of art. When that time comes, the human race will be capable of infinite regeneration.

"*And thus—at all times and everywhere, in any conceivable internal and external circumstance, between all degrees of ability, in the work place, institutions, the street, work circles, research groups, schools—the master/pupil, transmitter/receiver, relationship oscillates . . .*

The ways of achieving this are manifold, corresponding to the varying gifts of individuals and groups. THE ORGANIZATION FOR DIRECT DEMOCRACY THROUGH REFERENDUM is one such group. It seeks to launch many similar work groups or information centers, and strives towards worldwide co-operation."

This brief summary of Beuys's revolutionary social plan would be deficient if it failed to mention that in 1974 Beuys founded the largest political party in the world. It epitomized his unique definition of worldwide cooperation. It was an artwork called *Political Party for Animals*. People were permitted to join, but only on the condition that they were willing to cooperate with all of the other members.

BEUYS POSTSCRIPT:

Joseph Beuys created art objects, but many believe his greatest artwork was his own persona. The themes, motifs, and morals of his art were contained in his face and body, his posture, his clothing, his words, and his deeds. Gilbert and George, Carolee Schneemann, Paul Thek, Vito Acconci, Jeff Koons, and James Luna are also charismatic individuals whose physical presences have entered the annals of art history along with the objects they produce.

Andrea Zittel

ANDREA ZITTEL was reared in Southern California in the midst of material plenty. After graduating from college, she was forced by financial constraints to live and work in a tiny

200-square-foot storefront studio. Being impoverished taught her a new kind of luxury—the luxury of being free of material possessions. Zittel stopped painting to develop a new form of art that extends this gratifying experience to others.

MENTAL COMPOSURE

A to Z 1993 Living Unit, 1993
Steel, wood, and objects, 60 x 40 x 30 in. (bed)
Courtesy Andrea Rosen Gallery, New York

Andrea Zittel

See colorplate 15, page 31

Born Escondido, California
San Diego State University, California: BFA
Rhode Island School of Design, Providence: MFA
Lives in Brooklyn, New York

STACKED ON THE SHELVES of the local supermarket are 156 varieties of coffee. Habit-forming jingles and celebrity testimonials pander to shoppers who must choose between slow roasts and instant crystals, wake-up brews and bedtime tonics, by-the-cup and by-the-pot packaging, familiar and exotic flavors, freeze-dried and fresh grounds, bargains and luxuries, drips and microwavables, filter packs and coffee bags. Most options are offered in a range of sizes and brands, all pledging the fullest satisfaction. Choosing one requires rejecting 155 possibilities, a demanding and inescapable enterprise for coffee-drinkers.

This superfluity of choices applies to painkillers (175 kinds), soda (269), cable channels (500 +), and countless forms of medical plans, investment options, magazine subscriptions, cable networks, and eyeglass frames. Options have even proliferated in careers, mates, and places of residence, all of which were once determined for the individual by family and custom. In all the ages of humankind, people have never encountered so many alternatives.

Some people revel in options, but many suffer from the stress associated with conducting the business of life amid such plenitude. Andrea Zittel's work offers salvation to those mall-shopping, Prozac-swallowing individuals whose nerves are frayed, whose sensory apparatuses are taxed, and whose mental operating systems are faltering on overload. It recognizes the ironic fact that the compulsion to accumulate material products derives from their ultimate failure to satisfy. New purchases invariably provoke disappointment. Their imperfections are perhaps intentional, since they lock consumers in a cycle of trading-up. In addressing this issue, Zittel asserts that *"we are so inundated with material weight that it finally loses its ability to anchor and satisfy."*[1]

Anyone who yearns for simplicity, stability, and tranquility is a potential collector of Zittel's work. But don't expect to purchase a painting

that depicts a state of mental composure. Her works of art are works of life. They actually restructure their owner's daily habits, breaking the cycle of unfulfilled desires and associated anxieties. These artworks release their owners from the discomfort of craving.

For perhaps the first time in history, there are masses of people for whom the stress from excess has replaced the anxiety of deprivation. In order to redress this contemporary psychological affliction, Andrea Zittel established an agency, A to Z Administrative Services. Its function is to re-erect the discipline that crumbles under the weight of excessive arousal. Toward this end it simplifies people's lives, assuming an agenda that is as broad as the areas of clutter and the sources of confusion in daily lives. A to Z Administrative Services designs systems for sleeping, dining, cooking, writing, sewing, dressing, reading, socializing, bathing, laundering, grooming, and so forth. It structures each of these activities for people too mentally exhausted to do the organizing themselves.

Zittel scrupulously designs each activity to eliminate indecision, redundancy, and waste. For example, *A to Z Clothing* is based on the concept of reduction and layering. It can be adapted to all weather and social situations. A brochure describing a complete wardrobe for a woman lists three items: one suit *"includes a jacket and either a skirt or pants"*; one jumper/smock *"that may be worn over other clothing both as a visual element and to provide function with pockets and holders"*; one jacket/utility coat, *"designed in a weight specific to the season and with enough pockets to eliminate the need for an additional pocketbook."*

These items are not additions to a person's existing wardrobe. They constitute an entire wardrobe. In fact, anyone who acquires an article of clothing designed by Zittel must sign a contract promising to store or discard all other clothing of that type and to wear Zittel's garment exclusively (several identical sets can be acquired to assure cleanliness). The client's life is not only streamlined, it is actually extended by the time once lost deciding what to wear or maintaining the inventory of redundant items most people have crammed in closets and stacked on shelves. For Zittel, this demonstrates that *"the most inter-*

esting part of the process is the point when collectors must evaluate how one of my pieces will fit into their lives . . . what are they willing to give up or consolidate . . . Most collecting is an additive process, but to acquire one of my pieces is more often a subtractive process. The collector must go through the same process of self-evaluation to live with one of my pieces that I go through when I create them . . . much more creative for them than simply writing a check!"[2]

One means to relieve people of their malaise is to liberate them from as many functions as possible. Those that cannot be eliminated are streamlined. In her "Purity" exhibition in 1993, Zittel exhibited a series of prototypes designed to cleanse, feed, and comfort the human body. The *A to Z Food Group (Work in Progress)* consisted of an alternative food created by the artist—a mixture of rice, oats, lying-lying, chickpeas, black beans, pinto beans, broccoli, spinach, onions, mushrooms, bell peppers, carrots, sunflower seeds, and pumpkin seeds. Instead of a traditional museum label, this art object was accompanied by the following statement: *"The complex nutritional needs of our bodies are virtually impossible to satisfy and can lead to an exhausting preparatory process and overly cluttered region in the home. The A-Z Food Group is designed to be perfectly balanced and at the same time to have an appealing taste. It may be eaten dried, or cooked into soups, loaves or patties. It is the healthful solution for liberation from catering to our bodies' demands."*

Eating is not the only function of the alimentary canal that received Zittel's attention in this exhibition. She also displayed *Chamber Pot*, a spun aluminum vessel 5 1/2 inches high and 9 1/2 inches in diameter. Its accompanying statement promises that *"The A-Z Chamber Pot provides freedom from the tyranny of bodily necessity. Attractive enough to set on your shelf, it is also portable enough to be easily transported to any location."*

A to Z's approach to such elemental needs reverses the pattern of most merchandisers. It pares down and seeks perfection. In the process, it revives the modernist dictum that inspired the social and artistic revolutions of the early twentieth century: "less is more" returns as a healing mantra, an antidote to consumer excess.

Although Zittel's relationship to the concept of perfection has varied over time, it offers a key strategy for restoring mental composure. A perfect object eliminates the urge to acquire another. When Zittel strives to exceed excellence and attain perfection, she counters the compulsion to return to the marketplace. Perfection is the best defense against continuous decision-making and object-accumulating. It certainly conserves psychological and physical energy.

Perfection, however, is a troublesome, even tragic notion. It implies universal and eternal truth, a concept that has been discredited by postmodernist thinkers. Even Zittel recognizes its futility. Yet she seems to prefer idealistic ambition to realistic cynicism: *"I accept the fact that I will ALWAYS be seeking perfection . . . If we could just find that perfect solution we would be cured . . . of what, I am not sure, but we still look for our fix!"*[3]

The Andrea Rosen Gallery in New York, where the artist presents her work, functions in the manner of a showroom displaying prototypes of her life-organizing products. Annual shows are mounted to present the newest and best versions of her designs. If and when perfection of an object is achieved, it will be mass-produced and distributed through normal merchandising outlets—perhaps Kmarts and Wal-Marts—at moderate cost. Meanwhile, the prototypes command high prices as artworks. The price covers the cost of research, design, and manufacture of the prototypes. Zittel herself doesn't need to earn much since her living style is stripped of superfluities. It is reported that she owns one winter outfit and one summer outfit and has lived with her pets in a space that is a mere 200 feet square.

While visionaries of the past typically applied a panoramic view to social planning by issuing sweeping resolutions, Zittel's perspective is focused and domestic. Her solutions enter

ANDREA ZITTEL
Dress, Fall/Winter, designed to accommodate all Fall/Winter wardrobe requirements, 1993
Wool and satin with leather suspenders, 44 1/4 x 46 3/4 in. (plus suspenders)
Courtesy Andrea Rosen Gallery, New York
Photo: Peter Muscato

society by addressing the ordinary requirements of individuals. Yet her purpose is no less heroic than that of her predecessors. *"Mine is a small social vision, not grand like in the early twentieth century. As small as a single utensil. Something*

ANDREA ZITTEL
Breeding Stock—Silver Sebright, 1992
Bantam chicken

Courtesy Andrea Rosen
Gallery, New York

we take for granted. I create something that has a widespread application. But it is still elitist. This is inevitable because I am a fine artist. The object will carry my image. It will have a long time span. By making household objects, mundane objects, I can still immortalize myself. So much art exists in storage."[4] Among the household items she has proposed are a per-

fect bowl, a multipurpose piece of furniture, a textile, and a perfect pet.

The perfect bowl will be fabricated in spun copper, which won't break like ceramic, or crack like wood. It will be the perfect size and shape to satisfy every imaginable containing function. It will hold liquids and solids that are thick or thin, hot or cold, heavy or light. It will stack for spacesaving storage. At the same time, it will be beautiful. Owners of this bowl will never again need to decide which bowl to use, nor will they ever be tempted to acquire another.

The perfect piece of furniture must be attractive, affordable, and ultimately adaptable. Its height will be adjustable: at 18 inches, it serves as a couch or a bed, at 30 inches it is a desk or a table, at 36 inches it becomes a counter or television stand. All furniture requirements will be satisfied with this single design. No other furniture is required.

The perfect textile is infinitely multipurpose, allowing its owner to dispose of every blanket, cover, coat, tent, tablecloth, carpet, sleeping bag, and curtain. Made of velvet and wool on the outside, linen or cotton on the inside, it is light, durable, and warm. Patterned in wide, alternating bands of black and gray, it is also beautiful.

The perfect pet, like any collectible, must please its owner aesthetically and psychologically. Through an elaborate breeding procedure, Zittel is "sculpting" the perfect pet Bantam chicken, which will then be stabilized to establish a new, identifiable, standard breed. Birds are selected in pursuit of an end-product that is quiet, clean, bright, obedient, good-natured, healthy, strong, good-looking, affectionate, and loyal. A to Z Administrative Services has undertaken the ultimate creative act; it is fashioning a new form of life: *"In the post-*

industrial society, there is a breakdown of class structure. The elite transferred their desire for exclusivity to their desire for purebred pets. Pure lines are the same thing that define royalty in people. Establishing a definition of purity reveals a longing to identify with an ideal. The new breed will be my creation. When my perfect bantam chicken is produced and it reproduces, my art will be available in an unlimited edition."

Breeding chickens demanded architectural habitats capable of organizing the activities of the birds and fostering reproduction among the most worthy specimens. These chicken-breeding units generated a new body of work—habitats for humans. In her most comprehensive work to-date, Zittel supervises the client's mental state by designing an entire living unit. Her goal is to "liberate the user from an overwhelming barrage of decisions and responsibilities by consolidating all living needs into a small organized living unit."[5]

A to Z architectural units are not merely efficient. They are conditioning boxes where people can recover from the stress of confronting too many options. Models for living an orderly existence necessarily circumscribe individual freedom. As Zittel recognizes, "My design would allow for each individual to self-impose a discipline . . . My architectural models are representative of this kind of conditioning . . . The agency [A to Z] designs programs in order to reorganize and simplify its clients' living conditions—it provides them with a discipline they could not impose on themselves—it creates the missing guidelines. It is really interesting to find that the imposition of these structures on people makes them feel more relaxed, more in control."[6]

Measuring 60 by 30 by 40 inches, Zittel's 1993 Living Unit is small enough to be totally portable. Its hinged steel framework can be folded shut when it is not in use, or opened and arranged in various configurations to accommodate the inhabitant's individual requirements. It is outfitted to provide all the ingredients of a functional house—kitchen, office, closet, folding cot, and two folding stools. This meticulously designed domestic nucleus boasts the ultimate in mobility, simplicity, and efficiency.

The 1995 Comfort Units exhibited at that year's Whitney Biennial offered several improvements. The mobility of three roll-up service carts—one for dining, one for office work, and one for washing—allows people to pursue these functions in any location. According to the brochure, "you never have to leave bed." An improved pillow "transforms once uncontrollable excess into comfort and support" by using the owner's clothing as its filling. The interiors themselves were aesthetically enriched with red corduroy upholstery, blue scalloped dishes, and white mugs. Videos shown with each Comfort Unit either projected abstract images or displayed simple activities such as washing hands. In every case, the rhythms of the images were unhurried and the soundtracks were ultimately soothing.

The reader may ask why Zittel is an artist and not a craftsperson. Zittel produces attractive, functional pots, furniture, and clothes, etc., yet these objects are not the end products of her efforts. Her output is defined by the mental composure these objects induce.

Since Zittel liberates minds, spares purses, and conserves energy, why is she an artist and not an efficiency expert? Zittel's interest in minimizing input and maximizing output is less a matter of conserving material resources than psychological ones. She strives to redeem wasted energy by offering satisfaction and thereby eliminating desire.

Why is Zittel an artist and not a dictator? Contentment lies somewhere between too much freedom and too much regulation. Zittel occupies this murky territory, hoping to avoid the debilitating effects of too many choices on the one side, while steering clear of fascistic impositions of control on the other. She entices people to try new formats in their lives, but she does not impose her solution upon them. "My work is for those who need guidance. For people who need me, I will serve."[7]

Why is Zittel an artist and not a commodity manufacturer? Western lifestyles are predominantly orchestrated by the narrow interests of product designers, advertising executives, marketers, and manufacturers. Their decisions have two by-products. One is avowed—they generate profit. The other is implicit—they influence the psychological states of their customers. In contrast, Zittel makes the well-being of the

consumer the primary goal of her domestic blueprints. Her conviction that the environment is largely responsible for determining behavior is paired with skepticism regarding the benefits provided by today's marketplace. Thus, she refers to her work as a *"therapy,"* a *"ministry,"* a *"cure."*

Why is Zittel an artist and not a therapist? Her efforts become art because they are not targeted solely at individuals. When her works are mass-produced, the ease they generate will filter through the populace. *"My outcome? It is changing society. This outcome requires my inserting myself into society however subtly, having an effect, improving people's lives, changing consciousness. The artist has a moral responsibility to society. Originally, this function was associated with pleasure or religion. Now the artist's function is even more heightened."*[8] Thus, bowls, coats, food, and pillows become works of fine art when they are made with the intention of conveying social truth, psychological insights, and/or uplifting solutions. Andrea Zittel's commodities accomplish all three. In suggesting that being a consumer is linked with feelings of anguish, confusion, and dissatisfaction, they offer us an opportunity to regain composure.

Zittel's promotion of the benefits of simplicity seems to be infiltrating popular culture through more conventional routes as well. In 1996, the book *Chic Simple* was published and marketed as "Essential reading for those who want to pare life down to the elegant basics." The "pared down life" it cultivated offered "100 coordinated outfits" and "over 150 delicious simple recipes," hardly matching Zittel's standards of simplicity. Perhaps the new profession of "life coach" provides a closer parallel. Coaches are family therapists, business consultants, financial advisers, household managers, and friends all in one. For fees ranging from $75 to $250 an hour, they keep their clients focused on issues essential to their happiness.

Zittel recognizes that the privileged status of the artist is accompanied by social accountability. *"The artist today exists in a less restricted position than any other type of producer (i.e., architect, fashion designer, industrial designer who all must answer to many authorities including the consumer). I am interested in experimentation and* *testing ways of reorganizing our lives and redefining our relationships with our possessions that perhaps those in a more restricted position could not do."*[9] The functions she addresses within her enterprise are those that are tied to necessity. They are mundane and unavoidable. She does not volunteer to write our poems for us, sing our songs, or arrange our flowers. Indeed, her work seeks to bolster our reserves of time, money, and energy so that our own creative potential can be revitalized. *"The artist is the authority, the designer of life. Her goal is mental. To produce a psychological state . . . Psychologically, I free you up, liberate you, free your mind. I give you a small nucleus of harmony. You are calmer, more relaxed, peaceful."*[10]

ZITTEL POSTSCRIPT:

Amazing discrepancies sometimes exist between an artist's intentions and an audience's responses. Andres Serrano, for instance, contends that he did not set out to lose friends and irritate people when he submerged a figurine of Christ in urine. Carolee Schneemann reports that she did not anticipate the scandal caused by her student depictions of a naked man, a fellow student. Orlan does not wish to disgust viewers when she displays documentations of her surgeries. Likewise, although this essay contains numerous quotes by Andrea Zittel, she advises readers to resist the conclusions they infer. *"I realize that some confusion may stem from the fact that when I talk about my work I really become an extension of it. My subjectivity is (an) important means of exploring or understanding my ideas . . . however I realize I am not the best person to talk to about the work on a more objective level."*[11]

Barbara Kruger

BARBARA KRUGER'S ART bears a triple resemblance to twin forms of mass communication that share a single goal. The goal: to communicate with a mass audience. The forms of communication: advertising and propaganda. The similarities: techniques of production, visual formats, and verbal style. Yet Kruger rejects both the advertiser's alliance with

We don't need another hero

commercial interests and the propagandist's dependence on governmental authority. She utilizes the tools of advertising and propaganda to campaign for gender equity.

Untitled (We don't need another hero), 1987
Photographic silkscreen on vinyl,
109 x 210 in. Collection Emily Fisher Landau,
New York
Courtesy Mary Boone Gallery, New York
Photo: Zindman/Fremont

GENDER EQUITY

Barbara Kruger

See colorplate 10, page 26

Born 1945, Newark, New Jersey
Syracuse University, New York, 1965
Parsons School of Design, New York, 1966
Lives in New York City

THE MEDIA-LADEN, information-generating environment offers an array of channels for transmitting messages. Each channel connects a particular kind of transmitter with specific categories of receivers. Barbara Kruger operates effectively at both poles of this communication network. On the one hand, she specifically targets the sophisticated art-viewing public. For this audience, she creates unique objects that are displayed in the conventional settings of museums and galleries, where they are offered for sale to wealthy collectors and art museums.

At the same time, Kruger employs numerous modes of communication designed to infiltrate the public domain and disseminate ideas to the widest possible audience. Adopting existing opportunities for mass communication, she designs billboards, book covers, T-shirts, matchbooks, music videos, and announcements that promote political groups, individuals, and institutions. Her posters are hung on telephone polls and vacant buildings. Simultaneously, she actively pursues a variety of professions: editor, curator, teacher, writer, and critic of film and television. All of these occupations are subsumed within her art career because they, like art, dispense ideas. *"To make art is the ability to objectify one's experience of the world. You can do that in a million ways—in a building, a painting, with photography, a novel, a music video—but it's your experience, not some intermediary's vision or some client's imposed boundaries."*[1] Kruger's work thereby augments the audience for art with taxi drivers, policemen, the homeless, high-school dropouts, indeed everyone who traverses public spaces or tunes into media outlets.

Kruger adopts the means but not the goals of the two dominant forms of visual and verbal persuasion: propaganda and advertising. Her artworks are not propaganda because their production is not orchestrated by a central governmental authority. Propaganda indoctrinates youth, censors news, stages parades, and

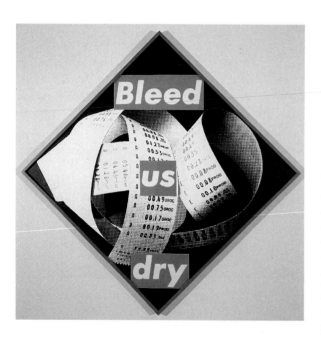

BARBARA KRUGER
Untitled (Bleed us dry), 1987
Photograph, 49 x 49 in.
Private collection

Courtesy Mary Boone Gallery, New York
Photo: Zindman/Fremont

produces demonstrations. It regulates art, literature, film, radio, music, and theater. There is no official propaganda in the United States.

Likewise, Kruger's artworks are not advertising because they do not promote commercial interests. Advertising is so inherent to the American way of life that urban centers and malls, and the highways leading to them, are basically fashioned by sales messages that are bold, brash, luminous, and congested.

Locating Kruger's work within the matrix bracketed by propaganda and advertising requires distinguishing between purposes and means. Kruger rejects propaganda's and advertising's aims, but their time-tested mechanisms of communication are ideally suited to her agenda. She exploits their visual strategies, honing their means to captivate the viewers' attention. Both propaganda and advertising have perfected techniques to compete in an environment already cluttered with messages vying for attention. Kruger loads exclamatory words upon emphatic images to stimulate the eye and activate the brain. Through these borrowed procedures, her works command attention.

These devices constitute today's visual and verbal vernacular. Because they are understood by everyone, they are capable of driving messages throughout the populace. Kruger admits to *"an infatuation with the power of pictures and words."*[2] She explored these devices during her brief stint as a student at the Parsons School of Design, where she studied graphic design, not fine art. Her success in the commercial field was astounding. By the age of twenty-two she was singlehandedly designing *Mademoiselle*, a national fashion magazine. She further refined these skills after she became an artist. Graphic design not only characterizes Kruger's aesthetic devices, it dictates her method of production. Her creative process bears little resemblance to the methods used by legendary artists. Kruger rejects the notion of individualized, handmade masterpieces in favor of mechanical procedures. Producing multiples enables her to reach the multitudes. She does not even fabricate her own framed museum pieces. Typically, she begins by selecting a pre-existing photographic image and devising text for it. Then, like a graphic designer,

she "lays up" the image, "pastes up" the text, and sends the "mechanical" to a printer for enlargement and duplication. Her artwork, therefore, is evaluated in the same way that propaganda and advertising are—by the force of its message, not the skill of its production.

Much of Kruger's imagery is derived from

> *"To make art is the ability to objectify one's experience of the world. You can do that in a million ways—in a building, a painting, with photography, a novel, a music video . . ."*

old film stills or advertisements. Their acute camera angles, harsh lighting, and close-ups are the baseline upon which she then erects hyper-theatricized representations. She augments their optical voltage by exaggerating, and thereby exposing, the manipulative strategies of the media. These strategies include cropping, enlarging, and focusing to escalate intensity; eliminating all neutralizing and distracting elements; limiting the palette to stark black and white and crimson red; choosing bold sans serif lettering; composing with dynamic diagonals.

Text further amplifies the aesthetic drama of the photos. Imperious pronouncements are stamped on top of the images, serving simultaneously as captions, titles, and dialogue. Some are rallying cries. Some are provocations. Others are accusations. In all cases, imperatives replace qualifiers. Kruger's work projects the cold and impersonal tone of mass-communicators. Her slogans parallel the rhetoric on World War II propaganda posters even though her activities are not controlled by a Ministry for Popular Enlightenment and Propaganda such as Hitler established in 1933:

> Nazi poster: *"One people. One nation. One leader."*
> Fascist poster: *"The Fascist man does not believe in everlasting peace."*
> Mussolini: *"Nothing has been won in history without bloodshed."*
> Kruger: *"Our Time is Your Money."*
> *"You are Getting what You Paid for."*
> *"We will no longer be seen and not heard."*

Advertising messages that are broadcast from every conceivable surface share the quick-punch

impact of propaganda. Cars, like most commodities, are identified by slogans that also serve as Kruger's paradigms:

> Nissan: *"It's time to expect more from a car."*
> Mitubishi Galant: *"Filled with your favorite things."*
> Lincoln: *"What a luxury car should be."*
> Toyota Parts and Service: *"I love what you do for me."*
> Saturn: *"A Different Kind of Company. A Different Kind of Car."*

"Look, there are politics in every conversation we have, every deal we make, every face we kiss. There is always an exchange of power, an exchange of position—it happens every minute. I make art about power, love, life, and death."

Kruger probes the boundaries separating advertising, propaganda, and art. *"I don't know what propaganda means anymore. I think it would be different if we were in Lithuania or Estonia, but we are talking about America and you have to think what that word, 'propaganda,' means. Is Peter Jennings propaganda? Are the Simpsons propaganda? I mean, how do words and pictures work? How do they influence people?"*[3] The answer suggested by her work is that the ruling forces in America are diffuse. Western moralities and values issue from manifold, competing sources: politicians, religious leaders, advocates of opposing causes, merchandisers of all kinds. They permeate society through myriad channels: commercial photography, posters, corporate insignia, newspapers, magazines, television, film, advertising, and fashion are all part of this web of influence. To some degree, attitudes are molded through the promotion of each candy bar and through the headlines on each day's newspaper.

As in propaganda and advertising, the images and texts in Kruger's works are not ends, but means to arouse and persuade the masses. Still, her work is honored in fine art circles. Her acceptance, despite the visual and verbal resemblances to non-art formats, derives from the fact that her position is located outside of these power systems. Government and commerce constitute her target, not her patron.

Kruger subverts established ideological and economic values by inserting an outsider's perspective into the information stream. She asserts the female point of view. Her work exposes the gender inequities that underlie the invisible and invincible voice behind the official announcements that congest the airways and the freeways. This voice speaks in the lower register, repeating patriarchal tenets established centuries ago in the West. Its one-sided perspective likens the media to agents of sexual indoctrination. Kruger interrupts its unimpeded course through society and reverses its objectives. She disarms the ideology of masculine dominance. *"I can't think of any moment when I wasn't totally involved in how one is defined and produced as a woman in this culture."*[4]

Kruger interrogates the sexual provocations contained in media texts and imagery by incorporating into her work the pronouns "we," "my" and "I." These pronouns are sexually explicit. In the official media, their implied gender is male. Kruger's statements, however, represent a female point of view. Her use of "we," "my," and "I" is incontestably female. Her "you," however, is directed at men who now become the recipients instead of the dispensers of public pronouncements. Their monopoly is broken. This inversion exposes the covert masculine ideology of our culture's print and electronic media. Furthermore, pronouns personalize texts and force viewers to take a stand in relation to Kruger's feminist aphorisms, either upholding or debunking the established gender hierarchies they disclose:

> *Your moments of joy have the precision of military strategy. Your assignment is to divide and conquer.*
> *You destroy what you think is difference.*
> *You rule by pathetic display.*
> *You molest from afar.*
> *Your creation is divine; Our reproduction is human.*
> *You make history when you do business.*
> *We received orders not to move.*
> *We don't need another hero.*
> *We won't play nature to your culture.*
> *We are your circumstantial evidence.*

*We are the failure of ritual
cleansing.
I am your almost nothing.
I shop therefore I am.
My lordship; my lancelot; my host
with the most; my Rambo;
my great artist; my popeye;
my pope; my sugar daddy;
my ayatollah . . .*

While Kruger's texts are brave
demands for gender equity, her
images present females in positions of
subservience and males in roles of
possession and control. Kruger applies
this power discrepancy to a great range
of critical issues: abortion, racism,
freedom of expression, religious intoler-
ance, war, consumption, sex, love,
murder, censorship, bigotry, domestic
violence, profit, money, power. She
demonstrates how many aspects of
our lives are affected by sexism.
*"Look, there are politics in every con-
versation we have, every deal we make,
every face we kiss. There is always an
exchange of power, an exchange of
position—it happens every minute.
I make art about power, love, life, and
death."*[5]

All of these issues were addressed
in April 1994 when Kruger converted
the Mary Boone Gallery into a giant,
multisensory arena in which a brutal
contest between the sexes was waged.
Inflammatory indictments plastered the walls,
hung from the ceilings, and even appeared on
the floor. The recorded sounds of a stadium in
which a male interlocutor expounded to an agi-
tated crowd reinforced the atmosphere of strife.
An enormous, floor-to-ceiling, wall-to-wall photo-
graph of a mass-gathering augmented the
impact of the crowd's roar.

The first image the viewer encountered
underfoot established the work's scornful and
ironic tone. A screaming cartoon figure and a
pointing figure were accompanied by the words,
"How dare you not be me?" The installation
probed the identity of this "you" and "me." Who
is daring? Who is taunted?

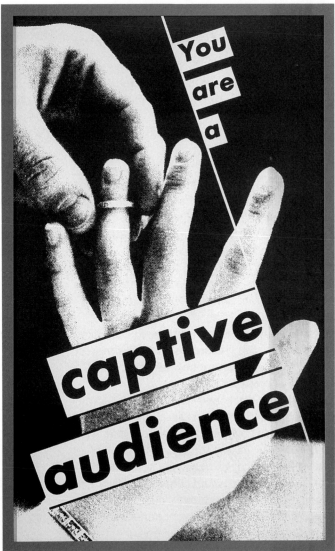

BARBARA KRUGER
*Untitled (You are a
captive audience)*, 1992
Photograph,
82$^{1}/_{2}$ x 50 in.
Collection George
Eastman House,
Rochester, New York
Courtesy Mary Boone
Gallery, New York
Photo: Fred Scruton

Genders clashed in
nine large, wall-mounted
photo-texts spewing
venom-laden pronounce-
ments. Examples include:

Text: *"Your inability to
empathize. Your eroti-
cized combats. You big
shots."*
Image: Man and woman in face masks, kiss.

Text: *"Your aesthetics of virginity. Your
image of imperfection. Your compulsive
seductions. Believe like us."*
Image: Two men being held aloft.

Text: *"Your pleasure panics. Your total lack of irony. Your dour literalisms. Laugh like us."*
Image: Woman biting carrot.

Text: *"Your frenzied dictations. Your control-freak vigilance. Your selective memory. Think like us."*
Image: Head of prone woman. Weapon directed at her.

A male voice bellowed threats against these accusations and commands: *"Just push me. Just push me a little harder and your world explodes. All your little niceties, your quality of life."* The crowd cheered and the voice resumed, *". . . picking up the kids from school. Renting a video. Stopping for gas. Doing the wash. Watching the game. It's all over. Smashed into the dreams of shopping malls . . ."* The sound of a woman screaming and groaning was heard. The voice continued: *"I slap you because it makes me feel good. I want you to have my babies because it shows how powerful I am . . ."*

Huge red, black, and white epithets looming overhead brandish the generic language of hate mongers. *"My God is better than your god, wiser, more powerful, all-knowing, the only god . . . What I believe is truer than what you believe. More righteous, factual and universal. What I hate deserves it. It's more evil, more insidious, more dangerous."* Images and text underfoot summoned the hell occupied by victims of oppression: *"Must we play dead to survive?"*

The voices were never silent. The drama never culminated. No escape was offered. If the piece redresses gender conflicts, it does so by helping female viewers build defenses against coercion and requiring that male viewers examine their sexual biases and behavior. Kruger explains, *"I could say that I'm involved in a series of attempts to displace things, to change people's minds, to make them think a little bit."*[6] *"I am interested in making art that displaces the powers that tell us who we can be and who we can't be."*[7] Making their implicit ideology explicit, she builds the public's resistance against sly forms of indoctrination. People are then empowered to form their own attitudes and determine their own behavior. In this way her work fortifies the public against the perils of mind control.

Transforming an obedient observer into an active thinker is a decidedly nonpropagandistic, noncommercial goal. Kruger explicitly denies that her work is intended to be subversive. *"My activity is not covert. Issues are never diametrically opposed. I don't think in binary terms. These are all elements of the male approach. As a feminist, I question these terms. I wish to open things up. I am interested in displacement, in asking questions, in analyzing why. I do not intend to smash capitalist lackeys. If I were to choose a slogan it would be the army's recruiting phrase, 'Be all that you can be.' We live in a mixed culture. We have different goals. We need to hear more voices. That is exciting. I don't want to exclude anyone. I don't want to be another warrior. I don't want to be another ideologue. The things I am asking have been totally absent from global agendas. It is up to women to contradict the existing order by allowing for difference."*[8]

KRUGER POSTSCRIPT:

In addition to conventional artworks displayed and marketed in conventional art settings, Barbara Kruger, Ericson and Ziegler, and Andrea Zittel all produce commodities intended to be mass-produced and mass-marketed through existing (non-art) channels of distribution. Thus, galleries and museums are not their only settings for display; art patrons and art critics are not their exclusive audience; critical acclaim and high prices are not their sole determinants of value. These artists are intent on extending their influence beyond wealthy art patrons by infiltrating the homes of ordinary citizens. Their mass-produced art objects are conditioning tools that transmit social programs.

Jeff Koons

JEFF KOONS is absolutely candid about his compulsion to become an t star and his willingness to achieve this goal by pandering to the media. is life and his art are orchestrated to attract publicity. Koons chose Ilona Staller to be his wife. She is a porn ar of international renown (they are

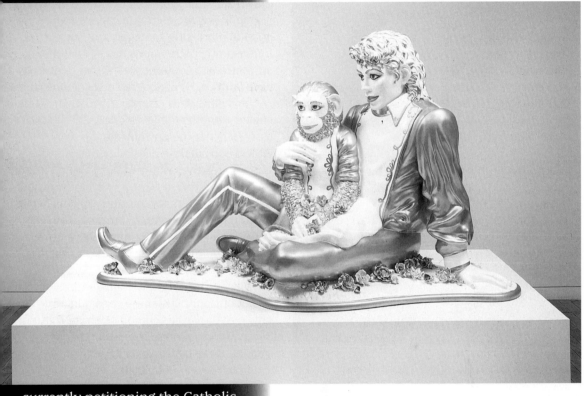

Michael Jackson and Bubbles, 1988
Ceramic, 42 x 70^1/$_2$ x 32^1/$_2$ in.
Courtesy the artist. Photo: Jim Strong

currently petitioning the Catholic Church to annul the marriage). Likewise, he selected another media celebrity, Michael Jackson, as the subject of one of his best known works of art. With competitive zeal, Koons outwitted Jackson by out-white-ing him, a bleaching he also lavished on Jackson's pet monkey.

Honesty

See colorplate 11, page 27

Born 1955, York, Pennsylvania
School of the Art Institute of Chicago, Illinois
Maryland Institute College of Art, Baltimore: BFA
Lives in New York City

JEFF KOONS
Bourgeois Bust—Jeff and Ilona, 1991
Marble, 44 1/2 x 28 x 21 in.

Courtesy the artist
Photo: Jim Strong

IN THE 1980s, Jeff Koons fulfilled his ambition to attain the heroic status of a contemporary hero despite his lack of physical prowess, courage, magnanimity, or genius. Today, there is little opportunity for personal heroism of the traditional sort. Consumer abundance and media-induced pacifiers have redefined the very concept of hero. Instead of brawn and guile, contemporary heroes excel at manipulating the communications industry and the marketing strategies that support it. In mastering both, Koons has earned the attributes of a contemporary hero: he is rich; he is famous; he conquered a sex-goddess.

It is difficult to respect an artist who is preoccupied with these shallow goals. Some art critics assert it is not merely difficult, it is impossible. Others consider the possibility that Koons's obsession with wealth and fame is a comment on hype and media frenzy. This essay presents a third possibility, that Koons not only highlights machinations that are as common throughout our culture as they are commonly scorned, he exposes the moral hypocrisy that surrounds such scorn.

Despite his modest origins as the son of the owner of Henry J. Koons Interiors in York, Pennsylvania, Koons has earned celebrity status and international renown. His work retains the imprint of the boom years in which his ascent occurred. Koons exploits that era's vastly expanded opportunities for self-promotion. With deftness and zeal, he "sculpts" his reputation before the media cameras and "designs" exciting copy to accompany it, deriving his strategies from the advertising, pornography, and entertainment industries. His career documents the conversion of the American ideal (to be a "self-made" person) into the brazen careerist dream (to be a "media-made" person). Madonna and Donald Trump—not Van Gogh or Jackson Pollock—are Koons's idols. A five-year career as a commodities broker on Wall Street served as the ideal apprenticeship for Koons's art career. Ped-

dling gold and cotton futures for prestigious firms such as Smith, Barney and Sons taught him the techniques of aggressive marketing. When Koons changed professions, he discovered that these skills were transferable to a field that promised greater rewards—art—and to the promotion of the product he loved the most—himself. He packaged his new career like the commodities he had been hustling and then sold it through sales campaigns, publicity stunts, and self-promotion.

Truly fame-obsessed individuals are populists because they demand attention from the multitudes. Koons is an authority on this subject. *"At one time, artists had only to whisper into the ear of the King or Pope to have political effect. Now they must whisper into the ears of millions of people."*[1] His work is calculated to recruit the masses into the ranks of his admirers. To this end he recapitulates society's banalities and adopts the language of the populace.

Art historians commonly cite examples of the integration of popular culture into fine art, a tradition that was established early in the twentieth century and found one of its greatest practitioners in Andy Warhol in the 1960s. But unlike his predecessors, Koons neither elevates the commonplace nor criticizes it. He allows kitsch objects to retain their own identity and thereby retain their ability to delight the multitudes. This fine artist adopts the aesthetics of Mattel, Hollywood, Disney, Hallmark, McDonald's, and Kmart. He swaps traditional criteria of quality in art for popular appeal.

But Koons's ambition is so extreme that he is unwilling to sacrifice the attention of the elite for fame among the masses. As an active member of the market economy, he recognizes that qualitative value (merit) is commonly measured according to quantitative value (price). Thus, he escalates his prices until only the wealthiest can afford to purchase his work. In this way he provides an opportunity that is greatly desired by art collectors who share his attitudes about wealth and power. Koons entices them to exercise their competitive instincts and display their wealth. Thus Koons's audience is all-inclusive because his work is scaled to the intellectual range of the masses and the price range of the elite. High prices make his work a luxury item. Lowbrow

taste makes it a popular one. Thus, he is both rich and famous.

True celebrities have others do much of their work for them. Likewise Koons manages to produce art without getting his hands dirty. Many of his sculptures are fabricated by European artisans who normally carve crucifixes and church sculptures. Employed by Koons, they direct their sculpting skills to different kinds of effigies: images found on postcards, knickknacks sold in dime stores, souvenirs from tourist attractions. Koons states that his original intention was for the workers to produce a finished product without his intervention. *"Boom, that's it. A Jeff Koons! But I realized there were no great artists around. I could not give these people that freedom . . . So I had to do the creating. I did everything."* This "everything," though, did not involve physical toil. *"I directed every color . . . Every leaf, every flower, every stripe, every aspect."*[2] On what objects did these leaves and flowers and stripes appear? An inventory of Koons's sculpture includes impeccably groomed Yorkshire Terriers, oversized teddy bears, an all-white Michael Jackson, two cherubs, and a little boy pushing a beribboned pig. Koons even created a version of Leonardo da Vinci's *St. John the Baptist* in which John embraces a suckling pig and a penguin. In sum, Koons's wealth and fame are derived from his choice of subjects—tiny saccharine objects intended for curio shelves—and their ten-time enlargement to bombastic proportions by ordinary craftsmen.

Similarly, his two-dimensional works are not of his own making. Koons's paintings are actually machine-produced oil-ink versions of photographs. Since this complicated process of reproduction and enlargement barely alters their appearance, one might wonder why Koons bothers to transfer the photographs to the medium of paint. Koons offers an explanation rooted in the traditional hierarchy of art media: *"A photograph for me does not have a sense of spiritual seduction, it does not have an essence, that this is something that permeates and which is eternal through time."*[3] Koons thus recapitulates the popular opinion that paintings are a more significant form of artistic expression than photographs. A key factor for him is that painters are wealthier and more famous than photographers.

At the same time that his works pander to popular taste, they also court the urbane audience. Only sophisticated art viewers are likely to recognize that Koons's paintings are mechanically produced and based on photographs.

These works appeal to yet another segment of the population as well: the academics and critics prone to ridicule collectors who use art to elevate their social status. They delight in the fact that collectors have introduced into their elegant homes artworks that appeal to people who wash their laundry in laundromats and dine at Friendly's. Koons's paintings consist of five-foot-high blow-ups of porno-magazine-style images or look-alike advertisements for Nike sneakers and Jim Beam bourbon. Such schemes have proven highly successful. At a major 1992 exhibition (held simultaneously in three cities), a guard had to be stationed at the entrance to each gallery to monitor the crowds. The exhibition sold out at $5,000,000. Koons's patrons were not only wealthy, they were also social luminaries.

Koons met Ilona Staller when she was already an established celebrity. Nicknamed Cicciolina (Dumpling) by her fans around the globe, Staller is the blond porn icon in such films as "Atomic Orgy" and "Porno Rocker." An astute businesswoman who founded Diva Futura to produce and market erotica, Staller was also, remarkably, a member of the Italian Parliament. She ran on a Green Party, anti-nuclear, pro-environment, sexually progressive platform, campaigning naked from stages in clubs and theaters as she sang and danced with her six-foot python. In 1987 she became the elected representative of Italy's Radical Party, a left alternative to the Communists.

Koons asserts that their marriage was a matter of destiny: *"she's a media woman, I'm a media man."*[4] And he boasts that over 1,000 articles were written about the event. Appearing in such publications as *Time, People, Newseek, Cosmopolitan, Vanity Fair*, and *Playboy*, they constituted the result of a carefully orchestrated campaign that included purchasing billboard space to trumpet his affair with his soon-to-be wife and distributing photographs of the wedding to news services throughout the world. Koons, who abides by the axiom "to be seen is to exist," seems undisturbed by the fact that a significant portion of

these articles accused him of unconscionable narcissism. He is willing to forgo respect in order to increase his ratings. The trouncings of reporters merely amplify his image, his prices, and his acclaim. The Koons and Staller marriage had all the characteristics of a joint enterprise dedicated to satisfying the public's craving for celebrities and sex. Their carefully orchestrated products consisted of sensationalist art objects and scandalous news stories about their life together.

Although he had married a readymade celebrity, Koons had to construct a charismatic image for himself to attain a Hollywood-worthy persona. *"I believe that artists must exploit themselves. And they must then take the responsibility to exploit others."*[5] *"In the service of the work,"* he took acting lessons, hired a professional accessorizer, had his hair done by David Bowie's stylist, and improved his physique with a regimen designed by Arnold Schwarzenegger.

Visitors to Koons's 1992 exhibition had the opportunity to inspect the success of this program. Every inch of his flesh was displayed, airbrushed, tinted, and burnished into a more perfect state. In the photo-paintings that lined the walls, he and his bride flagrantly presented themselves copulating in missionary and devilish positions. The bedroom banality that constitutes the typical setting for marital sex is here transformed into the never-never land of technicolor rainbows and garlands derived from early Hollywood romances. Staller played the role of ingenue bedecked in white lace stockings and a garland of flowers. But she also retained such porn queen accoutrements as boots, spiked heels, and bustiers. Marital sex was explicitly invigorated by such signs of non-domestic sex. At the same time, Staller was as idealized as the muse who inspires the great artist's creations of classical nudes. In sum, she fulfilled four historically inscribed roles celebrating womanhood: wife, lover, muse, model. Of course Koons is the man who wedded this ultimate woman. He proclaims that he is, therefore, the ultimate man.

Koons's craving for fame is not an end in itself. Being a star places the magnifying and multiplying powers of the communications industry at his disposal. He claims to exploit these prerogatives in order to advocate a unique

JEFF KOONS
Puppy, 1992
Live flowers, earth,
wood, and steel,
472 x 197 x 256 in.

Courtesy the artist
Photo: Dieter Schwerdtle

blend of social rectitude and spiritual redemption. Koons appears to have become a celebrity in order to become a missionary by reaching out to a segment of the population frequently excluded from the experience of fine art. He is neither apologetic nor judgmental about such viewers. In fact, he ministers to them. His simpleminded sermonizing eliminates the need for intellectual analysis in order *"to erase alienation."* It offers *"a total sense of ease," "no conflict, absolute beauty."* [6] *"I am interested in love and being beneficial to the rest of humankind."* [7]

Setting his own life as an example, Koons liberates humanity from guilt and proclaims a shame-free existence. For instance, he banishes the bohemian model of the artist who struggles through life, sacrifices comfort for art, and dies in neglect. Like the populace as a whole, Koons prefers success to tragedy, comfort to suffering,

wealth to poverty. In the service of art he demonstrates that it is possible *"to make a fantasy a reality."* [8] Most significantly, he is forthright about the means he employs to achieve good fortune. His work resolves into a series of six tenets that are commonly denounced as immodest, undignified, unethical, and offensive. They are, however, just as frequently practiced in the real world. As a result of this conflict between practice and belief, these tenets are nagging sources of guilt and regret. Conscience interferes with the enjoyment of the rewards they yield. Koons explains that his work *"is about embracing guilt and shame and moving forward instead of letting this negative society always thwart us—always a more negative society, always more negative."* [9]

TENET 1: *Sex is not embarrassing, private, illicit, or sinful.* As a condition of marriage, Koons required Ilona to retire from her porn-queen career and lavish her porn-queen libido exclusively on him. In this way their X-rated

sexuality was legalized through marriage and sanctified by the holy order of matrimony. In a series entitled *Made in Heaven* (1991), their sexual cavortings were staged as blessed acts carried out in the full light of day. *"Through our union, we're aligned once again with nature. I mean we've become God. That's the bottom line— we've become God."*[10] The artist displayed their nudity freed of sin and their erotic encounters

> *"At one time, artists had only to whisper into the ear of the King or Pope to have political effect. Now they must whisper into the ears of millions of people."*

without a trace of shame. Koons and Staller were less the Ken and Barbie of the art world than the Adam and Eve of a pop religion. In states of posed rapture staged in a plastic, candy-colored paradise, they displayed sex freed of the disgrace of the expulsion and the moral conflict that followed. In some of the images from this series, Koons even invited the serpent to be their witness. Ilona's hairless, pink pudenda demonstrated her chastity as a halo might. Sex was exalted to a plane where Ilona was *"his eternal Virgin."*[11] Koons's erections endure through eternity, and viewers enter *"the realm of the Sacred Heart of Jesus."*[12]

TENET 2: *Egoism and exhibitionism are prerequisites of fame.* Koons earnestly declares that his is the greatest contemporary art. He unabashedly compares himself to the Messiah, to the acclaimed artist Michelangelo, and to the celebrated pop star Elvis Presley. He announced one of his shows as *"the greatest contemporary art exhibition in history."*[13] To support such claims he summons the strategies from Pennsylvania Avenue, Wall Street, and Madison Avenue that have successfully promoted everything from hair-removers to politicians. They have proven that flamboyant boasting is an effective tool for aspiring celebrities. In magazine ads promoting an upcoming exhibition, Koons presented himself in three pretentious guises—king, teacher, and rock star. The fourth advertisement in the series seems uncharacteristically self-deprecating. This one utilizes a different time-tested promotional strategy, self-mockery. Koons's cheeky pink face peers out from between two plump, pink pigs. *"I was there with two pigs—a big one*

and a little one—so it was like breeding banality. I wanted to debase myself and call myself a pig before the viewer had a chance to, so they could only think more of me."*[14]

TENET 3: *Fine art is a commercial enterprise.* Koons is candid about the fact that his productions are backed by Lambert/Koons Advertising Agency. Although he is frequently accused of contaminating the refined art world with the crudities of the marketplace, he is neither moralistic nor cynical about his commercial aspirations. His guilt-free display of business tactics stands in sharp contrast to his colleagues, who are loathe to acknowledge the following truths: many museums hire public relations firms to promote their images; artists hire press agents to manage their careers; dealers use aggressive marketing devices to foster sales; art criticism is publicity; many collectors acquire art to improve their investment portfolios.

Most people decry the gross manipulation of commercial interests in art. In private, many participate. Koons is not a hypocrite.

TENET 4: *Kitsch is captivating.* In his goal to make art as powerful a force in society as advertising, Koons studied the aesthetic that sells pop music, mass-produced holiday decorations, greeting cards, car trinkets, and children's toys. Other artists draw on this material, but few would say, as Koons does, that *"I try not to use it in any cynical manner. I use it to penetrate mass consciousness—to communicate to people."*[15]

Art commentators frequently refer to Koons's versions of pop culture as blunt exposures of middle-class pretensions. But there is no evidence that Koons engages in such critical dialogues. His avowed mission is to treat viewers to pleasurable sensations. Some of his viewers enjoy kitsch. Others demand sophistication. *"For the lower and middle class, (my art) will lead to an ultimate state of rest; for the upper class it will lead to an unprecedented state of confidence."*[16]

TENET 5: *Price determines desire and merit.* It is not greed alone that motivates Koons's machinations to elevate his prices. The digits on the price tag also measure esteem. In today's society, the influence of critics is pallid compared to the influence of money. *"What I'm saying is that the seriousness with which a work of art is*

taken is interrelated to the value that it has. The market is the greatest critic."[17]

TENET 6: *Art is a luxury item.* Despite the lofty rhetoric that surrounds it, art is an object of consumer desire. *"In the system I was brought up in—the Western capitalist system—one receives objects as rewards for labor and achievement."*[18] Rich and poor alike covet that which they don't really need and can't quite afford, but which makes them feel good. The lower and middle classes find satisfaction in mass-produced knick-knacks; the wealthy buy fine art. Koons merges these two forms of reward and therefore wins the favor of people at both ends of the income scale.

Koons's works of art capture the frenzy of acquisitiveness that dominated the 1980s. They are glimmering, immaculate, captivating collectibles of such simplicity that no one can feel intimidated by them. At the same time, they are items of such luxury that wealthy art patrons can hardly resist them. An overview of his work reveals that his scrupulously selected materials range from stainless steel, favored by the poor, to the crystal and porcelain preferred by the rich. His subjects are chosen with equal precision. Koons incorporates vacuum cleaners and decorative Jim Beam bourbon decanters to satisfy the tastes of the middle class, while a Bust of Louis XIV and rococo mirrors appear as luxury items for the wealthy. *"I'm . . . trying to capture the individual's desire in the object, and to fix his aspirations in the surface in a condition of immortality."*[19]

This conjunction of bourgeois and aristocratic cultures culminated in Koons's presence at the 1992 Documenta International Art Fair in Kassel, Germany, a prestigious exhibition in which he was *not* invited to participate. Undaunted by his exclusion, Koons erected a towering forty-foot grinning puppy, seated on its rear haunches, obedient and irresistible, as if it were eagerly begging for a treat. This monumental canine, festooned from paw to tail with thousands of living flowers, was Koons's own alter ego—the one left out of the party who was incontestably more adorable than those who were included. Few international art celebrities left the fair without making a pilgrimage to its

site, located almost an hour away. The work dominated press accounts of the fair. Most enjoyed the puppy's uncomplicated charm, which was a welcome relief from the pretension of many of the official entrants. Koons boasted, *"I have my platform, I have the attention, and my voice can be heard. This is the time for Jeff Koons."*[20]

KOONS POSTSCRIPT:

It is not uncommon for contemporary artists to cross the borders that once protected art from the banalities and vulgarities of everyday life. Many of today's most esteemed artists willingly replace the distinguishing characteristics of art with the defining traits of non-art objects. Still, they maintain, their efforts qualify as fine art. Jeff Koons demonstrates that the depiction of fornication is not pornography if it thwarts the shame connected to titillation instead of arousing it. Barbara Kruger and Joseph Beuys prove that political themes do not constitute propaganda if such works encourage independent thought instead of imposing rigid ideologies. Andrea Zittel asserts that functionality does not constitute design if, in addition to fulfilling practical needs, objects also offer psychological rewards. Mel Chin demonstrates that a scientific experiment is art if it conveys a moral principle. Meyer Vaisman proves that a joke can be art if it promotes social awareness. Orlan demonstrates that surgery can be art if it expands the realm of human potential. In each case, these artists' works exceed the conventions of their ostensible category.

FIVE SOME AESTHETICS

THE SPLITTING of creative endeavors into specialized disciplines is a Western tradition that assigns to musicians the task of composing with notes, chords, harmonies, timbre, amplitude, melody, and meter. It gives to playwrights such compositional tools as actors, staging, sets, costumes, lighting, and dialogue. It allocates to visual artists such ingredients as shapes, space, lines, and color.

Similarly, specific physical stimuli are allocated to each art form. Musicians traditionally specialized in sound, artists in sight, dancers in kinetic expression. Even maverick artists, composers, and choreographers usually honored the idiom allotted to their artform. They limited their creative impulses to the invention of new styles, not new categories of expression.

The magnitude of innovation escalated throughout the twentieth century. By the 1990s, much art no longer occupies familiar fields of endeavor. Many visual artists have packed up the old rules and relegated them to a cultural attic where they are stashed alongside outmoded ideologies in science, government, and technology. Thus unencumbered, artists have stepped across borders and helped themselves to aesthetic elements from other epochs and other art forms.

This book has already charted examples of artists' alliances with science, politics, religion, technology, craft, and daily life. The current chapter extends this anti-exclusionary trend to art that incorporates sound, smell, and time, as well as humor and homeliness. In all these ways artists are reintegrating our physical traits (all five sensory organs), our metaphysical attributes (emotions, instincts, and intellect), and our relationships (to nature and to society). They reflect a well-documented trend indicated by the addition of the prefix "multi" to such words as "disciplinary," "media," "ethnic," "national," and "dimensional."

Aesthetics no longer resembles the discipline practiced by Plato, Aristotle, Hegel, and Santayana. It has shed its specialized interest in the science of beauty and is participating in the trend toward expansion and coherence. A wide spectrum of sensory inputs and emotive outputs has been assimilated—dissonant as well as harmonious, crude as well as refined, jarring as well as soothing, comic as well as solemn. Perhaps the end of the second millenium will resemble the beginning of the first, when Jesus healed both the soul and the body, when texts served equally as theology, literature, science, and history, and when an organic wholeness prevailed.

Meyer Vaisman

28

HUMOR TAKES MANY FORMS. Verbal humor is expressed through satire, farce, lampoons, puns, shaggy dog stories, parody, riddles, spoofs. Gestural humor involves slapstick, burlesque, grimaces, miming, clowning. Visual humor is commonly associated with cartoons and animation. Meyer Vaisman creates funny art, but he is neither a cartoonist nor an animator. Instead, he is respected as a "serious" artist, possibly because the jokes he depicts have morals tagged to their punch lines.

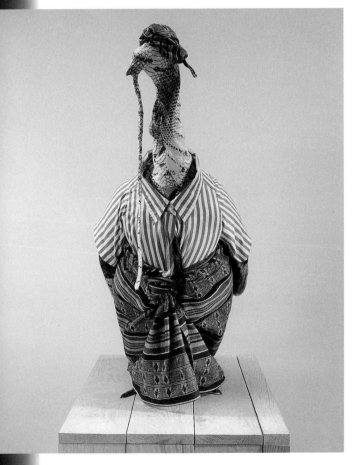

Untitled Turkey XV, 1992
Snakeskin, fabric, stuffed turkey, and mixed media on wood base, 30 x 32 x 14 in. (turkey), 37 x 17 x 32 in. (base)
Collection of the Tel-Aviv Museum of Art, Gift of Mr. Ronald E. Lauder
Courtesy the artist. Photo: Steven Sloman

HUMOR

MEYER VAISMAN
Untitled Turkey XIV, 1992
Icelandic lambswool, chickenwire,
stuffed turkey, and mixed media on
wood base, 28 x 28 x 27 in. (turkey),
30 x 35 1/2 x 31 in. (base)
Collection Eli Broad Family Foundation,
California

Courtesy the artist
Photo: Steven Sloman

MEYER VAISMAN
Untitled Turkey VII, 1992
Mixed media, 30 3/4 x 31 1/2 x 33 1/2 in. (turkey),
37 x 28 x 14 in. (base)

Courtesy the artist
Photo: Steven Sloman

MEYER VAISMAN creates art in pursuit of
a smile, but he is not an endearing clown who
pokes fun at his own fumbles and foibles. His
wit is searing and blisters nearly everyone. The
brunts of his jokes include complacent subur-
banites and social strivers, polite conformists
and trendsetting deviants, art aficionados and
dedicated philistines. His barbs and insults impli-
cate so many segments of the population that,
inevitably, self-revelation accompanies the gig-
gles they elicit. When jokes beget insights of this
magnitude, they acquire the significance of art.

In a recent series, Vaisman magnifies human flaws until they assume farcical proportions. His method involves transferring human defects to an animal. Of course, not any animal can serve as a surrogate for vanity, greed, ineptitude, gullibility, and arrogance. Ducks, for instance, are too cute. Why else would they be molded in bright yellow to make a child's bathtime a playtime? Likewise, swans are inappropriate because they epitomize grace and elegance. Why else would their arching forms be represented in such elegant materials as crystal, porcelain, ivory, brocade, and silver? The aptness of Vaisman's choice—the turkey—is evident in the answers to the following questions: Do you wish to own a pet turkey? Why don't cookbooks offer recipes for parakeet stew and canary pot pie but include dishes made of leftover turkey? Why has there never been a ballet entitled "Turkey Lake," but there is a ragtime dance that embodies the unruly energy of the Roaring Twenties called the "Turkey Trot"? Would you buy a car known to be a "turkey"? Would you covet the "turkey-of-the-year" award? Is going "cold turkey" a pleasurable experience? Is "talking turkey" an amiable form of discourse?

The divergence between the scorn turkeys endure through life and the esteem they accrue when they are dead and stuffed offers a rich vein of comedy that Vaisman mines with a vengeance. Alive, turkeys serve as poignant metaphors for ludicrous appearance, physical ineptitude, pomposity, and stupidity. But they rise, in their afterlife, atop mantles as hunting trophies or on platters as Thanksgiving treats. Dead, they conjure revered American values: the hunter's prowess in the first instance; the Puritan work ethic, wholesome family values, and respect for the will of God in the second.

Vaisman dramatizes the lunacy of turkeys' claims to glory by stuffing them like trophies and grooming them like pets. This lowly/lofty dichotomy becomes a wholesale burlesque when he then dresses these ungainly fowls in sumptuous accessories, treats them to lavish coiffeurs, and presents them as art.

In contriving this lofty perch, Vaisman exempts himself from four conventional categories of artistic expression. He is not an idealist

MEYER VAISMAN
Untitled Turkey VIII (Fuck Bush), 1992
Silk organza, men's underwear, stuffed turkey, and mixed media on wood base, 31 x 39 x 34 in. (turkey), 31 ¼ x 44 ¼ x 34 in. (base)
Collection Dakis Joannou, Greece
Courtesy the artist
Photo: Steven Sloman

who corrects the turkeys' natural dysfunctions, a romanticist who finds these flaws charming, a realist who renders their appearance accurately, or an expressionist who projects his emotions upon them. Instead, Vaisman is a comedian who aggravates turkeys' natural ineptitudes. His tactic involves a new form of dressing that is unrelated to bread and chestnuts. It consists of eccentric "fashion statements." Skirts constrict the turkeys' legs, exacerbating their awkwardness. Hoods, veils, wigs, and hats obliterate their eyes and muzzle their beaks. Clothes designed to cover certain parts of the body expose those parts and hide others. His turkeys are so stupid that they don't know over from under, top from bottom,

inner from outer. Their outfits are blatantly mismatched and some are even worn with cleaner tags still attached. Yet Vaisman's birds are too vain to be embarrassed by these displays of bungling. In fact, these attired turkeys resemble nothing so much as us: plump, graceless, and often narcissistic. They are stars in a riotous

MEYER VAISMAN
Uffizi Portrait, 1986
Process ink on canvas,
74 x 136 x 16 1/2 in.
Courtesy Jay Gorney Modern Art, New York

spoof on human personalities.

In Vaisman's funhouse farce, one turkey is transformed with a curling iron, which fashions its feathers into rippling cascades of ringlets. Another wears a red bouffant Andrews Sisters wig that covers every part of its body except the head. These birds are reminders of vanity's dual meaning as both narcissism and futility. Vaisman has endowed his turkeys with an essentially human prerogative to alter their appearance. By assigning these activities to a homely fowl, he pokes fun at our obsessive tampering with our natural attributes. Anyone who has straightened naturally curly hair, curled naturally straight hair, or dyed, streaked, and tinted their hair is a subject of these satires.

Impishly juxtaposing a bureaucrat's striped office shirt with an exotic sheath, Vaisman makes it as difficult to discern the identity of his turkey in the art gallery as that of many people on the street. His creatures display the hodge-

podge of possibilities that exist in today's cluttered and codeless society, combining clothes and hairstyles for punksters and nerds, rockers and bureaucrats, dowagers and whores. The human query applies equally to this turkey: is he a misguided conformist or a trendsetting rebel? Vaisman's burlesque mirrors the real-life comedy of misreadings that result from contradictory and oscillating identities. Since the 1960s, the norms of dress that once neatly announced social class, status, age, and sex have been disbanded.

At the time Vaisman was creating his turkeys, Madonna was appearing on stage in corsets and fingerless gloves; the gangster, Vincent (the Chin) Gigante was marching through the streets of New York in his bathrobe and slippers; Daryl Hannah was defining skateboarding pants as the new Hollywood chic; Don Johnson was making pink okay for men; Marky Mark was baring his boxer shorts; President Clinton was posing for pictures in jogging shorts. Fashion off the pages of magazines was in turmoil as well. On "dress-down Fridays," corporate executives go to work looking like maintenance workers. Country-club members wear sweatpants to church. Female lawyers arrive at work in business suits and sneakers. Even corpses are being laid to rest in "designer" jeans that are artificially aged, faded, torn, and patched. Waiters often dress better than their customers. Vaisman delights in stimulating laughter among gallery goers, the very people who are likely to be participating in this laissez-faire fashion environment.

Vaisman also shuffles the deck of such conventional body coverings as skin, feathers, fur, hair, and clothing. Creatures sacrificed to become attire now become the attired. In *Untitled Turkey VII* (1992), a turkey completely disappears beneath the long, white, winsome fur of an

Icelandic lamb. In *Untitled Turkey I* (1992), a turkey sports a white rabbit outfit. The viewer is likely to laugh at the preposterous notion that lambs and rabbits have supplied clothing for these turkeys, but less comical questions are raised in the process. Is wrapping human skin with fur and feathers a preposterous presumption too? Is it any more ludicrous for a turkey to wear a human wig than for a person to wear a feather hat? Do people dressed in fur look as ridiculous as these turkeys? These ludicrous species-to-species "cross-dressings" challenge the hierarchy that humans impose on the animal kingdom when they utilize nature for their own purposes and pleasures.

In other works, Vaisman employs cross-dressing to reveal the muddling of human sexual categories. He randomly assigns bully and sissy characteristics to Tom and hen turkeys, punning the proliferation of deviations from sexual norms that are paraded on today's city streets. He throws these ingredients into his turkey stew and brings it to a mirthful boil. The turkey in *Untitled Turkey VIII (Fuck Bush)* (1992) wears a pair of saggy (soggy?) men's underwear and a bouffant swirl of sheer silk organza satirizing butch lesbians and gay transvestites, customers of unisex boutiques, power-dressing career women, and primping men.

Even species and genera join in Vaisman's identity-bending abandon. One turkey sprouts a full set of antlers and a furry tail. Another is transformed mermaid-fashion into a snail. While we chuckle over the absurdity of these hybridizations, the sculptures raise nagging questions about the strange new life forms that may actually exist once genetic codes are fabricated instead of inherited. Scientists and manufacturers afford countless opportunities to tinker with our bodies and our birthrights. Social strictures have developed porous borders. Vaisman's flock of turkeys serves as allegories of interracial households, multiethnic matings, rearranged genders, and spliced genes. He proclaims, *"we are all mongrels."*

These unpedigreed inventions reveal as well Vaisman's real-life biography. His Molière mix-ups are not mere social comments. They are self-portraits too. In "I Want to Be in America,"

published in 1994, Vaisman described his sexual, ethnic, and religious background.

SEXUAL IDENTITY: *"I was born Meyer Vaisman Eidelman on a beautiful May morning in 1960 in Santiago de Leon de Caracas. I was so pretty as a newborn that the nuns who took care of Mom told her I should have been a girl. There have been many times in my life that I wished I was a girl."*

ETHNIC IDENTITY: *"My parents were born in neighboring villages, Dad in Hotin, Mom in Novasulita. These villages are located on the outskirts of the city of Chernovtsy in what is considered now the Ukraine, and what was considered earlier in this century, well . . . the Ukraine. Before it became the Ukraine again, it had been considered at different times and for different reasons the U.S.S.R., Imperial Russia, Rumania, Nazi Germany, and also the Austro-Hungarian empire. Dad sees himself as Russian, Mom as a Rumanian. I have been a witness and a participant in many a fight between them concerning this matter, and I have also been a witness in a centuries-old and, sad to report, ongoing feud concerning that part of the world. Three years ago I could have claimed citizenship in the U.S.S.R. Today I would have to trade it in—in much the same spirit and manner in which you would a car—for a Ukrainian citizenship. I also could claim my credentials as both a Russian and a Rumanian. I could travel anywhere in that area of Europe, or is it Asia, without having to feel like a mere tourist."*

CULTURAL IDENTITY: *"The diet (of my childhood) consisted of Stuffed Cabbage with Black Beans, Borscht with Fried Plantains, Stuffed Derma with Mondogno, and, my favorite, an occasional Milky Way candy bar. The beverages: Pepsi Cola, Chicha, Beer, and Rum. The music: a sampling of Salsa, Hora, Rock'n'Roll, and Bolero. The dress code: indestructible teenage gear, jeans and t-shirts."*

RELIGIOUS IDENTITY: *"Not long ago I was described as a one-man walking talking multicultural artifact. I grew up in a Jewish home. It was run-of-the-mill concerning*

religious practices. Major holidays and such. Emilia, the housekeeper, would come into my room in the middle of the night and quietly slip a crucifix on my neck, say a few words in Latin, and leave just as quietly as she came in. This procedure was repeated in reverse first thing in the morning. A Jew by day, a Catholic by night. I'll be damned!"[1]

"People should be relieved by my frivolity. The most incredible crimes have been performed by so-called serious and committed people with a mission in life. Nobody frivolous ever attempted to organize a bunch of people to murder their neighbors."

Jokes depend on such incongruities. In her analysis of the mechanisms of humor, Mary Douglas has written that "(Jokes) bring into relation disparate elements in such a way that one accepted pattern is challenged by the appearance of another which in some way was hidden in the first."[2] When unanticipated conclusions are discerned, we laugh. Douglas's description aptly applies to Vaisman's gags, which consist of improbable meanings replacing apparent or expected ones. The surprise of discovery is greeted by laughter.

Vaisman rejects the myth of the artist as a degenerate, tormented lunatic who ends up showered with prizes, stating, *"our civilization wants to make artists into clowns. It's like a circus act."*[3] He proceeded to transform this metaphor into actuality by parading as a clown and conducting his career like a circus act.

Self-mockery unites the turkey series to other works. In self-portraits, Vaisman presents himself in his most banal, bloated, impotent, unglamourous, and cowardly form. These self-portraits include grinning cartoons of his face. Some were drawn by an anonymous street caricaturist. Others present him as a hunting trophy, a booby prize awarded to those who collect his work. Still others titled *Morgue Slabs* (1988) profess that the wish to be immortalized in art is a wish to enter an early state of rigor mortis. In these portraits, the artist is equated with a mortician, just as the turkey series identifies the artist as a taxidermist.

Vaisman not only satirizes the veneration of the artist, he also targets six hallowed principles of art:

1. THE ENDURING MASTERPIECE: Vaisman's choice of the word "souvenir" as the title of a series of paintings pokes fun at the presumption that being awarded a place of honor in the annals of art history is anything more glorious than becoming a nostalgic memento, a mere souvenir.

2. THE ART COLLECTOR: *Post-Mortem Bull* (1987) is a painting of cartoonish images of mounted animal heads. Here, collecting art is likened to collecting carcasses. The title echoes "postmodern" bull and predicts that postmodern art will inevitably turn into trophies of a moribund effort. Vaisman's mockery is particularly prickly since he is one of the artists who led the postmodern crusade that has monopolized the art world since the 1980s.

3. CONNOISSEURSHIP: Connoisseurs who take it upon themselves to direct their tutored gaze upon a Vaisman painting are confronted with the foolishness of their self-aggrandizing "insight." Consisting of nothing but the enlarged pattern of canvas cloth, these paintings reveal that close scrutiny of a masterpiece is often more a matter of myopia than revelation. Yet even painting canvas weave by hand would be a self-glorifying act, displaying the artist's skill, style, and sensitivity. Vaisman pokes fun at the veneration of the creative act by employing a weaving pattern derived from readymade Press-Type. This pattern is photomechanically silkscreened to his canvas. Not even the silkscreening is executed by the artist, who assigns the task to studio assistants. In all these ways, he plays a practical joke on art connoisseurs. He has created a painting in which even the original is—according to convention—inauthentic.

4. ORIGINALITY: Vaisman mocked the pomposity of the gallery system in an exhibition of his works at a prestigious art gallery. His installation mimicked the display mode of a poster gallery in a suburban mall. Laminate coatings enclosed his paintings in shiny, transparent, durable packaging. They were stacked two or

three deep, implying they were mass-produced. Vaisman further adopted the mall's flagrant sales tactics, interjecting the "three-for-the-price-of-one" promise of a bargain. Paintings thus stripped of their illusions and pretensions are demoted to lengths of fabric that could be sold by the yard.

5. THE ARTIST AS GENIUS: Vaisman equates the lofty heroics of abstract expressionism with anal-expulsive acts by mischievously smearing a canvas with thick brown gel. To reduce the artist's soulful probings to the level of infantile play, he applies toy blocks and rubber nipples to some paintings. To demote the solemnity of the art object, he incorporates juvenile fabrics patterned with teddy bears, rabbits, and frogs.

6. SOPHISTICATED ART TERMINOLOGY: Vaisman's "dirty jokes" extract the comic potential of art journal terminology. The word "stretch" in *The Stretch Painting* (1987) does not refer to the process of attaching canvas to a frame, but rather to the work's portrayal of a pair of penile erections. *Painting of Depth* (1986-88) is not concerned with the rules of perspective; it presents three receptacles at pelvis height, inviting a phallic measurement of the canvas' depth. *Period Piece* (1989) has nothing to do with the history of art; it refers to the monthly functions of the female body. *The Whole Public Thing* (1986) is not related to art's social function; it displays privy-style toilets.

Invectives, insults, and disparaging remarks are the primary tools of all humor. To "get" a joke is to recognize the intended ridicule. Vaisman uses humor to assert that art is not necessarily the embodiment of lofty ideals, that connoisseurs sometimes act more like prigs than aesthetes, that artists are ordinary people. But his burlesque is not confined to the art world. *"The mechanisms that determine the art world also determine business, politics, and religion."*[4]

Vaisman is less likely to make meaning than to dismantle it. *"If you're asking me whether artists should render the violence they witness or offer up solutions—in other words where I place the notion of morality in terms of art—I would answer that there's little room for moralizing in art. You know, morality is based on a collective hunch. Everything in life is invariably polluted by subjectivity, and subjectivity not only changes with time, but also with cultural and ethnic dif-*

ferences. Though I've been repeatedly accused of being amoral, I'm not nearly as amoral as, say, Leonardo da Vinci was considered to be in his day. Da Vinci cut corpses open to study their insides. What we call anatomy today was considered a moral sin during the 16th century. What I would condemn in life I would condone in art. Art breeds a type of anarchy that can only be sustained by tyranny. Leading a life of art is like leading a life of crime. I try not to impose my own morality onto my work and I guess I have succeeded given my reputation."[5]

Vaisman's holdups are conducted with gags instead of guns. They rob the viewers of delusions, not dollars. To those who still believe that humor compromises art's eminence, Vaisman comments, *"People should be relieved by my frivolity. The most incredible crimes have been performed by so-called serious and committed people with a mission in life. Nobody frivolous ever attempted to organize a bunch of people to murder their neighbors. What the world could use is more people like me."*[6]

VAISMAN POSTSCRIPT:

There are many ways of learning. Each suggests an attendant method of teaching. These varied means of instruction are widely allocated among artists. Meyer Vaisman teaches by making us laugh. Christian Boltanski teaches by making us cry. The Gerlovins teach by stimulating new patterns of thought. Jeff Koons teaches through outlandish displays of honesty. Joseph Beuys took chalk in hand, stood before a blackboard, and taught by teaching. Gonzalez-Torres taught by modifying behavior patterns. Wolfgang Laib teaches by setting an example in his life. Andrea Zittel teaches by designing lives. Mel Chin teaches by distributing scientific information.

Kate Ericson & Mel Ziegler

IN DESCRIBING THE WORK of the collaborative team of Kate Ericson and Mel Ziegler, art critics must add to their aesthetic vocabularies such unlikely words as musty, pungent, foul, fragrant, and aromatic. These words convey the work's metaphoric and expressive content. For smell plays a vital role in the perception of some of Ericson and Ziegler's most acclaimed projects.

SMELL

Smell & Taste of Things Remain, 1992
Antique cabinet, etched glass jars, perfume,
62$^{1}/_{2}$ x 48 x 16 in.

Courtesy Themistocles and Dare Michos, San Francisco
Photo: Orcutt Photo, New York

Ericson & Ziegler

Kate Ericson
Born 1955, New York City; died 1996
University of Colorado, Boulder
Sir John Cass School of Art, London
Kansas City Art Institute, Missouri: BFA
University of Texas, Austin
California Institute of the Arts, Valencia: MFA

Mel Ziegler
Born 1956, Campbelltown, Pennsylvania
Rhode Island School of Design, Providence
Kansas City Art Institute, Missouri: BFA
California Institute of the Arts, Valencia: MFA
Lives in New York City and Pennsylvania

EVERY WAKING INSTANT, multitudes of haphazard sensations are registered by the body, all in need of identification, recording, cataloguing, and storage. Their ports of entry are sense receptors located in eyes, tongues, noses, ears, and skin. Their destination is the brain, which not only monitors rapid-fire responses to these environmental stimuli, but stores them for future reference. It is believed that smells, tastes, sights, and sounds comprise the building blocks of memories. Sense impressions seem active in retrieving memory as well. Even the most fleeting sensation is capable of recovering a past event in all its evanescent complexity. The smell of freshly mown hay or the sound of a train whistle, for example, can summon a long-dormant memory.

Kate Ericson and Mel Ziegler applied this micro model to the macro sphere, examining the means by which a nation records and retrieves its history. Instead of painting pictures that chronicle history, they created experiences that activate remembrances of it. This goal led the artists, who worked as a team from 1978 until Ericson's death in 1996, to reject the presumption that art is exclusively optical. They enlisted smell and taste as well as sight to resurrect the sensual basis of our cultural legacy and the institutions that preserve it. In their art, "mixed media" refers to the accumulation of sensual impressions involved in a work's transmission and reception.

For *Smell & Taste of Things Remain* (1992), Ericson and Ziegler used an actual antique

cupboard, fabricated between 1875 and 1900 and known as a pie safe. These safes protected freshly baked pies from being consumed before their appointed time. Although the pies placed inside could not be seen or touched, their aromas escaped through the safe's perforated metal ventilating doors. In *Smell & Taste of Things Remain*, this cupboard now functions like the brain because it holds memories, not pies. The artists envelop the visitor in old-time aromas and bygone tastes that are both imagined and actual. The cupboard's shelves are lined with eighty large jars whose surfaces are etched with the names of 400 regional American pies. These inscriptions are written in a quaint, old-fashioned script that recalls the era prior to transnational, mass-produced desserts by Pepperidge Farm, Mrs. Smith, and Sara Lee. Homebaking and regional traditions are the sources of "Shaker Shoofly," "Jefferson Davis Pie," "Florida Key Lime," "Mississippi Mud," "Yosemite Mud Bavarian," "Blue Grass Chess," "Trigg County Pecan," "Door County Montmorency Cherry," "Charleston Lemon Chess," "St. Landry Parish Sweet Potato Pecan Praline." The names alone rekindle forgotten flavors and scents.

In this work, the artists involve two means by which America's memories are stored and retrieved. Their selection of pie names honors an unofficial archive of recipes gathered from families, churches, and other community groups throughout the country. This archive is entrusted to mothers and grandmothers who perpetuate our culinary heritage by sharing recipes with members of succeeding generations. It represents an ad hoc manner of sustaining our cultural legacy.

"You can't own a smell. It is not stable. It won't last. It will dissipate."

Ericson and Ziegler also incorporate our nation's official history, rejecting the representation of its battles or treaty-signings in favor of the replication of its smell. It is upon this whiff that the nation's history is ushered into the present. The amber-colored liquid that fills the jars in the pie safe was commissioned by the artists from a custom scent designer, Felix Buccellato. Scent designers, commonly referred to as "noses," are trained to analyze the components of an aroma, interpret its character, and then synthesize it in a laboratory. The specific fragrance requested by Ericson and Ziegler was not a perfume. It was not even the tantalizing aroma of fresh-baked pies. Buccellato was hired to replicate the musky smell of the National Archives in Washington, D.C. This immense institution is the official repository of past events. Like a national brain, it stores the residue of our collective inheritance. Thus its aroma is, quite literally, the smell of American history.

Buccellato and the artists gained permission to enter areas in the National Archives that are not normally accessible to the public. Buccellato then returned to the laboratory and simulated this peculiar, pungent aroma. It is this aromatic essence of American history that fills all eighty jars in the pie safe. Although it appears as enclosed and protected as the artifacts in the Archives, the fragrance permeates the gallery just as it does the Archives building itself, where the smells emit from the decomposition of the materials stored there. Significantly, the artists did not choose a smell associated with preservation (e.g., formaldehyde). The work's message is lodged in the smell of decay. By presenting a sensual emanation of the passage of time, Ericson and Ziegler demonstrate that our nation's past is as tenuous as a person's. The Archives prove that even our most determined efforts to preserve memories are futile. The artists' description of smells applies equally to history, *"You can't own a smell. It is not stable. It won't last. It will dissipate."*[1]

The artists further note that the smell of the National Archives imparts the collective heritage of the United States and its democratic ideals: *"We chose to work in the Archives because it is said that every U.S. resident is listed in the Archives at least seven times. Everyone is represented. If you pay your taxes or write to your congressman, you are there."* The piquant, layered, rich, and pleasant aroma of the Archives sustains our national ideology. Like regional pie recipes, it celebrates the co-mingling of diverse cultural traditions.

Certainly, the smell of decaying documents has little in common with perfumes, car fresheners, scented cosmetics, household cleaners, aro-

matic air sprays: the olfactory muzak that pervades many of today's public spaces. Yet Ericson and Ziegler used this smell again in *Soap Samples* (1992), which was displayed in the exhibition, "Anyone Can Make History" at the Michael Klein Gallery in New York. The artists' intentions for the work exceed such an exclusive setting. Awakening historic memories demands a sensual relationship with the work of art, a relationship prohibited by the gallery's "don't touch" rules. Furthermore, historic memories belong to all the populace, not just art viewers. In order to reach the vast number of individuals who are not gallery goers, Ericson and Ziegler have devised a route directly into the commercial stream of the nation. They plan, someday, to manufacture their soap in a factory and market it across the country in normal merchandising networks. Then their art will no longer be restricted to vicarious experiences for a privileged group.

What makes mass-produced soap eligible to be art? The artists respond: *"The soap will be art because every aspect of making the thing will have meaning: the color, its imprint, its scent, its wrapper, its shape . . . It will become part of everyone's daily activities. Art will infiltrate the domestic setting. It may not appear like art, but everyone will recognize that it is special. People will scrutinize the aroma, shape, size, color, and when they use it, they will think about the process of using it, the effect, about all similar things in their lives."*

When art ceases to look and function like art, is it still art? Ericson: *"Our projects usually do not call attention to themselves as 'art,' and they are not introduced into a context in order to beautify it."* Ziegler: *"Well, it's not even a necessity that our projects be called 'art'."*[2]

When self-expression is sacrificed to social utility, are the creators still artists? *"We view (art) as a way of directing attention away from us—to point out towards different situations, rather that focusing attention on ourselves as the creators of objects."*[3]

How do Ericson and Ziegler define their artistic roles? *"We see ourselves as catalysts*

KATE ERICSON and
MEL ZIEGLER
Historic Cleansing,
1992-93
Plastic bottles, labels,
prototype for public
project
Courtesy Michael Klein
Gallery, New York
Photo: Orcutt Photo, New York

to intervene in the processes of society that already exist. We want our work to be in line with the pragmatic production of the house painter, the plumber, or the carpenter. We work from within a system, but we put a social spin on it."[4]

Non-visual aesthetic stimuli bring the past into the present. Other apparently divergent works of art by Ericson and Ziegler also instigate a healthy reappraisal of history among the masses. *"We look for forms that have pragmatic application, that are common, that represent a universal need, cheap, replaceable, things that remind us of choices and our conditioning."*[5] These works define four options for relating to history: discard it, romanticize it, suppress it, or ignore it.

DISCARDING THE PAST: Histories are too long and complicated for every occurrence to be recorded and assigned equal significance. Some events are remembered. Others are omitted and eventually forgotten. Chronicles of the past are, unavoidably, invented narratives. This selective process applies to histories that are personal, familial, and national. The weeding and pruning that occur on all three levels create identities and

dry sinks to factories, and from manual effort to fully automated machines.

Historic Cleansing (1992-93) is a proposal for a project that focuses on the ongoing conflict between preservation and progress. It highlights the trend in which farms are sold to become malls, and landmark buildings are demolished to make room for highrises and parking lots. In this work, Ericson and Ziegler focus on the threat-

ened destruction of an architectural masterpiece, Le Corbusier's *Unité d'habitation* in Firminy, France. Their proposed project is a pun on the term "historic cleansing." It consists of replacing the cleaning fluid in bottles of a locally produced household cleaner with one of their own devising. Instead of the original ammonia smell, the artists plan to create the smell of "monument," a word

KATE ERICSON and
MEL ZIEGLER
Self-Absorbed, 1992
Printed paper towels,
prototype for public
project

Courtesy Michael Klein Gallery,
New York
Photo: Orcutt Photo, New York

determine destinies. *Keep an Eye on Your Pickles* (1993) applies this process to American history by conjoining an unlikely trio of found objects, each from a different historic era. It presents evidence that our

assigned to things that are old but worth preserving. The cleaner's normal label will be altered by inserting images of the threatened landmark building. The newly bottled cleaner will be sold in local grocery stores. In this and other works, the artists seek *"to return a sense of power to the individual over his/her built environment . . . We do not project a specific position that we cherish—or we would like to impose."*[6]

past is an accumulation of disparate traditions. A dry sink recalls domestic life prior to indoor plumbing and heated water. It refers to an era in which labor was arduous, manual, and honorable. The names of 300 Sears prefab houses refer to the middle years of the twentieth century, when pride of workmanship and individuality were exchanged for instantaneous housing for the soldiers returning home from World War II. Mass-produced jars of pickles document the transfer of food production from kitchens with

ROMANTICIZING THE PAST: *Anybody Can Make History* (1992) consists of an early American cabinet filled with glass jars containing commercially produced latex house paints. Their commercial names are etched on each jar— "Pilgrimage," "Patriot," "Fox Hunt," "Hospitality." These names don't provide any information about tone and hue, but they cleverly exploit the public's nostalgia for eighteenth-century values. Manufacturers thus "make history" by choosing paint names that capitalize on the popular

appeal of Colonial-style architecture and furniture, which survive despite their proximity to CD players, VCRs, microwaves, air conditioners, and satellite dishes. The artists alert us to marketing strategies that romanticize our past.

SUPPRESSING THE PAST: *Eminent Domain* (1992) also utilizes a paint chart to satirize the malleability of history. But instead of presenting the idealized truths that have been included in the public record, here Ericson and Ziegler concentrate on uncomfortable truths that have been omitted. The colors on this paint chart have been renamed by the artists to resurrect a chapter in American social policy that is ignored by paint producers and bypassed on patriotic occasions—the controversial history of public housing in the United States. Paints are assigned such telling names as "FHA Gingerbread," "Authority White," "Blue Ribbon Panel," "HUD Cream," "Tenement Condition," and "Housing Census Shadow."

IGNORING THE PAST: *Self-Absorbed* (1992) is a project that involves mass-producing a paper towel and distributing it nationally in grocery stores. The pattern printed on the towel consists of a photographic reproduction of the first letter of the first word of the United States Constitution, which is then turned upside down and backwards. In the process, "we" becomes "me." Thus "we the people of the United States" is altered to become a witty and unsettling comment on the self-absorption of members of the "me" generation and their disassociation from the moral grounding provided by the founding fathers. The Constitution's preamble clearly announces their unifying vision: the first "we" is followed by a collective noun, "the people," and the collective phrase, "to form a more perfect union." In *Self-Absorbed*, a cherished patriotic event is demoted, as it often is in life, to a decorative motif on a trivial object.

Each time Ericson and Ziegler insert into the living present such antiquated experiences as farm life and homemade food, they fortify memory against the inevitable ravages of time. *"This is not a confrontation, but subconscious. It cannot be seen but it cannot be avoided."* The parameters of conventional art are transgressed in order to assure these experiences are encountered by a vast public. Some pieces are dispersed sensually in the form of the aromas of history.

Others enter the lives of the populace functionally as mass-produced and marketed commodities. In both cases their work drifts into the life of the user and gently exerts its influence within the context of everyday experience.

ERICSON AND ZIEGLER POSTSCRIPT:

Many living artists reject the notion that art is a solo occupation. Kate Ericson and Mel Ziegler divided labors and shared responsibilities on the domestic and the studio fronts. Rimma Gerlovina and Valeriy Gerlovin have a similar relationship, but Gilbert and George do not. Instead of being partners, Gilbert and George abandon their individualities to merge into a single art entity. For many years Marina Abramovic's companion, Ulay, was her masculine alter ego, who served as her lover and the co-creator of her art. The associations formed by Rosemarie Trockel with machinists, Donald Sultan with studio assistants, Orlan with plastic surgeons, and Jeff Koons with artisans concern the allocation of tasks, not decisions. Sherrie Levine selects partners who can no longer voice opinions; they are deceased. Mike Kelley also works with silent partners, the anonymous women who crafted the toys in his sculptures. Paul Thek and Vito Acconci invite two kinds of collaboration: one occurs during the process of creation and the other during the period of display. This proliferation of shared efforts gives significance to the solo efforts of Janine Antoni, On Kawara, Wolfgang Laib, and Chuck Close.

Vito
Acconci

TWO ISSUES—"where we are" and "who are we?"—are not merely posed by the title of a 1976 work of art by Vito Acconci, they are inflicted on unsuspecting viewers. No one in hearing range of *Where We Are Now (Who Are We Anyway?)* can escape the interrogation it instigates. This artwork contains a script and a score. Viewers are thus also listeners. They encounter a barrage of sound projected from two seventy-minute audiotapes: muffled voices, a dramatized recitation, musical instruments, and such noisemaking objects as clocks and gavels.

Where We Are Now (Who Are We Anyway?), 1976
Exterior view of installation
Courtesy the artist and
Barbara Gladstone Gallery

SOUND

Vito Acconci

Born 1940, Bronx, New York
Holy Cross College, New York
University of Iowa, Burlington: MA literature
Lives in Brooklyn, New York

VITO ACCONCI
Trademarks, 1970
Activity, undetermined number of ink-prints
Courtesy the artist and Barbara Gladstone
Photo: Bill Beckley

WHAT IS THE SOUND of art-viewing?
The hushed stillness of intense perceiving.

What kind of demeanor is welcome in museums? A silent viewer engrossed in the contemplation of a silent art object.

What is the ultimate exchange between the viewer and the artwork? A rapture in which language is halted and time is suspended.

Concurring with these answers suggests the opinion that sound is an alien aesthetic ingredient in art, one that impinges upon such long-established tenets as: art is an inaudible, tangible representation of a mood, event, or thing; spoken words belong to theater, not art; instrumental sounds belong to music, not art; environmental noises belong to life, not art.

Contemporary artists like Vito Acconci challenge art viewers to expand the aesthetic territory of art. *Where We Are Now (Who Are We Anyway?)* (1976) bombards the audience with clatter and clamor emitting from two tapes playing simultaneously at different locations within an art gallery. Sound surmounts one-dimensional viewing of two-dimensional paintings and three-dimensional sculptures. The interface between the audience and the artwork unfolds as a dynamic sensorium in the surround. Art's dimensions expand from the physical edges of an object to the limits of the space. Multiple senses are engaged. Events unfold in time. Tension escalates. Suspense builds. The visitor does not interrogate this artwork; it is the artwork that interrogates the visitor.

Because sound's scale is boundless and its essence invisible, it is an unlikely component in visual art. Art incorporating sound mirrors the new technologies that no longer specialize in single-sense transmissions. Music videos, CD-ROMs, and videophones have annexed visual partners to auditory forms of communication. Virtual reality and robotics combine multiple faculties of perception. Computers speak. Security systems are

voice-responsive. Acconci's unfettered use of words and noise parallels this sensory fusion. An argument can be made that static, silent, optical art may eventually seem as archaic as silent movies, phonographs, and typewriters.

VITO ACCONCI
Following Piece, 1969
Activity conducted in various locations in New York City
Duration 23 days
Sponsored by the Architectural League of New York
Courtesy the artist and Barbara Gladstone Gallery

The altered turf on which art is created has necessitated changing its ground rules. Since the early 1970s Acconci has been at the forefront of this revision.

In that decade, he poked into various art forms, plucking and assembling their components to create art that offers diverse, non-visual perspectives. He seemed never to have considered working with canvas and paint or other conventional art mediums, nor to have thought of art as embellishment. His springboard into art originated in poetry. His training in literature, philosophy, psychology, and sociology disposed him toward forms of expression that employ words and evolve over time. Even Acconci's titles are composed like poems. For instance, the implications of the two deceptively simple sentences in *Where We Are Now (Who Are We Anyway?)* are expanded by the last words in each phrase. The "now" introduces thorny issues of lifelong destinations. The tag "anyway" raises metaphysical speculations about group identity. They define the themes of this landmark piece.

Acconci has frequently stated that he abandoned his writing career because *"the physical space was confining."* It was not the room in which he wrote that he found restrictive; it was the page on which his words appeared. When his creative endeavors sprang from the printed page and occupied space, he became an artist. In the literal sense, his art activities explore physical boundaries. But physical boundaries are not simply sculptural concerns. They transmit psychological hurdles and social divisions as well. Acconci tampers with accepted borders between private and public, mine and yours, control and dependence: *"The goal of making work is to create some kind of peopled space from which to get back information about one's culture and the relationship to culture."*[1]

Another border Acconci transgresses is the one surrounding the components of art. The novel activities that comprise his career make these boundaries ever more permeable. One of his first goals as an artist was to eliminate paper and substitute his own body as the surface on which he made marks. In *Trademarks* (1970), Acconci bit himself until the marks of his teeth left deep impressions in his flesh. But here, as in writing, the art object (his body) was self-contained; it implied a boundary that separated the active artist from the observing audience.

A work that integrated the audience, even if it consisted of just one person, is *Following Piece* (1969). In it Acconci followed a stranger in the streets until that person entered a private place. Because the artist was dependent on the decisions of the stranger, the audience was active, but the artist was passive and inaccessible. Seeking a balanced exchange with the public, Acconci invented ways to dissolve the boundary encircling his private life. In *Mail—Service Area*

(1970), he arranged to have his personal mail delivered to New York's Museum of Modern Art, where it was publicly displayed for the duration of a show entitled "Information."

Acconci surmounted another boundary by devising two-way transmissions, from the artist to the audience and from the audience to the artist. In *Claim* (1971), the blindfolded Acconci—wielding a crowbar and two lead pipes—ranted repeatedly, *"I want to be alone!"* For three hours he drove himself to the brink of frenzy, daring visitors to challenge him or to admit their timidity and retreat. Either response fulfilled the intentions of this piece because each reaction necessitated action. *"I never leave out public opinion, not public appreciation but public consideration . . . , people are a part of all the pieces I do. I anticipate the range of responses."* [2]

Yet there remained another closed circuit between artist and viewer. Acconci broke through that boundary by removing himself from the artwork and creating emotionally charged settings that engaged many people simultaneously. *Where We Are Now (Who Are We Anyway?)* belongs to this endeavor. Sound plays five distinct roles in this work. It envelops visitors and becomes the catalyst for the unmediated exchanges with the public that Acconci consistently pursues.

ENGAGEMENT: As Marshall McLuhan observes, the human body has no earlids. Because we can't shut out sound, listeners are immersed in stimuli that reverberate in the body. These stimuli cannot be escaped, and they cannot be altered. Acconci exploits the tyranny of sound by choosing a theme that invites consideration of oppression. *Where We Are Now* addresses the ruthless competition in the art world.

SPATIAL STRUCTURE: Aural components establish the physical parameters in which the contest for fame within the art world is waged. Because ears detect the locations of noises, sound is adaptable as a sculptural medium. It erects the nontangible armature for *Where We Are Now* by differentiating inside from outside and high from low. In this piece sound dramatizes the opposition between art stars and art-star strivers.

SPATIAL DYNAMICS: A whisper requires that people stand close; it is intimate and personal. A shout spans distance and is used to attract attention or express anger. Sound without pattern is disorienting and may induce psychotic feelings. Acconci exposes visitors to all these aural forms of control. Noise prods them into action.

EXPRESSIVE VEHICLE: Acconci orchestrates noises, voices, and instruments, exploiting sound's full aesthetic range—the hypnotic effect of repetition, the disorientation from abrupt shifts in amplitude and tempo, and the oppression from barrages of speech. They erect palpable emotional resonances and disallow passive reception.

CONTENT: The audiotape gives structure to the story line and conveys the work's narrative. The distinctive voice on it belongs to Acconci, who describes his manner of speaking as *"what you would expect of a voice making an obscene phone call,"* [3] and as being, *"a storage of sexual associations (Humphrey Bogart, Ida Lupino). Also, it seems to come out of some depths, so it probably promises intimacy, sincerity, maybe some deep, dark secret."* [4] In a voice charred by the incessant smoking of pungent French cigarettes, Acconci delivers a mesmerizing volley of words.

Where We Are Now was created at the Sonnabend Gallery in 1976. This prestigious gallery is situated in the United States (then the international headquarters for contemporary art), in New York (the capitol of art in this country), in SoHo (the central art district in New York), on West Broadway (the main artery in SoHo). Acconci exploited this location, the seismic center of art world politics. The characters who perform his artwork are gallery visitors, the actual people who participate in SoHo's frenetic

"Art that results in empathy is a failure. Empathy is inactive. Empathy doesn't lead to action."

competition. As Acconci explains, *"I'm here to re-design, re-decorate a gallery—I'm working as a behavioral designer for an already-defined (pre-behavioral) public."* [5]

In this work, the gallery was divided into two areas: an enclosed room which could not be entered, and an open corridor which contained a long, bare table. Stools were set up on either side of the table. The table extended forty feet across the room, but it did not stop at the outer

wall. The table protruded out of the third-story window to form a plank or a diving board hovering over the street below.

These visual components were enriched by auditory experiences that cannot be conveyed through photographs. Tapes played continuously in both areas of the gallery. Muffled voices of an amorphous crowd could be heard coming from the boxed room, while the sounds of a meeting in progress filled the room that contained the table/plank and chairs. The contrast between chaos in one and organization in the other was dramatized by the addition of other sounds. Disorder was magnified by the continuous banging of a gavel, a futile attempt to establish order. The regimen of the meeting was intensified by the ticking of a clock. It introduced the impression of regulated schedules, appointments, timetables. These recorded sounds made the social dynamics of each gathering seem vivid, although the only bodies actually present in the gallery were those of the visitors.

The auditory narrative, which is the focus of this essay, seems to originate with the ticking of the clock. Acconci's voice is heard in the role of a presiding officer. He is soliciting opinions of individuals whose presence is implied by the stools around the table:

> *Now that we're all here together . . .*
> *(And what do you think, Bob?)*
> *Now that we've come back home . . .*
> *(And what do you think, Jane?)*
> *Now that we were here all the time . . .*
> *(And what do you think, Bill?)*
> *Now that we can take it . . .*
> *(And what do you think, Nancy?)*
> *Now that we take it or leave it . . .*
> *(And what do you think, Joe?)*
> *Now that we take what we can get . . .*
> *(And what do you think, Dan?)*
> *Now that we get what we deserve . . .*
> *(And what do you think, Barbara?)*
> *Now that we're satisfied . . .*
> *(And what do you think, John?)*

VITO ACCONCI
3 views of *Where We Are Now (Who Are We Anyway?)*, 1976
Installation: wood tables and stools, painted wall, 4-channel audio, 10 x 30 x 70 ft.
Courtesy the artist and Barbara Gladstone Gallery

These vacuous formalities accomplish no business. The meeting is a mere ceremony in decorum. Suddenly there is a startling shift in dynamics. A voice announces: *"Now that we know we failed . . ."* At this instant the clock stops ticking and is replaced by the tension-mounting sound of a violin being played very quickly. There is a sudden call: *"RISE! Change places! RISE!"* and then *"SEATS! Everybody! Take your SEATS!"*

The sound suggests a frantic shuffling in which the imagined participants scramble to assume new seats at the table. Acconci has invented a lunatic game of musical chairs. »Who will occupy the head? Who will be the flanking subordinates? Who will be eliminated? Who will be expelled? The tape continues: *"(But there's one left over . . . what do we do with that one . . . where do we put that one . . . what do we do with that one? . . .)."* These words transform the table's perplexing extension out the window into a tragicomic symbol of ostracism. It takes on the ominous appearance of a gangplank. Visitors recognize that the odd person out walks the plank, one more victim of the legendary rivalry that dominated the art world during this era.

Most visitors to this SoHo location are artists competing for "a place at this table." The scrambling, clawing, and yelling that is transmitted from the exitless room manifests their states of being. But Acconci doesn't present them with a simple "win-lose" scenario. He demonstrates that even those who have been awarded a place at the table are usually ill-fated. The aural text now projects a sequence of phrases. Each appears to be the final sentence of a long discourse describing the troublesome lives of those assembled:

> *So the family wept when we lost you that winter.*
> *So we answered the note for the kidnapper's ransom.*
> *So you criticize yourself. So you criticize your use of language.*
> *So you can't separate theory from practice.*
> *So you can't separate fact from fiction.*
> *So you came back out and sat down with us,*

> *and said you had sabotaged the factory.*

The sequence ends with the assertion: *"So now it's 1917. So now it's 1968. So now it's 1996"*—suggesting that the unhappy conditions of the chosen few existed in the past and will likely prevail in the future.

Again, there is the sound of the gavel and the call for *"ORDER! ORDER! ORDER!"* The crowd is heard saying:

> *We are the people. We have the people.*
> *We make the people, We make up the people.*
> *We have all the people we want.*
> *We have all the people we need.*

The crowd noises die and the voice over the table chants a series of disquieting contradictions:

> *And then you say go*
> *And then you say stop*
> *And then you say yes*
> *And then you say no*
> *And then you say kill*
> *And then you say die*
> *And then you say front*
> *And then you say back*
> *And then you say . . .*

The clock resumes its ticking and the interrogation continues with a new round of antithetical options and new players' names. The sound of the violin and the call to *"RISE! Change places! RISE!"* are heard anew. The competition for power is repeated. The frantic maneuvering for advantage recurs.

The art world provides a model of human dynamics that applies equally to relationships in business, government, and even families. In all of these categories, there are stars and there are supporting actors. That is why human interactions inevitably involve seduction, deceit, abuse, alliance, and conflict. Stars can't exist in isolation. *"I began to use the idea that there are these parts, but each part has no value except within the whole. Like in a baseball team. The second baseman alone means nothing. The second baseman in combination with the rest of the team makes it."*[6] Visitors to *Where We Are Now* weigh their frustrations against their accomplishments.

This theme recurs in Acconci's subsequent films, videos, playgrounds, and other interactive sculptures.

Three examples of recent sound pieces perpetuate Acconci's determined effort to *"provide some kind of situation that makes people do a double-take, that nudges people out of certainty and assumption of power."*[7]

Convertible Clam Shelter (1990) is an oversized clam shell that can be configured to serve in five different household capacities: a bed, an alcove, an arch, a tent, and a couch. It emits the rhythmic sounds of the sea, which contrast with conventional sounds of domestic life: radio, stereos, and television.

In *Home Entertainment Center* (1991), male and female dolls are converted into multifunctional toys for adults. Three orifices are proffered by these anatomically correct playthings. Acconci inserts a strobe light in one and an audio speaker in another. The third is brandished at the viewer at hip height, inviting sexual engagement.

Acconci's irrepressible impertinence takes center stage in *Adjustable Wall Bra* (1990-91). At 8 feet by 21 feet, it is the size of a conventional wall. And like a wall, it is fabricated of rough plaster and metal lathe. Amusingly, however, it is not flat like a wall, but full-bosomed. The bra is adjustable and can serve as a chair, a bed, or a room divider. Outfitted with lights and audio systems, it delivers a taped clatter of radio, stereo, and television mixed with the sounds of heavy breathing. Thus it provides the occasion for a hilarious jumble of sex, comfort, and regression.

Acconci compares the gallery to a *"laboratory."* There the artist serves as a *"behavior designer"* who reforms social conventions. But this seems too gentle an analogy for this artist's renegade efforts. Acconci's work can more readily be defined as a guerilla attack on entrenched bourgeois values. The gallery is the combat zone for his hit-and-run tactics. Recorded sound and text constitute potent weapons to irritate areas of sensitivity, disrupt belief systems, mock social norms, and exploit insecurities. Sometimes they nudge, but often they persecute the viewer, intentionally inducing a state of distress.

This approach to art-making is diagnostic, not therapeutic. *"I might want to shake up the existent order, but I don't really know what that ideal system should be. I think of art as anti-institution. Whatever becomes rigidified, I want the opposite of."*[8] For this reason, Acconci refuses to express his feelings about the human condition, arguing that, *"Art that results in empathy is a failure. Empathy is inactive. Empathy doesn't lead to action."*[9] Thus he goads, prods, insults, and flatters museumgoers until reaction overflows into action and a lifelong shift in behavior occurs.

Where We Are Now dispenses no advice, but it does offer a warning: people who fight their way through the querulous crowd risk a graceless dive to the pavement. Acconci's husky, monotone voice intones, *"I don't want people to jump. That is dynamic, but it would have pretty limited consequences."*[10]

ACCONCI POSTSCRIPT:

Painters and sculptors typically tell stories by depicting a dramatic instant or presenting a sequence of images. Laurie Simmons's dramatized tableaux provide an example of the former. Sophie Calle's photographic documentation of sleepers is an instance of the latter. The incorporation of sound, however, greatly expands art's storytelling potential by introducing the element of time, the natural medium through which narratives unfold. Sound enters visual art on tape in works by Vito Acconci, Amalia Mesa-Bains, Gilbert and George, Mike Kelley, and Barbara Kruger; on video in works by Orlan, Mike Kelley, and Carolee Schneemann; in virtual reality in works by Toni Dove; and in live voice by James Luna and Joseph Beuys.

Mike Kelley

MIKE KELLEY has earned acclaim as an artist by exhibiting old, soiled toys purchased from thrift shops. Art collectors eagerly pay large sums for these works of art although they are not beautiful, refined, sophisticated, rare, or uplifting. Kelley once confessed, *"I was scared...that I*

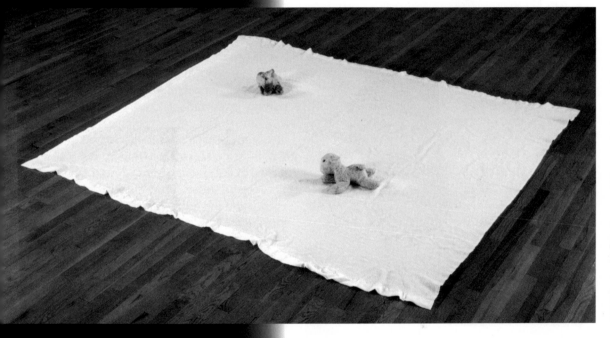

Shift, 1990. Stuffed animals and blanket, 83 x 89 x 7 in.
Courtesy Norman Stone and Norah Sharp Stone

would be accused of being a lazy artist."[1] What motivates an artist to subject his art and himself to ridicule? Apparently, Kelley thought the gain was worth the risk. He perceives art as an opportunity to foil mindlessly heeded, socially inscribed, and often damaging ideals and objectives.

homeliness

Born 1954, Detroit, Michigan
University of Michigan, Ann Arbor: BFA
California Institute of the Arts, Valencia: MFA
Lives in Los Angeles, California

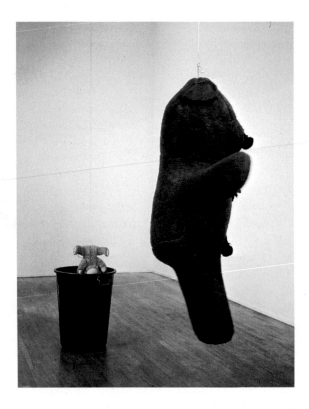

MIKE KELLEY
Reciprocal Relationship, 1991
Stuffed animals, plastic, wire,
dimensions variable

Courtesy the artist and Metro Pictures, New York

THE GERBER BABY, the Michelon Tire baby, the Pampers baby, the Johnson's Shampoo baby, the GAP baby, and countless other images of babies in popular culture are undeviatingly adorable. Similarly, paintings of bright-eyed, sweet-tempered, freshly bathed, and rosy-cheeked babies pervade the history of art, created by Raphael in the sixteenth century, Nicolas Poussin in the seventeenth, François Boucher in the eighteenth, Pierre-Auguste Renoir in the nineteenth, and Mary Cassatt early in the twentieth. Such idealized images of babies are so deeply implanted in the Western mind that they seem less an ideal than an assumed norm. There is evidence that they have come to dictate parents' expectations.

How would the psychological effect of these idealized baby pictures be translated into art that is created by a white boy from a blue-collar family in Detroit who grew up watching the race riots on the streets, children's programs on television, and the avant-garde films of William Burroughs; who attended Catholic parochial schools but delved into spirituality and scientology; who listened to the music of Karlheinz Stockhausen as well as Iggy Pop and the Stooges, Black Flag, Minute Men, X, Germs, and the Blasters; who read *MAD Magazine* and the philosophical treatises of Theodor Adorno, Antonin Artaud, and David Cronenberg; who joined the White Panthers, ate junk food, promoted anarchism, associated with the Students for Democratic Action, and performed with the alternative bands Sonic Youth and Destroy All Monsters?

Mike Kelley exploits his fluency in these multifarious forms of discourse. They are the basis for his shrewd and penetrating cultural assessments. But it is not merely the breadth of his experience that distinguishes his work. His acclaim stems as much from the mental posture he applies to this endeavor. Kelley preserves that painful stage of human development situated between the innocence of childhood and the socialization of maturity. He revels, perpetually,

in the ravaged excesses of adolescence. Kelley has become fixed in a state of hormone-driven belligerence. His art smells, sucks, and seethes like a teen ordeal. The most despised ingredients of modern life become the menu from which he chooses his subjects. He explores trash, feces, acne, bad breath, incontinence, eyeglasses, coffins, impotency.

Likewise, the aesthetic ingredients of his work are antithetical to socially endorsed definitions of beauty and value. He is attracted to things that are common, crude, cheap, old, soiled, and banal. Kelley frames what is tasteless and creates monuments out of objects branded disagreeable. The artist describes his special predilection for the things most people despise as encompassing *"death and anything that shows the body as a machine that has waste products or that wears down."*[2] When he goes to work, he first loads the object with pathos and then prevents you from liking it: *"You don't feel sorry for it, you want to kick it. That's what I wanted out of the thing—an artwork that you couldn't raise, there was no way you could make it better than it was."*[3]

Kelley's first recognition in the 1980s coincided with the counterfashion craze known as Grunge. Its name, purportedly a contraction of the words "grubby" and "dingy," resisted the prettifying and decorating aesthetic that is identified with the commercial establishment. Things in our environment that are bright, new, colorful, and visually appealing are usually things designed by advertisers and packaged by producers to lure customers. "Pretty" came to seem devious and manipulative. Ugliness and abasement became their honorable antidotes. Kelley's homely artworks share Grunge's self-denigration. Both seek relief from marketing conceits. The subjects and the aesthetic ingredients of Kelley's sculptures are all ripe for "kicking." He relishes the material that has been edited out of our history books: the sordid details that have been suppressed in the name of patriotism, decency, and high art. His intemperance and indiscretion comprise a zealot's pursuit of realism. Experiencing his work is like a hot-rod ride without safety belts. The viewer careens past familiar signposts and crashes headlong into the truth. In the wreckage lie rules of decorum and sanitized versions of history.

In some works, Kelley is overtly contentious, as when he transforms Superman into an oversexed pederast or the Supreme Court building into an outhouse. In others, his depictions are disconcertingly accurate. Summoning the neglected facts of history, Kelley topples cherished cultural icons from their positions of honor.

"Dolls represent such an idealized notion of the child, when you see a dirty one, you think of a fouled child and so you think of a dysfunctional family."

Suicide commemorates Mark Rothko's accomplishment. Bloodstains recall Abraham Lincoln's role in history. Naziism emerges as Plato's legacy.

The massing of rules, expectations, and delusions around the subject of mother and child has made that relationship a particular target of Kelley's merciless scrutiny. The bond between mother and child is honored by society and blessed by God, recorded in high art and reinforced by Hallmark greetings and the Brady Bunch. All these forces describe a mythic ideal: mothers are pure, self-sacrificing, tender, and joyfully devoted to maintaining the sanctity of the family. Children are innocent, obedient, sweet, and dutifully grateful to their mothers.

In shattering this myth, Kelley uses stuffed dolls as emblems of this idealized vision of the family. But his dolls are not the cute creatures in pastel colors with oversized eyes, smiling faces, and rounded bodies that embody romanticized notions of childhood and serve as compelling metaphors for wholesome family life. Kelley is sly. He reverses the meaning of this readymade metaphor, debunking its flattering attributes. The dolls he chooses for his sculptures are often used and soiled. Parts may be missing. Ears may be frayed. In fact, their descent from beloved playthings to trash is confirmed by Kelley's method of acquisition. He purchases them from thrift shops and fleamarkets where they appear after having been discarded by their original owners. He then reconfigures these pitiful, anonymous castaways and exhibits them in the elite settings of art galleries to disclose the distressing truth about the institution known as the American family.

Kelley does not represent his subject matter. He presents it. Conventional art mediums are rejected because they are neutralizing elements. *"If you want to talk about certain things, you just can't get them across (with art mediums). Take the stuffed animals. It's all about their tactile presence. You can't convey that in a drawing. Also, if they're dirty or fouled, you just can't convey that."*[4]

He describes his contribution—at its most successful—as being virtually invisible. *"When my doll works, the viewer isn't led to reflect on the psychology of the artist but on the psychology of the culture."*[5] The cultural psychology revealed by dolls not only applies to children who play with them, but also to adults who make or purchase them. Whether mass-produced or hand-made, dolls manifest adult notions of childhood. *"Dolls represent such an idealized notion of the child, when you see a dirty one, you think of a fouled child and so you think of a dysfunctional family. In actuality, that's a misreading, because the doll itself is a dysfunctional picture of a child. It's a picture of a dead child, an impossible ideal produced by a corporate notion of the family. To parents, the doll represents a perfect picture of the child—it's clean, it's cuddly, it's sexless, but as soon as the object is worn at all, it's dysfunctional. It begins to take on the characteristics of the child itself—it smells like the child and becomes torn and dirty like real things do. It then becomes a frightening object because it starts representing the human in a real way and that's when it's taken from the child and thrown away. In our culture, a stuffed animal is really the most obvious thing that portrays the image of idealiza-*

"The whole modernist cult of the child in which the child was seen as this innocent figure of pure, unsocialized creativity . . . is a crock of shit and is part of the problem, not the solution."

tion. All commodities are such images, but the doll pictures the person as a commodity more than most. By virtue of that, it's also the most loaded in regard to the politics of wear and tear."[6] A damaged and dirtied doll provides incontrovertible evidence that children don't fulfill the ideal. The child who used this toy was not always sweet, harmless, and obedient.

As these references to things "fouled" suggest, Kelley goes for the jugular in exposing deep-seated myths about American family life. This requires presenting real toys whose wear and tear are evidence of a real child's attachment. Retrieving one from a thrift shop suggests that a mother discarded it and hence was, at least for that moment, neither caring nor patient. Perhaps these toy sculptures are disturbing because they mirror the discomfort provoked by real children. Kelley's sculptures are "frightening objects" because they raise unsettling questions. Do parents treat their children the way they treat their children's toys, rejecting them when they no longer conform to an ideal? Are discarded toys evidence of mothers' disappointment and frustration? Do real children suffer when they are compared to ideals they can't fulfill?

In *Arena #2* (Kangaroo) (1990), a child's real security blanket becomes the backdrop for a fictionalized birth. The birth is enacted by a toy kangaroo and witnessed by two cuddly elephant dolls, one blue and one pink. The blanket is in a pathetic state of disrepair. Its faded color and tatters provide evidence that a real child sought security in its folds: a safe haven that is also suggested by the kangaroo's pocket/womb. Even if the child who was once so attached to this blanket eventually outgrew its use, the fact that it was discarded indicates a disregard for the meaning it once held. Through such associations, the sculpture heightens concern about circumstances that destroy children's confidence.

In *Eviscerated Corpse* (1990), the vagina of a hanging doll discharges a mass of stuffed toys that tumble fourteen feet out onto the floor. The world is indifferent to their birth.

Double Figure (Hairy) (1990) presents a goofy doll's head with a wagging tongue sewn between the spread legs of a stuffed, hairy monster. *Estral Star 3* (1991) merges two identical sock monkeys at the groin. Both sculptures shatter the illusion that youngsters are sexually innocent. Most are curious about sex. Some are coerced into sexual activity and subjected to sexual abuse.

Arena #5 (1990) stages a psychothriller with two E.T. dolls who bend over a third, recumbent doll. Is it a victim? Is it injured? Is it dead? A

fourth doll, a witness, is placed in the corner. Its head is hung as if in shame. This sinister drama may be staged with fantasy characters, but the violent circumstances they enact are facts in many children's lives. Tragically, real children witness death, rape, and assault.

The "lumps" in *Lumpenprol* (1991) refer to objects buried under a huge afghan blanket. The "prol" refers to the working class. The German word "lumpenproletariat" refers to the lowly, and, by implication, contemptible masses. The viewer never sees what lies hidden under the blanket, but an audiotape that accompanies the sculpture provides a clue. It plays sections from Henrik Ibsen's "Ghosts," recounting the terror of a son who fears he may have inherited syphilis from his father. The piece is a memorial to children who are inflicted with their parents' indiscretions.

In other works, Kelley scorns the idealized conception of motherhood that continues to be reinforced by the church, the media, and politicians despite the fact that motherhood has ceased being a predictable role. Many women who choose the "mommy track" swerve off the path of the nuclear family to become stepmothers, working mothers, lesbian mothers, postmenopausal mothers, single mothers, and artificially inseminated mothers. Under the glare of his fuming pubescent scrutiny, Kelley pierces our lingering delusions. He employs toy-giving as a metaphor for tangible exchanges between mother and child as well as those, like self-sacrifice, that are emotional. The title of a 1987 sculpture, *The Wages of Sin/More Love Hours Than Can Ever Be Repaid* sums up conditions attached to both kinds of gift-giving. Kelley invented the term "love hours" to describe this currency of exchange. Instead of signs of affection, gifts are signs of extortion because the transaction between giver and receiver involves the expectation of repayment.

Love hours are the debt children owe their mothers, who expect to be reimbursed in the form of affection and obedience. Kelley suggests that family "bonding" implies a creditor mother and a debtor child. *"Basically, gift-giving is indentured slavery . . . There is no price, so you don't know how much you owe. The commodity is the emotion . . . And if you can't pay it back right away, it keeps accumulating."*[7] Hand-crocheted

MIKE KELLEY
The Wages of Sin/More Love Hours Than Can Ever Be Repaid, 1987
Wax candles on base with stuffed animals and afghans sewn on canvas, 26 x 24 x 24 in. / 96 x 127 x 6 in.
Courtesy Metro Pictures, New York
Photo: Douglas M. Parker Studio

toys are especially powerful symbols of maternal needs. The mother who crochets a toy uses a method that is outmoded and inefficient in terms of production, but highly successful in terms of demanding a child's devotion.

Kelley's doll sculptures are distress signals for frustrated mothers and insecure children. They suggest that romantic idealizations of family must be uprooted if today's epidemic of abuse and neglect is ever to be quelled. A recent surge of popular films indicates that confronting the crisis in the American family is a shared pursuit. The darker side of motherhood

is represented in "Serial Mom," "The Grifters," "Postcards from the Edge," "Terms of Endearment," "Mommie Dearest," and "Ordinary People." The painful ordeals of childhood are represented in "Boyz 'N the Hood," "My Girl," "What's Eating Gilbert Grape," and "American Heart." "Prince of Tides" dramatizes the emotional toll that a horrific childhood experience exacts throughout a lifetime. All confirm that motherhood can be tainted by selfish needs and that childhood is often encumbered by obligations.

In their original state, toys convey the myths and ideologies of the dominant culture; they are cute, hygienic, asexual, and compliant. Old, worn, and reassembled as art, they become symbols of the corruption of these standards. If subscribing to society's unattainable myths is destructive, perhaps destroying these myths is constructive. Kelley's art is social therapy that doesn't equivocate. *"The whole modernist cult of the child in which the child was seen as this innocent figure of pure, unsocialized creativity . . . is a crock of shit and is part of the problem, not the solution."*[8]

Kelley has produced an enormous body of work: drawings, paintings, videos, performances, banners, installations, constructions, sculptures. Each series is united by theme, not medium. Along with exposing the myth of "family values," he consistently debunks religion, government, and education. If uplifting missions survive his scrutiny, they are transferred to unlikely sources. Janitors become the gateway to the sublime. Mass murderers are presented as the true artists. Garbage is a source of deep meaning. Clumps of dirt are deified. All provide his critics ample opportunity to deride what Kelley calls his *"perverse, malicious desire to drag the good taste of modern art down into the gutter of mass subculture."*[9]

When his doll series was first exhibited in 1987, an appalled public decried the gall of presenting these pathetic objects as art. Sophisticated art viewers asked why an artist would risk his reputation on items designed by toy manufacturers (not an act of inspiration), produced in bulk by factory workers (not the unique work of an artist), available in Wal-Marts and Sears (not an art gallery), and already soiled and disfigured through use (neither beautiful nor desirable). Even those that had been hand-crocheted seemed utterly ineligible as art. Crocheting was rejected as a hobby (not an art), a mere amateur pursuit (not professional), made in the home (not a studio). Furthermore, it was seen as women's work (not worthy of a man). Finally, the crocheted objects had been designed for children (not sophisticated).

Ultimately, these stuffed toy sculptures have earned Kelley the renown and financial remuneration that were never available to the mothers and factory workers who originally made them. Yet he apparently cares less if you like or dislike his work than if you are changed by it. Indeed, those offended by his art constitute his ideal audience. *"I like to think that I make my work primarily for those who dislike it. I get pleasure from that idea . . . I believe that art is socially useful. If it is destructive, it is constructively so."*[10]

KELLEY POSTSCRIPT:

Mike Kelley, Jeff Koons, Vito Acconci, and Meyer Vaisman all have reputations as bad-boys. Through their art they flaunt their indiscretions against social norms, flagrantly disregarding manners and continually devising opportunities to cultivate naughtiness. Typically, one target of their rebellious activities is the edifice supporting the decorum of the art world. But they are as likely to unmask the hypocrisies that surround society's moral values, class structures, and economic behaviors. Perhaps Mike Kelley speaks for his colleagues when he states, *"The viewer is ultimately responsible for my moral point of view and responsible for becoming conscious that they're the ones who are taking a stand in relationship to it. It's not me preaching to them."*[11]

Paul Thek

VAST ACCRETIONS of eccentric items comprise Paul Thek's mysterious installations. Imagine a work of art that consists of a room filled with candles, onions, old shoes, tissues, eggs, bathtubs, plants, stuffed animals, old newspaper, works of art by other artists, and objects left over from previous pieces by the artist. Despite the extraordinary effort that

was expended in their creation, each environmental art work by Paul Thek was dismantled after it had been exhibited. Some elements were discarded. Others were recycled into future works.

EPHEMERALITY

Missiles and Bunnies, 1983
Mixed media, dimensions variable
Installation: Plans for the Arts, Pittsburgh
Courtesy Alexander and Bonin, New York

Paul Thek

Born 1933, Brooklyn, New York; died 1988
Art Students League of New York
Pratt Institute, Brooklyn, New York
Cooper Union School of Art, New York

See colorplate 15, page 31

PAUL THEK
Noah's Raft, 1985
Mixed media, dimensions variable
Installation: Bienal de São Paulo
Courtesy Alexander and Bonin, New York

PSYCHOLOGISTS commonly report that the desire to overcome death often drives the artistic impulse. This seems especially true for artists who strive to materialize the essence of their being. Once transmuted into an enduring form, these artists survive beyond their lifetimes, eternally present in the annals of art history. They imagine their works protected from the ravages of time, isolated from the elements, and exempt from the fickle nature of human memory. Art offers the ever elusive promise of immortality.

The aspiration to everlasting renown is difficult to maintain alongside the belief that the present is sandwiched between dreaded expectations of the future and aborted dreams from the past. Today, many regard the environment, popular culture, medical care, educational systems, and political institutions as imprinted with history's failures. There is as much to deplore as to celebrate. Better to forget than to remember. In fact, no one, no concept, and no thing seems exempt from the threat of oblivion.

At the same time, doubt has replaced confidence that civilization will flourish into the next millennium, or that it will even endure. Few living artists presume their work will enter the

accumulated legacy of cultural achievements. Art-making still invests artists' lives with intention and significance, but it no longer offers the promise of immortality. Some contemporary artists have acquiesced to the evidence that all things on earth perish in time. Creating fixed objects in a stable material has assumed the character of a futile effort to halt this relentless and inevitable passage. The work of these artists mirrors instead a new transitory model. Some have created art out of ice that melts, or organic matter that decomposes, or dust that blows away. Some enact performances. Others designate their thoughts as works of art. I have selected Paul Thek to represent this shared realization because of two factors that intensify its implications: Thek's work manifests a lifelong preoccupation with time and mortality, and he died of AIDS in 1988 at the age of 54.

Even before he became ill and was forced to confront the deterioration of his body and his impending death, Thek acknowledged the inevitable brevity of existence. Transience is at the core of his major works, which are neither paintings nor sculptures: they take the form of constructed scenarios. These environments require that visitors abandon the traditional mode of art-viewing, in which frames and pedestals erect boundaries that separate the art object from the observer. Thek discarded such barriers, inviting his audience to enter the work of art by traversing a course—literally walking over ramps and bridges and passageways—observing along the way arrangements of dramatically illuminated objects that were either found, created by the artist, or contributed by collaborators. Thek provided a constellation of experiences that evolved through space and time.

The contest between the ephemeral and the enduring pervades these theatrical settings. The drama takes place within architectural forms that suggest pyramids and cathedrals. Thek refers to them as *"Temples of Time,"* monuments to the desire to extend the limits of human life. They are accompanied by objects that manifest the actual brevity of earth time: clocks, piles of daily newspapers, and sprouting bulbs. Tissues, mere wisps of matter, are suspended over areas of sand where every visitor's foot leaves its imprint, disrupting a carefully raked pattern. All are part of Thek's obsession with the inevitability of transformation, the relentless passage of days and nights, the futility of believing in enduring legacies.

These attitudes diverge from the commercial motivations that drive human activity in most spheres of today's social complex, including the field of art. Thek rejected the power-seeking, money-accumulating method of attaining

"To paint something beautiful is not as good as BEING something beautiful."

immortality, a method he associated with the capitalist system. This disparity determined every component of his output. The subject of his work, its physical form, and his working method were governed by the acceptance of flux and transition in all things material and secular. His disinterest in erecting enduring monuments refutes the economic and social values of his Western heritage.

Perpetual evolution characterized his method of working. In his installations, Thek rejected the convention of commencing with an inspiration and ending with the work's material manufacture. He believed that the creative process itself was a bearer of meaning and should not be confined to the studio. Impulse and labor entered the space of the museum and extended beyond the opening day of an exhibition. Thek's work continued to evolve throughout the duration of the show or as long as circumstances would allow. On one occasion he actually lived in the museum, locked in at night to continue the process of adding, subtracting, and rearranging his installation's elements. Whether it was messy, clumsy, halting, or inspired, the creative process itself was placed on display, not as a preparatory act, but as an event of significance.

Moreover, Thek repudiated the notion that an artist's career could be segmented into units, each of which commenced with an idea for a work of art and culminated in a finished product. Instead of creating many discrete works, Thek continually unfolded a single work of art until his death. The title of the installation *Pyramid/A Work in Progress* (1971-72) urged viewers to

consider each exhibition as a segment of an ongoing drama. Resolution was perpetually postponed. Thus, just as the process of creation did not end when an exhibition opened, it did not terminate when the show closed. At this time some of the work's components would be destroyed. Others were preserved for inclusion in

refuge from the profane world and guided them toward a spiritual path. Eternity—no longer a goal for this world—was implicitly reserved for the afterlife.

The temporary nature of Thek's installations was attuned to the provisional quality of the tangible world. These works in progress undermined confidence in the possibility of achieving immortality through ambition, output, and material consumption. They were settings where viewers might catch their breath, escape the realm of clocks and calendars, and experience the merging of past, present, and future, birth and death, growth and decay. Thek molded secular time into liminal time. *"I sometimes think that there is nothing but time, that what you see and what you feel is what time looks like at that moment."*[2]

> ## *"I sometimes think that there is nothing but time, that what you see and what you feel is what time looks like at that moment."*

future pieces. Parts served as iconographic elements that were recycled again and again, reappearing in ever new and original circumstances. Each exhibition, by providing ingredients for the next, became physically integrated with its successors. Thek's installations are woven into one continuous fabric.

The materials Thek chose further incorporated his dynamic principle. Grass sprouted. Fruit decayed. Candles expired. Flowers wilted. They broadcast the actuality of time as a thematic and form-giving aspect of his work.

People were also an ingredient. He sought their interaction in every form. Several long-term collaborators, like Ann Wilson, participated in both the conceptual and the physical aspects of Thek's works. In some cases they occupied his museum installations, playing music, writing, or sitting among the work's components. Thek also embraced non-artists. In every country, people seemed drawn to his Pied Piper charm. His life, like his art, was imbued with a communal, improvisational spirit. *"To paint something beautiful,"* he once said, *"is not as good as BEING something beautiful."*[1]

Thus, instead of seeking to arrest time, Thek embraced the essential qualities of nature and culture: mutability, mobility, dissolution, and physical extinction. This emphasis on the transitory nature of materialism was not an end in itself. It proclaimed Thek's intense religious convictions. A devout Catholic, he lived simply according to self-imposed vows. The fervor of his belief drove him to attempt over and again to gain admission into a monastery. Ultimately he transferred this religious ardor to his works of art. Asserting the vanity of seeking immortality in this life, Thek offered secular-minded visitors a

Thek often scheduled shows to coincide with Christmas and Easter. He used these opportunities to present art as sacrament. The museum experience became a mass in celebration of creation, death, and resurrection. Creation was made manifest through his use of materials and objects that are metaphors for primordial events: water, eggs, and sprouting tulips. Death appeared in the guise of beeswax forms painstakingly painted to look like chunks of bloody, raw meat, which Thek arranged in the shape of a birthday cake with stainless steel candles, or in which he inserted tubes for drinking "blood cocktails." There were also battered shoes, tomblike constructions, dismembered warriors, human hair, lit candles, ashes, a stuffed raven. Resurrection was indicated, as it is in many mythologies, through trees, ladders, and bridges. There was also room for comedy. Through the introduction of roller skates and bathtubs with oars, Thek implied that this great cosmic journey could be accomplished in unconventional ways. At the same time, his imagination was infused by his own travels. For example, he cited as an influence *"those Baroque crypts in Sicily: their initial effect is so stunning you fall back for a moment and then it's exhilarating. There are 8,000 corpses—not skeletons, corpses—decorating the walls, and the corridors are filled with windowed coffins. I opened one and picked up what I thought was a piece of paper; it was a piece of*

dried thigh. I felt strangely relieved and free. It delighted me that bodies could be used to decorate a room, like flowers. We accept our thingness intellectually, but the emotional acceptance of it can be a joy."[3]

Thek's environments led the visitor on a pilgrimage that parallels the Catholic mass but is distinctly different from the formal, canonical, priestly tradition that is commonly practiced today. He revived the Christianity of its original practitioners, those who worshipped in secret in the depths of the catacombs during the centuries immediately following the death of Christ. There, as in Thek's environments, no priests were present. Thek created a setting for communal celebration. As a humble, modern-day redeemer, he described himself as a composite of the Pied Piper, Bo Jangles, Bozo the Clown, Hippie, Fishman, Tarbaby: *"It was just me . . . I wanted to be Tarbaby. I wanted people to become stuck in my ideas, so you couldn't get away from them."*[4]

Thek did not aspire to mundane forms of immortality and so was not inclined to erect shrines to himself. His ego yielded to a spirit of equanimity that he sustained even as he became progressively more ill. His friends relate that he approached death, step by step, with more joy than resistance. During the last months he grew a garden of huge yellow flowers in coffee cans on the roof of his tenement loft in lower Manhattan.

Because Thek welcomed collaborators, chance, and the processes of nature, none of his installations survive. Nor did he endorse photographic records as art objects. The material elements of his work evaporated into a residue of experience. But it is through their ephemerality that the visitor came to fully sense that we live "in time," and must face the inevitability of our own transmigration. Thek demonstrated that there is only one way to be released from clock time and historic time and the dreaded end of life. Religion allows us to experience eternity. His installations are measured by their effect on a person. They are sacraments to be enacted, not owned.

In fact, Thek wrote 96 Sacraments. The concluding seven encapsulate the spirit of his efforts:

> *To wink, Praise the Lord!*
> *To appreciate cobwebs. Praise the Lord!*

> *To have a tooth ache. Praise the Lord!*
> *To be left alone. Praise the Lord!*
> *To be afraid of the dark. Praise the Lord!*
> *To be confused. Praise the Lord!*
> *To be.*[5]

THEK POSTSCRIPT:

It is no longer assumed that art should be metaphorical and that literal forms of expression are reserved for scientific pursuits. Today's artists adopt the means appropriate to their ends. Metaphorically minded artists weave circuitous routes, revealing their purposes through intimations and evocative references; they welcome the imprecise and unstable world of symbols. Literally minded artists forge direct paths toward their goals; they are purveyors of facts and seek specificity of meaning. For example, Andrea Zittel's designs for living offer imaginative solutions to real problems; they improve the quality of daily life. Similarly, Mel Chin actually reclaims tainted earth, David Hammons constructs a house, Orlan refashions her flesh. Paul Thek, on the other hand, reveled in the evocative qualities of materials. Oblique symbolic references loosen the grip of practical considerations and release the mind into territories not affected by such banalities. His installations, like Mesa-Bains's altars, serve as meeting grounds for the material and the spiritual, the past and the present, the personal and the communal, the divine and the mundane.

Gerlovina & Gerlovin

RIMMA GERLOVINA AND VALERIY GERLOVIN describe their works as "photoglyphs," a conjunction of two contradictory words that derive from the Greek. Photo means "writing with light." Glyph means "carved symbol." Photoglyphs, therefore, link writing with carving, light with matter, action with object, transience with permanence. Illogical pairings are typical ingredients of the Gerlovins' work. These two artists intentionally subvert logic.

Serpent, 1989
Ektacolor print,
$37^1/_2$ x $37^1/_2$ in.

Courtesy Steinbaum
Krauss Gallery, New York

IRRATIONALITY
IRRATIONALITY

Gerlovina & Gerlovin

See colorplate 5, page 21

Rimma Gerlovina
Born 1951, Moscow, U.S.S.R.
Moscow University
Lives in Pomona, New York

Valeriy Gerlovin
Born 1945, Vladivostok, U.S.S.R.
School of Art and Theater and Stage Design, Moscow
Lives in Pomona, New York

TO WHOM DO YOU TURN for wisdom and advice? A scientist? a congressman? an astrologer? a priest? your parents? a teacher? a psychologist? Categories of authority vary over time and reflect the dominant operational forces in a society. Control of knowledge may be invested in God or in government, or it may reside in technology and science. For the past five centuries Western society has placed its faith predominantly in the institutions that utilize empirical methods and in the people who excel in rational thought. Logic is the bulwark upon which the West's language, culture, philosophy, and science are erected.

Yet Rimma Gerlovina and Valeriy Gerlovin have renounced such faith in analytic thinking and its goal, the discovery of enduring truths. Their art may contradict these inherited convictions, but it is in perfect accord with current experience. New information is constantly being discharged and, just as precipitously, discarded. Presumed truths hardly seem different from fads in technologies, fashions, celebrities, songs, foods, and toys. They are all perpetually edited, corrected, reconsidered, and revised. The following four excerpts from news stories, all of which appeared in a single week in the *New York Times*, demonstrate that facts about health, history, science, and culture are actually unstable and unreliable.

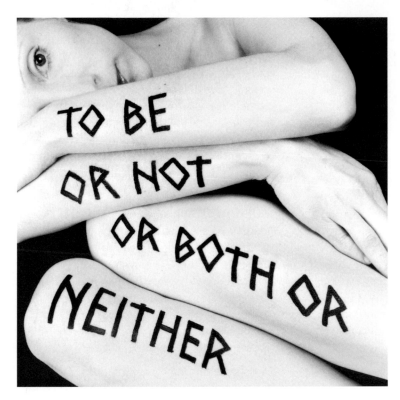

RIMMA GERLOVINA and
VALERIY GERLOVIN
To Be, 1989
Ektacolor print, 37 ½ x 37 ½ in.
Courtesy Steinbaum Krauss Gallery,
New York

HEALTH: *(Sunday, April 17, 1994)* "When a new study, published last week, found that vitamin E and beta carotene—two of the so-called antioxidants—might not protect against cancer and heart disease after all, that they might even cause harm, it came as something of a shock . . . The recent study of 29,000 Finnish men who were heavy smok-

RIMMA GERLOVINA
and VALERIY GERLOVIN
BE-LIE-VE, 1990
Ektacolor print, 48 x 48 in.
Courtesy Steinbaum Krauss
Gallery, New York

ers, was the first rigorous scientific test of the purported powers of beta carotene and vitamin E. To almost everyone's surprise, the vitamins did nothing to protect the men against cancer or heart disease. Even worse, the men taking beta carotene had 18 percent more cases of lung cancer, more heart attacks, and an 8 percent higher overall death rate."

HISTORY: (Monday, April 18, 1994) "Today is Patriot's Day, the anniversary of Paul Revere's Ride in 1775. Every American has heard the story of that event . . . but we haven't all remembered it the same way. The best known version is still Longfellow's poem of 1861, written to help the Union cause . . . The generation of Theodore Roosevelt turned the silversmith into a military hero, calling him 'colonel Revere.' Its pur-

pose was to praise the martial virtues and celebrate selfless service to the nation-state. The idea rang hollow after World War I, and a new breed of American, the historical 'debunker' came into existence around 1923. Some debunkers delighted in demonstrating that Revere never reached Concord . . . The debunkers fell quiet in December 1941. (Revere was used to) celebrate the ordinary American in an hour of extraordinary peril. With the crusading in the 1950's, Revere was converted into . . . a capitalist on horseback . . . After Vietnam and Watergate, the myth of the midnight ride was attacked with unprecedented fury . . . The new iconoclasts raged against America and made the rider a symbol of evil."

SCIENCE: (Tuesday, April 19, 1994) "For years, molecular biologists have held fast to a deep-seated belief about the nature of cancer. Malignancy, they argued, must have something to do with a loss of molecular brakes that halt the growth and division of cells . . . But that picture has recently changed. Basic research on the cell cycle and studies of the genetic causes of cancer have now built to a crescendo . . . The crescendo reached a peak last week with a paper in *Science* magazine announcing a newly discovered cancer gene . . ."

CULTURE: (Thursday, April 21, 1994) "A leading Picasso scholar says that hundreds of paintings and drawings made by the artist during the 1920's were inspired by an infatuation with the American socialite and jazz-age luminary Sara Murphy, and are not, as has long been thought, idealized figures or depictions of the woman who was Picasso's wife at the time, Olga."

Artists are among representatives of countless disciplines who face the vacuum formed by the dissolution of faith in enduring and reliable knowledge. Many have sought tenets to fill this void. The Gerlovins' art presents a cogent visualization of some of these new ideas:

Relativism: Truth is contingent on circumstance.
Pluralism: Theories, approaches, and inter-

pretations can be multiple and equally viable.

Dissolution of hierarchies: There are no secure criteria of value and no abiding measures of significance.

Synthesis: Apparent opposites can coexist because all things are interconnected.

Suspension of belief: Deep insight can only be attained by discarding assumptions, hypotheses, and facts.

Rimma Gerlovina and Valeriy Gerlovin give visual form to propositions that contradict mental "sense" and our physical "senses." Their art asserts such illogical propositions as the possibility that the past and the future are contained in the present, that two bodies can occupy the same space at the same time, that space has energy, that living and nonliving entities are not easily differentiated, that there is order in randomness, that a speck of dust contains the truth of the entire universe. Incredibly, these unlikely constructs are being proven by advanced science. Apparently such illogical principles now define the nature of the physical universe.

The Gerlovins produce "photoglyphs," a term they originated to describe their gorgeous color photographs of mind-bending non sequiturs written on the artists' bodies and faces. For instance, in *To Be, Or Not, Or Both Or, Neither* (1989), the title is stenciled in bold, black letters onto Rimma Gerlovina's alabaster-colored skin. Both of her arms and legs are marked with an inference that has no rational conclusion. For this work, the artists have borrowed Hamlet's famous question, "To be or not to be?" and extended it by adding two additional alternatives: to be and not be; to neither be nor not be. The dilemma of this renowned four-hundred year-old hero is thereby updated to make it relevant at the end of the twentieth century.

Hamlet's tidy duality is thus transformed into a bewildering conundrum. It asserts the futility of the search for unequivocal answers. Neither logic nor deductive reasoning is capable of mastering its proposition. No known authority can provide the answer. In the photoglyph, Gerlovina's body, the bearer of the words, is curled in on itself as if she has withdrawn into irresolution. She is literally and metaphorically marked by her confusing destiny. Her image extends beyond the edges of the resulting 37-inch-square Ektacolor print, suggesting she can't be contained by its tight, logical borders. *To Be* envisions life in a state of paradox. By relieving visual and verbal languages of their obligations to convey verifiable information, it portrays illogic. People who depend on these languages to construct meaning undoubtedly find this work disorienting.

The Gerlovins' interest in the evasive nature of truth has particular relevance to their biographies. Both were born in the former Soviet Union, Rimma in 1951, Valeriy in 1945. They lived in a country where the slippery nature of language was entrenched in state policy. Journalistic writing was manipulated to construct an "official" version of news. Information was censored. Rhetoric was determined by propagandistic necessity. Double meanings and duplicity were employed in the service of espionage.

Paradoxically, these techniques of deception were also utilized by individuals who defied the official dictates of the Party. The Gerlovins were among them. Active in the Soviet avant-garde art movement in Moscow in the 1970s, the decade prior to the dawning of glasnost, they were leaders of a community of artists that conducted clandestine activities and mounted secret exhibitions. Verbal and visual subterfuge was utilized to veil the subversive content of their works. Double meanings, puns, and innuendos protected them from detection by government authorities who themselves used double meanings to support the state.

The Gerlovins emigrated in 1980 to the United States, where they discovered new evidence of linguistic and optical irrationality. Democratic governments and capitalistic economies are not exempt from stretching and collapsing, manipulating and orchestrating meaning. These strategies pervade the euphemisms in political rhetoric and the deceptions in the commercial naming of products. The latter is the target of a cartoon by Steve Kelley in which he stocks supermarket shelves with Greasy Pieces, Fat Nips, Lard Cakes, Sugar Fatty Flakes, Cholesterol Crisps, and Oily Puffs. Even in ordinary usage, language is not a factual medium of communication.

Vocabulary fashions views. Linguistic structure imposes assumptions about relationships. Even the use of nouns is misleading because it implies the existence of static, discrete objects. Advanced science reveals that objects (nouns) are perpetually in a state of flux. In today's version of the truth, the physical universe can only be described using verbs.

The Gerlovins give form to the proposition that reality is defined by paradox. Viewers exam-

RIMMA GERLOVINA
and VALERIŸ GERLOVIN
Unanswerable Question, 1990
Ektacolor print, 48 in.
diameter

Courtesy Steinbaum Krauss Gallery,
New York

ining their work, therefore, are led to acknowledge this troublesome proposition. The photoglyphs that they have been producing since 1989 concoct multiple, contradictory, logic-defying situations. They mirror our times.

BE-LIE-VE (1990): Two strands of hair cross over Rimma's face to form an X that divides it into four sections. The word "BELIEVE" is written across her forehead, its three middle letters—LIE—isolated in the top section. Faith (believe) is united with deception (lie). Oppositions merge.

Serpent (1989): Rimma is shown in profile with her tongue protruding. A snake is painted on her forehead and continues down her cheek where her open mouth becomes the serpent's mouth. She and the snake share the same

tongue. Here Eve unites with the serpent; innocence and guilt converge.

I Am Mortal (1988): Valeriy inserts his finger, painted with a scarlet letter A, into the word "immortal," which is painted across his face. The gesture creates a confluence of opposites: "I am mortal" merges with "Immortal." Two equal, opposing, and irreconcilable possibilities (finite life and eternal life) coexist.

Unanswerable Question (1992): The unanswerable question is presented as an unrecognizable arrangement of letters. The spiraling question mark in the middle of Rimma's forehead refers both to the undeciphered message and the meaning of the words. Like the third eye, this question mark signals the enlightenment that unknowing yields.

True-False (1992): In this work, a mirrored reflection of Rimma's profile inverts its meaning. The words "true" and "false" become each other's likeness. They even share their common endings, the letter "e," which is inscribed on an egg hovering in the space between the two profiles. Presumed dichotomies merge into a whole egg. The words are as logically absurd as they are metaphysically true: the nucleus of life is both true and false, right and wrong, good and evil.

Theories advanced by such renowned scientists as David Bohm confirm that the illogical unification of dichotomies actually abounds in the universe. Physical reality is an undivided whole, not a collection of separate objects or phenomena. Bohm carries this perplexing observation beyond the field of science. In dialogues with the Indian mystic Jidhu Krishnamurti and the Tibetan spiritual master, the Dalai Lama, he discussed the meaning of nature, existence, death, truth, reality, intelligence, and so forth. The three thereby set the supreme example of the merging of dualities by demonstrating that a Western physicist and Eastern mystics pursue identical issues and offer complementary revelations.

The Gerlovins, like Bohm, disturb the elemental assumptions that constitute Western world order. Those who are invested in language, cognition, and classification attempt to solve the riddle and to search for rational conclusions. But the Gerlovins provide no answers to their conundrums. Indeed, they deny the possibility of a sin-

gle answer. *"Light does not exist without shade. Unity comes in a fusion of duality. We regard art as an organic union of interrelated parts, whose balance, as any living organism, is important to maintain."*[1]

Although the artists intentionally erode confidence in objective thought and certain knowledge, they do not abandon the viewer to a traumatic psychological rupture. The Gerlovins have discovered opportunities for spiritual growth in incongruity. Relinquishing dependence upon the mind is a prerequisite for the actualization of the spirit. *"We view art only as a vehical* [sic] *to obtain a spiritual experience that transcends the intellect."*[2] The existence of pure awareness beyond thought has long been a neglected source of insight and creativity. Photoglyphs train the spiritual faculties of the mind; they *"open the soul to look inside . . . We have to rely not only on social sources of information, but we have to look inside for our development. The more we develop inside, the better we deal with each other and improve the world."*[3]

In search of a means to "transcend the intellect," the artists revised an old, venerated Russian art tradition, religious icon painting. Their photoglyphs are vested in this legacy. Like the painted icon, they dematerialize the physical world and arrest time. Their subject is, most often, Rimma's porcelain face, which glows with the grace and enigmatic calm of a madonna. Furthermore, the photoglyphs recapitulate the format of an icon. Rimma's figure is positioned centrally in the composition. She exists in a dark space devoid of references to the mundane world. Her *"still performances,"* as she calls them, consist of poses, facial expressions, and gazes that resolve into the monumental stasis that speaks of eternity. Rimma embodies the mysticism of the Russian icon. These works envision a nondimensional, nontemporal, nonphysical world.

Other sources of imagery in the Gerlovins' work include Raja Yoga, Eastern philosophy, Gnostic iconography, Biblical symbolism, Jewish mysticism, Russian poetry, Zen philosophy, Greek and Roman mythology, Egyptian hieroglyphics, alchemy, numerology, and scientology. All of these ancient systems describe a struggle for truth that is strangely appropriate to the post-industrial era. They forsake sensual contact with the world, abandon the expectation of natural causation, quiet the intellect, empty the consciousness, and purify the mind. Rimma has whittled these complex issues down to a succinct maxim: *"Dreams are true while they last. A lie can come in the form of a truth. Each has some of it, none has all."*[4]

GERLOVINA & GERLOVIN POSTSCRIPT:

In the early days of photography, photographic equipment was so cumbersome and the process of taking pictures so slow that all but the most determined photographers were confined to the studio. The advent of smaller cameras in the early years of the twentieth century and the invention of the 35mm camera in the 1920s lightened and streamlined the picture-taking process and allowed photographers to take to the boulevards, the fields, and the back roads, where they directed their cameras at lived realities. Now many artists who use photography—among them the Gerlovins, Laurie Simmons, Orlan, James Luna, Jeff Koons, Sherrie Levine, and Andres Serrano—have returned to the studio. This reversal is not due to necessity. All seem motivated by the desire to invent the circumstances, construct the narratives, and contrive the aesthetics of the images they photograph. The fact that so many artists utilize studio locations suggests that candid shots of random occurrences don't capture contemporary experience. The contrived intensity of today's media environment is more accurately chronicled by synthesized images produced in studio settings.

OVER THE COURSE OF HISTORY, individuals displaying multiple talents have received receptions ranging from praise to scorn. In the Renaissance, for instance, practitioners of diverse occupations were venerated as geniuses. After the Industrial Revolution, however, people who resembled the multifaceted Renaissance masters were ridiculed as dilettantes. Gerhard Richter's distinguished career provides

Gerhard Richter 34

evidence that generalists may be regaining credibility over specialists. Richter aspires to proficiency in an extraordinary range of artistic pursuits. But he has not resurrected the myth of the Renaissance man. Richter's motivation seems rooted in his association of specialization with fanaticism.

Stadtbilt Paris. 1968. Oil on canvas, 78³/₄ x 78³/₄ in.
Courtesy Marian Goodman Gallery, New York

Portrait of a Young Woman, 1988. Oil on canvas, 26¹/₃ x 24²/₅ in.
Courtesy Marian Goodman Gallery, New York

INCONSISTENCY

Gerhard Richter

See colorplate 9, page 25

Born 1932, Dresden, Germany
Kunstakademie, Dresden
Staatlichen Kunstakademie, Düsseldorf
Lives in Cologne, Germany

WOULD YOU RESPECT a musician who claims to have mastered all the instruments in an orchestra? Would you entrust your health to a doctor who fills teeth, performs open-heart surgery, delivers babies, and provides psychiatric services? Do you admire an artist who fluctuates between abstraction and representation? Who is sensual and conceptual, improvisational and systematic, linear and chromatic? Who paints, sculpts, photographs, makes books, creates performances, and presents inventories of his diverse activities as works of art?

Gerhard Richter is such an artist. Erratic variation from artwork to artwork is commonly condemned as evidence of immaturity, amateurism, or superficiality. He would not seem to be a likely candidate for honor in our museums, libraries, and classrooms. These halls of fame accord secular forms of immortality to individuals credited with accomplishing exceptional deeds. They exalt the concept of individuality and nurture an abiding faith in the creative powers of the uncommon man or woman.

Artists who are commemorated in these institutions are typically innovators who invent forms of expression that differentiate them from both their predecessors and their successors. Bracketed between the past and the future, their work becomes so identifiable that even unsigned pieces can be recognized as theirs. These distinguishing characteristics are the hallmark of Western masterpieces. They are known, collectively, as style.

Within this tradition, the process of developing a style is expected to proceed in a logical manner until it culminates in the production of works of art that embody the artist's abiding world view. Art earning masterpiece status conforms to a biological metaphor that compares the invention of new styles to the evolution of new species. Each is a deviation from an established norm. It stabilizes long enough to receive a defining name before mutating into the next form. Rarely are artists credited with inventing more than one style.

Gerhard Richter's thirty-year career seems an anomaly within this context. Despite his disinterest in inventing one distinctive style or asserting his uniqueness, he is honored as one of the most significant artists of his generation. His life's work is devoid of the sustained vision that ennobled artists in the past. Arranging his work chronologically reveals an array of techniques,

GERHARD RICHTER
778-2 Gray, 1992
Oil on canvas,
40 ½ x 28 ½ in.

subjects, mediums, and attitudes, and an assortment of contradictory preferences, beliefs, and temperaments. The only "ism" that suits Richter's career may be "pluralism."

Richter's pursuit of heterogeneity can be traced both to internal motivations and external factors. Born in Germany in 1932, he not only grew up in a doctrine-laden society, he witnessed the devastating effects of World War II. The stifling atmosphere of East German dogmatism directed his art training to the constricted, institutionalized schemes allotted to socialist-realists. These early

biographical experiences resound in his mature work. They convinced him that ideological thinking is not only limiting, it is dangerous. Credos advance the sinister designs of dictators and propagandists who, according to Richter, use them to *"seduce and exploit uncertainty, legitimize war."*[1] The artist defended himself against succumbing to these menacing forces by cultivating a state of non-belief. *"I have become involved with thinking and acting without the help of an ideology; I have nothing that helps me, no idea that I serve and am known for . . . no rules that regulate the how, no belief that gives me direction, no picture of the future, no instruction that produces an overly ordered mind."*[2]

Although Richter's withdrawal from doctrines originated in wartime Germany, it resonates today. Many politicians and law-abiding citizens seem to share his distrust of the impassioned rhetoric that erodes rational judgment and threatens respect for authority. They associate such strong convictions with members of independent militias, bombers of abortion clinics, fundamentalists, cross-burners, hijackers, and Ku Klux Klansmen. Devotion is linked with fanaticism, terrorism, and militancy.

Further evidence of the relaxation of convictions can be observed in behavior that was once condemned as a breach of commitment, loyalty, or integrity, but is now accepted as normal. Public opinion is kind to politicians who join the party they once denounced; to baseball players who exchange uniforms; to corporate executives who accept job offers from the competition; to Christians and Jews who seek forms of spirituality in the East; to individuals who abandon their childhood homes or sue for divorce.

Erosion of authority can also be discerned within the major institutions in the West. Social commentators frequently observe that neither religion nor school, family nor state, provides the infrastructure upon which individuals can erect orderly lives. For example, where can artists turn in search of guidelines? Governments don't supply official standards. Traditions don't offer established conventions. Academies don't teach rules. Critics don't apply reliable criteria of merit. The collapse of structure in art is so typical that it provides the theme for many of the masterworks of twentieth-century art, literature, and philoso-

phy. In them, the individual is often depicted as isolated, lost, vulnerable.

In contrast, Richter seems to welcome the dissolution of ordering systems, reveling in the freedom it allows. Indeed, his visual emancipation proclamation is fueled by a world in disarray. He excuses himself from his predecessors' search for unity and allows discontinuity to be his ruling mechanism, demonstrating that an abnegation of stylistic consistency is not an abnegation of spirit, but proof that the barriers to creative exploration have finally been eliminated. The tremendous disparity between Richter's works of art celebrate anarchy. As he explains, *"Inconsistency is simply a consequence of uncertainty . . . At all events, uncertainty is part of me; it's a basic premise of my work. After all, we have no objective justification for feeling certain about anything. Certainty is for fools, or liars . . . (My pictures) make no statements at all, so they can't fool us."*[3] The exhilaration conveyed in his work offers viewers a release from their own fixation on coherence and unity. Richter proclaims that art promotes *"lost qualities, for a better world; for the opposite of misery and hopelessness."*[4]

Richter finds a world of limitless options in the multimedia excerpting of the history of art that is broadcast through print and electronic networks, often as the background for advertising display. *"What counts is the world of the mind and of art in which we grow up. Over decades, this remains our home and our world. We know the names of those artists and musicians and poets, philosophers and scientists; we know their work and their lives. To us they—and not politicians and rulers—are the history of humankind; . . . for rulers can make their mark only through atrocities."*[5] He utilizes materials, subjects, techniques, and expressive devices from the vast repertoire provided by his predecessors and colleagues. His withdrawal from any specific system—and the diversity of his efforts—can only be appreciated when numerous works are taken into consideration. Richter himself demonstrates the importance of taking this broad view. He keeps immaculate records. In his inventories, which themselves have been exhibited as works of art, every work is numbered and represented by a miniature scale model.

By revising and reassembling the vocabulary of past styles, Richter announces the *"futility of the history of avant-garde painting's attempt to outdo itself . . . by proposing always one more attempt at possibility, at extending the boundaries of art."*[6] But he also resists nostalgia. *"I see no sense in exhibiting painting's old, lost possibilities. I want to say something. I'm interested in new possibilities."*[7] With two significant exceptions—he rejects specialization and discards the need for a single, identifiable style—Richter's art is all-embracing. The following list provides a synopsis of the range of his work.

REPRESENTATIONAL PHOTO PAINTINGS:
Portraits, still lifes, cityscapes and landscapes.
Bird's-eye points of view and frontal points of view.
Repainted photographs from family albums, newspapers, magazines, year books, encyclopedias, etc.
Paintings based on Richter's own photographs.
Paintings that streak, blur, or completely obliterate evidence of their photographic source.
Straightforward, enlarged, handpainted copies of photographs.
Expressive handpainted images.
Paintings of photographs accompanied by text.

ABSTRACT PAINTINGS:
Free Abstract paintings—records of the artist's feelings.
Smooth Abstract paintings—impersonal; they either present geometrical forms or suggest enlargements of blurred microscopic photographs.
Gray paintings—undifferentiated fields of gray.
Color Charts—enlarged copies of paint sample charts.

STYLE: The following terms, many of which are mutually exclusive, have been used to describe Richter's paintings: kitsch, sublime, classic, romantic, ugly, beautiful, realistic, sentimental, diagrammatic, objective, subjective, systematic, expressive, neutral, complex, tactile, visual, conceptual, transcendent, material, modest, hard-

edge, soft-edge, spatial, linear, chromatic, monochromatic, straightforward, exuberant.

TECHNIQUE: In some paintings the paint is brushed. In others it is sprayed, rolled, or stippled. Some works indulge in a display of virtuosity through bravura brushwork, compositional complexity, heavy impasto, and rich polychromatic orchestrations. Richter adopts a wide variety of tools, painting with small brushes, house painter's brushes, rakes, rollers, sprays, and palette knives. He sometimes uses a tiny brush to create wide strokes. Other works show indifference to dexterity through the adoption of mechanical means or systematic procedures. Richter also employs chance to explore unanticipated options. He works alone and in collaboration. Even within a single abstract painting, he avoids a consistent technique, further proof that he finds congruity confining.

BEYOND PAINTING: Richter creates free-standing constructions out of glass, doors, and mirrors. He composes books and performances and such conceptual pieces as a complete inventory of his own paintings.

Yet even these manifold options do not fulfill the artist's penchant for colors, forms, and subjects. Richter invites reality itself to enter his art. In one sculpture, the everchanging aspects of real life are seen through the freestanding construction of panes of glass. In another, reflections of reality are captured in mirrors. But even these works are apparently too bound to specific intentions, for Richter also creates works in which glass is covered with opaque gray paint that obliterates the environment.

Richter explains such self-induced contradictions by stating that *"my method, or my expectation which, so to speak, drives me to painting, is opposition."*[8] Even in the midst of working in a given manner, he rejects the basic premises upon which that style is based. For example, a painting may begin as a precisely painted illusionistic copy of a black-and-white illustration, and then be overpainted with abstract expressionist style brushstrokes. Or the process of creating an abstract expressionist painting will be intentionally interrupted to break its emotional continuity. Or a carefully painted image may be sabotaged by pressing newspapers onto its wet surface. By exhibiting the resulting mutilated

image, Richter proposes that destruction, too, is a viable artistic option.

Closure is another option, and therefore another opportunity to resist conclusions and the convictions they denote. Richter sometimes chooses not to complete a work. *"There is no concrete, utopian moment . . . The only paradox is that I always begin with the intention of obtaining a closed picture, with a properly composed motif. Then, with a relatively big effort, I proceed to destroy this intention piece by piece, against my own will almost, until the picture is finished—that is, until it has nothing left besides openness."*[9]

Paintings are generally perceived to be more congenial to self-expression than photographs, which are more conducive to information. Richter deliberately subverts these expectations. He obscures the content of photographs by blurring, erasing, or streaking them; or he paints over them by hand to destroy their mechanical basis. To avoid even these broad parameters congealing into a credo, he also produces straightforward, painted copies of ordinary found photographs. Sensual paintings imbued with *"erotic desire and love of both painting and the woman depicted"* are included in his compendium of approaches. Other works thwart such romanticism, as when he paints a straightforward image of a cow borrowed from a children's book and then makes its simplicity yet more explicit by incorporating the word "cow" into the composition.

Richter's embrace of oppositions extends as well to his use of color, whose descriptive, symbolic, and expressive functions he both exploits and suppresses. A series of monochrome fields of gray paint impedes emotional and interpretive responses. *"Gray is for me a welcome and unique possibility of achieving indifference, of avoiding definite statements."*[10] Yet Richter also manages to strip some fully hued paintings of color's communicative potential. For example, he enlarges copies of standard paint sample cards, mixing colors in predetermined proportions. In these cases, art-making occurs *"without inner involvement, like crushing stones or painting a building. Making is not an aesthetic act."*[11]

The rigorous methods of applying paint to canvas in the color charts are also barricades

against the expression of personal intentions. Richter uses as well an antithetical technique for this same purpose. He gambles with chance, hoping *"that something will emerge that is unknown to me, which I could not plan, which is better, cleverer, than I am, something which is also more universal . . . in the expectation that a picture would emerge there . . . one that represents our situation more accurately, more truthfully; that has something anticipatory; something also that can be understood as a proposal, yet more than that; not didactic, not logical, but very free and effortless in its appearance, despite all the complexity."* [12]

Richter is disengaged from belief systems. He presents no platform, forms no alliances, promotes no doctrines, expresses no preferences, and creates no trademark style. But a lack of style does not indicate a lack of purpose. *"So it may be . . . the important thing for me is that this kind of negativism and pessimism is a useful strategy in life; there is a highly positive side to it because one has fewer illusions."* [13] Nor does lack of style indicate a complete lack of constancy. Like the practices of those who wear different suits on different occasions, Richter's unwillingness to remain loyal to one kind of artwork does not eliminate his personality. *"All the different pictures at different times do have one consistent foundation; that's me, my attitude, and my intention, which may express itself in different ways, but never essentially changes. The variety is superficial."* [14]

Richter's message can be summed up by his statement that *"Hypocrisy is the murder weapon that suits us best."* [15] *"That is why I think so highly of psychoanalysis, because it removes prejudices and makes us mature, independent, so that we can act more truly, more humanly, without God, without ideology."* [16] By creating diversity he hopes to achieve *"the most perfect form of humanity."* [17] Richter insists that art without doctrine is capable of conveying the *"highest longing for truth and happiness and love."* [18] *"In abstract painting we have found a better way of gaining access to the unvisualizable, the incomprehensible . . . This is not some abstruse game but a matter of sheer necessity; the unknown simultaneously alarms us and fills us with hope, and so we accept the pictures as a possible way to make the inex-*

plicable more explicable, or at all events, more accessible . . . Art is the highest form of hope." [19]

Richter's work presents a reverse utopia, one in which optimism, peace, and security are discovered in disparity, incongruity, and unpredictability. Like a politician who employs evasion as the surest route to election, Richter's suspension of belief allows him to embrace oppositions, ignore contradictions, and include everyone in his propositions. As his work makes clear, two options confront everyone. Within our fragmentary and unstable environment, we can either succumb to confusion or revel in the opportunity it offers.

RICHTER POSTSCRIPT:

Artistic merit can be discovered in orderly arrangements as well as in chaotic jumbles. Haim Steinbach's commodities are arranged with meticulous precision. Christian Boltanski's clothing is heaped in disarray. Amalia Mesa-Bains scatters the elements of her work. David Salle and Toni Dove orchestrate a great accumulation of visual elements. Janine Antoni welcomes the collapse of order in her lard cube. Chuck Close obeys the rigid scheme of a grid, but he has recently discovered opportunities for improvisation within it. Meyer Vaisman utilizes discordant elements as a satirical device. Vito Acconci contrasts the order of a meeting with the clamor of a crowd. Paul Thek arranges and scatters accumulations of objects. Felix Gonzalez-Torres erects neat stacks but also spills random piles. Gerhard Richter occupies multiple sites along this range of compositional possibility.

Sherrie Levine

SHERRIE LEVINE is best known for
taking photographs of famous
photographs by well-known photog-
raphers and presenting them
as her works of art. But instead
of instigating accusations of
plagiarism, her blatant confiscations
are accepted as new works of art.
They certainly are a new way
of creating art. They also convey a
totally new idea: they challenge
the assumption that originality is
desirable or relevant.

EDWARD WESTON. *Neil, Nude*, 1925
Gelatin silver print, $9\,^1/_3$ x $7\,^1/_5$ in.
© Center for Creative Photography, Arizona Board of Regents

This is the famous Edward Weston photograph
subsequently rephotographed by Sherrie Levine.

UNORIGINALITY

Six Nudes of Neil, 1925 by Edward Weston
Poster announcing publication of a limited edition
portfolio printed by George A. Tice

Copyright 1977, Witkin Gallery, Inc.

Sherrie Levine's *Untitled (After Edward Weston)* was
shot from this poster.

IN THE LONG VIEW of history, "What's new?" is not an old question. It may seem old to those who are nostalgic about year-old tunes on the radio, who replace last season's wardrobes before they are worn, or choose their reading from top sellers' lists. But within the broad span of time, the expectation that things will and should change is a modern concept. So too is the idea that great artists invent new forms of art. For most of civilization, the making of art conformed to well-established traditions; its practitioners thought of themselves as artisans, not creators. There was no anticipation of novelty.

Today, novelty is entrenched in our assessments of art. It is responsible for the autumn ritual that sends collectors, curators, and critics scurrying to the galleries to discover fresh talents. These art enthusiasts hailed Sherrie Levine as a great discovery in the late 1970s when she produced a body of work that, ironically, subverts the very notion of original creation. She took photographs of famous photographs and presented them as her works of art. Her bold displays of imitation assert that innovation has again ceased to be a prerequisite to merit in art.

By the time Levine was born, the battle for photography's acceptance as a fine art had already been won. Levine is one of the artists who instigated photography's second challenge to artistic convention. She not only utilizes photography as a medium for artistic expression, she makes photography itself the subject matter of some of her art.

Levine points her camera at pre-existing photographs, not at a sunset, or farm scene, or

blossom. In truth, her eyes, like ours, see photographs far more frequently than they do these conventional art subjects. Photographs are everywhere. They document history, convey news, record family events, promote candidates, advertise products, and identify us on driver's licenses, library cards, credit cards, and passports. Photographs are even relied upon to record phenomena that are invisible to the human eye: distant planets, deep-sea creatures, infinitesimal units of DNA, unborn babies, and the inner functions of the human organism. Photographic images in the media establish standards of beauty and transmit scenes of atrocities, elevate heroes and intensify evil, serve as courtroom evidence and as tokens of affection. Some critics declare that the camera has usurped our imaginations by cramming our minds with readymade images.

It is on another category of photographic replication—illustrations of famous works of art in magazines, books, and other printed materials—that Levine focuses her lens. She neither recomposes nor reinterprets. Creativity and originality are expunged so that the images remain true to their reproductive sources. Readers are invited to join the viewers of her work by asking themselves the following questions. Those who answer "few" to the first question in each set, and "many" to the second, provide justification for Levine's bold disregard for authenticity.

> Of all the places around the globe that you can identify, how many have you actually visited?
> How many do you know through photos?

> Of all the people whose faces you recognize, how many have you actually met?
> How many do you know through photographic reproductions?

> Of all the works of art you can name, how many originals have you seen?
> How many are known through illustrations in books, magazines, and other printed material?

A wholesale confiscation of fine art photography is committed each time one of these photographs is reproduced by the media. Levine draws attention to this sanctioned form of thievery. Her appropriation of fine art photographs confronts the contradiction between photography (an infinitely reproducible medium) and fine art (commonly considered a unique object). Many art photographers artificially curtail the size of their editions to give their work the aura of a unique object. This exclusivity is compromised when their work is then reproduced in books and magazines. Levine rescues them from this process. The images she photographs originate in the media; but in framing and presenting them as singular works of art, she returns them to the privileged arena of fine art where such mid-twentieth-century photographers as Edward Weston and Walker Evans intended them to be seen.

This homecoming, however, is short-lived. Since 1977, when critics began writing about Levine, her work has attracted so much attention that images of it are invariably dislodged from the fine art setting. They too are returned to the public domain as reproductions accompanying discussions of her work. Referring to a famous photograph by Edward Weston of his son's torso, this process of appropriation can be summarized as follows.

In 1925, Edward Weston created a series of photographs of his son Neil. He enlarged three of the negatives, cropped them, and made palladium contact prints that have become hallmarks in the history of photography. The Witkin Gallery in New York purchased the original negatives from Neil Weston in 1977. They then commissioned George A. Tice to make new prints from six of Weston's negatives. These prints were assembled as a portfolio in an edition of twenty-five. Tice used essentially the same printing technique as Weston, but he did not crop the images as Weston had.

Tice's full-negative reproductions were used on a poster announcing the Witkin Gallery's publication of the portfolio. It is at this point that Levine enters the narrative. In 1981, she photographed Edward Weston's photographs from this poster.

Nor does the tale end here. Lawyers representing the Estate of Edward Weston ultimately protested Levine's confiscation, arguing that—unlike sanctioned reproductions of Weston's work in art books and magazines—it violated

copyright laws. The irony is compounded by the fact that Weston had based his own work on a classical sculpture of a male nude. His photograph, too, was a form of appropriation from the Greek sculptor, Praxiteles.

George A. Tice is an esteemed photographer. Sherrie Levine is an esteemed artist. Both have created new Edward Westons, but their efforts support contrasting attitudes. In an interview in April 1996, Tice explained to me his role in producing posthumous prints from Weston's negatives: "Edward Weston is my hero. Working with his negatives was a chance to pay him back for the things I learned through him. I try to give back twice as much as I take. I do not try to win at the expense of someone else, and this is not a kind of stuttering in which someone only regurgitates. It's a collaboration. I am paying attention to Weston. I try to make the most beautiful prints possible. I'm not in business as a printer. I take an image and I make it an art object. I memorize it. It becomes mine." In sum, both Tice and Levine acknowledge the beauty of Weston's image, but he seeks to enhance its inherent qualities while she utilizes it to advance new intentions.

Ironically, two of Tice's own most famous works were rephotographed, annotated with Tice's forged signature, and submitted to a Sotheby's auction in 1989. News stories reported that these photographs of photographs were counterfeits and that the person who made them was subject to federal prosecution. Tice said, "I'm a victim in this situation." Yet he denies that his reuse of Weston's negatives victimized Edward Weston.

Why isn't Levine's work discredited as counterfeit? Despite the correspondence between the originals and her copies, Levine's versions cannot be mistaken for the original photographs, or even for copies of the original photographs. She works as hard to avoid deceiving viewers as forgers work to betray them. A distinct trail of evidence reveals the multiple recyclings of her images. Size and color, for example, often mimic the mass-produced reproductions of the photographs, not the originals. And her exclusive borrowing of renowned works by now deceased artists assures that her own pieces are recognized as flagrant copies. Indeed copying itself becomes so apparent that it functions as the theme of her work. Through the simple act of making a copy of a pre-existing copy, Levine weakens common assumptions about originality,

> **"Reproduction of imagery became a question of property: what is original? what can we own? You didn't need a philosophical or art-historical background to think about these issues; they had significance beyond the art world."**

value, and possession. Highlighting the prevalence of experiences—both within art and without—that are neither "original" nor "authentic," she exposes the alternative mandates of our "Age of Reproduction."

AUTHENTICITY: Levine disrupts the role of authenticity in art when she refuses to invent her own images. Any photograph complicates the conventional process of authenticating a work of art, a process that has traditionally been conducted by connoisseurs who scrutinize the nuances of style and the minutiae of markings for evidence of an artist's physical and mental presence. Levine makes their task even more problematic because her work has three authors: the artist who originated the photograph; the photographer who copied it for reproduction in a book; and Levine herself, who took a photograph of the reproduction and presented it to the public as a new work of art.

ORIGINALITY: Levine's contribution to art is often measured in terms of the absence of originality. Her titles proclaim the secondhand nature of her activity. Each includes the word "after" followed by the name of the artist whose work has been reproduced: e.g., *After Edward Weston*. Thus she formally disqualifies herself from established criteria for artistic acclaim by announcing that her work is not original. It is an inquiry into the nature of originality.

INDIVIDUALITY: Levine purges her art of individuality by closing the gap between the thing observed and the artist's representation of it. In this way she seals the space in which artists interpret their subject and express their individuality. Eliminating her personality from the art that bears her name subverts the idea

that great art must be associated with great artists.

VALUE: The significant difference between Levine's image and the photograph by Weston, for example, is its meaning, not its appearance. Her work therefore wreaks havoc on traditional measures of merit. It also implies that a copy is no less valuable than an original. Levine's copies may even be more valuable because they embody a new and possibly more profound artistic concept.

POSSESSION: Levine's work only infringes on another's efforts if standard definitions of ownership are applied. But this definition has already been usurped by the widespread proliferation of reproductions. The artist asks: *"What does it mean to own something, and stranger still, what does it mean to own an image?"*[1]

MASTERPIECE: The artworks that Levine uses as her subjects are examples of early twentieth-century masterworks created by esteemed members of the avant-garde. Levine is not a subscriber to their terms of renown. She is not innovative. She does not aspire to virtuosity. Her work does not embody evidence of a unique personality. It cannot be considered a masterpiece. Yet her un-masterpieces are exalted.

GENDER INEQUALITY: The images that Levine utilizes in her photographic works were created by acclaimed male photographers who were active in the 1930s and 1940s. They typically directed their cameras at disadvantaged members of society: children, the poor, the insane, women. If Levine were alive then, she might have been one of their subjects. Instead, she boldly reverses roles with these luminaries by claiming their work as subjects for her art. She thereby subverts male authority and establishes an example for women to be assertive, to take control. *"In the late 70s and 80s, the art world only wanted images of male desire. So I guess I had a sort of bad girl attitude: you want it, I'll give it to you. But of course, because I'm a woman, those images became a woman's work."*[2]

Levine invites viewers to seek parallels between her work and their personal experiences. *"Reproduction of imagery became a question of property: what is original? what can we own? You didn't need a philosophical or art-historical back-*ground to think about these issues; they had significance beyond the art world. I'm interested in the ways in which the art world reflects culture and, at times, epitomizes it. I believe that the most compelling art-historical issues also have meaning outside the art world."*[3]

Non-art situations demonstrate that the value system implicit to Levine's art is a part of everyday contemporary experience. Faxes and xeroxes churn out endless copies. CDs, videos, and computer simulations generate multiples that never even had an original prototype. Manufacturers produce and market copies with full disclosure of their artificial status. Their commercial success is evidence that fakes have lost their pejorative connotations. Plastic plants, astroturf, margarine, Gucci clones, new Colonial furniture, replicas of sports cars, theme parks, and recorded music are all acknowledged counterfeits. So are industrially produced building materials that mimic marble, terrazzo, and other luxury materials. Textiles feign silk and leather. Even museums market replicas of their collections. A young man from New Jersey in a Doors tribute band simulates the performance of the long dead rock star, Jim Morrison; despite his lack of originality, he is a respected performer, not an impersonator. Fake material goods and events constitute the bulk of our real experiences, including our experience of art. Simulated art is a product of an era in which simulated experiences have become the norm. Levine's art reflects the public's acceptance of counterfeits.

Photography is not Levine's exclusive medium. She has based several series on paintings. Levine frames pre-existing reproductions of Franz Marc's work and makes her own copies of paintings by such artists as Vincent van Gogh, Ernst Ludwig Kirchner, and the great Russian Suprematists. In her appropriated self-portraits by Egon Schiele, she "becomes" a tragic male artist: *"I really thought it was a joke. Schiele always seemed like the ultimate male expressionist."*[4] All these works—many times removed from the originals—parody the creative act by proclaiming themselves "Sherrie Levines." *After Degas*, for example, is a photolithograph of a photograph of a reproduction of a painting by Edgar Degas.

Levine has gradually distanced the final product from its source. In 1985 she began to create generalized appropriations rather than copies of particular works. *"What they appropriate are concerns of other artists rather than a specific image. This confuses the issue of originality even more, which I find amusing."*[5] *Meltdown* (1990) takes the form of four woodcuts, each consisting of twelve colored rectangles. These patterns were computer-generated through an analysis of the colors in Levine's own 1983 reproductions of reproductions of paintings by Piet Mondrian, Ludwig Kirchner, Claude Monet, and Marcel Duchamp. The computer scanner transformed these images into blocks that averaged out the colors in those areas. This complex, multimedia process was conducted without the intervention of the artist's hand, eye, or personality. Levine photographed the reproduction and fed it into the computer, which manipulated the image and generated a printout. The image on the printout was made into a wood block from which the final image was then printed.

Levine's work records life amid mass-produced fabrications, synthesized experiences, and an unprecedented proliferation of reproductions. From an ecological standpoint, this surfeit has had disastrous effects. The demand for frivolous commodities, paired with the ease of unlimited replication, depletes our natural resources. Discarded objects and packaging choke our landfills. Emissions and toxins pollute the earth, water, and air. In this context, Levine refers to her work as "antidotal," a remedy to counteract the effects of material excess and environmental abuse. *"The world is filled to suffocating. Man has placed his token on every stone. Every word, every image is leased and mortgaged."*[6] Her art activities fulfill three of the recommendations offered by ecologists. Recycling replaces consumption and disposal; material once considered waste becomes a valuable resource; the circular rhythms of nature replace the linear pursuit of progress. It is nevertheless important to note that Levine, like so many artists, resists being identified with an artistic program. *"I try to make art that celebrates doubt and uncertainty, which provokes answers but doesn't give them. Which withholds absolute meaning by incorporating parasite meanings. Which suspends meaning while perpetually dispatching you toward interpretation, urging you beyond dogmatism, beyond doctrine, beyond ideology, beyond authority."*[7]

"'Appropriation' is a label that makes me cringe because it's come to signify a polemic."[8]

"I'm not making art to make a point or to illustrate a theory. I'm making a picture I want to look at which is what I think everyone does. The desire comes first."[9]

LEVINE POSTSCRIPT:

Visual material from the image-saturated environment is appropriated into the work of many contemporary artists. Their individual concerns are illuminated by the specific source of their selections and the manner in which they integrate these images into their work. Sherrie Levine plucks reproductions one by one. David Salle grabs them by the fistful. The varying size of their seizures is significant. Her selectivity communicates the renunciation of originality in favor of recycling readymade masterpieces. His acquisitiveness illustrates the abundance accessible to him. Jeff Koons, on the other hand, selects material goods and images from popular culture. He then magnifies their most appealing qualities by making them cuter, or more luxurious, or more dazzling, or more embellished, but always more irresistible. Barbara Kruger chooses images based on their political content and then exposes the covert partisan messages they transmit.

HOW IS AVANT-GARDE ART EVALUATED?

VALUE IN AN AGE OF CHAOS

THOMAS McEVILLEY

THE LAST GENERATION—the thirty years or so that this book deals with—was arguably the most abnormal, surprising, chaotic, and troubling era in the entire history of art. All traditions in the realm of the visual came tumbling down to an extent never demonstrated before. Inherited ideas about the relationship between visuality and reality in general were confounded. As visual styles exploded, reality itself seemed to be threatened. A social reaction set in.

In a theoretical sense, what was going on was the overthrow of the Kantian-Hegelian theory of art. The Kantian side of this ideology, articulated most influentially in Immanuel Kant's *Critique of Judgment* (or *Critique of Taste*) of 1796, emphasized the idea of pure form and its immediate impact on sensibility. It was an essentially aesthetic theory of art, which held that Beauty is a universal force that enters the soul with immediate, unquestionable authority at the instant when the soul approaches the beautiful object with openness to it.

This theory prevailed in an overlording way for about two centuries (since before Kant's authoritative articulation of it, actually). In that time it came to seem so natural as to be obvious and unquestionable—not a theory but a fact. The Hegelian element, added about a generation later in the early Romantic period, emphasized the idea of History as a dynamic force, with the conviction that change was a historical necessity leading toward progress.

The urge toward change, of course, was not an entirely new development. Here and there, in the long history of the art of both the East and the West, pockets of this urge—for example, in the shift from the Northern to the Southern Sung landscape style, from running style to grass style calligraphy, from Renaissance to Mannerism, from Cubism to Futurism—existed alongside vast areas

where a fruitful or pleasant or profitable stasis reigned, as in Old Kingdom Egypt, medieval Europe, or Ming Dynasty China.

Yes, nuanced variations, or "developments," in the visual surface had been abroad for ages. But in the years that Linda Weintraub is discussing in this book, something else was happening. Around 1960, the idea became widespread that the aesthetic approach was not really the only available theory of art, or the only available way to make and appreciate the importance of art. Countermovements to this view had already arisen early in this century, most clearly in Dada and Surrealism, and the recent apparent Age of Chaos in art history has been a revival of those earlier, similarly motivated countermovements. The lineage of the last thirty years goes directly back to the era of Dada and Surrealism, roughly from the First World War—which occasioned a tremendous disappointment in the course of Western civilization—to the Great Depression, which returned focus in a desperate way to the needs of bodily survival. At the beginning of that period, Marcel Duchamp had acted out the outlines of the rebellion against the Kantian tradition through two essential strategies: the introduction of real-life objects and chance procedures into art practice.

Granting this simple and obvious lineage, one might say that the recent age of chaotic-seeming pluralistic deconstructionisms was to an extent a replay of the World War I reaction against history. But it was a replay with a broader scale. The impact of Dada and Surrealism in their day might have been as challenging to society in general if it had been more widespread. But those movements functioned as small cultic groups in the midst of a vast proliferation of traditional

aesthetic art modes still articulating the Kantian theory. The ante was upped in the 1960s in terms of scale, and it has been going up ever since.

In addition to the increase of scale, the later generation of artists had a cannier grip on the cognitive and social problems they were dealing with. They were aware that the capitalist Culture Industry had succeeded, more or less, in coopting the intentions of

"One of the principal values of this new canon is its lack of commitment to style, its willingness to mix different visual languages that tend to nullify one another. In fact, one of the central values of this new, yet shifting, canon is its featuring of inner contradiction as a way of pointing to the unavailability of certainty about anything."

Dada and Surrealism. In his book *Dada and Surrealist Art* (1968), William Rubin had gone so far as to say that those artists definitively failed in their attempt to go beyond the Kantian aesthetic theory. Although they tried to produce anti-art, he argued, they helplessly produced great aesthetic art—proving the universality of the aesthetic mode, or the mode of beauty-as-a-universal. Rubin emphasized the residual aesthetic habits that did in fact still inform the work significantly, and ignored the deconstructive force that artists and poets such as Alfred Jarry, Marcel Duchamp, and others seem to have thought was the main point of their work. Dada and Surrealism were perceived as sufficiently small and peripheral to be explained away.

In fact, the deconstructive impulse of the Dada and Surrealist movements was lost in the flow of aesthetic history. For roughly two generations—from, say, 1928 to 1958—artistic practice returned to essentially aesthetic, Kantian explorations. This phase culminated in Abstract Expressionism, the work of the

New York School painters and sculptors such as Barnett Newman, Mark Rothko, and David Smith, and its decadently beauteous aftermath, Color Field Painting.

In the wake of World War II, however, art that sought only to be pretty began to strike many as insubstantial. Within a generation, the deconstructive urge to find radically new approaches began to reappear. But the artists of the 1960s and after were more wary than the Dadaists and Surrealists, having seen the reversal of intentions that their works underwent in the mainstream critical discourse. In Europe and America, artists such as Robert Morris, Joseph Kosuth, Lawrence Weiner, Robert Barry, Marcel Broodthaers, and Hanne Darboven tried determinedly to avert the possibility of such a misunderstanding by rigorously eliminating the aesthetic impulse. Their work, while it had its own agendas, was aimed to a large extent against the theoretical foundations of the previous canon.

This tactic had first appeared (or reappeared) in such phenomena as the Black Mountain school in North Carolina where, in the years 1947-1951, John Cage revived Duchamp's introduction of chance—his abdication of control—into the creative process.

Similarly, Robert Rauschenberg and others revived Duchamp's practice of introducing everyday objects into his artworks. The two great strategies of the recent age were afoot.

"The point is that despite their contradictions of one another, each canon that develops and matures is valid in its own right and in its own sense."

By the late 1950s and early 1960s, when some of the Abstract Expressionists were dead and the survivors had increasingly lost authority, these phenomena multiplied and began to take over the field. Happenings, Pop art, Conceptual art, Body art, and other newly named tendencies were the beginning of the phase known as post-Modernism. Important moments included the first exhibitions of Pop art, in 1962, and the first retrospective exhibition of Duchamp's work, in 1963.

Soon—by, say, 1967—a new canon began to emerge. This canon implied a set of values as much as the Kantian aesthetic canon had. But this new set of value-criteria featured the deconstructive and critical view of art that had arisen in opposition to the aesthetic approach, perhaps merely in a rhythmic reaction to it that is still going on. Ironically yet fittingly, this force—embedded in the work by its makers—served before long to deconstruct their own new canon. The Age of Chaos began to emerge. One "ism" began to follow another quickly, from Conceptual art to Body art to Minimalist art to Postminimalist art, and so on. But this multiplicity was not historically linear in the way of modernist art history. It was simultaneous, or what came to be called pluralistic. As each new canon emerged in the development of the oeuvres of groups of related artists, the prior ones did not simply cease to exist. Old and young, they existed side by side. A generation later, this proliferation of canons and tactics is still intensifying. Much recent art has been called Neo-Conceptual, suggesting the durability of the primal post-Modernist canon as well as the loss of the illusion of historical linearity to a vague combination of cyclicity and chaos.

At first this emerging set of alternative canons seemed aimed in a Duchampian way at the Kantian theory, but things have passed beyond that now. Approaches to the use of art as a critical and deconstructive tool are no longer new. They have gained their own momentum and no longer feel they are aimed against some archaic ideology. They have a new set of values, but these are still values. Instead of pure form and color, the values of criticism, analysis, cognition, social commentary, wit, humor, surprise, and reversal now prevail. These values have become the generalized underpinnings of a broad post-Modern approach that contains many styles.

This pluralism of approaches within a broad new canon is the underlying subject of

Linda Weintraub's book. The list of artists in her table of contents—from Wolfgang Laib to Vito Acconci to Christian Boltanski to Sherrie Levine, and many more—embodies the chaotic urge (as in Chaos Theory, which has to do with radical and instantaneous changes of state). Though there are obvious shared values among the oeuvres of these artists, their works nevertheless can be seen as deconstructing one another and, often, themselves. Laib's orientation toward nature, for example, seems at odds with Levine's enclosure within culture. This type of dichotomizing could go on and on in the discourse, where it is not only called pluralism but also difference. The term "difference," as opposed to "pluralism," implies an internal war and irreconcilability, as is inevitable when forces resistant to traditional ideas of coherence or meaning are in the forefront.

In much of this art, with its emphasis on inner contradiction, the idea of certainty is not an appreciated value. The kind of aesthetic certainty, for example, sought by a Pollock or a Rothko, might seem a betrayal of openness or freedom. Rather, nuances of uncertainty and modes of seeking an apparent lack of meaning became leading values in art. And, each in its own way, they could be recognized and appreciated by an audience of art aficionados as readily as could a pretty line or a comely color. There is a relationship here, in certain others of the world's cultures, to the preference for emptiness over fullness, or potentiality over actuality.

One of the principal values of this new canon is its lack of commitment to style, its willingness to mix different visual languages that tend to nullify one another. In fact, one of the central values of this new, yet shifting, canon is its featuring of inner contradiction as a way of pointing to the unavailability of certainty about anything. In this new situation, any position seemingly articulated in a work, an oeuvre, or a school should simultaneously be negated in that same work or

oeuvre or school. A sense of skeptical balancing of yes and no became a stylistic tendency appearing in many forms that are discussed in Weintraub's book.

The point is that despite their contradictions of one another, each canon that develops and matures is valid in its own right

> "The point is that it is innately appropriative and even hiddenly imperialistic to claim that any specific canon is exclusively and universally valid."

and in its own sense. The situation might be compared to the so-called wave-particle theory in twentieth-century physics, or to the relationship between quantum theory and the theory of relativity. Each member of these pairs contradicts the other, yet science has found both valid. In fact, it seems that from a truly post-Modernist, pluralistic point of view, the continuing practice of Kantian-style aesthetic art by older artists such as Robert Mangold, Robert Ryman, and Agnes Martin, as well as by younger artists such as Donald Sultan and Sean Scully, must also be considered valid in this relative way. The point is that it is innately appropriative and even hiddenly imperialistic to claim that any specific canon is exclusively and universally valid. That was the way of the aesthetic theory of art, which held that the values of a pure sensibility simply could not be wrong, or relative. Among the major changes in the period in question is a loss of faith in the idea of beauty as a spiritual universal and, consequently, a change in the idea of the role of the artist. The artist actually came to be the destroyer of the idea of beauty, a trait seen in many of the artists in this book, from Joseph Beuys to Mike Kelley.

It is for this concatenation of reasons that Western society in the last decade has become increasingly hostile to and uncomprehending of what artists are doing. In 1992 in the United States, the remarkable spectacle arose of art becoming an important issue in national politics. This hadn't happened since the McCarthy era.

One presidential candidate embodied the public's confusion and hostility in a promise not only to shut down the National Endowment for the Arts but to seal and fumigate it. The same year saw the so-called NEA 4,

> *"Among the major changes in the period in question is a loss of faith in the idea of beauty as a spiritual universal and, consequently, a change in the idea of the role of the artist. The artist actually came to be the destroyer of the idea of beauty . . ."*

performance artists whose works involve the use of bodily fluids as materials, become national pariahs in the public's eye. Recent and ongoing cuts in the NEA budget show an intense distrust and fear of the arts due to their recent determination to embody the force of radical change.

Yet it has always been a part of the idea of democracy that it must have built-in mechanisms of self-criticism, of which the arts can be one, among others. That's what the Greek tragedians supplied to their culture, and their work was entirely government supported: the Athenian government sponsored its own critics. That is more or less the function that artists have been performing in our culture in the last generation, far more openly than, say, Bosch or Goya or David were able to do in their days. This again is part of the value system that underlies recent art in a way often disturbing to those members of the public who do not experience art directly, at firsthand, so much as in journalistic and political accounts of it. Linda Weintraub explicates clearly a variety of particular cases of these themes in this valuable and welcome book.

ONE SOME THEMES

1

1 Quoted in a conversation with Cindy Sherman, in "The Lady Vanishes," *Laurie Simmons* (Tokyo: Parco Co., Ltd., 1987), 11.

2 Quoted in Beth Biegler, "Surrogates and Stereotypes, Allan McCollum and Laurie Simmons Under the Rubric of Post-Modernism," *East Village Eye* (December/January 1986): 43.

3 Laurie Simmons, lecture presented at the Drawing Center, New York, February 1995.

4 Quoted in Dara Albanese, "Context of Scale," *Cover* (May 1990): 16-17.

5 Quoted in Biegler, 43.

6 Each artist mentioned in the postscripts is also the subject of a chapter in this book.

2

1 Quoted from the author's interview with the artist, New York, 1 March 1996.

2 Quoted in an interview by Suzanne Page, in Harald Szeemann, *Wolfgang Laib* (Paris: Musée d'Art Moderne de la Ville de Paris, 1986), 18.

3 Author's interview, 1 March 1996.

4 Page interview, 20.

5 Ibid., 16.

6 Ibid., 18.

7 Ibid., 16.

8 Author's interview, 1 March 1996.

9 Page interview, 17.

10 Ibid.

11 Author's interview, 1 March 1996.

12 Quoted from an interview of October 1993 by Dider Semin, in "A Piece by Wolfgang Laib at the Centre Pompidou," *Parkett*, no. 39 (1994): 81.

13 Page interview, 17.

14 Semin interview, 80.

3

1 Unless otherwise noted, all quotations are from the author's interview with the artist, 21 May 1993.

2 Mel Chin, "Art and the Environment—The Ingredient," *FYI* 8, no. 1 (Summer 1992).

4

I am grateful to Dr. Burton Brody, Professor of Physics at Bard College, for his guidance in preparing this essay.

5

1 All quotations are from Doris van Drathen, "World Unity: Dream or Reality, A Question of Survival," in *Marina Abramovic*, ed. Friedrich Meschede (Stuttgart: Edition Cantz, 1993).

6

1 Quoted in "Sophie Calle in Conversation with Bice Curiger," in *Talking Art I*, ed. Adrian Searle, Institute of Contemporary Arts (London: Croft & Co. Ltd., 1993), 30.

2 Ibid.

3 Ibid.

4 *Sophie Calle*, "The Sleepers," 1979.

5 Quoted in an interview by Lawrence Rinder, in *Sophie Calle* (Berkeley, CA: Matrix Gallery, The University Art Museum, 1990), 3.

6 Quoted in "Sophie Calle in Conversation with Bice Curiger," 29.

7 Quoted in an interview by Deborah Irmas, in *Interview Magazine* (July 1989): 73-74.

8 Ibid.

9 Quoted in "Sophie Calle in Conversation with Bice Curiger," 33.

10 Ibid., 34.

11 Ibid., 32.

12 Ibid., 37.

7

1 Quoted in Douglas C. McGill, "Two Artists Who Probe the Meaning of Life," *New York Times* (5 May 1985): 29.

2 Ibid.

3 From a conversation between Gilbert and George and Demosthene Davvetas, quoted in *Gilbert and George. The Charcoal on Paper Sculptures, 1970-1974* (Bordeaux: Musée d'art contemporain de Bordeaux, 1986), 14.

4 Ibid., 13.

5 Gilbert and George, "What Our Art Means," in Ibid., 7.

6 Ibid.

7 Gilbert and George, *A Day in the Life of George & Gilbert, the Sculptors* (Gilbert and George, 1971).

8 Quoted in Carter Ratcliff, *Gilbert and George, 1968 to 1980*, ed. Jan Debbaut (Eindhoven: Municipal Van Abbemuseum, 1980), 26.

9 From "Floating," a 7-part charcoal on paper sculpture depicting the artists in a jungle.

10 Gilbert and George, "What Our Art Means," 7.

8

1 Quoted from the author's interview with the artist, May 1995.

2 Orlan, "I Do Not Want to Look Like . . . Orlan on becoming-Orlan," *Women's Art Magazine* 64 (May/June 1995).

3 Ibid.

4 Orlan, "Interventions," unpublished statement, trans. Tanya Augsburg, Michel A. Moos, and Rachel Knecht, April 1995.
5 Ibid.
6 Orlan, "I Do Not Want to Look Like . . . Orlan on becoming-Orlan."
7 Ibid.
8 Ibid.
9 Ibid.
10 Orlan, "Interventions."
11 Ibid.
12 Orlan, "I Do Not Want to Look Like . . . Orlan on becoming-Orlan."
13 Orlan, "Interventions."

9

1 Adelbert H. Jenkins, *The Psychology of the Afro-American: A Humanistic Approach* (New York: Pergamon Press, 1982).
2 Quoted in Iwona Blazwick and Emma Dexter, "Rich in Ruins," *Parkett*, no. 31 (1992): 26.
3 David Hammons, "Speaking Out: Some Distance to Go . . . ," *Art in America* 78 (September 1990): 81.
4 Ibid., 80-81.
5 Ibid.
6 Ibid.

10

1 Amalia Mesa-Bains, "Imagine," *International Chicano Poetry Journal* 3 (Summer/Winter 1986).
2 Quoted in Lucy R. Lippard, *Mixed Blessings: New Art in a Multicultural America* (New York: Pantheon Books, 1990), 82.
3 Quoted in the transcript of "A conversation with Amalia Mesa-Bains," a radio interview by Meredith Tromble, KQED-FM (8 October 1992).
4 Mesa-Bains, "Imagine."
5 Quoted from the author's conversation with the artist, 21 January 1995.
6 Quoted in Sherry Chayat, "Mysticism Pervasive in Everson's 'Other Gods'," *Syracuse Herald American Stars Magazine* (February 1986).
7 Amalia Mesa-Bains, *SOMA* (July 1988).
8 Ibid.
9 Quoted in "A conversation with Amalia Mesa-Bains."

11

1 Quoted in *James Luna. Actions and REactions: An Eleven Year Survey of Installation/Performance Work, 1981-1992*, essays by Andrea Liss and Roberta Bedoya (Santa Cruz: University of California Press, 1992), 9.
2 Ibid.
3 Ibid.
4 James Luna, "Allow Me to Introduce Myself," *The Canadian Theatre Review*, no. 68 (Fall 1991): 46.
5 Quoted in "James Luna: Half Indian/Half Mexican," *News from Native California* (Fall 1991): 11.
6 Quoted in Philip Brookman, "The Politics of Hope:

Sites and Sounds of Memory," in *Sites of Recollection: Four Altars & a Rap Opera* (Williamstown, MA: Williams College Museum of Art, 1992), 35.
7 Quoted in an interview by Julia Mandle, in Ibid., 71.
8 Quoted in "An Interview with James Luna," by Neery Melkonian, in *James Luna* (Santa Fe: The Center for Contemporary Arts, 1993).
9 Ibid.
10 Quoted in *James Luna: Actions and REactions*, 13.

12

1 All quotations are from the author's interviews with the artist, May-October 1994.

13

1 Quoted in "Felix Gonzalez-Torres," an interview by Tim Rollins, in *Art Press* (1993): 23.
2 Quoted in Anne Umland, "Projects" (New York: Museum of Modern Art, 1992).
3 Rollins interview, 17.
4 Quoted from the artist's correspondence with the author, spring 1994.
5 Quoted in Robert Nickas, "Felix Gonzalez-Torres, All the Time in the World," *Flash Art* (November-December 1991): 88.
6 Quoted in an Andrea Rosen Gallery press release, spring 1994.
7 Quoted in Nancy Spector, "Travelogue," *Parkett*, no. 39 (1994): 24.
8 Ibid.
9 Artist's correspondence with the author, spring 1994.
10 Rollins interview, 13.
11 Ibid., 31.
12 Quoted in Nickas, 18-19.

14

1 Quoted in "Pure Painter," an interview by Robert Pincus-Witten, in *Arts Magazine* (November 1985): 78.
2 Quoted in Paul Taylor, "How David Salle Mixes High Art with Trash," *New York Times Magazine* (11 January 1987).
3 Quoted in an interview by Peter Schjeldahl, in *Salle* (New York: Vintage Books, 1987), 48.
4 Ibid., 39.
5 Ibid., 22.
6 Ibid., 69.

TWO SOME PROCESSES

15

1 Unless otherwise noted, all quotations are from the author's interview with the artist, 23 September 1993.
2 Quoted from the artist's correspondence with the author, November 1993.
3 Quoted in Laura Cottingham, "Janine Antoni: Biting Sums Up My Relationship To Art History," *Flash Art*, no. 171 (Summer 1993): 104-5.

4 Correspondence with the author, November 1993.
5 Quoted in Cottingham, 104.
6 Janine Antoni, lecture presented at the Whitney Museum of American Art, 20 May 1993.
7 Quoted from the artist's conversation with the author.

16

1 Donald Sultan, unpublished statement, 1995.
2 Quoted in an interview by Barbara Rose, in *Sultan* (New York: Vintage Books, 1988).
3 Quoted in Carolyn Christov-Bakargiev, "Interview with Donald Sultan," *Flash Art*, no. 128 (May/June 1986): 49.
4 Ibid.

17

1 Quoted in "Haim Steinbach," an interview by Joshua Decter, in *The Journal of Contemporary Art* 5 (Fall 1992): 115.
2 Ibid.
3 Ibid., 119.
4 Haim Steinbach, "McDonald's In Moscow and the Shadow of Batman's Cape," a conversation with Tricia Collins and Richard Milazzo, in *Tema Celeste* (April-June 1990): 36.
5 Ibid., 35.
6 Decter interview, 117.
7 Steinbach, "McDonald's In Moscow," 36.
8 Elisabeth Lebovici, *Haim Steinbach: Recent Works* (Bordeaux: Musée d'art contemporain, 1988).
9 Quoted in Cathy Curtis, "There's Art in Arrangement of Everyday Objects, Haim Steinbach finds meaning where it might escape others," *LA Times* (15 April 1990): calendar section.
10 Decter interview, 120.
11 Ibid., 120.
12 Haim Steinbach, "Joy of Tapping Our Feet," *Parkett*, no. 14 (1987): 17.
13 Ibid.

18

1 Quoted in an interview by Jutta Koether, *Flash Art*, no. 134 (May 1987).

19

1 Quoted in Cindy Nemser, "An Interview with Chuck Close," *Artforum* 8 (January 1970): 55.
2 Ibid., 54.
3 Ibid., 53.
4 Ibid., 51-55.
5 Quoted in *Vija Celmins Interviewed by Chuck Close*, ed. William S. Bartman (Prescott, AZ: Art Press, 1992), 20.
6 Ibid.
7 Ibid., 26.
8 Quoted in "Dialogue: Arnold Glimcher with Chuck Close," in *Recent Work* (New York: The Pace Gallery, 1986).

THREE SOME MEDIUMS

20

1 Quoted in Mary Jane Jacob, *Christian Boltanski: Lessons of Darkness* (Chicago: Museum of Contemporary Art, 1988), 12.
2 Quoted in Georgia Marsh, "The White and the Black: An Interview with Christian Boltanski," *Parkett*, no. 22 (December 1989): 37.
3 Ibid.
4 Ibid.
5 Ibid., 39.
6 Ibid., 38.
7 Ibid.
8 Ibid., 40.

21

1 Quoted in an interview by Simon Watney, in *Talking Art I*, Institute of Contemporary Art (London: Croft & Co. Ltd., 1993), 124.
2 Quoted in Lucy R. Lippard, "Andres Serrano: The Spirit and the Letter," *Art in America* 78 (April 1990): 239.
3 Quoted in Vince Aletti, "Fluid Drive," *The Village Voice* (6 December 1988): 120.
4 Watney interview, 125.
5 Ibid., 127.
6 Ibid., 120.
7 Quoted in Celia McGee, "A Personal Vision of the Sacred and Profane," *New York Times* (22 January 1995): Arts and Leisure, 35.
8 Watney interview, 128.
9 Gauguin's painting is in the collection of the Albright-Knox Art Gallery (Buffalo, New York).
10 Quoted in *Andres Serrano* (Nagoya, Japan: Gallery Center, 1990).
11 Quoted in McGee, 35.
12 Watney interview, 124.
13 Quoted from a letter to the author, 24 December 1984.
14 Quoted in McGee, 35.
15 Watney interview, 122.
16 Quoted in Lippard, 239.

22

1 Unless otherwise noted, all quotations are from the author's interviews with the artist, March, May, and June 1994.
2 Quoted from a letter to the author, June 1994.
3 Ibid.
4 Ibid.

23

1 Toni Dove, "Theater Without Actors—Immersion and Response in Installation," *Leonardo* 27, no. 4 (1994): 281.
2 Toni Dove, "The Blessed Abyss—A Tale of Unmanageable Ecstasies."
3 Dove, "Theater Without Actors."

FOUR SOME PURPOSES

24

1 Quoted in an interview by Willoughby Sharp (1969), in *Joseph Beuys in America: Energy Plan for the Western Man. Writings by and interview with the artist*, ed. Carin Kuoni (New York: Four Walls Eight Windows, 1990), 84.
2 Quoted from an interview by Achille Bonito Oliva (1986), in Ibid., 166.
3 Sharp interview, 85.
4 Ibid., 92.
5 Ibid., 87.
6 Ibid., 85-86.

25

1 Quoted from the author's interview with the artist, May 1993.
2 Quoted from a letter to the author, 10 July 1993.
3 Author's interview, May 1993.
4 Ibid.
5 Letter to the author, 10 July 1993.
6 Quoted in "Areas of investigation," an interview by Benjamin Weil, in *Purple Prose* (Autumn 1992): 30-32.
7 Author's interview, May 1993.
8 Ibid.
9 Letter to the author, 10 July 1993.
10 Author's interview, May 1993.
11 Quoted from a letter to the author, 20 July 1994.

26

1 Quoted in "Words, Pictures and Power," an interview by Moira Cullen, in *Affiche*, no. 13 (Spring 1995): 36.
2 Quoted from the author's conversation with the artist, 23 July 1994.
3 Quoted in *Breakthroughs. Avant-Garde Artists in Europe and America, 1950-1990*, ed. John Howell (New York: Rizzoli, for Wexner Center for the Arts, The Ohio State University, 1991), 228.
4 Ibid.
5 Cullen interview, 40.
6 Quoted in *Breakthroughs*, 228.
7 Conversation with the artist, 23 July 1994.
8 Ibid.

27

1 Quoted in *The Jeff Koons Handbook*, ed. Anthony d'Offay (New York: Rizzoli, 1992), 38.
2 Quoted in an interview by Burke & Hare, in *Parkett*, no. 19 (March 1989): 47.
3 Quoted in Andres Renton, "Jeff Koons: I Have My Finger on the Eternal," *Flash Art* 23 (Summer 1990): 111.
4 Quoted in Dodie Kazanjian, "Koons Crazy," *Vogue* 180 (August 1990): 340.
5 Quoted in Daniel Pinchbeck, "Kitsch and Tell," *Connoisseur Magazine* 221 (November 1991): 34.
6 Quoted in Renton, 112.

7 Ibid., 114.
8 Ibid., 111.
9 Burke & Hare interview, 45.
10 Quoted in *The Jeff Koons Handbook*, 140.
11 Quoted in Renton, 111.
12 Quoted in *The Jeff Koons Handbook*, 130.
13 Quoted in Mark Stevens, "Adventures in the Skin Trade," *The New Republic* 206 (20 January 1992): 29-30.
14 Quoted in *The Jeff Koons Handbook*, 90.
15 Quoted in Paul Taylor, "The Art of P.R. and Vice Versa," *The New York Times* (27 October 1991): Arts and Leisure, 1.
16 Quoted in Giancarlo Politi, "Luxury and Desire. An Interview with Jeff Koons," *Flash Art*, no. 132 (February/March 1987): 72.
17 Ibid.
18 Ibid., 71.
19 Ibid., 72.
20 Quoted in *The Jeff Koons Handbook*, 120.

FIVE SOME AESTHETICS

28

1 Meyer Vaisman, "I Want to Be in America," *Parkett*, no. 39 (1994): 155.
2 Mary Douglas, *Rethinking Popular Culture: Contemporary Perspectives in Cultural Studies* (Berkeley: University of California Press, 1991).
3 Quoted in an interview with Meyer Vaisman and Peter Halley by Claudia Hart, in *Artscribe* (November/December 1987).
4 Ibid.
5 Quoted in Jack Bankowski, "I'm Not an Artist's Artist Any More Than I Am a White Man's White Man," *Flash Art*, no. 147 (Summer 1989): 122.
6 Quoted in "Les Infos Du Paradis, Inter/VIEW," by Trevor Fairbrother, Meyer Vaisman, Andy Warhol, *Parkett*, no. 24 (1990): 137.

29

1 Unless otherwise noted, all quotations are from the author's interview with the artists, May 1993.
2 Quoted in Joshua Decter, "Ericson and Ziegler," *Journal of Contemporary Art* 2 (Fall/Winter 1989): 63.
3 Ibid., 70.
4 Ibid., 61.
5 Quoted in Bradford R. Collins, "Report from Charleston: History Lessons," *Art In America* 79 (November 1991): 71.
6 Quoted in Decter, 69.

30

1 Quoted in David Salle, "Vito Acconci's Recent Work," *Arts Magazine* 51 (December 1976): 90.
2 Quoted in an interview by Richard Prince, in Peter Noever, *Vito Acconci: The City Inside Us* (Munich: Prestel, for the Austrian Museum of Applied Arts, 1993), 176.

3 Vito Acconci, visiting artist lecture presented at Bard College, Annandale-on-Hudson, New York, 11 February 1993.
4 Prince interview, 171.
5 Vito Acconci, "Double-Spacing (Some Notes on Re-Placing Place)," 1978.
6 Quoted from the author's interview with the artist, 1980.
7 Prince interview, 175.
8 Quoted from the author's interview with the artist, July 1981.
9 Ibid.
10 Vito Acconci, visiting artist lecture presented at Bard College, Annandale-on-Hudson, New York, July 1992.

31

1 Quoted in an interview by John Miller, "Mike Kelley," *ART Press* (New York: Art Resources Transfer, 1992): 15.
2 Quoted in an interview by Paul Taylor, in Thomas Kellein, *Mike Kelley* (Stuttgart: Edition Cantz, 1992), 86.
3 Ibid., 8.
4 Ibid., 59.
5 Quoted in "Dirty Toys," an interview by Ralph Rugoff, in *XX Century* (Winter 1991-92): 88.
6 Ibid., 86.
7 Quoted in John Miller, "Mike Kelley," *Bomb* (Winter 1992): 28.
8 Taylor interview, 87.
9 Quoted in Bernard Marcade, "The World's Bad Breath," *Parkett*, no. 31 (1992): 97.
10 Ibid., 101.
11 Miller interview, 15.

32

1 Quoted in Franz Deckwitz, *Paul Thek. The Wonderful World That Almost Was* (Rotterdam: Witte de With, 1995), 22.
2 Quoted in an interview by Suzanne Delehanty, in *Paul Thek. Processions* (Philadelphia: Institute of Contemporary Art, University of Pennsylvania, 1977).
3 Quoted in G. R. Swenson, "Beneath the Skin," *Art News* (1961).
4 Quoted from an interview by Richard Flood (*Artforum* 1981), in "A Maverick Ahead of His Time," *Print Collector's Newsletter* 23 (January-February 1993): 223.
5 Quoted in Deckwitz, 137.

33

1 Quoted in "Rimma and Valeriy Gerlovin," *Recent Exposures* (Sandy Carson Gallery, 1992).
2 Quoted from a letter to the author, 21 July 1993.
3 Rimma Gerlovina, quoted in Catharine Reeve, "Art Institute Exhibits Offer Latter-Day and Early Pioneers," *Chicago Tribune* (12 May 1989): B-1.
4 Quoted in Patrick Finnegan, "Rimma Gerlovina and Valeriy Gerlovin, Robert Brown Contemporary Art," *Contemporanea International Art Magazine*, no. 23 (December 1990).

34

1 Quoted in *Gerhard Richter: Werken op papier, 1983-1986* (Amsterdam: Museum Overholland, 1987).
2 Ibid.
3 Quoted in an interview by Sabine Schutz (1990), in *Gerhard Richter: The Daily Practice of Painting. Writings and Interviews, 1962-1993,* ed. Hans-Ulrich Obrist, trans. David Britt (Cambridge, MA: MIT Press, 1995), 251.
4 Quoted from an interview by Benjamin Buchloh, in Roald Nasgaard, *Gerhard Richter. Paintings*, ed. Terry A. Neff (New York: Thames and Hudson, 1988), 25.
5 Gerhard Richter, "Notes, 1992," in *Gerhard Richter: The Daily Practice of Painting*, 242.
6 Quoted in Nasgaard, 79.
7 Buchloh interview, 28.
8 Ibid., 24.
9 Ibid., 27.
10 Ibid., 79.
11 Quoted in Coosje van Bruggen, "Gerhard Richter, Painting as a Moral Act," *Artforum*, no. 9 (May 1985): 86.
12 Buchloh interview, 25.
13 Quoted from an interview by Hans-Ulrich Obrist, in *Gerhard Richter: The Daily Practice of Painting*, 252.
14 Schutz interview, 211.
15 Richter, "Notes, 1992," 245.
16 Buchloh interview, 22.
17 Gerhard Richter, "Notes" (10 December 1986), in *Gerhard Richter: The Daily Practice of Painting*.
18 Quoted in *Gerhard Richter: Werken op papier*.
19 Quoted in *Documenta 7* (Kassel: D. & V.P. Dierichs, 1982).

35

1 Quoted in "After Sherrie Levine," an interview by Jeanne Siegel, in *Arts Magazine* 59 (June/Summer 1985): 141-44.
2 Quoted in "Sherrie Levine Plays with Paul Taylor," in *Flash Art*, no. 135 (Summer 1987): 55.
3 Quoted in an interview by Lilly Wei, in *Art in America* (December 1987): 114.
4 Quoted in "Sherrie Levine Plays with Paul Taylor," 57.
5 Wei interview, 114.
6 Quoted in Germano Celant, *Unexpressionism. Art Beyond the Contemporary* (New York: Rizzoli International Publications, 1988), 356.
7 Ibid.
8 Siegel interview.
9 Ibid.

INDEX TO ARTISTS